NERVE

THE FIRST TEN YEARS

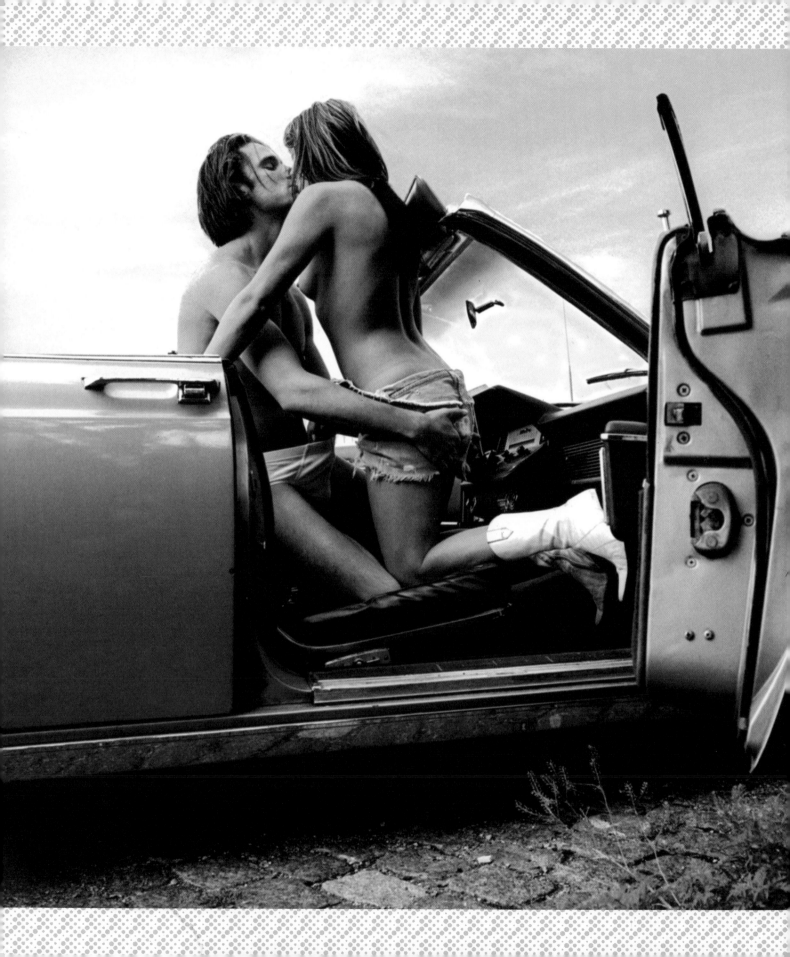

FROM THE EDITORS OF NERVE.COM

NERVE

THE FIRST TEN YEARS

ESSAYS, INTERVIEWS, FICTION, AND PHOTOGRAPHY

CHRONICLE BOOKS
San Francisco

LIBRARY OF CONGRESS CATALOGING-IN-
PUBLICATION DATA AVAILABLE.

ISBN 978-0-8118-5987-5

MANUFACTURED IN HONG KONG

DESIGN BY BROOKE JOHNSON

10 9 8 7 6 5 4 3 2 1

CHRONICLE BOOKS LLC
680 SECOND STREET
SAN FRANCISCO, CA 94107

WWW.CHRONICLEBOOKS.COM

PAGES 2-3: GLENN GLASSER

"PURITANISM: THE HAUNTING FEAR THAT SOMEONE, SOMEWHERE, MAY BE HAPPY."

—H. L. MENCKEN

CONTENTS

(ALL PHOTOGRAPH CREDITS ACCOMPANY THEIR CORRESPONDING IMAGE) › ELIZABETH YOUNG

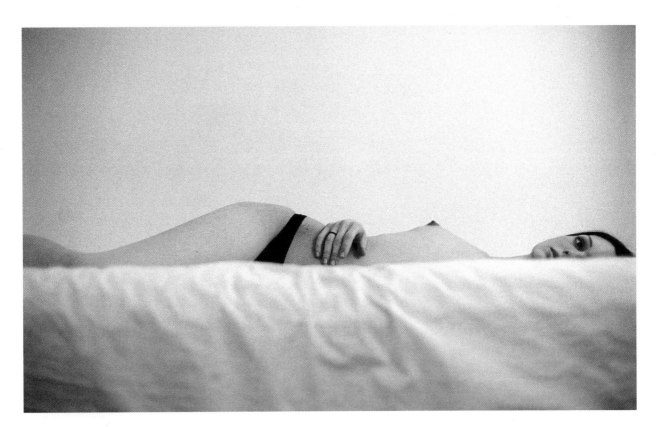

PREFACE

We created Nerve.com way back in 1997 because we wanted to read a smart magazine about sex, and we thought a few other people might too. The plan was to challenge the best writers and photographers of our generation to create work that was explicit in both senses of the word—honest and sexy. Work that would avoid the precious euphemisms of erotica on the one hand, and the mechanical thoughtlessness of porn on the other. We believed that somewhere in between these failed genres—porn representing the limitations of the male perspective, and erotica the female—we could identify a category of writing and photography that would speak powerfully to both men and women.

We chose sex as a category for the obvious reasons. Sure, there was an adolescent desire to break the rules, shock relatives, and attract readers. But we had some less obvious ones as well. We chose it because sex is a subject that people lie about, which provides a great opportunity to do some truth telling. We chose it because it's a subject rutted with clichés and fogged by convention; a subject few have navigated with originality. And we chose it, finally, because it is a crucible human experience, sometimes humbling, other times triumphant, in which we push up against the limits of sentience and quite literally the limits of ourselves, the places where we end and others begin.

With the benefit of hindsight, we timed the launch of Nerve well. June 1997 was before the Lewinsky scandal, before the popularization of Internet porn, and after several decades of cultural conservatism emboldened by the AIDS crisis. Nerve predated the blog explosion, yet confessional writing, in the form of the memoir and personal essay, was ascendant. In the next few years we would see the Starr Report, the rise of HBO's new brand of sexy award-winning television programming, and a torrent of Internet porn that would make a once-scandalous subject alternately absurd and funny.

Throughout the decade, Nerve.com published some of the most honest and provocative writing and photography about sex and sexuality, online or offline. Selecting the material that appears in the pages that follow was nothing short of excruciating because there was so much great work from which to choose. We published more than 5,000 articles and 75,000 photographs during the decade, out of which we selected 43 articles and over 190 images for this volume. Some of the selections that follow are historically specific: Joycelyn Elders, the former surgeon general, weighs in on masturbation; the late Spalding Gray shares his struggles with monogamy; Jack Murnighan excerpts the, um, pithiest moments of the Starr Report; Jane Ross decries the effeminacy of unemployed metrosexuals after the dot-com implosion; Sarah Hepola fantasizes about the disembodied voice of Ira Glass. We included indelible interviews with Norman Mailer, Mary Gaitskill, and David Cronenberg. And we included a number of memorable contrarian positions: Ada Calhoun defends romance between teenage girls and middle-aged men; Jonathan Lethem challenges filmmakers to make better sex scenes; Chuck Palahniuk proposes a new religion based on storytelling. Then there is the funny stuff: Joe Wenderoth drops naughty notes in the Wendy's suggestion box; Lisa Gabriele schools novices on how to be a groupie; Jonathan Goldstein narrowly survives a marathon handjob. And finally, closest to the heart of our enterprise, we have selected some of the boldest pieces of writing we have ever published: the late Lucy Grealy uses sex to overcome her disfigurement; Debra Boxer confesses that she is a virgin at 28; Robert Olen Butler uses a nuclear apocalypse as a pickup line; Lisa Carver learns from her father how to seduce women; Vicki Hendricks imagines a Siamese twin's loss of virginity.

As this book makes clear, publishing Nerve.com every day for the last decade has been a great pleasure for us. Though rarely as sordid as relatives have imagined, or as glamorous as our more generous friends have supposed, it has been riveting work—the stuff of life.

—RUFUS GRISCOM

> RICHARD KERN

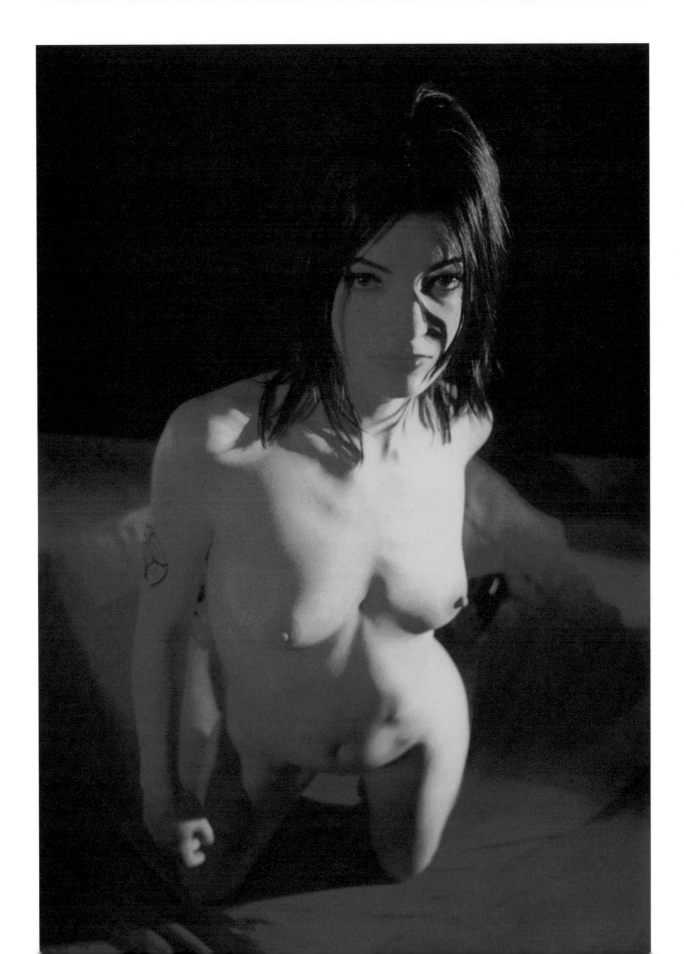

WHAT ARE WE THINKING?
A LETTER FROM THE COFOUNDERS

We created Nerve because we think sex is beautiful and absurd, remarkably fun, and reliably trauma-inducing. In short, it is a subject in need of a fearless, intelligent forum for both genders.

We believe that women (men too, but especially women) have waited long enough for a smart, honest magazine on sex, with cuntsure (and cocksure) prose and fiction as well as striking photographs of naked people that capture more than their flesh.

Nerve intends to be more graphic, forthright, and topical than "erotica," but less blockheadedly masculine than "pornography." It's about sexual literature, art, and politics as well as about getting off—and we realize that these interests sometimes conflict. Erotica does not always understand this—that once our desire reaches a certain clip, attempts at artistry become annoying obstacles in the path of the nouns and verbs (or precious pixels) that deliver the goods. We find ourselves hunting for the naked details in erotica like rushed shoppers in a crowded store. Nerve intends to be direct with both word and image in this space, whether the result is flushed faces, genitals, or perhaps just reflective thought.

This is why we thought the subject of sex deserved an online magazine of its own, and now a book—less to celebrate the gymnastics of sex than to appreciate the way it humbles us, renders us blushing teenagers. Our bodies are fickle, oblivious to convention, and not always beautiful. But we think shame (in small doses) is to be cherished—it makes us honest and human and trims our paunchy egos. It is also lush terrain for good writers; after all, rarely is honesty as difficult and memorable as it is in bed. We still have a smelly-fingered fascination with our shame and desire, and encouraged others to unveil theirs on Nerve.com's Fiction and Personal Essays, which recount various experiences of gender, bodies, and cranky libidos.

As you may have gathered, we see sex as more than a popular sport and marketing tool. Sex calls our bluff—it makes us want to lie, sermonize on the weather, spill our beer. We think this is good reason to look a little closer, examine our discomfort, maybe finish the drink.

Thankfully, sexual squeamishness has diminished a bit over the decades—enough, we think, to make a magazine like Nerve possible. We are grateful for this historical opportunity, and hope that you will help us make the most of it. Even if you don't share our fascination with sexuality, you will find here some of the most exceptional writing and photography in the country.

Finally, we should make plain that while we at Nerve believe in sexual freedom and obvious political rights, we are not on some fix-eyed mission to rally the forces of sexual revolution. Though some would dispose of taboos

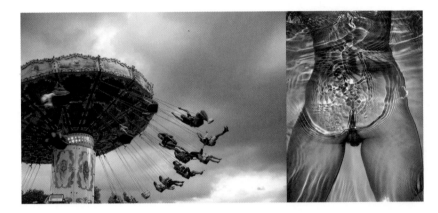

entirely, we prefer to gnaw on them like squeaky dog toys. Of course it's not lost on us that a world without taboos would be a little less in need of Nerve.

But there is little threat of that. So make yourself at home, and dig into the first ten years of Nerve. And then please join the conversation—we'd love to hear your thoughts, whether confessions, manifestos, harrumphs, or hallelujahs, at www.nerve.com/firsttenyears.

—RUFUS GRISCOM AND GENEVIEVE FIELD

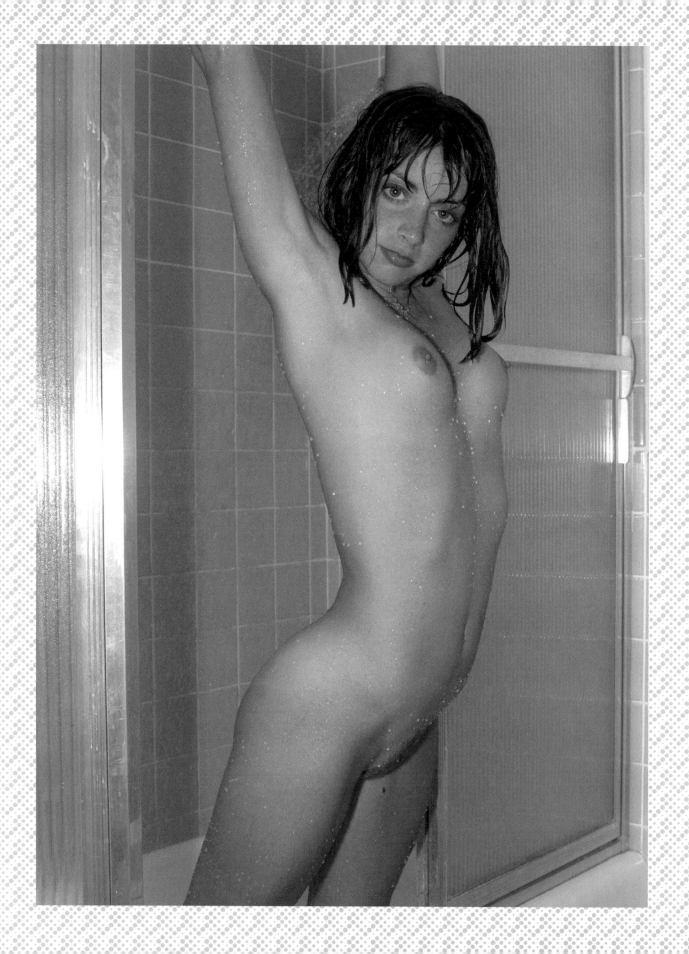

1997

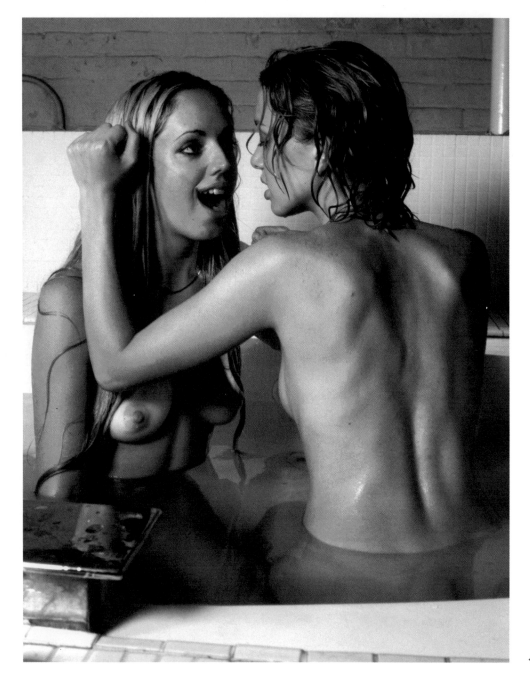

‹ › RICHARD KERN

PHOTOGRAPHY BY
RICHARD KERN

On a sweaty June day, the stoop of Richard Kern's East Village apartment building is crowded with guys shooting the shit and eating takeout. They stop talking and watch me approach. "Kern is 3F," one of them says." "Oh. Thanks," I mumble, and push the buzzer to the apartment whose walls could—and do—tell stories. Hundreds of "girls" have shown up here over the past decade—Kern's *New York Girls*. There are bolt holes in almost every doorway, where some of Kern's more daring models have been strung up for the lens. He leads me into his office and proffers a glass of water. "Hope the slice of lemon is OK." The photographer's southerly sliding vowels and gentle indifference somehow render moot the question I came here with: Why the women in *New York Girls* seem so blasé about being so nasty. Best known for the brutally sordid films that sent audiences running from theaters in the '70s and '80s, and for his noir-inspired photographs of predaceous women who look like they have a taste for pain—perhaps your pain—Kern is now more interested in "making sense" than causing a stir. The photographer seats himself in a sunny corner and looks out the window onto a vacant lot for most of the following conversation. In the silences he incrementally raises and lowers the shade, adjusting the light.
—GENEVIEVE FIELD

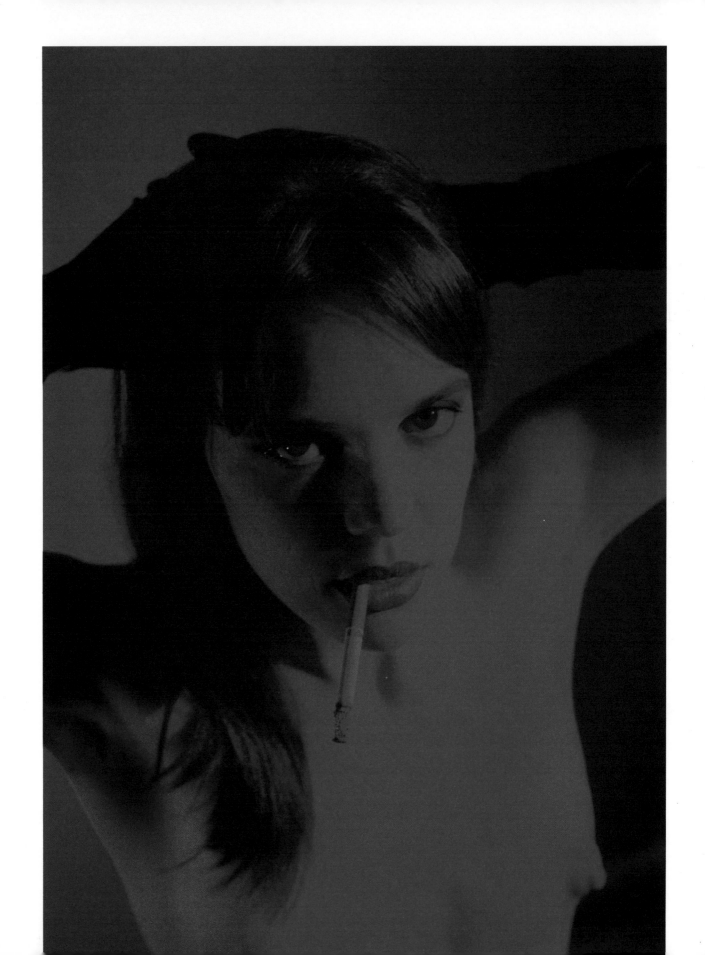

SOME OF MY BEST FRIENDS ARE SENSUALISTS

BY LISA CARVER

There are two main ways of doing it: sexually or sensually. Sexualists are into sex. Sensualists are into eroticism: stuff that isn't sex but involves the suggestion of sex. Sensualists are romantic—they set the mood. They notice details like texture and scent. They light candles. They have plenty of time and they are ready to *explore* the options. Baths have a purpose beyond getting clean if you are a sensualist. You take retreats and sabbaticals. You lie in mud. You kiss for a wicked long time. And I suspect you of liking jazz.

Sexualists, on the other hand, are more enthusiastic, garish, brutal. We're on a mission. Food is something we eat when we are hungry. We don't see the whole picture. While the sensualists toil over preparations for the perfect evening, sexualists make do. We screw in our work clothes at a truck stop in five minutes flat. We're just that way. I'm not waiting around while someone lights some damned candles. If you know what you want, why do other stuff first? We sexualists are propelled forward in life, not sideways. While sensualists luxuriate among the world's endless possibilities, sexualists live with definite goals, which we pounce on and pummel into submission.

I had sex with a sensualist once. He hung his long hair (ugh!) around my face like a tent, cutting off all my light, and said, "How does that look and feel?" Then he paused. I realized he was waiting for me to compliment him on his eroticism—and until I did, he was withholding. Withholding thrusts! So I lied and said, "That's so cool."

Sensualists have sex without orgasms on purpose. They call it tantric sex. I'd call it a bad date. Let's tell it like it is: sensualists are sick. They sniff feet and get a hard-on. I'm fixated on a single star—I jump on a rocket ship and explode in orgasm, and that's it. So much is *going on* with those other people. They have a richer world. Secretly, I wish I too could get all excited about colon hydrotherapy and the rest of those wacky fetishes. I just don't understand it at all.

Sensualists do stuff with their fluids. Why? When giving a blowjob, the obvious thing to do is swallow the semen—it's neat, polite, and efficient. I don't smear it or drip it into the guy's mouth, or any of those other things that I know sensual people are going around doing. The guy already came; he doesn't want to be doing anything messy anymore. Getting come sprayed in your hair or on your breasts or wherever is fine, because it adds to the excitement of the ejaculation. The woman gets to be defiled (which is always a good time) and the man gets to actually see his claim being staked on the woman's person. It makes

sense. Of course, being a little anemic myself, I always prefer to swallow (for the protein).

Sexualists hate nothing more than someone who takes too long. Oh god, it's so awful—they peer into your eyes, and they stroke you and say, "Mmm." I read recently that 51 percent of Canadians surveyed said they valued their partner's satisfaction above their own. *Above their own!* Quit looking at me, Canadian lover! It's a lot of pressure having someone hovering up there, worrying about my orgasms. Just leave me alone—I know how to get there. I mean, don't leave me alone, but . . .

Sensualists write long letters. Erotic letters should be two lines: "You are the most attractive person I have ever met in my entire life. I'm dying with desire—*dying!*" This should get your message across with a minimum of fuss. I wonder about people who send four-page single-spaced letters about what they'd like to do. Just come over to my house and do it already! Once you've figured out your feelings, wouldn't acting be the next logical step? The Scorpions said it best: "There are no words to describe all my longings for love."

69 is strictly for the sensualists. They want to have their mouth on an organ, scent in their nostrils, and flesh in their fists while you-know-what is going on down there. Not me! I need to concentrate. I can't even think, much less perform, while that's going on. Why do two half-good jobs concurrently instead of two marvelous deeds separately, one after the other? One must prioritize.

One activity I'm not sure about is anal sex. It works and it hurts, two things we sexualists like. But it's considered gross and deviant, so their kind goes for it as well.

I recently learned there are two ways to fuck a tub. In a conversation with a sensualist, it came out that we both masturbate by lying under the bathtub faucet. But she likes to let it just barely dribble onto her you-know-what and let the pressure slowly build, while I turn it up all the way and swivel right up to the opening where the water rushes hardest. That's when I understood: the sensualists are in it for the long haul—they want to be enfolded in sensation, they want to expand their consciousness to the breadth of the universe, encompassing everything. Whereas I want to lose everything. I want to be smashed to pieces.

You can tell right away which category people fall under. Well, of course, if the man has long hair, he's sensual. Oh lord, protect me and my kind from the

Where's the best place to engage in outdoor sex?
Just about anywhere. I've done it in the creek, I've done it on horse blankets. I've done it in the long grass, got thorns in my ass. Hell, once I smoothed out pine needles and threw her down right there. Boy, I tell ya, I've done it all outside. On a horse one time, too. I just had her sit on my lap and got the horse in a trot. Shit, man, it worked real good.

A male friend of mine is having a hard time making his girlfriend come. What's your advice for him?
First of all, he should give her to me. Because, goddamn, I'd lick her cross-eyed.

My girlfriend is afraid to try anal sex. How can I encourage her?
Hmm, that's a tricky one. There was this one time I talked this girl into trying it. She said okay, so I'm lickin' her and lickin' her, I got it all juiced up good. Then I go to put it in. I had her underneath me. I poked her pretty hard, 'cause it wasn't goin' in good. She shot right out of my arms, hit her head on the headboard and said, "That's it." She wouldn't let me do it no more. So I don't know, boy, what can I tell ya? Some of 'em will, some of 'em won't. I guess you just gotta sweet talk 'em.

Any other words of wisdom?
Well, I'd say patience. Boy, I tell you: you know what they say about it being a virtue? Well, it's true. You just got to lick 'er and slick 'er, then broom-grab her 'til she hollers.

long-haired man and his slithery ways! Dangling hair in their faces, dangling pauses in their speech (to show how meaningful they are), dangling promises (threats) of future love, strange hands and arms dangling all over me. They're big danglers, those sensualists. They wear soft, spongy footwear and sculpt designs in their beards and bestow multitudinous casual compliments to all. They're messy human beings, with all that dangling and complimenting and beard-growing. They're billowing with layers. Layers of issues, layers of scents, layers of spirituality, layers of meanings to their song lyrics, layers of vests and scarves and belts and brooches and other ungodly items I can't imagine having the time to collect, store, coordinate, and put away at night.

Whereas there's something startlingly accurate about the sexualists. They're unfettered by facial hair or accessories or issues. They have no issues. None! They have one or two beliefs, to which their lives are devoted. You see them so sharply focused, so unswerving, and it's such a challenge . . . you're dying to swerve 'em just a little. The externals might be slightly in disarray (shirt half-tucked-in, half out), but inside they are robots on fire. They can appear cruel and emotionless . . . and, well, on a bad day, they are. But at least they're not hypocrites, issuing protestations of caring for others in order to show off their soul and paw your body. Plus, sexualists have better shoes.

I can spot a sexualist on the street blocks away. They pass by me, and I am briefly but utterly possessed by their voracious yet uncaring eyes. Oh my god, I do like them. I want to be had in a doorway by each and every one of them. Sexualists burn everything out—habits, towns, lovers—because they are so ravenous. Burn me out, please!

Henry Miller and Marilyn Monroe stand out as sensualists. Jack Nicholson is a big sexualist, though I hate to admit he's in our camp because he's such a lech. That's okay—we have Joan Collins and Xena the Warrior Princess, too.

Some of my best friends are sensualists. Though I don't understand their ways, and would rather they didn't have their way with me, sensualists do make interesting and loyal friends. Like Rachel. Rachel will dance for hours naked in front of the mirror. If I found myself all alone in the house, naked and dancing, I'd say, "What am I doing?!" and put some clothes on and go back to work. I always read you're supposed to do little things just for yourself to bring out your sensual side, but what kind of game is that? Can you really flirt with yourself? You already know what the outcome is going to be. I can make myself come in two minutes. Why spend two hours? I suppose I admire sensualists for their patience, just as I admire babies for having such a good time with round plastic things all day. I envy aspects of their experience, but finally both babies and sensualists are aliens to me—I can't imagine trading places with either one.

There's more sensualists than sexualists. More sexualists were raised Protestant, and more sensualists Catholic. And since the Catholics greatly outnumber us Protestants, so do the sensualists. I see an army of massage-oiled zombies looming and leering, promising pleasure, as we cower, shaking, in the middle of our small wagon-circle defense. It's not enough that they have each other—they want us, too! They want to play our bodies like fine-tuned cellos, employing all their acquired lovemaking skills. But we'll fight for our right to cram our pleasure into a few minutes—a powerful concentration of destructive joy—rather than letting it linger on, seeping all over our precious afternoon. We'll fight for the right to ram and be rammed! Um, do you want my phone number?

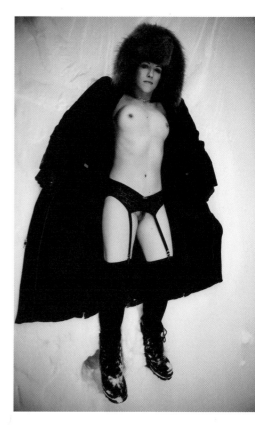

PLACES

Sensualists	Sexualists
Outdoors, when it is warm and remote and mossy	Outdoors, at night, when it is cold.
In the hot tub	In the bathroom, against the wall
In France	In public

POSITIONS

Sensualists	Sexualists
Sitting up in bed (I think they call this the Lotus position)	Woman in chair or on table, man standing
Blowjob in meadow, man lying down	Blowjob in car, man driving
Missionary with mutual gazing	Doggy-style

THE DREADED "M" WORD

BY M. JOYCELYN ELDERS, M.D., WITH REV. DR. BARBARA KILGORE

Masturbation: it's not a four-letter word, but the president fired me for saying it. In this so-called communications age, it remains a sexual taboo of monumental proportions to discuss the safe

and universal sexual practice of self-pleasure. No doubt future generations will be amused at our peculiar taboo, laughing in sociology classes at our backwardness, yet also puzzled by it, given our high rates of disease and premature pregnancy. We will look foolish in the light of history.

Over the months since I left Washington and settled into my home in Little Rock, I have pondered the rage, embarrassment, and shock with which the word *masturbation* is met in our culture. What other word, merely voiced, can provide justification to fire a surgeon general—or anyone? What horrible betrayal of our proud race does masturbation conjure in our minds? As a physician, and as the nation's physician, it was important to answer every question posed to me with clear information. Informed decisions require knowledge. To insure the health and well-being of a patient, age-appropriate information must be made available. Some call it candor—I call it common sense and good medicine. On the other hand, coquetries can be more than deceptive: both the refrain from self-gratification and the concealment of it can result in sexual dysfunction.

Yet to study masturbation would be to admit its role in our lives—one that many of us are not comfortable with. Instead, we discourage the practice in our children, dispensing cautionary tales that read like Steven King novellas. These myths were more understandable before Pasteur enlightened the world to the presence of germs in the 1870s; prior to his discovery, no one really knew where diseases came from. Masturbation was blamed for dreaded conditions like syphilis and gonorrhea, as well as for their ramifications: dementia, blindness, and infertility, to name a few. It's remarkable that some of these rumors still circulate despite clear evidence that they are unfounded.

The wall of myth surrounding self-sex is just beginning to crack—thanks, in part, to President Clinton, who put it in the news. For the first time the topic is being broached on popular television shows, and comedians are able to joke about it without alienating their audiences. You can even find a variety of "how-to" books in the "sex and health" section of most bookstores. The overwhelming majority of psychologists and medical professionals seem to believe that sex-for-one is a natural part of living; we all touch our hair, necks, knees, and many other spots on our bodies in public to calm ourselves or to scratch itches, and it is no less acceptable, they assure us, to touch other body parts in private.

A friend, a senior citizen, stopped me after church one Sunday and said, "Please tell the children that masturbation won't hurt them. I spent my entire

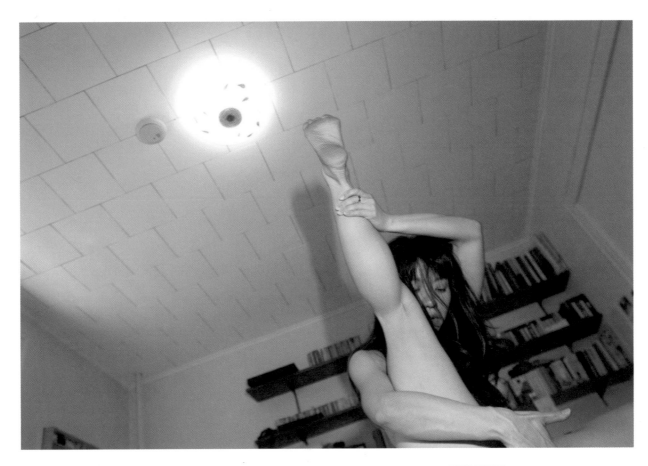

youth in agony waiting to go blind, because my parents told me that's what would happen if I masturbated. I guess I could have stopped, but going blind seemed the better option." We all want to tell our children the truth about their bodies and sex, but many of us are afraid of the consequences. Parents need to let go of the idea that ignorance maintains innocence and begin teaching age-appropriate facts to children. Informed children know what sexual abuse and harassment are, what normal physical closeness with others is, what should be reported, and to whom. Rather than tell children that touching themselves is forbidden, parents may gently explain that this is best done in private.

One enlightened friend shared with me the story of how she taught her preschool-aged daughter about her anatomy: The mother told the girl about her vagina as they examined theirs together with mirrors. There was some discussion and admiration. Later that day, friends came to dinner at their home, and at the dinner table the father asked his daughter what she had done during the day. Of course, she told him the most interesting thing that had happened: she and Mommy looked at their vaginas. But hers was prettier than her mommy's—"Want to see?" The stunned dinner guests were silent as the mother quickly retreated with her daughter to explain privacy. It is never okay to shame children for natural inquisitiveness or behavior: that shame lasts forever.

Masturbation, practiced consciously or unconsciously, cultivates in us a humble elegance—an awareness that we are part of a larger natural system, the passions and rhythms of which live on in us. Sexuality is part of creation, part of our common inheritance, and it reminds us that we are neither inherently better nor worse than our sisters and brothers. Far from evil, masturbation just may render heavenly contentment in those who dare.

AUTOBIOGRAPHY OF A BODY

BY LUCY GREALY

Lucy Grealy, poet and author of the celebrated memoir Autobiography of a Face, *died on December 18, 2002, at a friend's house in Manhattan. She was 39. Grealy's memoir recounted how she lost*

half her jaw to Ewing's sarcoma, a rare form of cancer, at age 9, and spent the next two decades undergoing operations to rebuild her face. Grealy contributed twice to Nerve: first, this personal essay described how she sought out sex to prove she wasn't ugly and learned that "beauty is only an easy label for a complex set of emotions: feelings of safety and grace and well-being." More recently, Grealy visited the Sex Maniacs' Ball in London, an annual event hosted by the Outsiders, an organization that promotes sexual freedom for the disabled. There she discovered that her sexuality was "part of something I am, a state of being rather than a state of action. And that's true whatever my body looks like from the outside."

No cause of death was announced. The New York Times obituary noted that, according to friends, Grealy was despondent over recent operations on her face. Her legacy is a body of work that rises above the clichés of victimhood; it wasn't until she completed her memoir, she once said, that she realized, "I'd actually done not only well, but very well, considering those circumstances."

This essay was originally published in October 1997. —EMMA TAYLOR

I began my seductions incognito, as a boy. With hair shorter than my brothers' had ever been and my thin body almost breastless, the only thing which might have given away my true sex was my rather curvy (though at the time I would only describe them as "too big") hips. This problem was solved by wearing huge shirts and baggy pants, clothes usually bought in the boys' or men's department of the local thrift store. At one point, at the age of 20 or 21, I was denied entrance to a PG-13 movie because the ticket seller was convinced I was a 12-year-old boy. A degree of pride deepened my voice when I told my friends about the incident.

A few other times men approached me in the bars I haunted with my friends. I could see them eyeing me from across the room, and I'd watch them slowly but surely work their way through the crowd towards me.

"What are you drinking?" "I haven't seen you here before." "You look just like someone I know. What's your name?" The lines were ancient and predictable. And just as predictable was the gallant quickness with which these men would scramble away as soon as they heard my high, undeniably female voice. These were, after all, homosexual bars.

I told my friends about these comic scenes too, but I left out crucial elements to the story. I left out how secretly thrilling it was to have these men desire me, even if for only a minute, even if only by mistake. I left out how safe I felt, knowing that I could "pretend" to be attractive, yet without challenging my

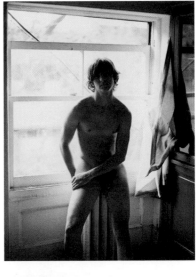

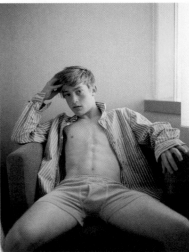

deeply ingrained habits of fear. I was afraid, no, make that *sure,* that I was ugly, that no one would ever want me, that I would die an unloved virgin. My chin and jaw were scarred and distorted from childhood jaw cancer, and the words *scarred* and *distorted* were, without doubt, synonymous with *ugly,* which was synonymous with *unlovable.*

Being "ugly" was the cause of all my life's despair, of this I was sure. It was true I had many friends who loved me, but the fact that I didn't have a lover, even by the time I graduated from college, was proof that I would never be a card-carrying member of the sexual world. Beauty was the key to all happiness, and the only way I would ever find love; without it, I was meaningless.

Sex became a litmus test; if I could get someone to have sex with me, that would prove that I was lovable. I overlooked the fact that all the men I knew were gay, and that I made no attempt whatsoever to find a lover—no, my virginity, my unhappiness, my sense of self, and my face all grew so intertwined that I became unable to respond, "I'm depressed," when someone asked me how I felt. All I could say, believing this said it all, was, "I'm ugly."

During my first year of teaching, I asked my English Composition students to write a paper about a time when they were truly afraid. To my surprise, every single one of them wrote about either a ride on a roller coaster, or a horror film they had seen. I had no doubt that they'd experienced real fear in the course of their lives, but it struck me as sad and foreboding that they could only recognize it clearly when it happened vicariously. No fear that originated within them was acknowledgeable.

I had a similar blindness to the nature of my relationship with gay men. Gay men, especially the kind that frequent particular clubs in lower Manhattan, structure their personalities around the grammar of sex. My friends throbbed and sweated and grinded around me, spoke constantly in overt innuendoes; yet there I was, poor little old me, secretly learning about sex by osmosis, pretending that none of this had anything to do with me.

Even at the age of 21, sex was still a murky thing—I wasn't entirely sure how people could bear to look at each other afterwards. All those legions of friends who adored me and who told me I was beautiful and lovable meant nothing in the face of such an event; only actual intercourse would convince me I was worth anything at all.

A week after moving to Iowa to attend the Writers' Workshop, far away from the safe male homosexual world of college, I lost my virginity. Looking back, I have no doubt I was an easy mark for Jude, the man who had the honors. He was tall, broadly built, and extremely chivalrous. We met when I asked him the time at a local auction, where I was buying furniture for my barren apartment. I must have glowed with naiveté, and I know now that this was precisely what attracted him to me, for Jude was without doubt an opportunist and, in

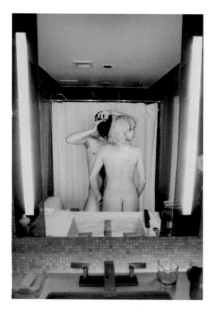

many respects, a bastard. He was seventeen years older than me and deep in the throes of a rather unoriginal midlife crisis that demanded he drive imported sports cars and seduce young virgins. Of course, I did not see it this way at the time.

In my mind, Jude was the most dashing thing going, and I could not believe someone as worldly and as handsome as he would want me. Jude was obsessed with sex. Fortunately, he was experienced and taught me both the basics and the exotics: the precise place on a man's penis that was most sensitive; how, while sitting on top of a man, I could vary the speed and depth of the thrusts; that if I hummed as gutturally as possible while performing oral sex it had a noticeable effect. He taught me all this openly, even academically, standing or lying there stark naked in his living room, speaking as evenly as if he were teaching me how to drive a stick shift. "You'll drive men wild for the rest of your life," he told me. The thought filled me with power, yes, but also hope: someone might one day love me.

Unfortunately, I began to assume some of his philosophies about sex. If before I had confused sex and love, now I was slowly becoming exactly the kind of person I'd never quite understood before: someone who could use sex as a weapon, someone who could distance herself from a lover through sex. This hit me one day while listening to a Leonard Cohen song in the car—a song about a man leaving a woman. My whole life, up until that point, I'd always identified with the lovelorn woman; suddenly, I realized I identified with the man who just wanted to be free.

It was not only for his immediate sexual pleasure that Jude taught me things. Jude, who had been raised in an orphanage, was deeply unable to commit to any one woman, yet, at the same time, was desperate to mean something special to women. Jude wanted me to go out and sleep with other men, but he wanted me to always think of him when I did so. A dedicated emotional manipulator of women himself, he told me how to manipulate men sexually. He taught me how to choose and then perform a specific yet nonsexual act during sex, such as a certain way of stroking a man's forearm, or tapping his elbow. Do this often enough and the act becomes sexualized, so that, in public (and it was important that it be in public), all I would have to do was tap my man's elbow and immediately he would get a hard-on. This kind of power astounded me—astounded me that it was *me* who had it, and astounded me that anyone could be that easily manipulated. Once more, I felt unloved, no longer because a person *wouldn't* have sex with me, but because mere calculation could steer them towards desiring me.

Jude also taught me about the complicated relationship most men have to their anuses; how sexually charged yet humiliating this arousal is for them; how, if I could break that barrier with them subtly and correctly, they would

become dependent upon me to provide that secret pleasure. Now I could not only convince men to have sex with me, and then resent them for it, but, if I used their desires against them, cause them to resent *me* for it. Jude's world was all about emotional dominance and manipulation, about tricking people into becoming obsessed with you, and, ultimately, about the total absence of love. I had come full circle.

But I'm getting ahead of myself here. In one year I went from dressing like a boy to becoming a seductress—quite a swing of the pendulum. Once Jude had me under his sexual wing, he started instructing me in how to dress. Short leather skirts, high heels, garter belts. These were items I'd never have considered wearing only a short time ago, but the simple fact that Jude was "willing" to sleep with me gave him power over me. And even though I still hated my face, I had to admit I had a good body. Yet the scant clothing I wore became just as much a costume as my asexual garb had been previously: it hid me from myself, from my own fears. I became dependent upon the clothes to the point where I could not even go to the grocery store without dressing up.

Before I'd ever had sex, I saw it only as a way to prove that I was not ugly, and therefore lovable. Yet because the sex-equals-love equation didn't bear out, I continued to feel ugly and concluded I was not having *enough* sex, or *good-enough* sex. This was, after all, easier than reconsidering the basic truth of the equation itself. Despite the fact that all I really wanted was for one special person to love me, I persisted in believing I could only conjure this person by being as sexual with as many people as possible.

At Jude's urging, and even long after we had our final split, I went out and seduced men whenever and wherever I could. I vaguely reasoned that each man I slept with brought me five to six inches closer to the man who would ultimately love me. Bent on proving I was desirable, I worked my way through a series of affairs that always ended, I was absolutely certain, because I wasn't beautiful enough. Convinced that anyone who might actually want to have a relationship with me was someone I didn't want, I began hurting people, though of course I never saw this. If they regretted my leaving (my favorite ploy was simply to move to another city or even another country), I simply refused to believe I could matter that much. I felt I had only tricked them into loving me, and therefore their love could never be genuine. In retrospect, I see my lovers dropped me many hints that it was more than this, but at the time I thought I had to hedge my bets by investing my energies in quantity.

There was no easy way to climb out of this cycle, which cavorted on for years. Each man offered some type of power: I slept with a friend's boyfriend because it made me feel sexier than her, I slept with a plastic surgeon in his examining room because it made me feel less like a patient, and I slept with numerous married men because, perversely, I wanted to be married. I slept with

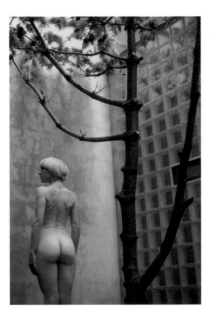

▲ CLAYTON JAMES CUBITT

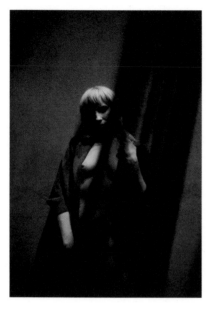

sleazeballs because I thought it would prove I didn't care, I slept with drunks because I was drunk, and I slept with men I hated because I thought it would prove I would do anything for love.

Though often sorrowful throughout the years of my sexual rabidness, I do not want this to stand as a parable on the virtues of monogamy. What caused my sadness and my deep-seated insatiableness was not a moral breakdown on my part (as conservative cultural watchdogs would have us believe) but rather my credulousness in believing beauty equals worthiness. I had not yet recognized all the subtle clues that beauty is only an easy label for a complex set of emotions: feelings of safety and grace and well-being.

Most important to my blindness, I think, was my belief that I was in this alone, that I was the only one who had these doubts. Though very subtly, without my ever knowing it consciously, my sexual and emotional lives were slowly forming some kind of underground harmony. Consciously, however, I still did not recognize sex as a shared experience: I saw it as a contest, two people in different rooms trying to push various buttons, despite all the hints that Fate was dropping me.

I remember once having sex inside a wax museum in Berlin with one of the curators. He was a very handsome curator—a bit like Paul Newman, but with bad teeth. We were behind the Franz Liszt display: a dusty Liszt in a yellow brocaded coat seated on a bench mechanically and repeatedly bent forward and sat up in front of a piano that was playing the same solo over and over again. My lover and I fruitlessly rubbed against each other. Museum patrons kept clopping past us, hidden from view by a fake wall.

"I think this I can't do," he finally told me in his heavy accent, sitting up. "Too many people. And, I keep thinking how I could lose my job."

"But you do think I'm attractive, don't you?" I asked him, worried again.

He looked at me quizzically for a long moment, the piano starting again at the beginning of its loop. "Of course," he said, and paused again, a line of deep and serious concern on his face. "We both are. It is the music that makes us so."

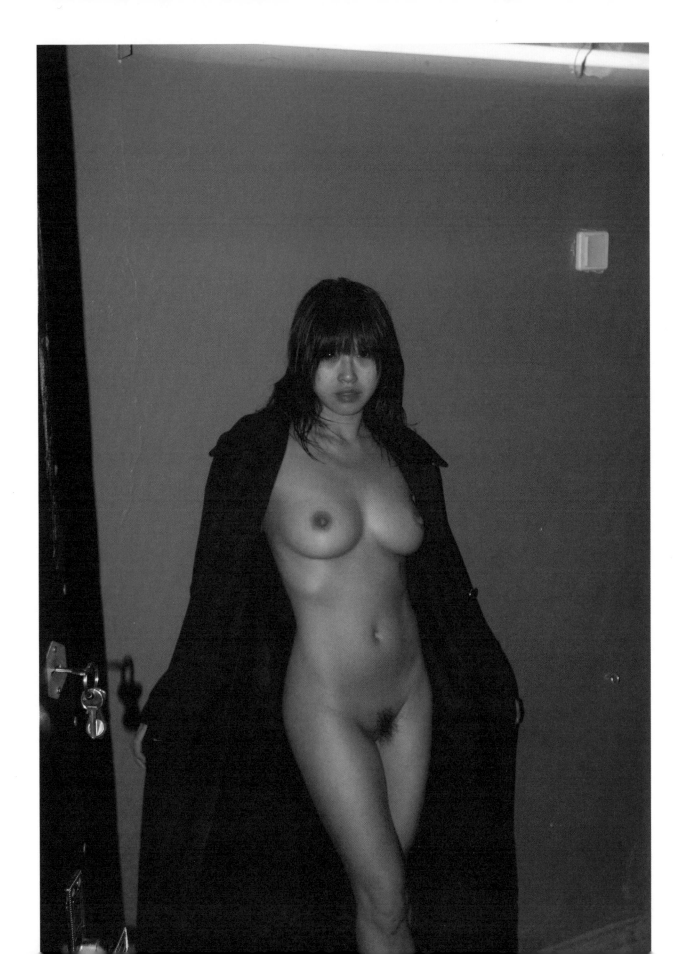

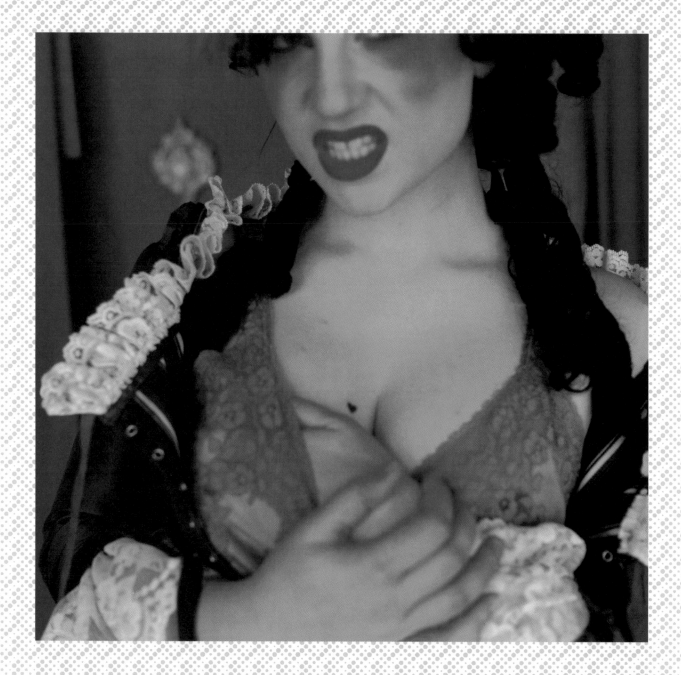

1986

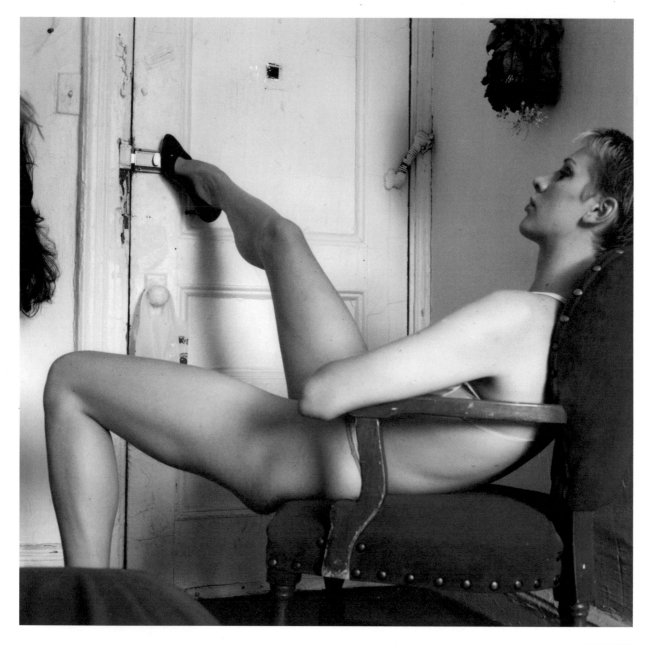

PHOTOGRAPHY BY
GEORGE PITTS

George Pitts is a painter, photographer, writer, and famed photo editor of *Vibe* and *Life* magazines. Something tells me he'd like to make movies—fill his scenes with lots of long-legged, melancholic women with bad posture and bad habits. His heroines would apply their make-up in poorly lit mirrors and sleep too much, but they'd always be smarter than the men they loved and hated. But maybe Pitts will be content to pay homage to his favorite filmmakers—Jean-Luc Godard, Rainer Werner Fassbinder, George Cukor—in photographs like these.

There are traces, here, of what Pitts calls Godard's "passionate yet detached way of looking at women," but the women who pose for Pitts remind me more, in their steely-eyed vulnerability, of the seamy goddesses in Fassbinder's *The Marriage of Maria Braun*. Pitts loves the way Fassbinder "dumped the most beautiful aspects of his persona onto his heroines." I like the idea that a photographer might think of his models as heroines (rude ones!) and the result it produces.
—GENEVIEVE FIELD

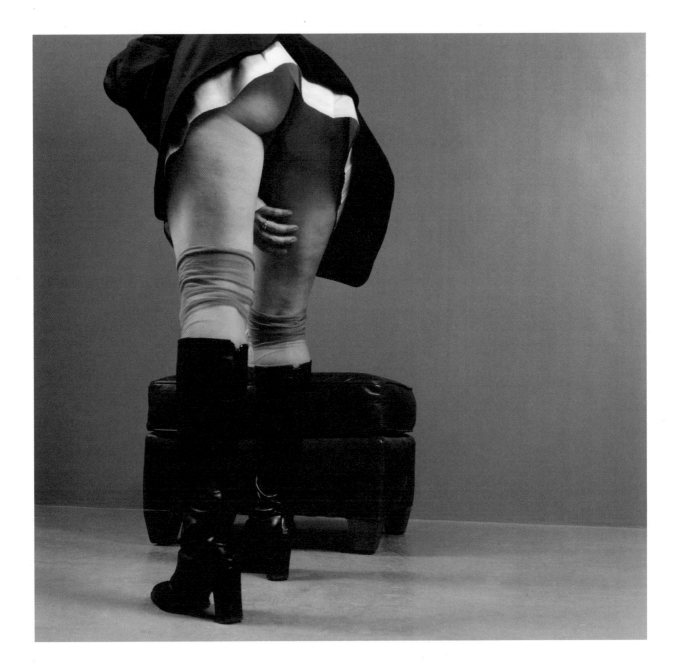

THE BEST OF JACK'S NAUGHTY BITS
THE STARR REPORT

It is a curious moment in history when the steamiest literature you can get your hands on is a Congressional investigation, and the male protagonist is no Fabio, no stablehand on the Chatterley estate, but the President of the United States. For despite what Ken Starr might have us believe, his *Report* was written as, and is certainly meant to be read as, a love story. It has all the components of the pinkest romance novel: the oblique promise of *l'amour propre* is continually proffered in the resiliency of Monica's naïve optimism. And bad Bill's responses are marked by the diffidence and resignation of a man who sees the writing on the wall. We see him committing the classic error of forgetting that there was a mind behind the convenient lips, a heart within the heaving chest, of seeing Monica Lewinsky not as a person, but as an appliance. Thus the abstraction of his responses, as if what was transpiring involved historical chessmen or universal allegories, not flesh-and-blood humans. When she suggested she might tell if he didn't treat her better, he rejoined, "It is illegal to threaten the President of the United States." Now this is a phrase I could never imagine saying to a lover (and not only because I might have inhaled); it confuses self and office, man and symbol. Lovers' quarrels are not resolved by consulting the Constitution. Bill, stick in hand, was clearly trying to scrape off the unfortunateness he had stepped into. And Monica, meanwhile, persisted in her hopes, questioning if he really knew her, asking him if he wanted to, only to be silenced by his kisses. Kisses that said, in effect, "Dear girl, don't you know that real emotions are not permitted on the stage of a Trauerspiel? Identity is unimportant here; a hand is moving you. I am that hand . . . "

I myself have come to fear such encounters, where an atavistic urge or momentary impulse leads me into temptation, or into tempting, a woman but a decimal of my years. And, like decimals, it is hard to remember that they are also wholes, and harder still to remember that they might see you as larger than life, or larger than you are. The easily won, never asked for heart is worn like a lodestone, a mantle of lead we try to wriggle out from under. I feel for Clinton because it's hard not to wield power, to not feel and lust for the very act of wielding, and then to shrink beneath the burden of its consequences. Power scripts its own abuse. And thus I feel for Lewinsky, too. For it is all too easy to come under its spell. To say, as she did again and again, "Even though he's a big schmuck . . . "

And we, the American people, will we not in the end permit this to pass, murmuring to ourselves the very same sentiment?

* * *

From *The Starr Report*

DECEMBER 31 SEXUAL ENCOUNTER

According to Ms. Lewinsky, she and the President had their third sexual encounter on New Year's Eve. Sometime between noon and 1:00 P.M., in Ms. Lewinsky's recollection, she was in the pantry area of the President's private dining room talking with a White House steward, Bayani Nelvis. She told Mr. Nelvis that she had recently smoked her first cigar, and he offered to give her one of the President's cigars. Just then, the President came down the hallway from the Oval Office and saw Ms. Lewinsky. The President dispatched Mr. Nelvis to deliver something to Mr. Panetta.

According to Ms. Lewinsky, she told the President that Mr. Nelvis had promised her a cigar, and the President gave her one. She told him her name—she had the impression that he had forgotten it in the six weeks since their furlough encounters because, when passing her in the hallway, he had called her "Kiddo." The President replied that he knew her name; in fact, he added, having lost the phone number she had given him, he had tried to find her in the phone book.

According to Ms. Lewinsky, they moved to the study. "And then . . . we were kissing, and he lifted my sweater and exposed my breasts and was fondling them with his hands and with his mouth." She performed oral sex. Once again, he stopped her before he ejaculated because, Ms. Lewinsky testified, "he didn't know me well enough or he didn't trust me yet."

JANUARY 7 SEXUAL ENCOUNTER

"[W]e made an arrangement that . . . he would have the door to his office open, and I would pass by the office with some papers and then . . . he would sort of stop me and invite me in. So, that was exactly what happened. I passed by, and that was actually when I saw [Secret Service Uniformed Officer] Lew Fox, who was on duty outside the Oval Office, and stopped and spoke with Lew for a few minutes, and then the President came out and said, oh, hey, Monica . . . come on in . . . and so we spoke for about ten minutes in the [Oval] office. We sat on the sofas. Then we went into the back study and we were intimate in the bathroom."

Ms. Lewinsky testified that during this bathroom encounter, she and the President kissed, and he touched her bare breasts with his hands and his mouth. The President "was talking about performing oral sex on me," according to Ms. Lewinsky. But she stopped him because she was menstruating, and he did not. Ms. Lewinsky did perform oral sex on him.

Afterward, she and the President moved to the Oval Office and talked. According to Ms. Lewinsky: "[H]e was chewing on a cigar. And then he had the

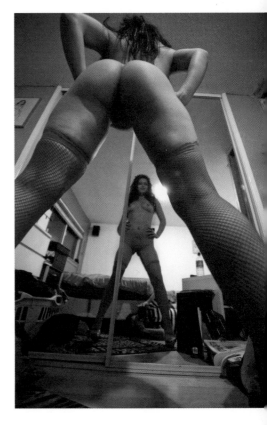

^ NATHAN APPEL

cigar in his hand and he was kind of looking at the cigar in . . . sort of a naughty way. And so . . . I looked at the cigar and I looked at him and I said, 'We can do that, too, some time.'"

JANUARY 21 SEXUAL ENCOUNTER

"I was feeling a little bit insecure about whether he had liked it or didn't like it . . . I didn't know if this was sort of developing into some kind of a longer-term relationship than what I thought it initially might have been, that maybe he had some regular girlfriend . . ."

According to Ms. Lewinsky, she questioned the President about his interest in her. "I asked him why he doesn't ask me any questions about myself, and . . . is this just about sex . . . or do you have some interest in trying to get to know me as a person?" The President laughed and said, according to Ms. Lewinsky, that "he cherishes the time that he had with me." She considered it "a little bit odd" for him to speak of cherishing their time together "when I felt like he didn't really even know me yet."

They continued talking as they went to the hallway by the study. Then, with Ms. Lewinsky in mid-sentence, "he just started kissing me." He lifted her top and touched her breasts with his hands and mouth. According to Ms. Lewinsky, the President "unzipped his pants and sort of exposed himself," and she performed oral sex.

FEBRUARY 4 SEXUAL ENCOUNTER AND
SUBSEQUENT PHONE CALLS

The President telephoned her at her desk and they planned their rendezvous. At her suggestion, they bumped into each other in the hallway, "because when it happened accidentally, that seemed to work really well," then walked together to the area of the private study.

There, according to Ms. Lewinsky, they kissed. She was wearing a long dress that buttoned from the neck to the ankles. "And he unbuttoned my dress and he unhooked my bra, and sort of took the dress off my shoulders and . . . moved the bra . . . [H]e was looking at me and touching me and telling me how beautiful I was." He touched her breasts with his hands and his mouth, and touched her genitals, first through underwear and then directly. She performed oral sex on him.

After their sexual encounter, the President and Ms. Lewinsky sat and talked in the Oval Office for about forty-five minutes. Ms. Lewinsky thought the President might be responding to her suggestion during their previous meeting about "trying to get to know me." It was during that conversation on February 4, according to Ms. Lewinsky, that their friendship started to blossom.

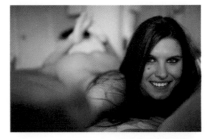

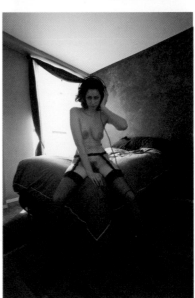

When she prepared to depart, according to Ms. Lewinsky, the President "kissed my arm and told me he'd call me, and then I said, 'Yeah, well, what's my phone number?' And so he recited both my home number and my office number off the top of his head." The President called her at her desk later that afternoon and said he had enjoyed their time together.

MARCH 31 SEXUAL ENCOUNTER

According to Ms. Lewinsky, the President telephoned her at her desk and suggested that she come to the Oval Office on the pretext of delivering papers to him. She went to the Oval Office and was admitted by a plainclothes Secret Service agent. In her folder was a gift for the President, a Hugo Boss necktie.

In the hallway by the study, the President and Ms. Lewinsky kissed. On this occasion, according to Ms. Lewinsky, "he focused on me pretty exclusively," kissing her bare breasts and fondling her genitals. At one point, the President inserted a cigar into Ms. Lewinsky's vagina, then put the cigar in his mouth and said: "It tastes good." After they were finished, Ms. Lewinsky left the Oval Office and walked through the Rose Garden.

MS. LEWINSKY'S FRUSTRATIONS

Continuing to believe that her relationship with the President was the key to regaining her White House pass, Ms. Lewinsky hoped that the President would get her a job immediately after the election. "I kept a calendar with a countdown until election day," she later wrote in an unsent letter to him. The letter states: "I was so sure that the weekend after the election you would call me to come visit and you would kiss me passionately and tell me you couldn't wait to have me back. You'd ask me where I wanted to work and say something akin to 'Consider it done' and it would be. Instead I didn't hear from you for weeks and subsequently your phone calls became less frequent."

Ms. Lewinsky grew increasingly frustrated over her relationship with President Clinton. One friend understood that Ms. Lewinsky complained to the President about not having seen each other privately for months, and he replied, "Every day can't be sunshine." In an email to another friend in early 1997, Ms. Lewinsky wrote: "I just don't understand what went wrong, what happened? How could he do this to me? Why did he keep up contact with me for so long and now nothing, now when we could be together?"

FEBRUARY 28 SEXUAL ENCOUNTER

According to Ms. Lewinsky, she and the President had a sexual encounter on Thursday, February 28—their first in nearly eleven months. Wearing a navy blue dress from the Gap, Ms. Lewinsky attended the radio address at the President's

invitation (relayed by Ms. Currie), then had her photo taken with the President. Ms. Lewinsky had not been alone with the President since she had worked at the White House, and, she testified, "I was really nervous." President Clinton told her to see Ms. Currie after the photo was taken because he wanted to give her something. "So I waited a little while for him and then Betty and the President and I went into the back office," Ms. Lewinsky testified.

In the study, according to Ms. Lewinsky, the President "started to say something to me and I was pestering him to kiss me, because . . . it had been a long time since we had been alone." The President told her to wait a moment, as he had presents for her. As belated Christmas gifts, he gave her a hat pin and a special edition of Walt Whitman's *Leaves of Grass*.

Ms. Lewinsky described the Whitman book as "the most sentimental gift he had given me . . . it's beautiful and it meant a lot to me." During this visit, according to Ms. Lewinsky, the President said he had seen her Valentine's Day message in the *Washington Post*, and he talked about his fondness for Romeo and Juliet.

Ms. Lewinsky testified that after the President gave her the gifts, they had a sexual encounter: "[W]e went back over by the bathroom in the hallway, and we kissed. We were kissing and he unbuttoned my dress and fondled my breasts with my bra on, and then took them out of my bra and was kissing them and touching them with his hands and with his mouth.

And then I think I was touching him in his genital area through his pants, and I think I unbuttoned his shirt and was kissing his chest. And then . . . I wanted to perform oral sex on him . . . and so I did. And then . . . I think he heard something, or he heard someone in the office. So, we moved into the bathroom.

And I continued to perform oral sex and then he pushed me away, kind of as he always did before he came, and then I stood up and I said . . . 'I care about you so much . . . I don't understand why you won't let me . . . make you come; it's important to me; I mean, it just doesn't feel complete, it doesn't seem right.'"

Ms. Lewinsky testified that she and the President hugged, and "he said he didn't want to get addicted to me, and he didn't want me to get addicted to him." They looked at each other for a moment. Then, saying that "I don't want to disappoint you," the President consented.

For the first time, she performed oral sex through completion. As a final note, I want to mention in passing the similarity between the section of the *Starr Report* quoted above and my excerpt from García Márquez's *Autumn of the Patriarch* from some time back. I'm not saying that Clinton gets his sex ideas from his confessed favorite author, nor am I suggesting that he even read the book. It seems much more likely that a man in his position wouldn't have time to read entire novels and would have to resort to abbreviations, brief selections that would highlight his favorite bits . . . now I wonder where he'd find those?

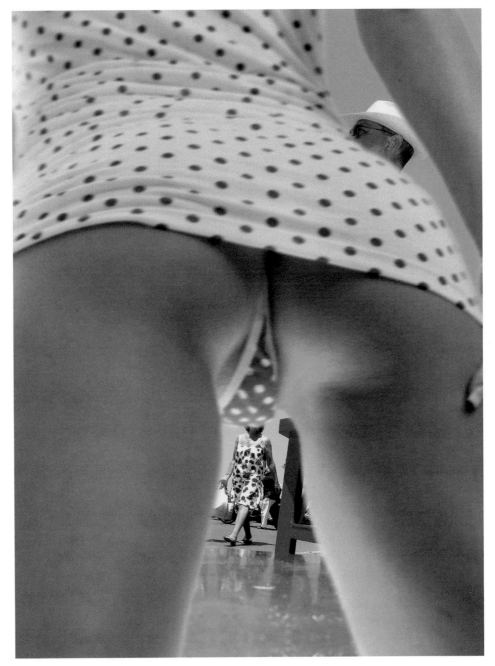

‹ PETER FRANCK

INNOCENCE IN EXTREMIS

BY DEBRA BOXER

I am 28 years old and I am a virgin. People assume a series of decisions led to this. They guess that I'm a closet lesbian, or too picky, or clinging to a religious ideal. "You don't look, talk, or act like a virgin," they say. For lack of a better explanation, I am pigeonholed as a prude or an unfortunate. If it's so hard to believe, I want to say, then imagine how hard it is for me to live with.

I feel freakish and alien, an anomaly that belongs in a zoo. I walk around feeling like an impostor, not a woman at all. I bleed like other women, yet I feel nothing like them, because I am missing this formative experience.

I won't deny that I have become attached to my innocence. If it defines me, who am I without it? Where will my drive come from and what will protect me from becoming as jaded as everyone else? I try to tell myself that innocence is more a state of mind than body. That giving myself to a man doesn't mean losing myself to a cynical world. That my innocence doesn't hang by a scrap of skin between my legs.

In college, girls I knew lost it out of impatience. At 21, virginity became unhealthy, embarrassing—a female humiliation they could no longer be burdened by. Some didn't tell the boy. If there was blood they said it was their period. I cannot imagine. Some of those same boys thought it was appalling, years ago, that I was still a virgin. "I'll fuck you," they said. It sounded to me like, "I'll fix you," and I did not feel broken.

I don't believe I've consciously avoided sex. I am always on the verge of wholly giving myself away. I think emotionally, act intuitively. When I'm attracted to someone I don't hold back. But there have been only a handful of times when I would have gladly had sex. Each, for its own reason, did not happen. I am grateful to have learned so much in the waiting: patience, strength, and ease with solitude.

Do you know what conclusion I've come to? That there is no concrete explanation, and more importantly, there doesn't need to be one. How I got here seems less important to me than where I am.

This is what is important. Desire. The circle of my desire widens each day, so that it's no longer contained inside me, but rather, it surrounds me in concentric circles.

Desire overrides everything and should be exploited to its fullest potential. It is the white-hot space between the words. I am desire unfulfilled. I hover over that fiery space, feeling the heat without knowing the flames. I am a still life dreaming of animation. I am a bell not allowed to chime. There is a deep stillness inside me. There is a void. A huge part of me is dead to the world no matter how hard I try to revive it with consoling words or my own brave hand.

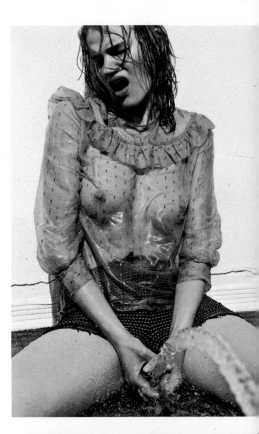

I am sick of being sealed up like a grave. I want to be unearthed.

I pray for sex like the pious pray for salvation. I am dying to be physically opened up and exposed. I want to be the source of a man's pleasure. I want to give him that one perfect feeling. I have been my only pleasure for too long.

Do I have dreams about sex? Often. There is one recurring dream in which I can't see whole bodies at once. But I know which parts belong to my body. I know they're mine. I know, better than anyone, my curves, my markings, my sensitive places. If I close my eyes now, I can see the man's body. Thin, smooth, light-haired, limbs spreading and shifting over me like the sea. A small, brick-colored mouth opens and closes around the sphere of a nipple. Moist eyes, the color of darkest honey, roam up and down my spine. A sensation of breath across my belly induces the first wave of moisture between my legs. This reaction crosses the line into wakefulness, and I know when I awaken, the blanket will be twisted aside as if in pain. My skin itself will feel like a fiery blanket, and I will almost feel smothered by it.

In some versions of the dream I am on top and I can feel my pelvis rubbing against the man's body. Every part of my body is focused on the singular task of getting him inside me. I try and try and am so close, but my fate is that of Tantalus who was surrounded by water he could not drink. Thank God for masturbation.

My fingers know exactly how to act upon my skin—they have for over half my life now. There is no fear or hesitation. When I masturbate I am aware of varying degrees of heat throughout my body. It is hottest between my legs. Cool air seems to heat the moment it hits my skin, the moment I suck it in between my lips. After, my hands shake as if I'd had an infusion of caffeine. I press my hand, palm down, in the vale between my breasts, and it feels as if my heart will burst through my hand. I love that feeling—knowing that I'm illimitably alive.

Though I've never had a man inside me, I have had many orgasms. I have talked with girls who not only can't have one with their lover but can't bring themselves to have one. I was shocked at first until I saw how common it was. And then I felt lucky. My first one scared me. At 12, I did not expect such a reaction to my own touch; I thought I'd hurt myself. But it was such a curious feeling, such a lovely feeling, that I had to explore it further. I felt almost greedy. And well, I got better at it until it was ridiculously easy. Still, it is always easy.

I don't expect it to be so easy with a man. I've come to believe that sex is defined by affection, not orgasm. There is that need to be held that doesn't disappear when we learn to walk on our own. If anything, it intensifies.

I love being a girl. I think of my body as all scent and soft muscle. It is an imperfect body, but beautiful still, in its energy and in its potential. I love

looking at my curves in the mirror. I love feeling them and admiring their craftsmanship. I love my hipbones—small, protruding mountains. Or maybe they are like sacred stones marking the entrance to a secret city. I trace the slope of my calf as if a slender tree trunk, and I am amazed at how strong, yet vulnerable, the human body is. I am as in awe of my body as I am of the earth. My joints are prominent, as if asserting themselves. I know my terrain well, perhaps better than any man ever could—the warm, white softness of my inner arms; the hard, smooth muscle of my bicep like the rounded swelling in a snake that just swallowed the tiniest mouse; the sensitive skin between my thighs; the mole on my pelvis nestled by a vein like a dot on a map marking a city beside a river. I have stared at my naked body in the mirror wondering what the first touch from a lover will feel like and where it will be.

Masturbation is pleasurable, but it cannot sustain a whole sexual life. It lacks that vital affection. I am left with the rituals, the mechanics of masturbation. I crash up against the same wall each time. It becomes boring and sad and does little to quell the need to be touched. I long to let go of my body's silent monologue and enter into a dialogue of skin, muscle, and bone.

There are sudden passions that form in my mind when I look at a man. Thoughts of things I want to do to him. I want to follow the veins of his wrists—blue like the heart of a candle flame. I want to lick the depression of his neck as if it were the bottom of a bowl. I want to see the death of my modesty in his eyes. Although I am swollen with romantic ideas, I am not naïve. I know it will not be ideal. Rather, it will be painful, awkward, damp, and dreadful—but that is always the way of birth. It is an act of violence. The threat of pain in pleasure, after all, makes seduction stimulating. I want the pain in order to know that I am alive and real—to leave no doubt there has been a transformation.

The fear is undeniable. It's a phobic yearning I have for a man's body, but I have to believe that everything, including fear, is vital when expressing desire. If sexual thoughts are either memories or desires, then I am all desires.

I am powerfully attracted to the male body. I want to watch him undress. See him touch himself. I want his wildness in me—I want to touch his naked body and feel the strength of him. His sweat sliding down the slick surface of my skin until it pools in the crooks of my limbs. I imagine the rhythm of our sex like the slick, undulating motion of swimmers. I imagine my own body's movements suddenly made new, so that we would appear to me like two new bodies. I imagine the sound of our sex—a magnificent, moist clamor of limbs.

I want to hold him inside me like a deep breath. I want to leave kisses as markers on the sharp slices of his shoulder blades, then surrounding the oasis of his bellybutton. I want to slide him in my mouth like a first taste of wine, letting the bittersweet liquid sweep every part of my mouth before allowing it to slide down my throat.

I will hold my mouth to his ear, as if I were a polished seashell, so he can hear the sea inside me—welcoming him. I will pause and look at him—up into his face. I will steady myself in his gaze, catch the low sun of his cock between my smooth, white thighs, and explode into shine. I will look at him and think, I have spent this man's body and I have spent it well.

^ SUSAN EGAN

In your line of work, people take off their pants and ask you to pierce their most private parts. Does consistent exposure to a vast array of bodies make you better in bed?
No. If anything, it's made me aware of how mean God can be to certain people. I've encountered women who've almost made me straight and men who've made me gayer. I've seen crazy amounts of lint in pubic hair.

What's the secret to a good rim job?
Do it in the shower and use anti-bacterial soap. As far as technique goes: circle, circle, dot, dot. Treat it like a clit.

Is it okay to tell my girlfriend that she makes unappealing sounds in bed?
When you're with someone in bed it's about both of you, and if one person is doing something that makes the other uncomfortable, you should say something. Just choose your words wisely, and be nice. But one time I dated a girl who sounded like a chimp in bed, and I had to say bye.

I want to get a tattoo of my girlfriend's name, but everyone says it's a terrible idea. What do you think?
There's the old myth that if you get the name tattoo, your relationship is doomed. But I got my girl's name on my nipple after six months—I was feeling crazy, she was making me crazy!—and we've been together for two years since.

THE LATE BLOOMING OF A MONOGAMIST

BY SPALDING GRAY

I have always thought of monogamy as a gift—a loyal commitment I should be able to give my partner in an ongoing, loving relationship. But it's the "should" that I balk at. I would prefer

monogamy to come naturally, like the love I have for my children, but for me (and the longer I'm around, the more I realize this is true for most men) it doesn't work that way. Nor is monogamy a desired state. It's not natural, it's cultural, and appears to make some societies run smoother. It gets you on a less complicated route from cradle to grave.

In the past, I have allowed myself to labor under the illusion that fully conscious, honest, unspoken agreements could be struck with women who were essentially strangers and that an arrangement could exist (other than masturbation) called uncomplicated sex. PROBLEM-FREE FUCKING! WHOOPEE! But with time we all find out that this kind of fucking is just swimming on the surface. Once you dive down and look into each other's eyes and see what's deeper, you're in over your head. That's when relationships get much more humane, much more complicated, and much more difficult to maintain with more than one woman.

I did try to carry on a duplicitous relationship with two women for about two years, and I don't think I could or would ever want to try it again. I expect that if both women knew—if it was a conscious, adult, consenting triangle—then it might have been different . . . for a while. But no, it was that old lopsided man-has-woman-on-the-side situation, and it all blew up when the woman on the side got pregnant and my wife did not. That was very heavy. The heaviest thing I've ever experienced. I really was not prepared for any of it. I was 51 years old and had never made a woman pregnant in my life. It was something I'd really given up thinking about. It was just not an issue. In fact, while I was having the long affair with Kathie, I was using condoms mostly just as a precaution against AIDS. The fear of pregnancy had all but slipped my mind.

When Kathie—with whom I'd been having what I thought was an uncomplicated, undemanding relationship based on fun fucking, recreational drugs, and long walks in the woods—got pregnant, my whole world changed, or maybe I should say, the two separate worlds came together with a crash. I thought back to a hotel room in Cambridge where I was lying beside Kathie in a state of after-intercourse bliss, and her saying, "You know, if I get pregnant with you, I'm going to want to keep the child." A stupefying "whatever" had played in the back of my head as I dozed. Now I realized that I would have to make a decision. I never dreamed that it would come to this, that I would have to choose between Kathie and my wife, Ramona.

^ RIKKI KASSO

I have to tell you that the freedom of choice is almost unbearable for me. I often find myself thinking more about the road not taken than the one I took. As a result, I am a very messy chooser. I tend to get paralyzed by the choice, then freak out, short-circuit, act out, and drive everyone nuts. So I was acting partly crazy from the time Kathie told me she was pregnant up until the time I first held my 8-month-old son in my arms. By then I had driven my wife away and most of our mutual friends. I came to realize that if there is anything comforting about death it is that there is no choice involved.

But of course, part of the choice was made for me by biology. Biological destiny. I couldn't have done it by myself, even in my head. After my wife left me to try to build and create her own boundaries, I did take a little time to myself, enough to allow me (question: Who is the "I" that allows the "me," and who is the "me"?) to realize that I needed and wanted at last to see my son.

When I arrived at her loft, Kathie, whom I'd not touched for almost two years, greeted me in a polite and formal way and told me that she would go wake up Forrest so that I could meet him. But it was I who resisted and said, "But don't you want to go to bed first?" She really looked good. She was in great shape for a woman who'd just had a baby. And when she said, "What makes you think I want to go bed with you?" her resistance turned me on. I think I responded, "Because I think it would be good for both of us." And it was. Like old times, we selected one of her roommate's chambers (she shared her loft with three other people). It was the female roommate's bed that always made things a little hotter. I was amazed that after all the lawyers, the money, and the just plain shitty sadness that had come and gone, we could still connect in such a fully satisfying way. We went through all of our favorite positions. The best aspect of sex with Kathie came back. I was amazed that it was not lost. She is what I call a phallic woman. She knows how to actively fuck me, and I like that. I liked the way we passed active and passive energy back and forth. At some points I felt my erection was no longer mine, but belonged to both of us with no separation. There was a nice rhythm of alternating domination, and it ended in mutual orgasm. It was like very good meat and potatoes comfort food, a homecoming—but as though no time had passed between us. Then came the waking of the child, like some fantasy of cause and effect: here's what you do to have a baby, and here is the baby. Very unreal.

In my recent book, *It's a Slippery Slope,* I talk at length about the whole phenomenon of first seeing my son. I describe him as "a little innocent Archimedes who made a fulcrum large enough to break the fusion, a fusion I never dreamed I wanted broken between Ramona and me. No other woman could have done that. . . . Back then there was always another woman . . . but there was never another son . . . I loved my son Forrest for the way he loved Kathie, his mom, and turned her into a mother before I could, leaving me to get to know

and love her for the woman she is." But that's another story, and you can read it there if you want to.

Now, in the wake of that big dramatic/traumatic life shift there are a couple of unexpected changes in my sexual life. One is rather easily called conscience, the other I might label my "biological clock." The biological clock is an entity I had never really known existed in men because women so vehemently claim it for themselves. But it does exist for men and it gets turned on sooner or later. The maddening issue for women is the brevity of their clocks in relationship to the longevity of our male clocks. Now I'm pretty sure that the more I fucked around the more my bio-clock, which I couldn't hear, was going off. Also, I suppose I was reconnecting with the primal need to spread my seed from nest to nest until one took and grew. It was a very basic and nondiscriminating drive, an old story. But something was complete when my first son, and then just as unexpectedly, my second son, was born. That really slowed me down—in a good way. It gave me the opportunity to experience a new kind of love that was not just based on carnal attractions. At its best it opened me up. It made me fuller. It made me want to be at home more.

Another odd and unexpected condition the children created was that their presence made Kathie often unavailable for sex. This unavailability re-created the dynamic sexual tension that was so present when we were having our affair. The children put boundaries on and around our desire and forced us to be creative, to seek out and find our little private erotic spaces.

That's when I slowly discovered for myself the redirection of sexual energy, sometimes referred to as "sublimation." I'd read about tantric sex for years, but as it turned out, it was downhill skiing that proved to be my means of redirecting sexual energy. I didn't entirely give up on sex, but found a way to be less compulsive with it. I've always experienced my sexual impulse as coming from the base of my spine and then spreading out from there. I often think of it as like the color and flavor spot that used to be in the center of the margarine in the late '40s when my mom would hand me what looked like a big cellophane-wrapped white brick of lard. Then, as I began to squeeze it, that little orange sun of color and flavor would break and spread out until the whole packet was a delicious yellow color. I've done yoga every morning for thirty years and that is what happens to the energy in my body. At first I feel and can sometimes visualize that flavor bud in the base of my spine and then I feel it spread into my whole body until I'm quite naturally awake. That for me is the best time to have sex if I'm going to have it (if Kathie is in the mood and the children are occupied somewhere else). But, as is often the case, I am left to redirect it without losing it. For me that means staying physical (not sitting down to write, read, and think).

Just last year I was able to really test it out at an intensive skiing workshop. At the end of the day I felt like I'd just had a seven-hour orgasm. And I

know now what my surfer friends are always talking about—the supreme redirection of sexual energy.

So, monogamy goes on or I should say, because it is not a natural state, we make it go on. Sometimes when I'm about to go out on the road on tour I fall into the old habit of buying a box of condoms "just in case." But Kathie always finds them and writes little notes on them in red ink like: "Think of your family in a time of need." Or: "Do you really want to use these?"

I laugh when I read these messages. They are like little postcards from home. Then I get out my family photos, look at them, take a cold shower, and go for a walk. But I do have to say that if I can believe in a future and not act on every impulsive sexual temptation that comes my way, when I get home to Kathie, we are able to share in the creation of the hot sex I didn't have on the road. My hotel rooms have changed from sex pads to sanctuaries. Before, hotel rooms were always lonely places that cried out for erotic relationships to fill them. I couldn't walk into one without thinking of sex with the unknown woman soon to be met. And often, the cheaper the hotel, the more driven I was to find after-hours companions. Now in my contracts, I request four-star hotels where I can treat myself to comfort, where I can be alone *and* be comfortable. If I am out on the road for too long without a visit from Kathie, and that old sexual energy builds up like a hot rock in my groin, I try to sublimate it. Occasionally I give into it with my favorite form of masturbation. And I swear to Kathie, even though she doesn't believe it, that that's why I sometimes carry condoms with me. I use those condoms with the little notes she's written on them to lend some realism to my masturbation. I place two firm couch pillows on the floor, stacked on top of each other, unroll a lubricated condom, and go to town. It makes for full, hip-thrusting, toes-to-nose orgasms. It's really a good way to get full release and free up your hands. To grab your own ass and pretend it's a surprise. And, it works; it really does.

So everything is working and in balance now. I try to avoid temptation rather than throw myself into the center of it. When unknown women smile and tell me that they love me, I try to remember that they mean they love my work, they love my image, my public self. My private self is really plugged into Kathie (and hers into me); I've become a family man.

^ SAMANTHA WEST

FLIGHT

BY ROBERT ANTHONY SIEGEL

My father has gotten himself into some kind of trouble involving money and the law, and for the first time I can remember, I have a role in his life—that of confidant. We spend large chunks of the

nighttime hours riding around town while he formulates his plans: compromise, counterattack—all depending on the fluctuations of his mood, which are extreme, from tears to rage and back again. I listen and egg him on toward the more fantastical choices—because at 16 I'm not aware that they are fantastical, and because they give me the chance to go on more car rides. I am especially pleased when he decides that we are going to skip the country together. "Fuck 'em," he says, his face a pale green in the light from the dashboard. "We'll drive up to Canada, then fly to Israel. No extradition, immediate citizenship under the Law of Return."

"When?" I ask.

"Tomorrow."

But the next day he doesn't show up. I talk to his answering machine, stare into his darkened windows, bang on the door. My valise feels like a ton of rocks in my hand, but I carry it all the way up the avenue, to Violet's house. Violet is the girl I have been—not dating, no—*circling* is the better word. I am, in general, a circler.

Violet and I sit on the couch in her basement talking, but I can't really listen because my brain is full of my father's darkened windows—that blackness.

"Running away?" she asks, looking over at the valise in the corner.

"Moving in. Your parents won't mind. Will they?"

"Funny," she says, and I am caught off guard as she leans toward me. I see her face approaching mine, growing larger and larger till it fills my vision, and I smell the sweet scent of her, then I feel her lips against mine, a very light pressure, hardly more than a tingling in the skin. I almost draw back, not because I don't want this but because it's too much, too much and yet not enough.

"How's that?" she whispers. I'm not sure if I actually hear her or am merely feeling her breath on my face, the shape of her words on my skin.

"Wow," I say, a little drunk with the sensation.

She moves back to look at me and her eyes are huge with interest, a childlike curiosity at the effect of her experiment. She looks like a kid who's just built something amazing with blocks that may tumble at any moment. "One more time," she says.

We kiss again, her body against mine, her arms around my back. It is a strangely anchored feeling, like climbing a tree and coming to a fork in the branches, the kind that allows you to wedge yourself in and dangle your legs, suspended in air with no danger of falling. And yet it feels like falling,

too—falling without the pain of landing. My lips move but no words come out; I can hear the click of our mouths, the rhythmic huff of our breathing. "Umh," she says, "mhrr," and I know exactly what she means: bird, sky, branch, lips. I can feel her hand reaching under my shirt, palm against the skin of my back. Everywhere she touches tingles.

So this is getting laid. I am falling and I am in the tree, watching myself fall. My father is in Buffalo, carrying a tote bag full of money and a passport with a new name on it. He is eating room service with the TV on. He is in his big white Caddy, driving toward the Canadian border, Niagara Falls a silent roar beyond his window. The world is neither good nor bad but huge, and a father can get lost in it.

"Stop," she gasps, sitting upright. "Take this off." She begins to work at the buttons of my shirt, fumbling. She looks a little cross-eyed, dazed, like someone coming out of a movie theater into daylight. The buttons come slowly, one after another, and then she is sitting with the shirt balled up in her hands, looking at me with that same expression of curiosity.

"Now you," I say, and begin lifting the T-shirt over her head—to stop the staring, really. I see the white of her stomach, the black lace of a bra, the curve of her throat. And then her face again, smiling through a mess of hair.

"Scared yet?" she asks, brushing the hair from her eyes. It is my first indication that we're playing chicken. She sits with her back straight and shoulders squared, clearly aware that of our mutual toplessness hers is the more powerful.

"No," I lie.

"Well, then." She lifts her hands to the black band of cloth between the lace cups of her bra, undoes the little hook that holds them together. "How about now?" she asks.

"Maybe." I stare for a while, trying to make the connection between all the pictures I've seen and these real things—Violet's breasts. They are instantly familiar yet completely new too, and I feel as if I've been waiting for them a long, long time. I lean forward to touch a nipple with my lips. I can feel her hands in my hair. Her body sways and my mouth fills. My father is flying, eating packet after packet of peanuts, the tote bag sandwiched between his legs. He looks out the window and sees clouds reflecting pink and gold. He tells the woman next to him that he is a salesman, a sex therapist, a professional wrestler. The world is huge and anyone can get lost; it's hard to fasten on.

"Oh," says Violet, a sound of surprise. I take my mouth from her breast; the nipple glistens with saliva. I follow the space between her breasts to the top of her stomach, kissing, kissing to the rivulet of hairs down toward her belly button, the waist of her jeans. "Hey, that tickles." She squirms free, gets up from the couch, stands over me, her hair in her eyes. I reach for the button

^ RYAN PFLUGER

of her pants, unzip her zipper, start pulling them down. Her body sways with my tugging. She watches with a distanced curiosity as her pants clear her hips, her thighs, bunch at her ankles. She is not wearing any underwear. "I'll fall," she says.

"I'll catch you."

I am down on my knees now, my hands on her hips, steadying her. I am face-to-face with the architecture of her pelvis, the tuft of hair that I have dreamt of and wondered about. Of course, of course, I tell myself, this is how it would have to be, this is how women are made. I look up at her face and see that her eyes are squeezed shut, as if it's the scary part of a movie. I kiss the sharp edge of her hipbone, the shallow plane of her pelvis, the shaggy patch of hair. I follow the curve downward between her legs.

"No, don't," she says. "I'm serious, I'll fall. Oh."

The smell is rich and shocking, like the breath of a cave. I feel her sway over me like tall grass, her warm thighs pressed to my ears.

Once abandoned, you will always be a thrown-away thing. You will never be able to possess or hold, will never understand the rituals by which people bind themselves to others. Everything is as fluid as air or water; names are to be changed, money to be hidden. Doors give you an irresistible urge to leave, just for the feeling of leaving. And you watch for this same urge in others: the thinking ahead, the absent laugh, the counting of money. You know people have thoughts they don't tell.

She sits down on the edge of the couch, a sticky look on her face as if she's just woken up from a long sleep. She lifts her feet and I remove the bunched-up pants from her ankles. "Your turn," she says. "Stand." I stand up and she unzips my zipper, begins to peel both pants and underwear down my legs. I am careful to pry off my shoes as she works, to step out of the pants when they reach my ankles—I am suddenly worried about looking ridiculous. But there is no helping it: I glance down at my sickly white legs, how they end in brown socks. It's hard to imagine that they're really mine, these limbs, that I stand on them. Is this getting laid, this nakedness? It's like losing your body.

She holds me at the back of my thighs, then takes my penis in her mouth, so quickly that I'm barely aware of it happening. It's not the sensation I expected, not explosive but gentle, like the pull of the water at the beach when it tugs the sand from between your toes. You want to follow, and you want to stay. "Not too much," I hear myself mumble. "I want to take off my socks."

"Leave them on," she says. "They're sexy."

She laughs, lying down on the couch. It is an invitation and I follow, spreading myself on top of her, careful for the sharp points of elbows and knees. "I've never done this before," I say.

"I know. You look like you're in shock."

"I just thought I should tell you." The truth is that I am vaguely worried about hurting her somehow—or hurting myself.

"Don't worry," she says. And I try not to as she slips me inside herself with a single easy motion. But it's a startling moment: suddenly my penis is gone and we are attached. I hesitate, rest my weight on her hips, then begin to move. I have to tell myself to move, actually; there's nothing natural or automatic about it. It is awkward, awkward, like trying to write lefthanded, but I find a rhythm of sorts, a careful bumpy rhythm, and things seem to be going okay. It's a precarious, perched feeling, moving over Violet. "I'm fucking," I tell myself, as if the word could sum up the mystery of this thing and of how I got here, naked on the couch with Violet. "I'm fucking!"

I must have said it out loud, because Violet laughs. "You are," she says. "We are." She has a look on her face as if she were standing at the prow of a ship, watching the sea come forward. Her hands are on my back and she rocks in time with my motion, lifting her knees in the air, breathing deeply. "Oh, yes. There. There. There."

Where? I want to ask. We are moving somewhere separately together and I want to know. My father is in Tel Aviv, sitting on a bench overlooking the sea, shocked by the Middle Eastern sun. This strange place is the Homeland, and these are Jews, carrying guns, shouting at each other in a language, both soft and guttural, he can't understand. His tote bag is almost empty now. Citizenship is automatic under the Law of Return, and it is this same law that brings him to the bench every day to watch the light burn on the water. He takes out his passport, just to check his name, his picture. It's easy to mix up who you are and who you're trying to be. One slip and the mistake is made.

"That's good," says Violet. "Yes, there. Keep going."

But I've gone too far already, past the stopping point, and when it is over I lie very still, my eyes closed, listening to her breathing—to the fact of her. I do not move because I can't bring myself to uncouple.

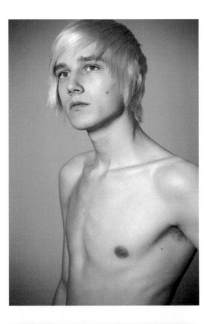

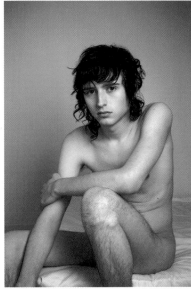

^^ ^ RYAN PFLUGER

THE BEST OF THE LISA DIARIES

BY LISA CARVER

In the Beginning

In 1997, I got the idea that if I didn't allow myself to seduce people, maybe I'd seduce God instead. It didn't work. I did not get God through abstinence; I got cranky. I snapped at clerks, and I didn't look good. I told my friend Kate in New York about the shriveled state of my soul, and on Valentine's Day in 1998, she handed me over to the king of the lotharios, Dick Rocket (I was his seventh date in February alone). My soul soaked up Dick's semen and grew strong again. Thereupon I entered the worst period of debauchery in my life. No one was safe from me. "No means *no!*" one lesbian told me after I'd sexually harassed a young homosexual until he almost cried (I got him after she went home). I was going from state to state. Jerry Wick was in Ohio; Dave was in Massachusetts; and the perverted people in New York were all gathered together at Squeezebox like a thousand tulips smooshed together in an overprotective old lady's flowerbox. This was back before Dave had forbidden me to ever do cocaine again, and while coke didn't change my sex life very much, it did give me more *time* to have it, what with no need for sleep.

THE BACH OF SEX
MARCH 11, 1998

After the dreadful be-in, I went to Dick Rocket's house. We pretty much said nothing. I felt shy. Then he said, "Do you want to hang out?" I did. So we took off our clothes and got in that beautiful bed. Well, I guess it's not actually a beautiful bed, but for me it's a flying ship of pleasure. Oh, Diary. Oh, God. The man is a genius. He's the Bach of sex, the Edison. That guy should not have to work—the government should just give him a grant, like they give any great artist or scientist, to have sex with people. I mean it. You know how most people have like nine techniques each for cunnilingus, fingering, and fucking, and the really good ones have nineteen? Well, he has about ninety-eight! He doesn't have to be always doing new stuff—I would be totally satisfied if he just did the old stuff to me again and again for the rest of my life. But there is new stuff. Female ejaculation is not a myth! I thought I was peeing. I said, "Stop, stop!" He was using the "c'mere" finger inside me. He said, "No, it's okay." I didn't believe him, so he did it to me again. I said, "Is this normal? Do other women do it?" He said some can. He watched a video on it! He is very dedicated.

Then he took the condom out. We hadn't even gotten to coitus yet. I laid back and sighed. I was so happy. Every millimeter of my body was happy, and I couldn't believe I was going to be allowed more happiness. I guess he thought I was sighing with irritation at how long it took with him, because he said, "If you want to go to sleep now, I don't mind. I'm good just like this." All he'd done

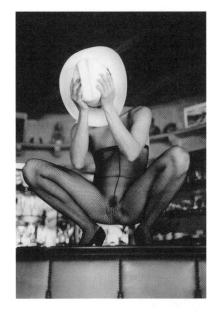

all night was wait for me to come back from my other date and then give me orgasms for an hour, and that was a good night for him! Now that's a gentleman. Kate insists we are in love, though neither of us believes her.

I want to do all these things before I turn 30: be in a real orgy; have full lesbian love; sleep with three different guys on the same night (not together—so that makes it different than an orgy). I still want to be married and have a baby, but my six months of abstaining turned me into a maniac. I want to see Adam again, too. He's so jittery, pent-up—completely bent out of shape. I just know I could smooth out his life. He needs some *fi-i-ine* luvvin'. It's not fair that all the fine luvvers are luvvin' each other. It ought to be spread around.

BATHROOM OF LOVE
APRIL 15, 1998

Kate— I'm unneccesarioly drunk. I'm a basthroom of love. Qi QWi Qil will say more tomorrow. Love yt9 youl. ALl I dAn xN XN can say is I was locked out of my house and I breo breok broke in with my foot— kivcked in the t door. You can imaginge my sex life. Love youu! See yuou so soon. —Lisa

That's the email I found in my "sent" box this morning. As best as I can remember, this is how I met Jerry Wick: We were backstage at a club in Boston. He didn't know I was a journalist there on assignment; he thought I was a Nashville Pussy groupie, and he got really angry—he thought I was going to get used. He said I was too innocent to be here. We were fighting about it—we didn't know each other's names or occupations, but we were very heated in our argument— and I was complaining because all the beers in the refrigerator were imports and I only like cheap ones. So he smashed his expensive bottle against the wall, and it was like he'd laid down his coat over a puddle for me, and I said, "That's it, you're coming with me." And I fucked him in the girls' room. I remember yelling from my stall: "Hey, anyone out there got a condom?" And all the girls applying lipstick tittered, but a little square plastic package did come flying over the stall door.

UP A BEWIGGED GENTLEMAN'S DRESS
MAY 1, 1998

It was a gay, gay weekend at Coney Island High. I licked the crotch of a man in a white wig and a dress on stage, sexually harassed a boy until he almost cried and his lezzie friend told me, "No means *no!*" Hopey, an unoutraged lesbian, stuck her tongue down my throat for my first lesbian kiss (I'd always gone for straight girls before). I stuck a dollar bill so far down a plump girl's panties I wonder if she ever got it out. Meanwhile, somebody was breaking into my car up the street; they took my radio and my mail. Dick Rocket was deejaying, so he witnessed all my shenanigans. It's so funny how people always end up putting just as many problems into non-relationships as they do into relationships. I mean, surely he's still doing stuff with other people; probably he didn't care at

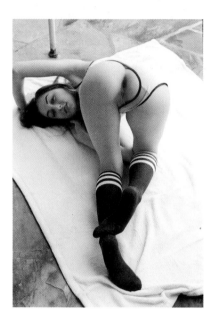

all, but now I'm wondering if he did, and that's what I mean about problems—worrying, not being natural.

Well, I'm just not a private person—not about privates, anyway. Reading, I think, is private, and should be done at home, while kissing is better the more eyes and lips there are. If I kiss lots of different people who have nothing in common in rapid succession, it's almost like I'm letting them make out with each other. I like to mix and match. Like I brought my conservative vice-president of a shoe company uncle over to the house of a 25-year-old woman walking around in bra and panties talking about her third husband, who is in jail. My uncle talked about her for months after. I love that last night I had my head up a bewigged gentleman's dress at the same exact time some thief in the night had his hands on my radio: I feel a part of some great transaction.

MY DAKOTA

MAY 13, 1998

Just as my friend T.R. made that turn on the highway lining the river where you suddenly see Manhattan, the sun went down so the light got sucked out of the sky and was concentrated in a glow that seemed to *rise up* from the buildings. And at that very moment, Billy Idol (who had been singing "Hot in the City" on the radio) cried out: *"New York!"*

Then we got lost, then we figured out where we were, then we got lost again, then we gave up and parked in a $6-an-hour lot and took a cab to Squeezebox. There, everyone looked like Billy Idol except they had black hair and some of them were women. Girls were dancing on the bar in bras and black leather panties, there was a drag queen in a hoop skirt and a powdered wig . . . then I saw Kate! She was moving through the crowd carrying on conversations and holding her drink above her head. I heard her barking laugh above all the other noise, and it felt like getting into a warm bath. I sidled up to her all proud. "Kate," I murmured. "Baber!" she yelled, and put her arms around me. She gave me her drink (which I finished off in one swig) and led me to our table. Mistress Dakota was there. I'd met her while visiting Kate in the dungeon she works at. Dakota looks like Cindy Crawford except Dakota's prettier. "Dakota never comes out," Kate said.

"I came tonight because I heard you'd be here," Dakota said, looking at me, and everyone else said stuff, but I couldn't hear anything—it felt like insects were inside my skull, and this feeling definitely wasn't happiness—it was a lot better than happiness, I thought. Then I realized people were talking about oral sex. "I never do a thing for men," Dakota was saying. "They satisfy me and then I do nothing back. I tell them I don't have to—I'm too beautiful."

If someone *thought* that, I'd find it despicable. But to *say* it, proclaim it . . . that made it ballsy and funny. Her arrogance made her even more glamorous.

"After I'm satisfied, I tell them: 'Clean the apartment. And then pay the rent.' I don't lift a finger." I vowed then that Dakota was going to lift a finger tonight. On *me*! And then when it was *her* turn for *my* finger, I'd leave. Just because no one ever does that to her.

"Can I buy you a drink?" I asked.

"I don't drink," she said.

So I got her a Coca-Cola, and a Jack and Coke for myself. Then I got another, because I was scared.

"No woman has ever made me come," I told her, hoping she'd take it as a challenge. T.R. made a strange noise and sunk down in his seat. "Maybe once one did—I wasn't sure. No woman has ever made me come where I was *sure* she made me come."

"Well, let's go," Dakota said, and we went to the bathroom. I closed the door behind us and leaned on it, but I was still half a foot taller than her. I took off my heels. "You don't want to be in stocking feet on this floor," she warned. "I don't care about that," I said, and put my hand on top of her head and pushed her down. Her breasts were fake—double Ds—and I felt them up as she rolled down my skirt and stockings and underwear. They were very firm, and *big*.

Then she was on her knees and her face was between my legs, and she was licking and fingering me at the same time. She fingered with one hand and with the other hand she squeezed my ass, pulling my hips into her face. I had one hand tight on the doorknob and the other on her head. She came up for air and looked up at me with her chin all wet and I said, "You are so beautiful." I bet people don't tell her that much, because she is *so* beautiful they must figure she hears that all the time, and they want to show they're different by *not* telling her. Anyway, she was beautiful. Especially with her face wet and at thigh-level, tilted up. She went back to it, but I was so drunk it was hard to feel anything. "Harder," I kept saying, and she'd do it harder and then I'd tell her to do it even harder, until she was practically beating me with her fingers and her mouth and her palm. And then I came. I was sure I came this time. When it was over, I realized people were pounding on the bathroom door, yelling about pee. Dakota was looking like a pet waiting to be petted. I remembered my diabolical plan, but in my plan I hadn't counted on how benevolent I'd feel post-orgasm.

"C'mere," I said, placing her in my spot against the door. I tugged her pants down to her knees. She didn't have any underwear on, and was waxed completely bald! Oh, it was too fine! I felt ashamed that I'd only trimmed and baby-powdered. I licked up the whole surface of it and couldn't feel even the *idea* of stubble. I stuck my tongue in, and it tasted like it looked. No wonder the men were happy just to go down on her.

2001 POSTSCRIPT: Shortly after that experience, I found a black-and-white phone sex ad with a photo of Dakota. I ripped out the ad and put it in a leaping goats picture frame and hung it over my desk for inspiration. This year Kate told me Dakota and Dick Rocket got married. Kate said they try to be swingers, but end up staying home instead. If I were them, I'd stay home, too—together they possess the most beautiful set of genitals in the state of New York.

MAY 14, 1998

Later that night, Jerry's van pulled up in front of the club. His band played, and then he and I went to a hotel room paid for by a Swedish magazine (I'm due to interview Jon Spencer later today). Jerry was reluctant to have sex with me. "I fooled around with two women a few hours ago," I confessed. (The second time this South American lady literally flew across the table at me after Dakota and I finally emerged from the bathroom. She was swearing and wrestling me, forcing her tongue into my mouth and squeezing my boobs. I think maybe she had a crush on Dakota and knew that was impossible, so my body was a sort of Dakota conduit.)

"I wait for you all the time," I told him, "and then you don't even want me. I got tired of waiting."

"You knew I'd be here in an hour, but you went to the bathroom with her?" he said.

"The last hour is especially painful," I explained.

"Are you going to let yourself be controlled by beauty?" said Jerry, and he put his cigarette out on the hotel wall and then he did it to me in every position, all across the single bed and the ripped-rug floor, and after that he broke up with me.

LICKING GUMS
MAY 25, 1998

I was supposed to be interviewing this wild southerner Jenny Mae in New York for my magazine, but I just made out with her and got in a fistfight defending her honor instead. Well, it wasn't exactly a fight—I told this bearded man to high-five Jenny Mae, and he refused, which I found to be insulting to my guest, so I punched him in the nose twice, and we all got thrown out by the bouncers. It turns out that Jenny Mae is best friends with Jerry Wick—can you believe it?! They both live in Columbus, Ohio. Jenny Mae told me there's this expression in Columbus: "getting Wick'd." That means someone is very rude to you. Jenny Mae said guys are always beating Jerry up and no girl will sleep with him, because all he does is talk about the Hindenburg exploding or Fidel Castro to girls and then tell them they're stupid for not knowing anything, until they cry. She also told me about the time she saw Jerry with his violin in hand (seriously), crying, as he was being kicked out of yet another house. I could feel myself falling in love.

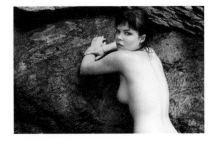

I finally made out with Adam, at Squeezebox. Dick Rocket's cutie-pie roommate Sean leaned over into my ear and said, "Lisa, you slut!" I said, "Sean, I love you too!" and I was kissing him while my pelvis was still attached to Adam's. Sean was surprised! Adam said, "Doesn't it bother you that he called you a slut?" I said, "I am a slut! Not only that, but you've been licking cocaine off my gums for the last fifteen minutes, Adam." Adam had never done cocaine, and was very disturbed. When he started kissing me again, I said, "Can you taste it?" That got him upset all over again. He was really annoying me, so I got off his lap and wandered away and found a nice young surfer type named Yoshi, and I molested him. He was saying (very good-naturedly): "This is really fun, but I'm gay. I'm not feeling anything. I think you're nice—you're funny, you're beautiful, but I'm gay. You're like an animal to me."

Back at Kate's house, the explanation for my behavior towards Yoshi came over the radio: "I guess it's just the woman in you that brings out the man in me . . ." I think it was Foreigner. Foreigner always tell it like it is. He was as limp as a dishrag—I licked it once just to be sure. I was happy, though. He tried. I don't demand an erection; I just say give it a try. I didn't want him to go to his grave without ever having tasted the softer side. I feel that we all have our special mission in life. Mine is: Anyone who has never kissed a girl—male, female, young, old—I gotta help them.

NEW HAMPSHIRE

JUNE 2003

"Are you Lisa Carver?" asked the policeman at my door, and I wasn't sure how to answer. He was young and probably Italian and was leaning against my porch post so that his hips and legs were at least six inches in front of his shoulders and head.

"Why, what has she done?" I joked. I had on that new, ultra-scientific double-barrier-protection roll-on antiperspirant/deodorant, so my underarms remained fresh and dry while the rest of me grew clammy.

"My friends and I just wanted to see what she looks like," he said, gesturing to the cop car from which three other officers waved. "Are you her?"

I stood there with lizard face, which apparently he took as assent.

"We read your column on Nerve—'The Lisa Diaries.' We're fans."

I felt awash in relief. So I hadn't committed a murder in my sleep—something I've always feared is bound to happen sooner or later. I tried to remember what the last week's diary entry was—oh yeah, taking my husband to the prostitute. Oh my God, wait—prostitution is illegal! I'd incriminated myself and Dave and the entire establishment at The Swedish Massage in Maine! If I say I made it all up, would the policeman believe me?

As if he could read my mind, he said, "We don't want to bust you on anything. We're just regular people. We wanted to see what you look like, is all."

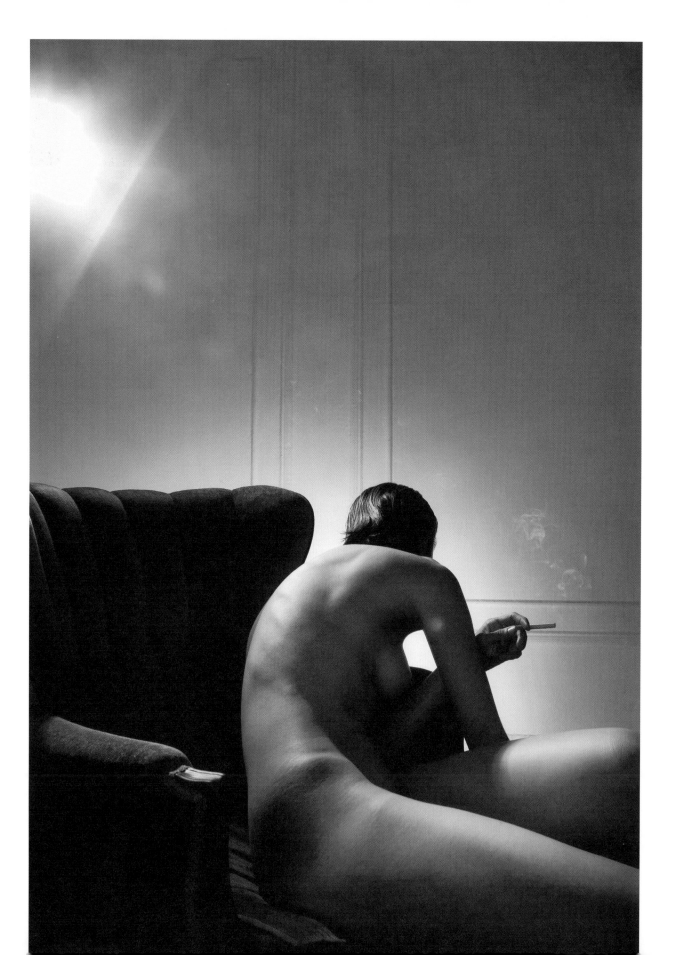

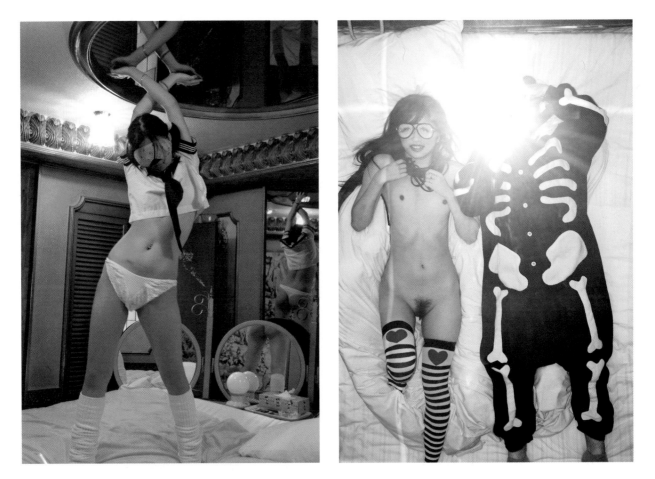

^ ^ RIKKI KASSO

< CLAYTON JAMES CUBITT

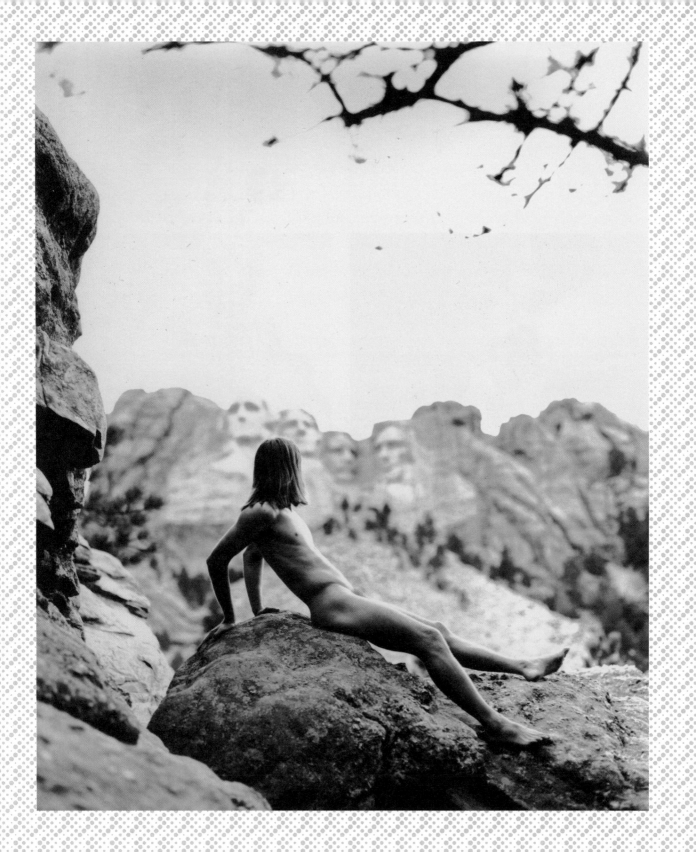

1999

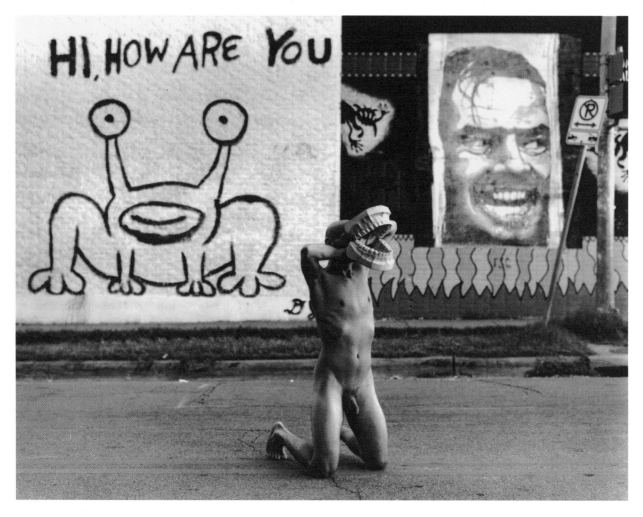

PHOTOGRAPHY BY
SPENCER TUNICK

"Naked States" represents a five-month journey across North America in which Spencer Tunick photographed nudes in every state. He traveled through cities and rural locales, searching for individuals who were interested in forming new American landscapes. The challenge of breaking past limitations imposed by regional mores created a dynamic tension between the bodies and the outside world. The end result is a combination of the artist's America Zone series of one- and two-person nudes and his Reaction Zone series, group nudes of more than 100 people framed by vast undefined spaces, combining elements of performance, sculpture, and installation, experiencing place and poetry through images of human nakedness.

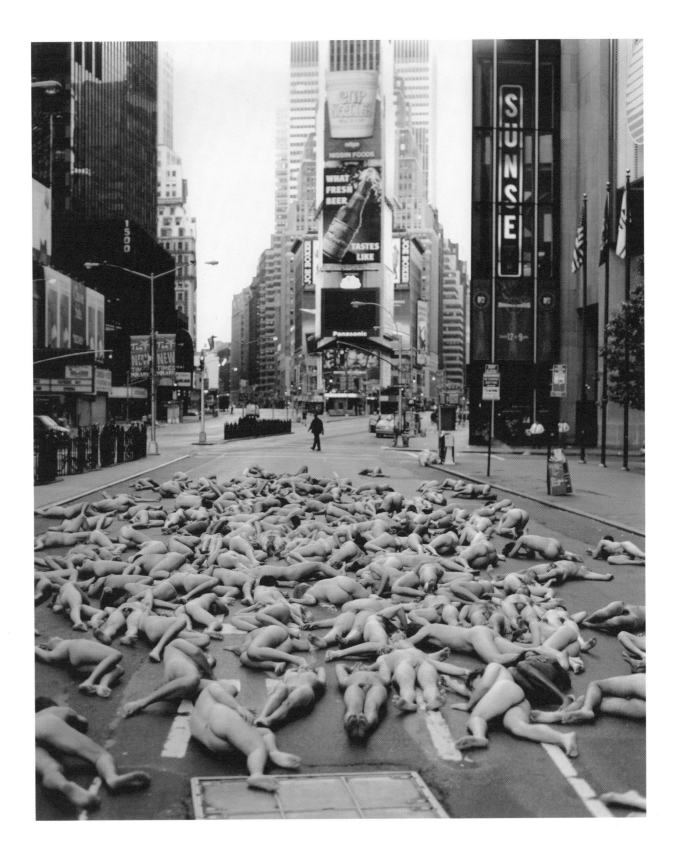

A STORY PROBLEM

BY DARCY COSPER

Let x = x. There are things to solve. There are many variables. There are elements to be accounted for. There are trajectories to identify. There are forces to be reckoned with.

Your answers will count. You must show your work. Pay attention.

You are at a party. Let us say, for the sake of argument, that it is a large party, it is a large city, it is deep summer. Let us say that there are many people and that they are restless in certain ways and dressed with intent and the room is big and less than bright but more than dim.

The party is very large and crowded and the music is loud and the heat is close and pressing and the women twist their hair up off their necks and pluck at their shirts and people flap their hands and everyone says to everyone else, *It's so hot it's so hot.*

There is only one person in this room you have fucked more than once. Let him be represented by the letter A. You were with him for years. It was not so long ago. He leans against the wall; you see him in pieces through a mass of people. He is talking to a woman, B, who is a close friend of yours. She is the former lover of C, a close friend of A's. Three of the four of you once shared a bed, a night, made certain exchanges, ignored consequences.

C is on the other side of the room, talking with D, frail and sleepy-eyed, a childhood friend of B's whom C tangled with for a month before some resistance brought things to a halt. Standing with them is E, sultry, sulky, once wooed and tumbled by A, the only time you know of that he stepped out on you. She is large and absurdly beautiful and angry tonight and you travel along her gaze to a corner of the room. She is looking at F, who has fucked B, D, and long ago, G, who is talking to him while she waves to you. J brushes past and his hand lingers at your waist; he is with the girl he was cheating on when years ago you let him seduce you, and now she is his wife. K, whose marriage is falling apart, comes to drop a kiss on your brow and asks you to dinner the following week; he is with the woman he would not harm though he wanted to when you tried to seduce him and didn't sleep for weeks imagining the length of his body and the shape of his face, and you are all smiling and dazed and everyone says to everyone else *It's so hot isn't it so terribly hot let's have another drink.*

Later you will talk to F, lean, dark-eyed, and he will let one finger come to rest on the delicate, sharp point of your hip, and E will come in her lovely rage to slip between the two of you and she will not cast a glance back to acknowledge the space you occupy nor will you move. Later F will take E home and return to the party and G will tell you that E is another in the string of women F has been with between the sheets, and for a moment you will imagine fucking H, the man who broke E's heart—you will imagine this not out of malice but out of a desire for continuity.

Later still, G will leave with a boy who pressed you against the bathroom sink, and you will wonder how many more people each of you would have to fuck for the sake of perfect symmetry. You will wonder what is to be added to this equation tonight.

Let us say that you are at a party and it is a dense late summer night and the weather will never break, never, and your shoulders are bare and slick, that there is a hand resting on one of them, and the hand belongs to a man and there is a wedding ring on this hand. He is standing beside a woman who is not his wife, a tall woman who gave you a slow, appraising smile that made your breath catch when she arrived. Now it is later, it is late, and this tall woman hands you a glass of wine and slips her arm around you and leans to kiss you, and when your wet mouths part the man who is married lets his hand slip from your shoulder and stares and asks, *Are you for real?* And she tells him *No, we're just a projection of your desires,* and you think that she may be right.

Let us say that everyone has had a certain amount to drink, and that you are watching L, a round-eyed cupid-lipped girl introduced to you by B, a girl who has pursued your friendship with a force that unsettles you. Tonight she is an object propelled and drawn by the heat of others. You watch her careen from one group to another, easing herself into the crevices that separate their bodies. Later tonight, so much later, she will kiss A, and he will walk away from her into the dark and call you from the street. And when he calls, one of the people in this room right now will be in your bed, and together from the tangle of sheets you will listen to the answering machine absorb his confession and his anger and his love. You will wish to be alone, you will regret nothing but the rawness between your legs, the rawness of your mouth, the ferocious roughness of the hands that gripped you tonight. You will stand naked in the dark at the door to your apartment and wave goodbye.

Let the letters not yet assigned stand for variables, individuals, situations you don't know, can't see.

Now solve for these things:

The weights of wine and ice and bourbon.

Melting points and breaking points.

The salt content of sweat, of semen. The surface area of naked skin.

The equal and opposite reactions.

The distance from all centers, the gravitational pull of bodies, the relation of objects.

The velocity of desire.

The probability of grace.

The sum of longing.

The space between us.

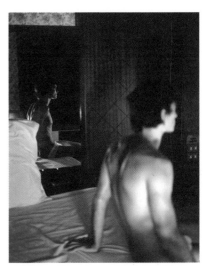

▴ OHM PHANPHIROJ

LETTERS TO WENDY

BY JOE WENDEROTH

The following letters were written on postage-paid "Tell Us About Your Visit" cards found in a Wendy's fast-food restaurant. They are excerpted from a series of more than 340 letters written over about a year's time.

SEPTEMBER 2, 1996

I love the cleanliness of a Wendy's. Such a clean is not in any sense a banishing of genitalia; it is the creation of a quiet bright mind-space that allows for the deliciousness of genitalia to become obvious. I look out over the colorful clean tables and the pretty food posters and *I like people* again; each has a dick and balls, or a cunt and titties, which, clean, are simply enjoyable.

SEPTEMBER 10, 1996

I wanted to say today to my register-person that my penis was broad. "My dick is broad," I would say, or "Do you understand how *broad* my cock is?" Maybe simply, "The breadth of my penis." What's the point? There are times when ambiguity is not a failure to tend to a specific concern, but rather, is an articulation of *the limits* of concern, without which we are certainly nobody.

SEPTEMBER 13, 1996

Rather than restrict sexual activity to a specific set of acts, or restrict the articulation of such acts, we need only draw real lines, lines upon the earth, to mark *whether or not* sexuality is in this place active. The question, then, is: *is sex now, here?* If it is, well then. If it isn't, as in Wendy's, it always isn't, then a campaign dawns, and we stand fast in the sexy inception of already failed propaganda.

SEPTEMBER 14, 1996

Last night I dreamt that I pissed on Wendy's head. I entered the restroom, approached the urinal, and started pissing, when suddenly I realized it was not a urinal at all . . . but Wendy. As I began to protest (to the dream itself) I understood that I *must have* known it was her. I felt ashamed, yet wronged. I also felt like the only thing I ever wanted to happen was finally happening.

SEPTEMBER 20, 1996

Today I had a Biggie. Usually I just have a small, and refill. Why pay more? But today I needed a Biggie inside me. Some days, I guess, are like that. Only a Biggie will do. You wake up and you know: *Today I will get a Biggie and I will put it inside me and I will feel better.* One time I saw a guy with three Biggies at once. One wonders not about him but about what it is that holds us back.

SEPTEMBER 21, 1996

If I had to say what Wendy really was—if she had to be one thing instead of a field of various energies—I think I'd have to say that she was a penis. Something about her face and the shape of her hair, the muffled red coherence of head and torso, and perhaps too her lack of arms and legs. A penis is found in just such a lack of limbs; it's really amazing when it arrives anywhere.

SEPTEMBER 24, 1996

I love to watch a dick slamming in and out of a cunt or an asshole. The only way TV could enhance Wendy's is if it was confined to showing nonstop hardcore pornography without sound. No ridiculous assertion of plot or personality. Just the real pleasure of lacking language. Just a reassuring view of the signifier itself as it finds its way to its ancient hiding place in broad daylight.

OCTOBER 3, 1996

I love being in a little girl's special place. That's how I look at Wendy's—it is no less than Wendy's special place, even if she has abandoned it, or been excluded from it, and even if it has been trespassed by countless strangers by now. If you sit still long enough, you realize you're deep inside a little girl's special place, and I don't care what the priests say—it feels wonderful.

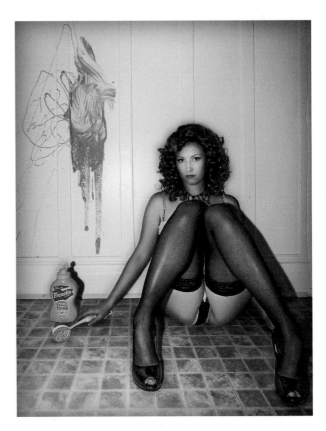

^ MERKLEY???

NOVEMBER 15, 1996

A beautiful woman with a Biggie. Nothing else—just a Biggie. She sat alone; she seemed like she was waiting for someone. What lucky soul could make a beautiful woman with a Biggie wait? Who has that kind of power? What person would a beautiful woman with a Biggie find attractive? Only one answer made sense to me: *another beautiful woman with a Biggie*.

JANUARY 4, 1997

It's wonderful to think of meat sculpted to resemble a penis, but it's a different thing to actually have it on your plate. So long as it's an idea, you can lick it, kiss it, without feeling strange. Its actually being meat is something the *idea* seems incapable of entertaining. That is, while the idea allows for a wonderful semblance, it forever infuses the necessary *biting and chewing* with unnecessary sadness.

FEBRUARY 8, 1997

Wendy, will you not even poke me? Not even a slow poke? I wonder why you treat me so. Am I a wooden board? Am I to be thought of as a simple wooden board? Come on, just give me a slow poke. I'm not a wooden board, honey. Come on, just poke me like you used to. Just a slow poke. Look into my eyes—are these the eyes of a wooden board?

MARCH 22, 1997

Today I ordered a hot wet pussy-dickhead shake with eyes and tongue. "We're all out," says the brave young employee. "You must've just run out," says I, "because I can still smell it." "Yep, just sold the last one," says the brave young employee. "Why don't you make more?" asks I. At this point the manager came over. "Is there a problem?" says he. "You're out of hot wet pussy-dickhead shakes," says I.

MARCH 26, 1997

Shall I put my penis on the counter? But what would it really accomplish? Would it change the world? Would it change me, or the attendant employees? No, no, and no. But should we judge an activity by whether or not it *changes* something? That would imply evolution as predetermined and full of specific purpose. My penis on the counter is resistance; it demonstrates evolution's indeterminate willfulness.

MARCH 27, 1997

We shall swing by the Anal Ranch, pick up the Lord, and we shall have a Butt-Fuck Week-End. The Lord will have a Biggie but not a drop shall be spilled. Our faces will be dripping with hot cum and we shall notice the way muscle is. The Lord will be our Butt-Fuck Buddy and we will be the Butt-Fuck Buddies of the Lord. But do not touch the Lord's Biggie—not ever.

JUNE 3, 1997

I took my Frosty into the bathroom and sat it on the floor. I pulled my pants down, got down on all fours, and buried the tip of my cock in the cold brown swirl. Then I forced my cock and balls all the way into the cup, Frosty spilling on to the floor. Then I thought real sexy thoughts. My erection slowly forced more Frosty on to the floor. This is the real test of a drink's thickness.

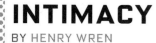

INTIMACY

BY HENRY WREN

If I sense that they're going to fuck back there (after twenty-six years in the business I can usually tell at the beginning of the evening, sometimes long before either of them have any intuitions

of intimacy) I'll drive them to Iwo Jima out in Virginia. Not only is Iwo Jima beautiful at night, all lit up, but it's a good long drive away; it allows ample time for him to move to her side of the seat, to kiss her on the cheek, for her to kiss him back, for him to kiss her neck, for her to crane it, to intimate a moan, for him to touch her breasts, to mess her hours of hair, to begin to undo the preparation, like winding a clock hand backward, for her to fumble with his cummerbund, for him to begin work at what is always an inconvenient dress, to look for quick ways in, of which there are never any, for her to help him help her out of the dress—the dark window between the driver and passenger compartments of the car is usually raised for all of this, but not always—for her to lick her palm before taking his cock, for him to move his hand down from her breasts, down to her belly, down to her pussy, which is usually wet, and sometimes leaves a water-soluble mark I have to take care of in the morning, for him to insert a finger or two in her pussy, two or three knuckles deep, for her to moan, for him to think about baseball, or his mother, or anything to distract the seven seconds of come knocking on the door of his existence, for her to lean over and wrap her lips around him, to take off her class ring and use her hand under her mouth, like she was trying to swallow a microphone, for him to pull back her hair to watch her suck him off, for her to sit up, to remove her panties from over her high heels, which she usually won't take off, I don't know why, for her either to spread her legs, bend her knees and pull him unto and into her, which is the most common way of accommodating to the backseat, or mount him, to use her hand to insert his cock into her from behind, to balance and torque herself with her hands against the defrost parallels of the back window, to push her chest into his face, for him to say, sometimes with a whisper into her ear, sometimes with a holler, *I'm fucking you, I'm fucking you, I'm fucking you, I'm fucking you,* because he's still in high school, still more aroused by the fact of his having sex than by the sex itself, for him to fuck her, to fuck her all the way to Iwo Jima, to roll down the window, which he thinks is something like a joke, and watch the city pass as they fuck, the city that I choose to give to them: the gay bars and rusting neon of Dupont Circle, the losing lottery tickets of Mount Pleasant, the fluted columns of the Tidal Basin, the baguettes and bag ladies of Georgetown, the numb yellow streetlights of the Whitehurst Freeway, the scenery that I choose for them as they fuck in my backseat.

This has been my job for twenty-six years. I drive a limousine. During most of the week I drive rich people who are used to limousines. I drive them from here to there, am never late, and never talk unless I'm spoken to. Just

before the summer, in mid and late May, early June, I drive high school kids to proms. These kids have never been in a limo before, and have saved up for months to pay for this one magical night. Some will actually call it that: the one magical night. Because of this, they very often have sex in my backseat.

I may have to drive around Iwo Jima several times, waiting to be sure they're completely done, and more than done, that they're at peace, rested, happy. That's my job, if I had to state it in such a way: to make people happy. I'll circle around while they finish up. I'll see our boys' faces, their right sides, from the back. I'll watch the names at the base circle by and blur. I'll try to count the soldiers in the statue, but it's almost impossible because of the way they're climbing all over each other. Every time you look at it you think you see another arm, or another boot. All of these must connect to another soldier, you think. (There are seven of them.) It doesn't bother me to drive as long as they need back there. I've driven around the memorial for hours waiting. Sometimes they'll finish only to start again. How do I know? After twenty-six years, you learn to know. I've memorized every fold in every shirt on the boys in the memorial. I know how the helmets fit on the heads. I know how the backpacks rest, and whose hand is where on the flag that they're so eager to stab into the island. Whose hand is on top.

When they're done in the back, I always get them out of the car to see the memorial. They like it when I do this. It makes the night feel more magical, more unique, like everyone else is in a limo but only they get a tour from their driver. Usually she'll be wearing his jacket, smoking a cigarette, a complete mess as compared to how she looked at the beginning of the evening. He'll look better than he did when we picked her up, more relaxed, I guess, and will sometimes hand me a couple of bucks, although I don't know why. "This is my job," I tell him. Which is not to say that I give it back. "Iwo Jima," I say, pointing to the memorial in front of us. "One of the volcanic islands in the North Pacific, south of Japan. Site of the greatest battle in Marine history." They're holding hands, always, this is how it always is, they're holding hands, and his attention is elsewhere, maybe at other girls walking around, maybe off in space, maybe replaying the events of a few moments ago, but she's listening, so I talk to her.

"I've never been to Japan," she says, "but I'd like to go."

"Well it's amazing. It's an amazing place. My brother wrote me letters from there, every day."

"Every day!"

"Every day," I'll say, and sometimes I'll feel proud of that. "We returned the island to the Japs in '68, so I don't know about since, but it used to be just beautiful. That's what he told me."

He'll kiss her. He'll put his hand on her butt, and she'll smile, as if for me. Am I happy for them? Of course I am. Who do I hate?

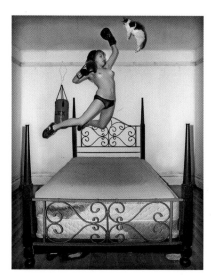

^ MERKLEY???

"It's a really pretty monument," she'll say.

And then we'll get to talking more. He isn't paying attention. He doesn't care. The farther away his mind goes—and he may even go for a walk on his own at this point—the closer we get. I've said everything I have to say for the evening, I don't want to say any more than I already have, so I let her talk. I let her tell me about how she's never been to Japan, but has been to Portugal, which is really pretty. She was there for a semester, because school was becoming too much. Home was. I let her tell me about how she doesn't usually smoke, she hardly ever smokes, she doesn't even know why she's smoking now. I let her tell me how she has a little brother with Down Syndrome, and he can really be embarrassing sometimes, I've never said this to anyone, I'm ashamed to say it out loud, but I've been drinking, you know, God, I hope it's okay that we had a couple of drinks in your car, but, well, it's just that I love him, but. You know. But. And then I let her tell me about her first boyfriend's car, and how the alignment was so bad, you're not going to believe this, but he actually had to hold the wheel upside down to go straight. I let her tell me about where she lost her virginity, it was so long ago, I can't believe how young I once was, I don't know why I'm telling you this, you probably think I'm some kind of weirdo. She flicks the ash, and I let her tell me about her father's girlfriend, and a food called panini, they're just little sandwiches, and how given the choice she'll always use a pencil. I let her tell me about her brother's school, which is a special school in Virginia, and the music she likes to listen to, and how her room is decorated, and her friend Tracy's night in Atlantic City when she won $400 but had to give it back when they asked for some ID. I let her tell me about what college she wants to go to, and her mom's sleeping pills. And after everything she tells me is my implicit response: "It's okay." I don't say it, I don't say anything, but it's there, hovering like the dust between the spotlights and the statue. I let her tell me again that she doesn't usually smoke. "It's okay." I really want to learn to drive a motorcycle. Do you know how to drive a motorcycle? "It's okay." All the while, she doesn't even realize that we've been walking, that I've been leading her around the memorial, around our young boys blown up huge like heroes against the night. The breeze makes her shiver, and I let her tell me about how she's allergic to peanuts, how if one touches her lips, even touches them, she could die, and I lead her to my older brother's name: HENRY J. TILLMAN, JR.

"This is my brother."

"Oh."

"Right there."

"He's—"

"My brother."

"I'm so—"

I interrupt her with my nod. I don't ask her to touch the name. Wouldn't do that. I don't tell her about how he died, or what he was like, or any of that. Not even if she asks, which she almost never does.

"That's him, anyway," I say.

By now he's usually come back from wherever he went. Sometimes he's been with us all along, and only mentally absent. Sometimes he won't let go of her hand. I've seen guys go off and take a piss in the bushes. I know that sometimes you have to take a piss after fucking, but still. "We should get going," he'll say, and I'll lead them back to the car. I won't look at her in the mirror, even if the glass is down. When I drop them off, he usually gives me another tip, this time a bit bigger, maybe a twenty. "It's my job," I tell him.

Then I drive home. The car stays with me. It's a leasing arrangement. I park it in a garage I rent from my neighbor two doors down. So no one will mess with it. I open my door, which involves four keys, and take off my jacket and pants. My apartment isn't fit for a king, but I'm not a king, so it works out fine. Two rooms. Kitchen. Bedroom. I make a good living. Since the car is with me, I can pretty much choose my own hours, which is good. I want to get up at noon, I get up at noon. I need some extra cash—not even need, want—I get up at the crack of dawn, or before. I'll use the car like a cab. I've got a sign I put on top. The neighbors upstairs are usually fighting, even though it's already the morning of the next day. Why do they fight so much? I wish they wouldn't fight so much. Not for me. I can take it. But. I pour myself something strong and carry it with me to my bedroom. I go to the TV, pull the video from my bag, and put it in. I sit there on my bed, in the half darkness of the approaching morning, and I watch it all again on the screen. I watch him kiss her. I watch her kiss him back. There's a little static, but it's all pretty clear. I can see almost everything. I watch him kiss her neck, watch her crane it and intimate a moan. I'm in the television's glow. I watch him touch her breasts, her fumble with his cummerbund, him begin work at what is always an inconvenient dress. I can see out of the rear window the receding rotunda of the Capitol, and the blurred image of someone crossing the street behind us. The person is looking at the car, which means maybe he can see. Who is that? What can he see? I watch her lick her palm, and I don't know why, but that part always makes me so sad. I rewind and watch it again. I watch it again. I watch it dozens, maybe hundreds, of times. She licks her palm before taking his cock. Stop. Rewind. She licks her palm. Stop. Rewind. She licks her palm. Stop. Rewind. She licks her palm. Stop. Usually that's as far as I'll watch. Sometimes I'll make it to the end. Then I take out the video, label it with date and names, and put it on the shelf with the others, none of which I ever watch after the night itself. Jenny Barnes and Mark Fisher—Friday, May 14, 1999. Beth Baxter and David Jordan—Saturday, May 15, 1999. Mary Robinson and Casey Proctor—Tuesday, May 18, 1999. Gloria Sanders and Patrick Williamson—Thursday,

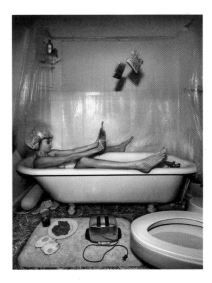

^ MERKLEY???

May 20, 1999. Leslie Modell and Ronald Brack—Friday, May 21, 1999. Chase Merrick and Glenn Cross—Saturday, May 22, 1999. I don't watch the videos to get off. I never touch myself, if that's what you're thinking. If that's what you're thinking then you haven't understood a thing.

Iwo Jima isn't real. The island is real. The battle is real. The monument is real, too. But it's based on a staged photograph. Joe Rosenthal, the Associated Press photographer who shot it, was there when our boys captured the island. There really were those seven marines. They really did grab at the flagpole. But he couldn't snap the picture in time. So he restaged it. While the smoke still hung behind the soldiers, while their foreheads were still pelleted with sweat, he arranged them for the picture. And who knows how similar it was to what actually happened. He swore it was the same. Exactly as it was, he said, right down to whose hands were where on the flagpole. The picture won Rosenthal the Pulitzer in 1945, and was the model for the memorial, as is how we have come to remember Iwo Jima. Our memories are bound to that image, which isn't even real.

If I can go to bed at this point, I go to bed. Usually I can't. They're still fighting upstairs, I wish they would stop fighting already, and I'm just not feeling good enough to go to sleep. I'll make a bowl of tomato soup from the can. Maybe a grilled cheese. I'll drink another. Morning is coming. Should I start early? I'll start early. I've got a prom at night. Bethesda. Lynn Mitchell and Ross White. Everyone, except for my neighbors upstairs, is asleep, and I can imagine the first rays pushing over the seven marines at the memorial. I can see it. I know how the sun will reveal them, how it will make them silhouettes before illuminating them. It's cold there and it's cold here. I'll go back out to the car with a rag from the cupboard and clean the backseat.

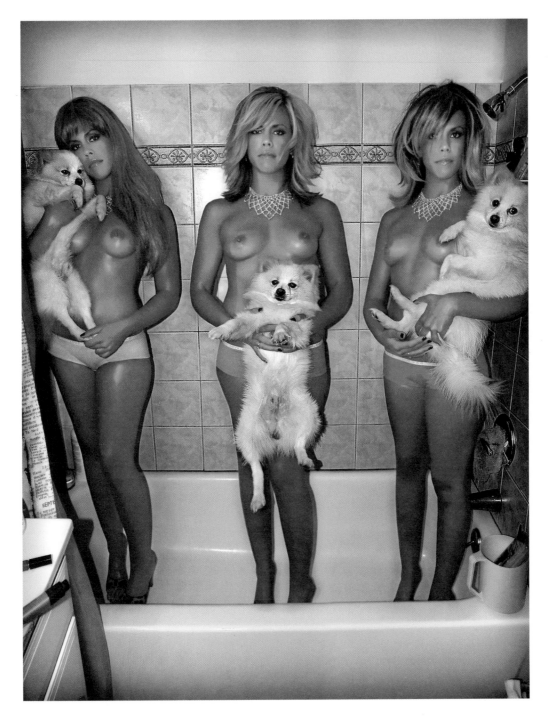

^ MERKLEY???

BED OF LEAVES

BY DANI SHAPIRO

Later, she will remember the leaves. The way they scratch and crumble against her back. The way her panties are smudged with dirt and she will have to ball them up and stuff them into her knapsack where her mother won't find them. Years later, as a woman, there will be a moment at the end of each summer when the scent of fresh-mowed grass will fill her lungs through an open car window, and she will close her eyes and her tongue will go soft, her inner thighs moist like the pale insides of a half-baked cake.

Eddie Fish is unbuttoning her shirt. There have been boys before this moment, boys who have stuck their fingers between her blouse and jeans, tugging the fabric loose, pushing their hands up around her bra and cupping her breasts. There have been boys—two, to be exact—who have unzipped her pants in the school basement, pushing their hardness against her cotton panties, eyes squeezed shut. But Eddie Fish is not a boy. Eddie is a man—28 years old—and Jennie knows these woods are about to become a part of her history. She is writing the story of her life, the story of her body on these damp suburban grounds with the man she has chosen precisely because he is a man. The blond hairs on his wrists glisten as he reaches around her and unhooks her bra. She is impressed by his skill at bra-unhooking, the ease with which he pulls the straps off her arms and hangs it on a nearby branch, a white cotton 32B flag of surrender. She is impressed by his warm, dry palms, which brush against her nipples, and by his eyes, dark blue in the noon of this clear Indian summer day, staring straight at her. "Lisa Wallach," he says, murmuring the name of his last girlfriend as he stares at Jennie's breasts.

She looks at him, flushed.

"Sorry," he laughs, "I can't explain it. Your hair, your tits—you look just like her now—"

She doesn't know enough to be horrified. To slap Eddie Fish across his pale stubbled cheek, grab her bra off the branch and streak through the woods, away from him. Instead, she is flattered by the comparison to Lisa Wallach, who is a woman, after all—at least 26—and who is very beautiful in that frosted blonde urban way. Lisa is a lawyer. She has an apartment in the city, and wears leather boots with stacked heels, long velvet skirts almost brushing the floor.

"What am I doing here with you?" he murmurs as he undoes the top button of her tennis shorts, bends down and unlaces each sneaker, pulls off her Fred Perry socks with their small green wreaths. He unzips her shorts and shimmies them down around her ankles, along with her panties. Parts of her have never felt the breeze before. Her ass, her crotch, each nipple seems to braid together into a rope twisting deep into her stomach, twining around itself, a noose which will remain forever inside her.

"Jailbait," he says, kissing her belly-button.

Years from now, Eddie Fish will be a gynecologist in Scarsdale. He will drive a Volvo, own an espresso maker, be the father of two daughters of his own—two daughters he would kill if he ever found them in the woods with a man resembling his younger self. But today, as he lights a joint and places it in Jennie's mouth, he is not focused on his future, the bright golden-boy future which unfurls before him like an heirloom rug. He has no doubts, no fears. His medical school degree is at the framer's, his internship in the city will begin in just a few weeks, and Lisa Wallach is finally a thing of the past. And here is Jennie, the beautiful neighborhood kid with the crush on him, Jennie, twelve years younger than he—16, for chrissake—three years ago he had attended her Bat Mitzvah! His eyes travel over her shoulders, down her breasts, lower to the blonde depths of her. A virgin? He doubted it. She had written him letters all through medical school, letters so steamy he and Lisa had read them to each other late at night. He stubs out the joint on a tree trunk, next to a carved heart with no names, no initials inside it.

Gently, he lays her down on a bed of leaves, her head resting against the root of a tree. She crosses her legs, her arms, trying to cover herself. She has no idea how sexy she is. He quickly pulls his polo shirt over his head, undoes his own shorts and steps out of them. Then, in his sneakers and tight white briefs, he lowers himself on top of her, careful to prop himself on his elbows.

Later, after it is all over, a friend will ask him why, after all, he did it.

"She was so beautiful," Eddie will say. "So fucking beautiful."

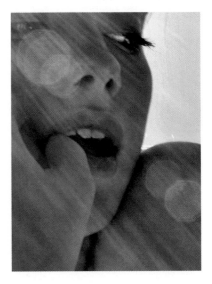

Eddie's head is between her legs. His mouth is moist, chin dripping, and he looks up at her as he twirls his tongue around and around. With his fingers, he spreads her apart. "Are you using anything?" he asks.

"Yes," she says. She wants him to think she's a woman of the world. A woman whose motto, like a Boy Scout's, is "be prepared." Her heart pounds as he slides a finger into her. Can he tell that she's lying?

He kisses her on the lips and she tastes herself. She is anticipating something awful, vomitous, some reason why her mother lines up bottles of sweet-smelling potions on the bathroom sill. She is surprised. The taste is not unpleasant: oceanic, vaguely like seaweed. Something dredged from the depths.

She wonders what he tastes like, if she will ever know.

Eddie wriggles out of his underwear and moves up her body so that his *thing,* this thing that she has been waiting for, is swinging above her mouth like a heavy, hypnotic pendulum. The last one she saw was Steven McCarthy's, back in third grade, when she accidentally-on-purpose opened the bathroom door while he was standing over the toilet.

Tentatively, she opens her mouth, darts out her tongue, runs her lips over the shaft. She is expecting something rough, something that feels like stubble. She is surprised by his smoothness, and she dips her head down and covers him.

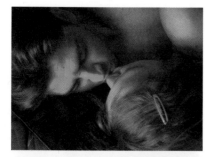

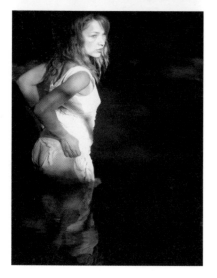

He moans a high-pitched sound she has never heard before, blending into the chirps and rustles all around them. Suddenly, Eddie pushes himself farther into her mouth with a small grunt and she tastes something faintly metallic at the back of her throat.

"Whew," he says, pulling away from her. "You sweet thing. Where'd you learn *that*?"

She feels heat rise from her breasts to her cheeks. Without even looking, she knows that a blotchy, red rash has spread across her chest and neck, a map to her inner world. She always turns blotchy when she feels anything complicated. She fights back the urge to gag at the drop of thick, slippery fluid trickling down her throat.

"I almost came," he says with a grin. "Naughty girl."

He slides down her body, his stomach pressed against her own, and thrusts into her. Jennie braces herself and grits her teeth, waiting for the pain. Will there be blood between her legs? Will he find out she's a virgin and recoil? Jennie knows this: Eddie Fish does not want her to be a virgin. For the rest of her life, boyfriends and husbands will ask about her first time, and the name Eddie Fish—that unfortunate moniker—will forever be whispered in a progression of beds.

Who was your first?

Eddie Fish.

And how was it, my darling?

It was—it was what it was.

He has pushed all the way inside her and she feels nothing. No pain, no magic. Her insides have widened to accommodate him as if a door has always been open, as if a room inside her has been drafty, just waiting to be entered.

Her breath seems loud to her ears, and her heart pounds erratically as Eddie moves to the rhythm of music only he can hear. She tries to time her heart, her breath, to his. *Ba-da-dum, ba-da-dum.* A tribal forest beat. The hairs on his thighs tickle her and she fights an urge to break into hysterical giggles. Her stomach is hot beneath him, an interior soup. She twists her head to the left and sees Eddie's hand flat against the dirt, his wrist encircled by a thin strand of leather that she remembers Lisa Wallach brought him from Brazil. The leather strand had magical powers, Lisa told him, and he would have very bad luck if he unknotted it himself. Jennie wonders if Eddie Fish will wear that strand of leather until it disintegrates.

Eddie speeds up. A vein in his throat pops out and he is looking down, down to the place where their bodies are joined. With a gasp and a grunt, he collapses on top of her. Jennie can feel his heart through her chest. Eddie Fish's heart! She will remember this moment, she promises herself: the faded blue summer sky, the worm inching along the edge of a pale yellow leaf, the soft smell of dirt. She will color it with a patina of great beauty. She thinks about Eddie's question—are

you using anything?—and her fingers grow icy. She wonders if it can happen the first time, if the grassy mess oozing between their legs can grow into something more complicated—a punishment, a life sentence. She closes her eyes and prays: *just this once, never again, please not now.*

"What?" asks Eddie, looking down at her.

"Sorry?"

"Your lips were moving."

"Oh, it's nothing."

"You're not getting weird on me, Jen, are you?"

She doesn't answer. *Getting weird.* Eddie's words echo and bounce through her skull. She twists her neck once again, her cheek resting on the cool earth, and stares at the empty heart carved into the base of the tree. She imagines her own initials there and then, like a stack of cards flipping through the wind, a hallucination, she sees the initials of every man who will ever become her lover. There are so many—perhaps dozens! More than she can possibly imagine. She is filled with the knowledge of what she does not know.

Eddie kisses her throat, his lips dry and papery, then jumps up and rummages for his briefs beneath a pile of fallen leaves. He looks down at Jennie and she squints at him, blinded by the sunlight behind his shoulder. From where she lies, he seems like a giant.

"I—I didn't use anything, Eddie," she falters.

He stumbles on one leg, awkward as he pulls on his underpants.

"What did you say?" he asks, stopping.

"I'm sorry—I didn't use anything," she says, this time with greater conviction.

"Jesus, Jennie!" He punches the air. "How could you—"

"I didn't know."

"But I thought you were—"

Tears stream down her face. The light, the woods are refracted, kaleidoscopic.

Eddie Fish's face becomes a blur.

"You bitch!" she hears, as if from a great distance. He is walking away from her, heels crunching against the leaves. "If anything happens, it's not my problem, do you hear me?"

Slowly, she gathers her things. She pulls her bra from the branch, stuffs her panties into her knapsack, buttons her blouse, and yanks on her shorts. She sits back down against the tree and searches the ground for a sharp twig. When she finds it, she begins scratching her initials into the empty heart, digging deep into the bark. She works carefully, with the precision of an artist. She fills the whole perimeter, so there will be no room for anyone else.

THE WOW OF POO

BY RUFUS GRISCOM

While talking with a *Village Voice* reporter a couple weeks ago, I apparently said, "We [at Nerve] have an interest in the humanity of the sexual experience, whether it's embarrassing, beautiful,

peculiar, ugly, sad, what have you. It's the same kind of curiosity that causes people to look at their feces before flushing." This wasn't exactly a shining moment of spin control—reading it later, it seemed that the metaphorical proximity between Nerve content and shit was a little tight. Nonetheless, I stand behind the spirit of the quote, which was really about our interest in body curiosity and the threshold of shame, which is much of what makes sex more interesting than, say, jogging.

I find myself attracted to this shame threshold in lovers—the point at which a woman looks down, averts her eyes, blushes. This isn't always easy to find in this sex-positive era—most of my girlfriends have been admirably happy with their bodies and the process of sharing them. Whatever shame they do feel usually recedes like a cold front with intimacy, and I instinctively chase after it until I can no longer.

My chase usually ends at the loo, the last outpost of bodily shame. Few people want company when they are hard at work on the throne, but somehow whenever my honey's in this position I feel a pressing need for a Q-Tip or conversation. More often than not I ask to be let in and press against the bathroom door, she shrieks, pushes back, and threatens violence. I then retreat, oddly satisfied by the whole encounter.

No doubt the vestigial mischievousness of an older brother is at play here, but there is more going on. My interest in these inopportune visits and my lovers' resistance to them derive, I think, from the same incredulity: How could a substance so rank come out of a body so sweet-smelling and beautiful? It seems somehow impossible, a cosmic mistake, a biological blunder to be kept under wraps. Indeed, I have heard men say, in all seriousness, that they don't believe that women fart; this is a difficult expectation to live up to. I suspect some women feel that they shouldn't defecate at all, as if it were some kind of unusual problem, a virus that could be treated with antibiotics. If surgeons could perform an operation at childbirth to prevent shitting altogether, how many women would have it done?

The likelihood that some of my fellow countrymen would opt not to shit saddens me, because for me anyway, excretion is a dulcet song in the human repertoire of sensual experiences. The spinal shivers, the brushfire of goosebumps, the flush of heat to the cheeks, the cool contact of air after the final nubbin is released, the conclusive involuntary sphincter clench—as many before me have said, there is nothing like a good dump.

It takes a strong fear of odor to offset these pleasures, and never has this fear been stronger than it is in our fastidiously sanitized late-20th-century America. Yet shitting is the one thing we can't seem to do away with—it's one of our few remaining tethers to the acrid, sweaty, moldy world in which our species has spent most of the last several million years. We've deployed sophisticated technology to contain the stench, we've pressed it back to the far recesses of our bodies with vigorous daily scrubbing and generous application of perfumes, soaps, and antiperspirants. We can fumigate our exteriors until every little cubbyhole has the bouquet of a flower girl, but the interior remains unconquerable (mouths aside, which have long been compulsively freshened). Massengill led a deodorizing foray to the interior in the '70s, and a few bold colon hydrotherapists voyage up the backside with aromatic fire hoses, but for the most part the deodorizing armies have begrudgingly accepted the nether orifices as natural boundaries and the stenches therein feisty, uncontrollable guerrilla factions. Each shit and fart is a sortie, an insolent rebel invasion serving mostly to remind the fragrant authoritarian regime of its inability to maintain absolute command.

▴ AUTUMN SONNICHSEN

As I guess I have revealed, I support the guerrilla forces, and enjoy seeing the deodorizing despots embarrassed. That said, I have not reached full comfort with the possibilities presented by the aft side in bed. I, too, am uncomfortable when I am on the john in front of a girlfriend; I, too, have been known to barricade the door. The fear, of course, is that a body that produces such scents is unlovable, that if someone really knew how bad we can smell, I mean the *full* extent of it, they would run for the hills and never look back. Perhaps so, but I think it's worth knocking on the door to make sure.

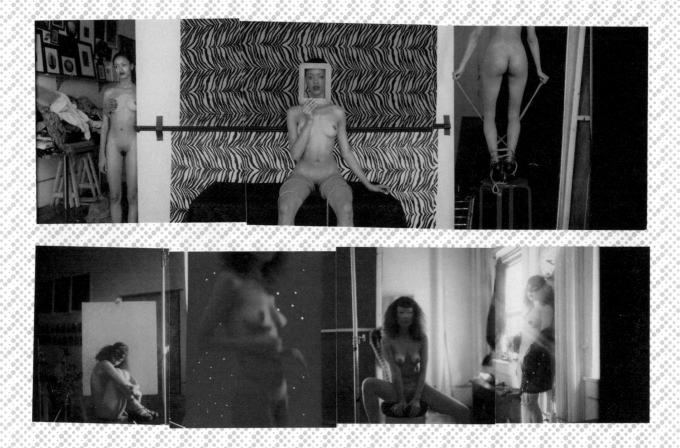

2000

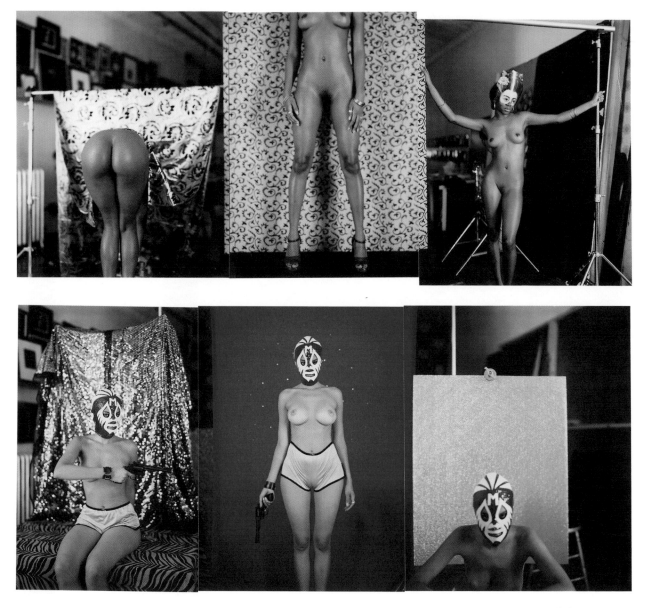

PHOTOGRAPHY BY

BARRON CLAIBORNE

In my junior high there was a wickedly pretty girl who barely ever spoke but had a reputation for being the class slut. She also had a propensity for pulling down her Jordache jeans and mooning surveillance cameras, passing cars, math teachers. But none of us knew anything about her. This seemingly reckless girl had hit on perhaps the only foolproof way to hide out in a crowd of adolescents: by emphasizing her nakedness. So it is with Barron Claiborne's triptychs of naked-girls-in-disguise. Gazing at the white girl in a cowboy hat,

the black woman in a geisha mask, and all of those luscious, faceless asses arching towards the camera, I try to decide if I feel walled-out or beckoned. "I just like the idea of anonymity," Claiborne says. "And I mean, if you put a mask on a naked girl, people care less about who she is than what the picture is about." Maybe these photos look like they're about icy, fearless, practically perfect girls. But not a lot has changed since junior high, and the best trick to keeping a secret is still in seeming to bare all. —RACHEL MATTSON

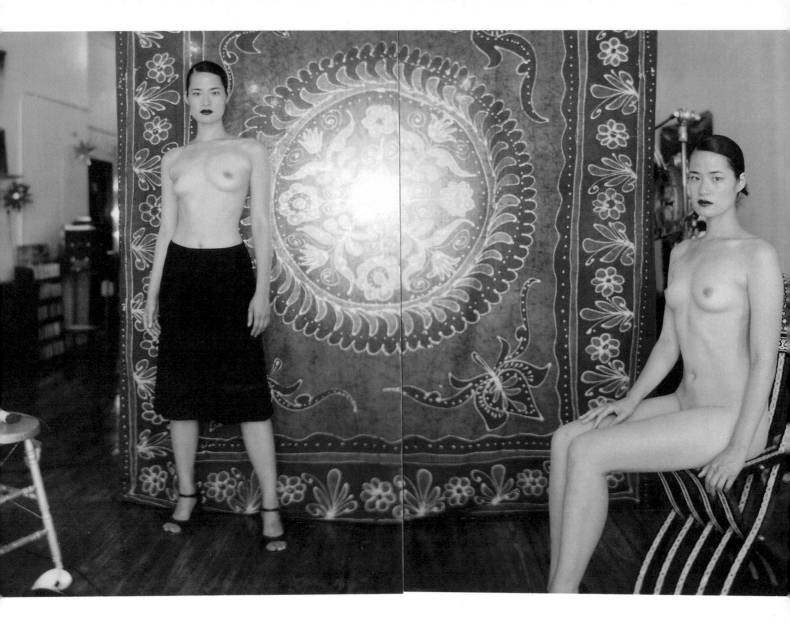

THE DEVIL INSIDE

BY LAUREN SLATER

My father sleeps with prostitutes. This is his late-life confession to us, his children and his wife, and he makes it on the shore in Florida: Florida, the state with the prettiest name and the skankiest

underside; Florida, a place where the beach is as white as a baby's bedsheet, and there are hookers galore, feathered, bangled, pointed and pierced, blooming like hothouse flowers above the black sewer grates of the southern city near where my father lives.

From the beach where we sit, I can smell that city, Miami. I can see the high-rises, sharp as syringes, poking through the hot smog. But it all seems so far away. Here, on the sand, my father is a little man. He is an older man, his red hair fading to gray. "I'm sorry," he says. His wife, my stepmother, looks pale, with trembly lips. My father turns over his wrist, so we can all see the display of veins, trefoiled and stringy. Very deliberately, he raises one forefinger and palpates a vein, over and over, and then makes a little whisking motion, as though to slice it.

"Dad?" I say.

Meanwhile the waves flounce in and out, each one frilled as a petticoat.

"Dad?" I say again.

"It's a disease," he says. "I have a disease."

"Sex," I say, "is a disease?"

"Not sex," he says, "but sex addiction, which is what I'm telling you I have. It's been diagnosed."

That's that, then. Say the word *diagnosis* and all the other doors—the ones that open onto sin, or spirituality, or responsibility—click closed. *Diagnosis* is slim as a test tube, its circumference confining but safe. My father has a disease.

He then tells us, there on that beach in Florida, that his behavior, which of course he's kept hidden from us, has been going on for the past ten years. He tells us what the disease of sex addiction consists of—its symptoms, so to speak, which include compulsive sexual behavior concealed from family and friends, repeated failed attempts to stop the behavior, and persistent sexual fantasies that interfere with functioning. He tells us that he loves us all very much, that he loves his wife, that he is sorry. He reports that he's in treatment: a twelve-step group called Sex and Love Addicts Anonymous; four-times-weekly behavioral therapy and psychotherapy; a cartload of medications, pills for depression and anxiety; and then, at last, a particularly ominous-sounding medication, what he calls—what is called—an antiandrogen, a testosterone-suppressing compound that evaporates the libido.

I listen to all of this. I feel so many things. I feel sad for my stepmother. I worry that they will now divorce. I can't believe my father, my little rabbinical father, has so much roar and romp in him. Part of me is proud. Part of me is horrified. Part of me is pissed and very suspicious. This "illness" thing. This disease. Does he think we'll let him off the hook if he can concoct a pathogen?

We leave the beach and go home. Tomorrow I will fly back to Boston. Tonight, in my father's house, I go through his cabinets, skeptical. My father apparently loves disease. I find his sleeping pills (is sleep a disease, or lack of it?), I find his antidepressants, his Dexedrine (is laziness—indolence—a disease?), and then what I guess are his antiandrogens—smooth pills, pink pills, of course. I put one on my tongue and it tastes confectionary, tastes pastille, a little bit like peppermint, and later on that night, alone in my bed in my father's house, I touch myself and feel dead.

I want to talk about disease. I am not dead. I am in my mid-30s. I am married and have sex and have a child. I am a writer and also a psychologist, which means I have the type of training that involves many mice and fat rats, elaborate mazes and smears of brie cheese, measurements, tissue samples, stimuli. In the world of the scientist, a world psychologists claim they are a part of, disease has anatomical correlates. It can be viewed beneath a microscope. It appears in tangles and plaques. Disease is the wayward cell, the hole in the lining of the stomach. Diseases are the swollen ventricles on the schizophrenic's brain, or the lit-up lobes of the obsessive's, all stoplight-orange and crisis-red, a burning.

If sexual addiction, as my father and his bevy of experts claim, is indeed a disease, then it must have physiological or biochemical manifestations. This is what I think. I think it that night, in my father's house. I think it the next day, flying back on the plane. I think it in Boston, where I live. Call me cold. Call me frigid. I should want to soothe my father, or my stepmother, a beautiful, showy woman with perpetually moist red lips and adorable toes, each one a little pearl-dropped doll. I should think about the family, not the science, but I am a little cold. People tell me so. "You know," people sometimes tell me, once they know me well, "you can be a little cold." At parties I stand in one corner and do my fair share of glaring. I am decidedly not demonstrative, except with my dogs. Dogs are perfect.

Human beings are not, and biological explanations have created the great moral loophole through which we all now seem to slip. *I can't; I must; I have to; it's inherited. It's in my genes.* And yet, if sex addiction is an illness, then who's to say that its chemical cousin, sex itself, or lust, or even love, are not subclinical expressions, or minor diseases, themselves? Maybe sex is to sex addiction what the common cold is to pneumonia. Maybe every arousal, every kiss, every baby is not an expression of health, but of decay, of death.

^ ANDREW BRUCKER

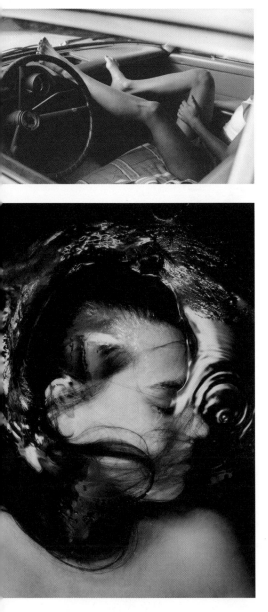

The point, the real point: If sex addiction is a disease, I want to find it. I want to hold it in my hand, like a cholesterol-clogged heart. I am driven in part by curiosity, in part by love for my father. I decide to do some research.

I am surprised by how much pops up on my computer screen. There are sex addiction FAQs and self-administered tests that deliver a diagnosis pronto, a yea or nay, a judgment, an absolution. One test, called the Sexual Addiction Screening Test (SAST), consists of twenty-six questions ranging from "Were you sexually abused as a child or an adolescent?" to "Do you regularly engage in sadomasochistic behavior?" to "Have you ever participated in sexual activity in exchange for money or gifts?" Many of the questions focus on fantasy, which seems to be a core component of sex addiction: repetitive masturbatory dreams. It is impossible, reading through the questions on this test, not to imagine my father in a way more intimate than I would like. The prostitutes I can handle, as there is something slightly exotic and even Bukowskian about the whole thing— red lights, ladies of the night—but the masturbation . . . does he really do that? Solo sex is suddenly, here, the ultimate taboo; we know our parents as a part of us, relentlessly relational, and yet they're not, he's not. I imagine him, because I cannot help it, passing hours, days, lost in a hot haze, his penis huge in his hand, the compulsive choking while a cocker spaniel sleeps in the well-appointed living room; this is not my father. But apparently it is. And if genes are catchy, which we all know they are, then in some sense, this is me, too.

As for the gene or set of genes responsible for sex addiction, none have been definitively identified. I do, however, find a set of biochemical theories, pioneered in part by the psychiatrist Martin Kafka (an unfortunate last name indeed for a sexologist). Kafka has explored what he calls the monoamine hypothesis of sex addiction. "Monoamines" is an umbrella term for three crucial neurotransmitters in our brains: dopamine, norepinephrine, and serotonin. According to Kafka (who is an assistant professor at Harvard Medical School and an attending psychiatrist at McLean Hospital in Belmont, Massachusetts), people with deviant or compulsive sexual behaviors may have a disturbance in the neurotransmitters of one or all of these chemicals. The most probable culprit is serotonin. Although a debate currently rages in the psychiatric community as to whether serotonin levels consistently correlate to any kind of psychiatric disorder, Kafka, for one, suspects serotonin exists in unusually low levels in people with sex addictions. One study published in a respected psychiatry journal found that decreasing serotonin levels in rodents and cats led to an increase in mounting behavior. Conversely, increasing serotonin levels, through good friends like Prozac and Zoloft, is known to inhibit the sex drive.

This hypothesis is interesting in all sorts of ways, primary among them its implication for how we view depression. Depression is also associated with

low serotonin levels, and many sex addicts carry a secondary or primary diagnosis of dysthymia, or low-grade depression. The most obvious assumption is that a sex addict engages in sex to relieve depression. However, sex, or hypersexuality, may in fact be driven by depression, may be a part of the depression, not its misguided cure. If this is the case, then depression is not only diminishment, but a disregulation in either direction; it can exhibit itself as enhancement, appetitive; it can provoke hunger as well as numbness, jagged peaks as well as white flatness, depending on who it's targeting. Depression as an aphrodisiac, a stimulant, an inducer of orgasms—how odd.

"And yet," says Dr. Charles King, a psychologist who specializes in the study and treatment of sexual addictions, "this is all in a speculative stage. Hormones probably play a role as well as monoamines, but no studies have shown any consistent findings." That 95 percent of the sexually addicted population is male, however, does suggest that testosterone may be implicated.

"So do you think," I ask Dr. King, "that sex addiction is primarily the result of faulty chemistry—that it's a disease?"

"Yes," he says, and that depresses me.

I suppose I should come clean here. I have my own impressive history of eating disorders and other psychiatric ills. Myriad addictions flow through my family's blood lines. I have a one-year-old daughter with half my genes (don't let her be doomed). I had always thought my father was the one more or less healthy outpost, a strong branch in our family tree. With his confession, I now cannot point out a single first-degree relative who is not somehow sick. I would rather be sinful than sick. A sinner, after all, can be saved, but a patient whose illness exists at the level of genes, at the level of inherited chemistry—such a patient cannot be cured. Such a patient can at best be given an Eli Lilly or a SmithKline Beecham crutch.

Dr. King tells me about Sex and Love Addicts Anonymous (SLAA), where many people with the diagnosis go for treatment. This is the twelve-step group my father mentioned. Late at night, I call information for the number. Do I imagine it, or does the operator deliver the listing to me in a voice of disapproval? "Come to bed," Benjamin, my husband, says. "I feel strange," I say, and lying next to him, I keep picturing the operator, and in my mind she has hair in a prim little bun, and her hands are very old. The house we live in is also very old, and suddenly I am sure the smoke detectors don't work. A fire crackles. The baby cries. Outside, a bird is picking picking picking at the scab of the sky. Sometimes sounds hurt. Sometimes babies cry. "Shhh," my husband says to me, and we make love, or make disease, and when I stand up afterwards, semen pours from me like pus.

It is a Thursday night and I go. To SLAA. The meeting is in a church in one of the wealthier suburbs just outside of Boston. Inside the hall, I see Christ

in his nave. I see beautiful stained glass. I smell the azalea bushes just outside, huge dense growths of green-topped tropical pink. They smell divine. The people sit in rows. There are six men and one woman. I focus on the woman. She has kinky blonde hair, a saddle of freckles over her nose. She is wearing tailored casual pants, chunky shoes, and a shirt that I know is from The Gap, because I have the same one, in a different color. She is streamlined in her figure, with a flat chest that I covet. She has a good figure.

I should lose weight. I recall a factoid left from my physiopsych class in grad school. Sometimes women with narrow hips and very flat chests have higher testosterone levels than the rest of us. She sits amongst the men, pretty.

"Hi," she says to me, smiling.

"Hi," I say to her.

"First time here?" she asks.

"Yeah," I say. "I have a family member who—"

"You know," she says, "family members are always welcome here, but there's also a group for them, too. A special set-apart group."

"Do you feel like this group's helped you?" I ask.

"On and off," she answers. "You have to walk your talk, you know."

"Well," I say—and this is relatively easy for me to say, because my career is all about probing, I am a professional busybody—"what brings you here?"

She tells me then. Her problem is compulsive masturbation. Her problem is that she fantasizes about other women, especially at work, and the fantasies are so intensive and compelling, she has to leave work early to masturbate, and one masturbation session ends only to start up another one, and it goes on and on, up the hill and over the dale, into the night and through the day, her life a series of compulsive clutches at herself, and then, in secret, seeking sex with other women, behind her boyfriend's back, and money spent as well on female prostitutes—it's a mess, because she loves her boyfriend, she's bi, it's really a mess—and although we are strangers she says all of this casually, easily, and I take it in, and then the meeting starts.

We sit in a circle. We say the Lord's Prayer, and before I can object, someone holds my hand, and so I am held. *Who Art In Heaven. Thy Will Be Done.* I say the words. I find them immensely comforting. Somehow I always have thought that whatever causes suffering—genes, sin, bad luck—its only cure is in surrender.

I listen hard when people speak. I note within myself two impulses that fuel my listening. The first is what I think of as the smut impulse. I assume attending an SLAA meeting will be a little bit like oral porn—instead of reading it, you speak it, or hear it. The voyeuristic part of me is hoping for more and even better descriptions than the one the young woman just gave me. I am hoping for

descriptions of orgasms so perfectly timed and pitched that the pleasure is pure shudder and moan. After ten years of monogamy, part of me could stand to hear these things.

And it seems significant to me that the people in this SLAA group do not once mention, or describe, their affliction in terms of neurotransmitters. Not once is the word "chemical" used. Neither are there, in the actual meeting itself, any anecdotes involving any sex. (A disappointment! I am a voyeur!) Instead, people speak of having humility. The topic is "Turning Points in Recovery." The woman, whose name is Bess, says, "For me, recovery has been about coming to accept that I am not the biggest piece of shit the world revolves around." A man who goes by the initials C.M. says, "My recovery rests on the fifth step."

For just the merest second I am confused by this comment, and look over at the set of steps leading to the stage, as though I might see his cure in a little apothecary bottle on one of the treads. But no, of course not. The fifth step is a "fearless and searching moral inventory." I know this from the pamphlet in my hand, and from clients I have treated. The fifth step is about confession; it's the mother of all memoirs, it's about dancing out of the dark, letting your true self be seen, because, as the twelve-steppers like to say, "You are only as sick as your secrets."

Now it's my turn to talk. All the others have shared their turning point, and I need to share mine. "I'm not a sex addict," I begin, "but my father is. I don't know, but maybe his turning point was when he confessed it to us."

Everyone nods. I've decided I really like this group. Bess has beautiful blonde hair. C.M. has wire-rimmed glasses and an Oxford cloth shirt. Through the open window I smell those azaleas, and the rich dirt of a wet summer.

"You know," I go on, leaning forward, "what confuses me is that the doctors and researchers I've talked to say it's a biochemical disease, but when I listen to everyone here talk, I get the feeling it's more about . . . about discipline, and having a relationship with God. Do you think of yourselves as having a real and definite physical disease?"

I am surprised at the response I get. Not a second's hesitation. Not a moment to reflect. Bess turns intentional and driven. C.M. pushes his glasses up against his nose. "Definitely," they say. "A disease," they say. "We're not talking metaphor," they say. "We are sick."

"If your addiction is a physical illness," I venture, "then how do you square that with everything you've talked about tonight in terms of taking responsibility for your actions? Owning up? Changing through a relationship with a higher power? If you really, really believe you're sick, don't you think you should be getting your treatment at a hospital, not a church?"

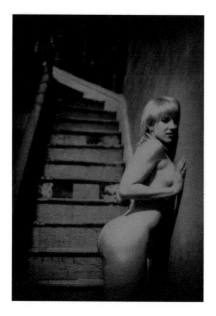

I, personally, think that's a smart question, certain to stump my new friends. Far from stumped, they are ahead of me. "You are always, always responsible," C.M. replies. "SLAA," Bess says, "is about learning to take responsibility for your biochemistry."

The rest of the group nods. A very handsome man speaks up. He is wearing a shirt and tie, and he has chiseled, perfect facial features, but his body is far too thin and his voice is broken. It is a rusty voice rising from a larynx that must have been riddled with cancer, a ghostly sound, a voice at the very end.

"We have," he says, "two brains."

"Two brains," I echo dumbly.

"Yes," he says, "and that is the explanation for it all."

"Two brains?" I say again.

"The animal brain," he says, "and the human brain. In this SLAA group, that's how we think of it. The animal part of the brain is what makes us do things, or want things, or act sick. But the human part of our brain, which is at the front of our heads, has the capacity to think and pray and make choices. You see?"

I do. Of course he's right. Hadn't I studied it in school? There is what's called the lizard brain, or the snake brain, that sits in a moist, meaty hump where the spine curves into the skull, and then there is the neocortex, or forebrain, hugest of all in humans, that bloomed above the baser instincts, allowing us, as some neurologists would say, to reason; as some ethicists would say, to choose; as some priests would say, to transcend.

This SLAA group, it occurs to me as I drive home that night, may have hit upon a truly unusual and insightful synthesis for the mind-body dilemma that has caused so much confusion and debate of late. These SLAA members, probably correctly, understand that our brains are both body and spirit, that the frontal lobes, while undeniably physiologically real, give rise to untenables, unfathomables like spirit, like sin, like choice. In this model—the two-brain model—the material brain contains the matter that allows it to transcend itself. We may have physiological diseases, but we also have spiritual choices about those diseases. Yes, anatomy is destiny, but because our anatomies are so infinite, that destiny is not reduced, but rich with possibilities for flesh and God.

So, I will hold my father responsible. Damn you, Dad. Why didn't you *think?* I will forgive him too, for who in God's name can think when there is such a toxic ruckus in the head? How do we learn to evolve ourselves from snake to lizard to primate to man to woman, to sound sense and balance and finally grace? SLAA says it's possible. I believe them. I have two brains.

I pull into the driveway at home. Benjamin is sitting on the porch in the dark, smoking a cigarette. The lit tip twinkles like a jewel in the corner of

his mouth. I once smoked like a fiend, two packs a day, but I haven't touched a cigarette since I was 24.

"How was it?" he says.

"Pretty tame," I say, but if that's the case, then why do I feel so suddenly untame? Why do I feel my snake brain right this minute hissing and curling like a cobra? Imagine it: sex all day. Dreams all day. A perpetual oil slick between the thighs, a desire for degradation. Blood and come. A condition of despair, of delight. Imagine that craving. I do.

And before I can stop myself I lean over and pluck the cigarette from my husband's hand, bring it to my lips, place my mouth where his wetness was, and inhale. A deep drag, a hot inward rush, the peppery taste of tobacco, my lungs assaulted and shocked, seizing up. My chest is having an orgasm, and it is not good. It shudders and heaves and then I hack whatever I can back up.

"Jesus," Benjamin says. He whacks me on the back. "That's unfiltered, you know. Since when have you started smoking?"

I shake my head. I was not prepared for how hard the bite would be. My eyes begin to burn, my skull to ache. "Can you believe my father?" I say. Something loosens in me, and I start to cry. For him. For us.

"What is it?" Benjamin asks.

"The cigarette," I say. "Now my head is killing me."

Like this. This is what he does. He sits me at his feet and works my cranium with his hands. He starts to massage at the base of the skull, where the snake brain sits, and then works his way up, up, I can feel him now, hovering over the thalamus, and then over the parietal lobe, and at last to the frontal lobes, right between the eyes; he presses with his thumbs, sweeps away tangles of pain, and then backs down again, to the snake brain, and up, and over to the wise forebrain, which he soothes and rubs, and as he does this some clearness comes, for me, for him, for my father, for my daughter, for all of us here some clearness can come, and if we are lucky it will last for a little while.

GIRLS

BY JOSEPH MONNINGER

Francie used to talk about the Wailing Wall, Israel, life on the kibbutz. She had gone there once and picked weeds for a summer. She showed me a slide show her parents had put together of a family trip to Jerusalem. She shot the slides against the white wall of the playroom, bright squares of light and desert, and afterward let me work through the zipper of her jeans, gold teeth clawing the back of my hand. This was in New Jersey, a long way from Israel.

Marie cocked her thumbs in the sides of her panties and stepped out of them. Beside her bed, on a rainy afternoon, she lay down and spread her legs, her right knee propped on a Kermit the Frog doll. Other dolls spilled to the floor, and the white, puffy curtains breathed in and out with the damp wind. When I stood to go to the bathroom afterward, the dolls stared up at me. Later, she made tea and loaded it with cream and sugar. She sat on the backyard lawn furniture, though it was April and chilly, and watched leaves collect in the corner by the patio door.

You'd go to Friendly's, order a milk shake, park around the back. Three or four guys in the car with you, waiting. Then the girls showed up, their cars smaller somehow, gum, cigarettes, barrettes scattered on the dash, birch inchworms coating their windshield. "Hey," you'd say. Then out in the darkness, leaning against the car, the engine warm, the painted lines on the parking lot smooth under your bare feet, and you'd notice she has painted her toenails, maybe for you.

Up and down, up and down, faster, faster, her hand yanking and swirling your penis, her head against your shoulder, her eyes closed against this courtesy. "Hmmmm?" she asks, and when you say "nnnnnnn" she works her hand faster, her face somewhere else, thinking about her outfit, about her mom, about the slow steady beat of the Beatles' "Norwegian Wood." When it starts she steps away and holds your penis out, introducing it to the large maple you had been leaning against, letting you finish anywhere, anyplace, as long as not near her.

In the eighth grade Chris Lambla played the same song five times on the turntable, "Never My Love," by the Association, and we danced in the basement of her parents' house. Her breasts lived in the soft wool pouch of her angora sweater. She told me that her mom had gone with her to pick out the sweater, the skirt, too, and that she hated shopping with her mom. Once, she said, she had gone shopping with her mom, had fallen asleep on the way home, and had come awake, hours later, in the vault of the garage. She thought she had been buried alive, something she had been learning about in Tuesday afternoon catechism. The saints, she meant, they had sometimes been buried alive. And she danced against me, the lights dim, the music syrup, and I moved my hand to her bra

strap, to her waist, and once, at the end of the night, to the round hump of her ass, weighing it like a farmer judging soil.

Cindy: "If you love me then you won't ask me to do anything I'm not comfortable doing. Do you really like me? Do you? Because I like you, I do, but it's not all about what we do right here. I mean, in a car like this. I mean, what do you really think of me?" She chewed cinnamon gum, the kind with the liquid center. "Cum gum," she said, laughing at the way the gum squirted when she bit into it. That was when she wasn't talking about love and respect.

In the school hallway, we tried to spot Jane Ritzo, who supposedly went on the pill her sophomore year. She went on the pill for Grady Whittle, lead guitarist in the Balloon Farm. The Balloon Farm played at every high school dance, every Teen Canteen, every backyard Sweet Sixteen. Jane Ritzo went on the pill as a gift to Grady, is what we heard. She put a bow on the pill packet and gave it to him. Now they were seniors. We had never heard of anything so fine and generous. When we managed to spot her in the hallway, we speculated about those pills. We pictured them, one by one, on her tongue, going down.

Snack bar cook, you grill hamburgers at Echo Lake Swim Club. Mrs. Staub has a plain piece of lettuce with cottage cheese glopped on top. A slice of pineapple, if one is available. She wears a white visor and comes to the snack bar in her bathing suit, bends to rub her foot free of sand or bark bits. You peek down the top of her suit, feel you must keep your distance from the counter. She pays with red nails, her purse snapping primly when she puts the change inside. "Thanks," she says. She walks to the picnic table and sits, eats with knife and fork balanced carefully in her hands. She is brown as pine ship tar, her lipstick pale pink. You see her legs sometimes under the table, watch as they live what seems a life separate from the one her hands live. At the end of the summer, at the pool dance, you kiss her daughter, Sally, who is small and timid, a ghost of Mrs. Staub. You put your hand on Sally's breast fast, faster than you should, and she lets you. She knows she is a ghost, a daughter ghost, and finally you dry hump on a pool pad in the towel room at the back of the men's locker room. Through movement, she becomes her new self, is no longer a ghost, and you kiss a lot, kiss like crazy, Sally becoming a new Mrs. Staub.

She left a note in my locker, slipped it through the vents, the note all curlicues, circle-dotted-I's, red paper. *Hi!* it said. *I had a great time last night!!!!!! See you in Chemistry, 3rd period!!!!!!!!*

I rode Sarah on the bar of my English racer bicycle, my arms braced on either side of her. She sat sideways to me, her hair smelling of Prell, my thighs stropping against her body as I pedaled. She turned to me and kissed me and closed her eyes. She closed her eyes while I pedaled and steered.

Skip and I once took this girl Carol out and we had her sit between us in his truck, and we both fiddled around with her crotch, our hands touching

^ CLAYTON JAMES CUBITT

sometimes. She let us. She put her hands on our crotches, too, arms out like she was flying, like she was holding our wankers as handles and leaning away, a hood ornament, a bowsprit. Even then, I wasn't sure what she got out of it.

Janie smelled like something sweet, something made up, like a candy store with the door closed too long. Claire smelled like a lawn product, hazy, aerosol, capped. Only Molly smelled of the outdoors. She kept crickets in the top drawer of her desk all winter. It became a ritual with her: in autumn, before the first frost, she captured a dozen crickets, carrying them to a Hellman's mayonnaise jar with hollow hands. She dumped them in, screwed on the top, and later put them to graze in the top drawer of her desk. They lived in grass clippings and cedar, and maybe that's why Molly smelled so good. At night, after we had turned to spoons, I put my nose against her hair. The crickets rubbed from the desk, summer, winter, spring, and cedar baked into the air at every breath.

Coach B said girls can drain you. Before the game, for a few days, he said, stay away from them. Keep your head on the game, he said. I used to meet Sue at the 7-Eleven in Mountainside. She wasn't my girlfriend, so it really wasn't against Coach B's rules. We stood on either side of the comic kiosk and spun it back and forth. I liked Silver Surfer, she liked Spiderman. In the buggy fluorescent light outside she smoked cigarettes and told me about her boyfriends. We pretended we were friends, that I was just listening, but we always ended up kissing in a group of beeches a block from the store. I used to put my hand on her breast and let it rest there, afraid to go further, afraid I wouldn't keep my head in the game. Her nipples, though, felt like buttons to some place I wanted to go.

They would place the rubber on the tip of your penis, check it for size like a mechanic checking a nut, then roll it forward. They did it while they looked up, or kissed, or did anything in the world except look at what they were doing. Some of them made you do it yourself, so you felt like a fireman suiting up or a surgeon fitting on gloves. The slow wrap of the thing squashed your penis like the muscle movement that lets a boa slowly swallow a rat. Afterward, when you saw your mom put shelf paper in the cupboards above the washing machine, you understood: no unsightly rings, no mess, always spongeable, always hygienic.

In the Lido Diner on Route 22, Paula reached her bare foot under the table and put it squarely on my crotch. She gazed at me and let her eyes go slack. We both pretended that was the first time anyone had done that to me—pretended, too, that she had never done that to anybody else.

One summer night, in the heart of heat, you walk with your best girl out onto the Echo Lake golf course. You don't dodge the sprinklers at all. You let them go over you and see her skin showing through her shirt, the hint of her skin, and you get water on your hair. You start kissing and you pull her down, or she pulls you down, and you get her out of her clothes fast. You, too. Naked, with the water whipping you once every twenty or thirty seconds, you screw

˅ BRANDON HERMAN

˅˅ MIKE DOWSON

˅˅˅ BRANDON HERMAN

like mad, like wild things, grunt, shove, dig into the dirt, grass, sky, the sprinkler, her, shove shove, and kisses, kisses like maniacs kiss, like dying people kiss, you love her, love everything, love that she likes the sky above you and the sprinkler, and you keep going. Then she says she's cold, so you lead her to a tall bank of grass, both of you carrying your clothes, and under a tree, out of the sprinkler whips, you make love, kiss more, talk to each other, say you love one another, and when you come it starts somewhere down deep, far away, and it arrives like a sound you have been waiting for, like a key in the door. You feel like crying and she holds you, and that starts you again. This time more simply, more gentle, and you kiss until you know it is late, very late, and then together you gather your things, dress, cut through Wittingham Place, over to Baldwin, and you can't stop kissing. You wonder why you can't sleep beside each other, what would it hurt, why is the world like this, and you kiss her one last time at her door, see the lights go up her house as she makes her way to her bedroom. You run for the holy hell of it back toward your house, roses out, stars up, the maple leaves throwing puppets of shadows from the streetlights. A part of you knows it will never be like this again, not quite, and you smell honeysuckle, hyacinth, soil. You sit at the kitchen table of your house and eat a bowl of Cheerios, it's late, the smell of her on each spoonful, milk, oats, sugar. You put the bowl in the sink, run water, splash it around. Your mom has left you a note telling you you're the last family member in, lock the door, so you do that, turn out the lights, climb the stairs. It is hot upstairs, coolness just outside, and you lay in a single bed, a childhood cowboy lamp beside you, your hand absently on your crotch. You think of her, remember her pulling you closer, using gravity to draw you to the center, and you fall asleep like that, one white sheet over you, your left leg out to get the last of the air on a summer night.

ALVIN HAPPENS UPON THE GREATEST LINE EVER

BY ROBERT OLEN BUTLER

There must be a God. Now that all those nations that got together, who knows which ones, I've never been any good in Mr. Frank's geography class—Russia's one of them and Korea's one, I think, some Korea or other—now that they've launched their nuclear missiles and we've launched ours and all the old geezer anchormen are crying at the same time—zap, zap, zap with the remote in my hand and Tom and Peter and Dan are weeping like babies right there before us, one after the other—now that all this end-of-the-world stuff everybody's been talking about till you just want to go, "Oh shut up, you people," now that it's finally suddenly happening, here I find myself sitting on a couch right beside the hottest girl in school, right here in the church teen center, and nobody else is around but her and me. Like, I've got these parents who are probably taking the trash out now, cleaning the toilets or something, determined not to let a thing like this upset their routine. They had to drop me off for the Youths for Jesus meeting half an hour early so I wouldn't be late no matter how bad things sounded on the TV. And Jennifer Platt is sitting here right next to me, her own parents out of town somewhere, and she walked over from her house, not even knowing how things were going in the world, her being the silliest, hottest, sweetest girl God ever created. And now she sits beside me, me of all people, with my face breaking out and my hair geeking around on my head, and her long daisy-blonde hair is rippling down her back and her big blue eyes are wide with terror, turned up to the TV watching Dan Rather mopping at his eyes with a handkerchief, and she's making a little choking sound in her throat.

"Is this, like, for real?" she finally manages to say.

"Yes," I say. "It's all over, Jennifer. Life on planet Earth."

"Aren't there supposed to be horsemen or whatever?" she says.

"Horsemen?"

"Like in the Book of Revelations?"

She's looking at me now in a way she never has. She's got nobody else. Her eyes are as blue as the sky that's about to disappear for a year or so in the nuclear winter and they are still wide with how wonked-out she is. These eyes are turning to me for guidance, but I never have listened very close to the prophecies and stuff that Pastor Lynch has been trying to explain. I've been too busy watching Jennifer Platt and thinking I didn't have a shot in the world at her and praying that I was wrong. God does answer prayer. I can finally testify to that.

I say, "Nobody ever knew what that horsemen stuff meant. Now it's clear. God's brought us together to *cleave* unto each other." I like that, "cleave." I think I've absorbed more in this place than I realize.

Her eyes widen a little bit more. "What are you saying, Alvin?"

› DIANA SCHEUNEMANN, FROM THE BOOK *DIANA SCHEUNEMANN* (DAMIANI EDITORE, 2005)

"I'm like the horseman."

"Pardon me?"

"To carry you away."

"You can't run from the bomb, Alvin," she says, and her voice is faint.

"I'm talking, like, in metaphors, Jen. Carry you away in the passion that God has put between a man and a woman when they, uh, cleave. Like, aren't we Adam and Eve here? Only in reverse? Like we're the last two left? See, God arranged this."

She's getting confused, but I figure that's okay. She's not saying "no" right off. I'm plugging into a thing she's been looking forward to. Maybe not with me. But I'm in the ballpark. I say, "The missiles are going to hit real soon. There's nowhere else to go. But here we are, you and me. God realizes that neither one of us wants to die a virgin."

Jennifer suddenly looks away and clamps down with her teeth on the knuckle of her right forefinger.

I can hear myself. I'm impressed. Here it is, what's going on outside, and with the White House about twenty miles from where I'm sitting, Jennifer and I are pretty much on ground zero—and I'm being cool as Harrison Ford or somebody.

Jennifer stops biting her knuckle and looks back at me. Her eyes aren't wide anymore. They're narrow. She's suddenly pretty cool herself. I know she's considering my geekhood. This is the moment when I'm vulnerable. I'm sitting here wishing I knew more about the Bible. I maybe could find just the right passage. Something like, "Give thou to the plain man and thou shalt have riches in Heaven." Which isn't bad, really. I'm thinking about quoting that and pretending it's real. But Jennifer lasers her eyes up and down my body and then she looks at the television.

Just as she does, Dan Rather stares straight at the camera and says, in a quavery voice, "Speaking simply for this reporter, I'd suggest you go as quickly as you can to someone you love and hold them close."

Jennifer's face swings back to me. I figure Dan has given me a real boost here. This should be it. But Jennifer seems to have simply gone back to checking me out, critically. I know there's not much time.

And suddenly I have words. I cry, "Jennifer Platt, the world's coming to an end! We must have sex!"

Her face softens. Well, not softens exactly, because it's still not, like, soft. But the criticism is gone. The hard eyes are no longer hard. She nods very faintly and she stands up and puts her thumbs in the elastic waistband of her skirt and I can feel my Little Mister Man rising in my pants like a mushroom cloud. I can even set aside the hatred I have for my mother giving such a name as that to my dick and making it stick in my head, like, forever. All that vanishes from me.

There is only Jennifer Platt, her skirt down at her ankles now and her legs long and smooth rising to her panties where her thumbs are now poised in the waistband and the very tip of me, the tip of, yes, Little Mister Man, is throbbing like crazy and I say a quick thank you to God, who is definitely in his Heaven.

And now the panties descend and a sweet golden plume rises from the center of her and it is a color darker than the hair that is cascading around her face now, this gold, it is not the color of daisies but of sunlight on a white wall at the end of the day. A stopping happens inside me. I cannot breathe from the beauty of it. The beauty of the hair of her loins and also the beauty of sunlight on the wall.

She is moving, lying down on the other end of the couch, and she opens her legs and I am still struggling to draw a breath, and something else is going on inside me. The sunlight will not show itself in this world like Jennifer Platt's pubic hair ever again, not with anyone alive to see it. Jennifer's legs are open and I look at this secret place on her body and it is as pretty as her face, it is the pink of my mother's azaleas and it is pouting like a spoiled child and I love this soft place as it draws me to it, asks me to enter, and it whispers to me now of all that there is to destroy in this world, my mother's flowers and her hands that tend them and the spoiled children and the good children, and I cannot move, I feel the warmth of my tears and I am afraid.

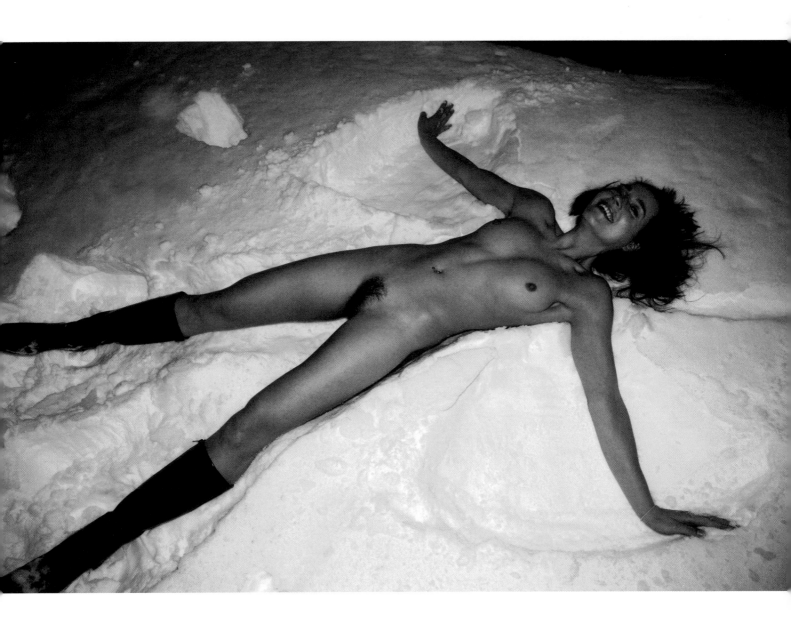

2001

<NATACHA MERRITT

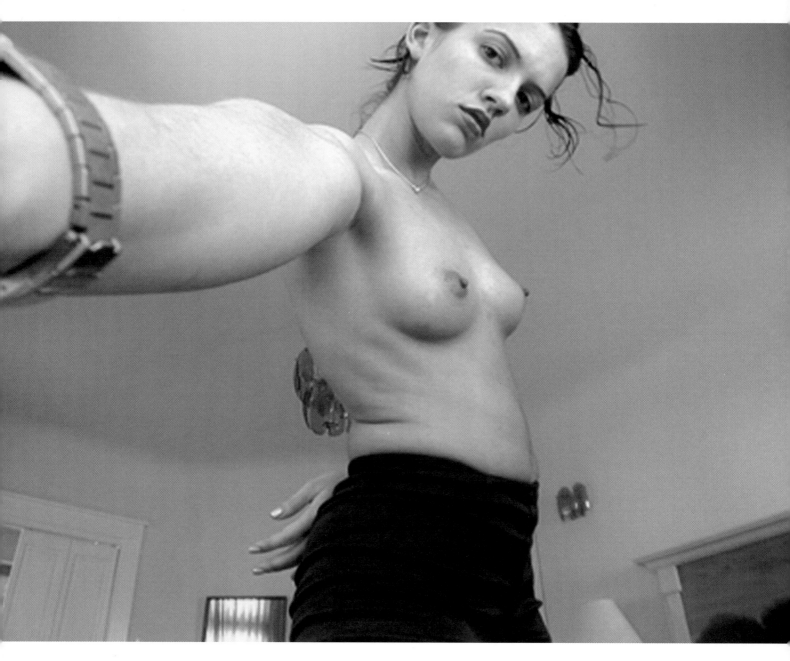

PHOTOGRAPHY BY
NATACHA MERRITT

As a twenty-one year old with no formal photography training, San Francisco–born Natacha Merritt picked up a Casio digital camera and began chronicling her sexual encounters and posting the pictures on the Internet. Her Web site soon caught the attention of fetish photographer Eric Kroll, who contacted her and eventually introduced her to German arthouse publisher Benedikt Taschen, who publishes Kroll's own photography books. The result: Merritt's hardcore Digital Diaries, found at www.digitalgirly.com.

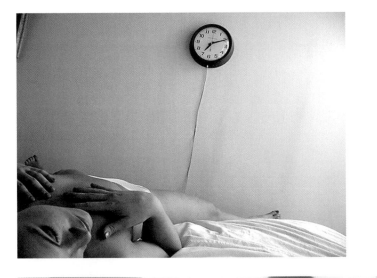

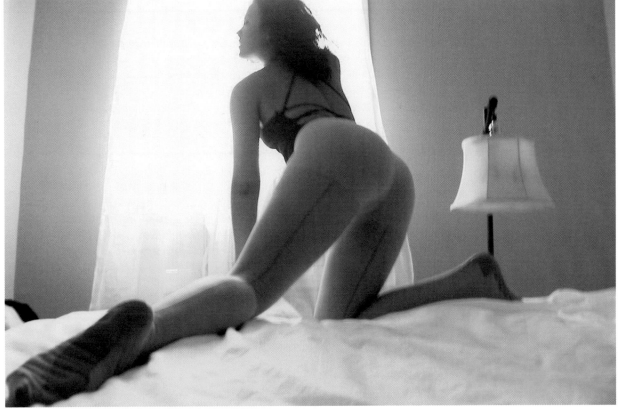

REBECCA

BY VICKI HENDRICKS

As her Siamese twin joined at the skull, I know Becca wants to fuck Remus as soon as she says she's going to dye our hair. I don't say anything—yet. I'm not sure she's even admitting it to herself.

The idea doesn't sit well with me, but I decide to wait and see just how she plans to go about it.

It's a warm, clear night, and not a bad walk to Payless Drugs. Becca picks out a light magenta hair color that to me suggests heavy drug addiction. "No, siree," I tell her. "I know my complexion colors. I'm a fall, and that's definitely a spring." No spring that ever existed in nature, I might add.

"Oh, stop it, Rebby. We'll do a middle part and you can keep your flat brown and I'll just liven up my side. I want to get it shaped, too—something that falls around my face."

"It better not fall anywhere near *my* face."

When we get home from the drugstore, she reads the instructions aloud and there are about fifty steps to this process by the time you do the lightening and the toning. Then she starts telling me which hairs are hers and which are mine. We've gone around on this before. It's a tough problem because our faces aren't set exactly even: I look left and down while she faces straight ahead and up. For walking we've managed a workable system where I watch for curbs and ground objects and she spots branches and low-flying aircraft. She claims to have saved our life numerous times.

"Oh, yeah? And for what?" I always ask her. And she always laughs. But now I know—so she can fuck Remus, the pale scrawny clerk with the goatee who works at A Different Fish down the corner. Now it's clear why Becca didn't laugh when I pointed out his resemblance to the suckermouth catfish. Also her sudden decision to raise crayfish. Those bastards are mean, ugly sons of bitches, but they suit Becca just fine. They're always climbing out of the tank to dehydrate under the couch, so we have to go back to the store for new ones. Fuck—I'd rather die a virgin. We entertain ourself just fine.

It's 2:00 A.M. when she finishes drying that magenta haystack and we finally get into bed. Then she stays awake mooning about Remus while I put a beanbag lizard over my eyes and try to turn off her side of the brain. I know where she's got her fingers. There's a tingle and that certain haziness in our head.

We barely make it to work on time in the morning. Then Becca talks one of our coworkers into giving her a haircut during lunch. The woman is a beautician, but she developed allergies to the chemicals, so now she works at the hospital lab with us.

They're snipping and flipping hair in the break room to beat shit while I'm trying to eat my tuna fish. "Yes!" Becca says, when she looks in the mirror.

Her side is blunt-cut into a sort of swinging pageboy. She tweaks the wave over her eye, making sure we'll be clobbered by a branch in the near future.

We get home from work that evening and—surprise—she counts the crayfish and reports another missing. I try to scramble down to look under the couch in case the thing hasn't dried out yet, but she braces her legs and I can't get the leverage.

"You know how much trouble it is for us to get back up," she says. "Anyway, it'd be covered with dust bunnies and hair."

At that moment I get a flash of guilt from her section of the brain—she's lying. There is no fucking anthropod under the couch. She wants badly to get back to that aquarium store.

I catch Becca smiling sweetly at me in the hall mirror. I forgive her.

She insists on changing into "sleisure wear"—that's what I call it—to walk down the street. The frock's a short fresh pink number with cut-in shoulders. I'm wearing my "Dead Babies" tour T-shirt and the cutoffs I wore all last weekend. Becca has long given up trying to get me to dress in tandem.

We see Remus through the glass door when we get there. He has his back to us dipping out feeders for a customer. His shaved white neck almost glows. The little bell rings as we step in. Becca tugs me toward the tank where the crayfish are, and I can tell she's nervous.

Remus turns. Straining my peripheral vision, I catch the smile he throws her. I can feel this mutual energy between them that I missed before. He's not too bad-looking with a smile. I start to imagine what it's going to be like. What kind of posture they'll get me into. Maybe I should buy earplugs and a blindfold.

Becca heads toward the crayfish, but I halt in front of a saltwater tank of neon-bright fish and corals. A goby pops its round, pearly head out of a mounded hole in the sandy bottom and stares at us. "Look," I say, "he's like a little bald-headed man," but she just keeps trudging on to the crayfish tank, where she pretends to look for a healthy specimen. Remus comes back with his dipper and a plastic bag.

"What can I do for you two lovely ladies tonight?"

Becca blushes and giggles. Remus reddens. I know he's thinking about his use of the number *two*. He's got it right, but he's self-conscious . . . like everybody.

She points to the largest, meanest-looking crawdad in sight. "This guy," she says. I figure she's after the upper-body strength, the easier he can knock the plastic lid off our tank and boost himself out over the edge. "Think you can snag him?" she asks Remus.

He takes it as a test. "You bet. Anything for my best customer—s." He stands on tiptoe so the metal edge of the tank is in his armpit and some dark

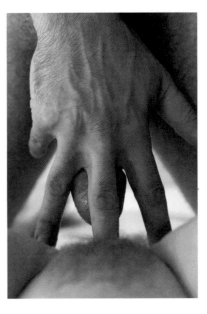

^ SUSAN EGAN

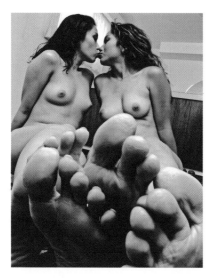

hair curls from his scrunched short sleeve. He dunks the sleeve completely as he swoops and chases that devil around the corners of the tank.

Remus is no fool. He's noticed Becca's new haircut and color. I'm thinking, *get your mind outta the gutter, buster*—but I'm softening. I'm tuned to Becca's feelings, and I'm curious about this thing—although, it's frightening. Not so much the sex, but the idea of three. I'm used to an evenly divided opinion, positive and negative, side by side, give and take. We might be strange to the world, but we've developed an effective system. Even his skinny bones on her side of the balance could throw it all off.

Remus catches the renegade and flips him into the plastic bag, filling it halfway with water. He pulls a twist-tie from his pocket and secures the bag. "You have plenty of food and everything?" Remus asks.

Becca nods slowly and pokes at the bag. I know she's trying to think of a way to start something without seeming too forward. Remus looks like he's fishing for a thought.

My portion of the gray matter takes the lead. "Hey," I say, "Becca and I were thinking we'd try a new brownie recipe and rent a video. Wanna stop by on your way home?"

Becca twitches. I feel a thrill run through her, then apprehension. She turns our head further to Remus. "Want to?" she says.

"Sure. I don't get out of here till nine. Is that too late?"

"That's fine," I say. I feel her excitement as she gives him the directions to the house and we head out.

When we get outside she shoots into instant panic. "What brownie recipe? We don't even have flour!"

"Calm down," I tell her. "All he's thinking about is that brownie between your legs."

"Geez, Reb, you're so crude."

"Chances are he won't even remember what we invited him for." Suddenly, it hits me that he could be thinking about what's between my legs, too—a natural *ménage à trois*. I rethink—no way, Remus wouldn't know what to do with it.

Becca insists that we make brownies. She pulls me double-time the four blocks to the Quickie Mart to pick up a box mix. I grab a pack of M&M's and a bag of nuts. "Look, we'll throw these in and it'll be a new recipe."

She brightens and nods our head, I can feel her warmth rush into me because she knows I'm on her side—in more ways than one, for a change.

We circle the block to hit the video store and Becca agrees to rent *What Ever Happened to Baby Jane?* She hates it, but it's my favorite, and she's not in the mood to care. I pick it off the shelf and do my best Southern Bette Davis: "But Blanche, you *are* in that wheelchair."

It's 8:00 when we get home, and the first thing Becca wants to do is hop in the shower. I'd rather start the brownies. We both make a move in opposite directions, like when we were little girls. She fastens on to the loveseat and I get a grip on the closet doorknob. Neither of us is going anywhere. "Reb, please, let go!" she hollers.

After a few seconds of growling, I realize we're having a case of nerves. I let go and race Becca into the bathroom. "Thanks, Rebelle," she says.

At 9:10 we slide the brownies into the oven and hear a knock. Remus made good time. I notice Becca's quick intake of breath and a zinging in our brain.

Remus has a smile that covers his whole face. I feel Becca's cheek pushing my scalp and can figure a big grin on her, too. I hold back my wiseass grumbling. So this is love.

Becca asks Remus in and we get him a Bud. He's perched on the loveseat. Our only choice is the couch, which puts me between them, so I slump into my "invisible" posture, chin on chest, and suck my beer. I know that way Becca is looking at him straight on.

"The brownies will be ready in a little while. Want to see the movie?" she asks.

"Sure."

Becca starts to get up, but I'm slow to respond.

Remus jumps up and heads for the VCR. "Let me," he says.

"Relax," I whisper to Becca. I'm thinking, thank God I've got *Baby Jane* for amusement.

The movie comes on and neither of them speaks. Maybe the video wasn't such a good idea. I start spouting dialogue just ahead of Bette whenever there's a pause. Becca shushes me.

The oven timer goes off. "The brownies," I say. "We'll be right back." We hustle into the kitchen and I get them out. Becca tests them with the knife in the middle. "Okay," I tell her. "I'm going to get you laid."

"Shh, Reb!" I feel her consternation, but she doesn't object.

The brownies are too hot to cut, so Becca picks up the pan with the hot pad and I grab dessert plates, napkins, and the knife. "Just keep his balls out of my face," I say.

That takes the wind out of her, but I charge for the living room.

Remus has moved to the right end of the couch. Hmm. My respect for him is growing.

We watch and eat. Remus comments on how good the brownies are. Becca giggles and fidgets. Remus offers to get us another beer from the fridge. Becca says no thanks. He brings me one.

"Ever had a beer milkshake?" I ask him.

"Nope."

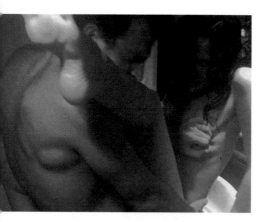

"How 'bout a Siamese twin?"

His mouth falls open and I'm thinking suckermouth catfish all the way, but his eyes have taken on focus.

I tilt my face up. "Becca would shoot me for saying this—if she could do it and survive—but I know why you're here, and I know she finds you attractive, so I don't see a reason to waste any more time."

The silence is heavy and all of a sudden the TV blares—*"You wouldn't talk to me like that if I wasn't in this chair—" "But Blanche, you* are *in that chair, you* are *in that chair."*

"Shut that off," I tell Remus.

He breaks from his paralysis and does it.

I feel Becca's face tightening into a knot, but there are sparks behind it.

I suggest moving into the bedroom. Remus gawks.

I'm named Rebelle so Mom could call both of us at once—she got a kick out of her cleverness—and I take pride in being rebellious. I drag Becca up.

She's got the posture of a hound dog on a leash, but her secret thrill runs down my backbone. I think our bodies work like the phantom-limb sensation of amputees. We get impulses from the brain, even when our own physical parts aren't directly stimulated. I'm determined to do what her body wants and not give her mind a chance to stop it. She follows along. We get into the bedroom and I set us down. Remus sits next to Becca. Without a word, he bends forward and kisses her, puts his arms around her and between our bodies. I watch.

It's an intense feeling, waves of heat rushing over me, heading down to my crotch. We've been kissed before, but not like this. He works at her mouth and his tongue goes inside.

The kissing stops. Remus looks at me, then turns back to Becca. He takes her face in his hands and puts his lips on her neck. I can smell him and hear soft kisses. My breathing speeds up. Becca starts to gasp.

He stops and I hear the zipper on the back of her dress. She stiffens, but he takes her face to his again and we slide back into warm fuzzies. This Remus has some style. He pulls the dress down to her waist and unhooks her bra. She shrugs it off.

"You're beautiful," he tells her.

"Thanks," I say. I get a jolt of Becca's annoyance.

My eyes are about a foot from her nipples, which are up like gobies, and he gets his face right down in them, takes the shining pink nubs into his mouth and suckles. I feel myself edging toward the warm, moist touch of his lips, but the movement is mostly in my mind.

Remus pushes Becca onto the pillow and I fall along and lie there, my arms to my side. He lifts her hips and slides the dress down and off, exposing a pair of white lace panties that I never knew Becca had, never even saw her put on.

He nuzzles the perfect V between her legs and licks those thighs, pale as cave fish. Becca reaches up and starts unbuttoning his shirt. He helps her, then speedily slips his jeans down to the floor, taking his underwear with them. I stare. This is first time we've seen one live. I feel a tinge of fear and I don't know if it's from Becca or me.

"Got a condom?" I ask him.

"Oh, yeah," he says. He reaches for his pants and pulls a round gold package out of the pocket. Becca puts her hand on my arm while he's opening it, and I turn my chin to her side and kiss her shoulder. We both watch while he places the condom flat on the tip of his penis and slowly smoothes it down.

He gets to his knees, strips down the lace panties, and puts his mouth straight on her. His tongue works in and I can feel the juices seeping out of me in response. Becca starts cooing like those cockatiels we used to have, and I bite my lip not to make a noise. Remus moves up and guides himself in, and I swear I can feel the stretching and burning. I'm clutching my vaginal muscles rigid against nothing, but it's the fullest, most intense feeling I've ever had.

Becca starts with sound effects from *The Exorcist,* and I join right in because I know she can't hear me over her own voice, and Remus is puffing and grunting enough not to give a fuck about anything but the fucking. His hip bumps mine in fast rhythm, as the two of them locked together pound the bed. I clench and rock my pelvis skyward and groan with the need, stretching tighter and harder, until I feel a letting-down as if an eternal dam has broken. I'm flooded with a current that lays me into the mattress and brings out a long, thready weep. It's like the eerie love song of a sperm whale. I sink into the blue and listen to my breathing and theirs settle down.

I wake up later and look to my side. Remus has curled up next to Becca with one arm over her chest and a lock of the magenta hair spread across his forehead. His fingers are touching my ribs through my shirt, but I know he doesn't realize it. I have tears in my eyes. I want to be closer, held tight in the little world of his arms, protected, loved—but I know he is hers now, and she is his. I'm an invisible attachment of nerves, muscles, organs and bones.

It's after 1:00 when we walk Remus to the door, and he tells Becca he'll call her at work the next day. He gives her a long, gentle kiss, and I feel her melting into sweet cream inside.

"Good night—I mean good morning," Remus says to me. He gives me a salute. Comrades, it means. It's not a feeling I can return, but I salute back. I know he sees the worry in my eyes. I try to take my mind out of the funk, before Becca gets a twinge.

Remus calls her twice that afternoon, and a pattern takes shape over the next three days: whispered calls at work, a walk down the street after dinner, a 9:10 Remus visitation. I act gruff and uninterested.

When we go to bed I try not to get involved. You'd think once I'd seen it, I could block it out, catch up on some sleep. But the caresses are turning more sure and more tender, the sounds more varied—delicate but strong with passion, unearthly. My heart is cut in two—like Becca and I should be. I'm happy for her, but I'm miserably lonely.

On the third day, I can't hold back my feelings anymore. Of course, Becca knows already. It's time to compromise.

"I think we should limit Remus's visits to twice a week. I'm tired every day at work, and I can't take this routine every night. Besides," I tell her, "you shouldn't get too serious. This can't last."

Becca sighs with relief. "I thought you were going to ask me to share."

I don't say anything. It had crossed my mind.

"Just give us a few more nights," she says. "He's bound to need sleep sometime too." I notice her use of the pronoun *us*, that it doesn't refer to Becca and me anymore.

She puts her arm around my shoulder and squeezes. "I know it's hard, but—"

"Seems to me that's your only interest—how hard it is."

I feel the heat of her anger spread across into my scalp. I've hit a nerve. She's like a stranger.

"You can't undermine this, Reb. It's my dream."

"We've been taking care of each other all our lives. Now you're treating me like a tumor. What am I supposed to do?"

"What can *I* do? It's not fair!" she screams. Her body is shaking.

"It's not my fault, for Christ's sake!" I turn toward her, which makes her head turn away. She starts to sob.

I take my hand to her far cheek. I wipe the tears. I can't cause her more pain.

"I'm sorry. I know I'm cynical and obnoxious. But if I don't have a right to be, who does?" I stop for a second. "Well I guess you do . . . so how come you're not?"

"Nobody could stand us," she sniffs.

I smooth her hair till she stops crying. "I love you, Becca . . . fuck—I'll get earplugs and a blindfold."

That night we take our walk down the street. There's nobody in the store but Remus. He walks up and I feel Becca radiating pleasure just on sight. He gives her a peck on the cheek.

I smell his scent. I'm accustomed to it. I try to act cheerful. I've pledged to let this thing happen, but I can almost feel him inside of her already, and the overwhelming gloom that follows. I put a finger in my ear and start humming "You Can't Always Get What You Want" to block them out. Then it hits me.

"Headphones—that's what I need. I can immerse myself in music."

"What?" asks Remus.

"Oh, nothing," I say, and then whisper to Becca, "I've found a solution." I give her a hug. I can do this.

The little bell on the door rings. Remus turns to see behind us. "Hey there, Rom," he calls, "how was the cichlid convention?" He looks back at us. "Did I mention my brother? He's just home from L.A."

Becca and I turn and do a double-take. In the last dusky rays of sunset stands a mirror image of Remus—identical, but a tad more attractive. A zing runs through my brain. I know Becca feels it too.

⌃ NATACHA MERRITT

COCKZILLA

"I'VE GOT A MONSTER IN MY PANTS AND IT'S SCARING AWAY ALL THE LADIES."

Dear Em & Lo,
I have a really big man-organ (how big is not important). Most people wouldn't consider this a problem. But it is. In the last six months, three women have told me it's too big. (Most common comment: "Whoa. That's not fitting in me.") So here's the question: 1) Do you have any suggestions as to how I can overcome this problem (I've already tried lots o' lube, to limited success)? 2) Is there a way of providing some sort of "prior warning" in my profile (or during a first date) without sounding like I'm trying to brag?
—Big Man on Campus

Dear B.M.,
DO NOT MENTION YOUR HUGE SCHLONG IN YOUR PERSONAL AD! Repeat: DO NOT MENTION YOUR HUGE SCHLONG IN YOUR PERSONAL AD. We can't tell you how many men make this mistake in these here Personals. It's as uncool as telling your girlfriend's parents she gives great head, as inappropriate as talking to your dinner guests about the great shit you took that morning, as crass as mentioning your huge schlong in your personal ad. You can't bring it up on a date, either—at least, not seriously. No reaching across the table, touching her hand gently, staring deeply into her eyes, and saying solemnly, "There's something you should know about me . . . " or, "I'm not like other guys . . . " And you especially can't mention the countless women who have run screaming at the sight of your sausage.

Here's why: First of all, a warning is never gonna work the way you want it to—it'll either gross her out or pique her curiosity. But even if she's grossed out, she'll probably stick around long enough to satisfy her curiosity (and have a good story to tell her friends). And if her curiosity doesn't trump her dude-that's-so-wrong reaction, you might have just scared away the one vagina that would have fit you like a glass slipper. Giving potential suitors a heads up (or should we say, a heads down) suggests some kind of medical problem. And mentioning all the size-ists in your past is just bad manners—a lady should never be forced to imagine another lady's chafed vagina while on a date. That kind of image gets burned into your brain . . . forever.

The only situation in which it might be acceptable to mention the magnitude of your manhood is if the conversation takes a turn for the saucy. You're out, things are going well, you've had a few cocktails, the innuendos are flowing freely, she recounts a suggestive story about that one time at band camp, and you retort with a lighthearted "I definitely don't mean to toot my own horn, but, well, I happen to have what you might call a, um, tuba in my trousers." Wink wink, nudge nudge. If she inquires further, you can talk about it very humbly and very vaguely, without getting into any gory details. If she doesn't probe, just laugh it off and consider her "warned."

But even then, what's the point? There are so many more factors at play when it comes to sexual compatibility. Sex isn't just about two bits fitting together, it's about chemistry, attraction, pheromones, politics, dogs vs. cats, kissing styles, creativity, emotional sensitivity, intelligence, sense of humor, birth control preferences, kink factor, body mass index, hygiene, bedsheet thread count, STD tests, self-esteem, stamina, exhibitionism, and asparagus intake—most of which you can't determine before the blessed event (which is why we're big fans of premarital sex). Mentioning size is like mentioning the way you smell down there—how it smells to you may not be how it smells to your partners, and how it smells to one luvva may not be how it smells to another. Some might find it ranker than their driving instructor's B.O.; others might find it sweeter than the nectar of the gods. Even if the majority of them aren't down with what you've got, you've still got to do the hard dating work like the rest of us to find out the very few people out there who are right for you.

So, you won't always be able to overcome size with enough chemistry and similar political views—sometimes the glove just don't fit and you must acquit. But the next time you get a "whoa" reaction, give them the above speech and then prove to them that the other factors matter more: Use more lube—as the experts (us!) always say—too much is almost enough. Keep reapplying throughout the sesh (that's where a pump dispenser comes in handy). And don't scrimp—K-Y might be cheap and readily available at the drugstore, but it can't compete

with the higher-end, longer-lasting, hardier, silicone-based lubes available at sex stores like Toys in Babeland and Good Vibrations. Make sure she's good and ready before you make your grand entrance: The more turned on she is, the more room there is in the back two-thirds of her vagina. Think shallow penetration and slow, gentle thrusting. (In fact, the coital alignment technique—just Google it—might be perfect for your special friends.) Try positions that let her set the pace (woman on top), or simply hold still in any position and let her thrust back at you. Accept that there probably won't be a lot of anal sex or marathon blowjobs in your future—but take comfort in the fact that your girlfriend(s) will always have that nice filled-up feeling so many women enjoy. Finally, get away from the idea that jackhammering is the only way to do "it." Embrace your inner lesbian and think about more creative, less penetrative approaches to sex to throw into the mix: frottage, "titty fucks" (just don't call it that), handwork, surrogate toys, etc.

And to all you wishful thinkers who keep writing to us about penis enlargement pills, penis pumps, penis weights, and penile surgery, take comfort in Big John's story: Bigger isn't always better.

We'd like to thank all the little people,
EM & LO

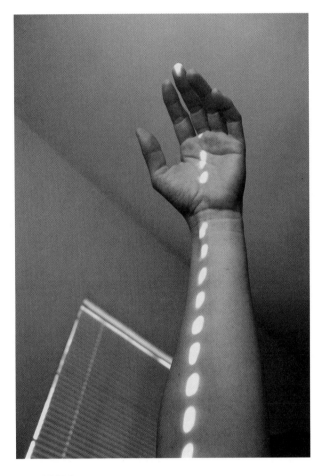

^ DUANE DUGAS

CONFESSIONS OF A SUSPICIOUS MIND

**IS IT OKAY TO BREAK INTO YOUR PARTNER'S EMAIL?
ONLY IF THEY'RE CHEATING ON YOU.**

Hello Em & Lo,

My boyfriend and I went out for almost two years. Recently he broke it off to have some "space" and "time to himself." I was hurt, certainly, but I understood. We didn't speak/see each other for about two weeks, but then began to spend time together again, and it has gradually become more and more frequent. We haven't had a talk that used the word "exclusive" since the breakup. But I got the impression that we were certainly getting into that arena again. He calls me his girlfriend, says he loves me, etc. Basically we're "back together," or so I thought.

I recently found out through a close friend that my boyfriend has a personal ad—on this site. Turns out my good friend was looking through some of the "potentials" with a coworker who has a personal ad, too. My boyfriend created his ad last year, when we were definitely 100 percent together.

Now it gets a little more complicated (sorry). I accidentally found out the password to his personal ad account. He had a window open on his computer and I saw it. Actually, it was for an email account, but it's the same password. I am not a snoop, but when I heard about the personal ad I was very hurt and insanely curious what it was all about. With a little digging, I found out he's been conversing with many (dozens) of women since beginning the account. And cheated! He made arrangements—and followed through on them—to have one of these women give him oral sex! I am officially dating a cheater. I am hurt, angry, you name it! And I'm also so angry with myself for having absolutely no idea. I found out about him cheating once before, last summer. I confronted him and he confessed to kissing another girl. So actually, I guess I've been dating a habitual cheater.

Here's where I need the advice, ladies. There's the obvious solution: lose the piece of garbage. But did I do the wrong thing by finding out his transgressions this way? I'm so upset! The man I have loved for years did this to me! Do I confront him? How?
—Hurt and More Hurt

Dear Hurt,
Lose the piece of garbage.

But first, you definitely want to confront him. Kickstart that awkward conversation by quoting a "friend" of ours who "accidentally" caught her boyfriend in a big fat lie via his email account: "I did something really bad, but you did something way worse." The confrontation will give him the chance to defend himself (as if there's just cause), get pissed at you for breaking into his email (a petty crime, at least compared to his felony), and/or try to win you back (not that you'd take him). But more importantly, it'll help you decide if there's even the slightest chance this piece of garbage might be worth recycling. If not, it'll at least give you some closure. At the very least, you'll get to watch him squirm.

To anyone else out there who has "accidentally" found a way to break into their chief suspect's secret life but has yet to exploit it, here's the right thing to do: *Don't dig.* Take the moral high ground and confront your partner about your suspicions instead. A mature relationship is built on trust and communication; if you suspect that trust has been violated, then you communicate your fears like a grown-up. Amateur detective work is nothing but another violation of trust, made even worse if you discover they've done absolutely nothing wrong. Everyone has a right to privacy, even the pencil-dicked, two-timing, scum-sucking bottom feeders who weren't loved enough by their mamas. Speaking of mamas, didn't yours tell you two wrongs don't make a right?

But here's what we would do: We would dig. At least if he'd hurt us before, there was good circumstantial evidence, and we wouldn't believe him if he denied it. (A spat with your partner over their crush on Brittany Murphy is not considered grounds for suspicion.) Hey, people lie and cheat all the time. It's not right, but thems the facts of life. If you were inundated with emails asking how to get away with cheating like we are, you'd lose a little faith in humanity, too. And when you find out that someone you've been dating isn't who you thought they were in one respect (e.g., they recently posted a personal ad when you're supposed to be "exclusive"), then it's hard to trust them in another

respect (e.g., them denying they used said ad for illicit purposes). They become an unreliable source of information to you, so you seek a second, secret opinion.

Oh sure, go ahead and tell us that this only creates a downward spiral of mistrust. Whine to us that even if we discover nothing's amiss, something's already been spoiled. Sic the ACLU on us. But things were spoiled long before we got here—by all the cheaters of the world who have created an environment of suspicion. If they can't stand the heat (or lack thereof) of monogamy, why do they insist on getting into—and staying in—monogamous relationships under false pretenses? They've got to get out of the relationship or into an open one. "But it's more complicated than that!" they cry. There's always an excuse. And so rationalization begets cheating which begets lies which beget inconsistent stories which beget suspicion which begets digging. It's a vicious cycle, but hey—the cheaters started it. And suspicious minds with faithful hearts are higher up on the evolutionary ladder than philanderers. We'll take the faithful's side every time.

Do as we say or do as we do, it's your call.

Two rights,
EM & LO

^ NATACHA MERRITT

FUCKING HIS WIFE FOUR MONTHS PREGNANT WITH THEIR THIRD CHILD

BY PAULA BOMER

After the kids pass out in their bunkbeds downstairs, *goodnight Tom, goodnight Mike, sleep well, who loves you? who loves you the most?* one more kiss, one more kiss, after they finish watching a sitcom on TV, after Sonia drinks that extra glass of wine, after Dick sips his scotch on ice, after they brush their teeth, relieve their bladders, and slide into the clean white cotton sateen sheets Sonia put on that very morning, Dick leans into Sonia's face and kisses her. First he kisses her on the edge of her cheek, on the part of the cheek that is right next to her mouth. Then he moves in closer to her lips, touching the corner of her mouth with his mouth. She turns her face toward him now, in the dark, her eyes closed, and he leans his upper body over hers and turns his face so his nose won't get in the way and he pushes his mouth against hers and, open-mouthed, they kiss. Their tongues reach out and taste, and damn, if it doesn't taste good. Damn if it doesn't taste like warmth, like booze and like that familiar flavor that is each other.

This is not a night when Dick will fart obscenely in bed next to her, pretending not to, and Sonia, despising him, will snap her magazine angrily into a perfect tent in front of her face. Nor is it a night, like so many nights just before this night, where Sonia, stinking of sweat from the summer heat, from the sweat of fear and the sharp stink of bile and vomit, is so disgusting, no not disgusting, so terrifying, terrifying in her foreignness, in her stink, in her pale, ugly, possum-in-a-trap look on her face, that Dick just wouldn't look at her. *I'm afraid! I'm afraid! I can't do this again!* her every movement said. She'd be folding laundry and she'd say something, *we're out of milk,* or, *Tom skinned his knee today,* or something like that, and he'd look at her, catch her eyes, and her eyes were full of fear and sickness. Her jaw loose and weak. Her face bloated and sickly. Her tone insupportably whiny.

Those first three months are over. Those three months of hell, that first trimester of pregnancy when the only thing Dick could do to survive being in the house with her was to pretend she wasn't there. Gone is that horrible time. Done with it. She'd be there, and he'd pretend, just like he did as a child when his father was yelling, or his mother was yelling, that the person in question was not there. Dick's imagination is so powerful and has always been so powerful that he can play this trick very well. He draws a white chalk line around the person, just like if the person were dead, and then "poof!" he can no longer see them. They disappear.

But not tonight. Tonight he can't not see her. He couldn't, if he wanted to—which he doesn't—imagine her gone. Tonight he is mesmerized. Tonight he looked at her on the couch, lazing with him in front of the TV, and he saw a beautiful, young woman. The woman he fell in love with. He saw her as she was

fifteen years ago, he saw her as no different than she was when she was barely 20. And now, in their marriage bed, in her blue nightgown that he lifts over her head, he sees her and loves what he sees. The bones in her face are strong but womanly, her mouth is wet and inviting, her eyes are smart but slightly troubled, definitely knowing. Often thinking of something dirty. His wife is still his dirty-minded college girl. And this, in the dark now, now that she is over that first part of her pregnancy, now that she no longer repulses him, no longer hates him, now that she is resigned to her body and the strange creature inhabiting her, the stranger that neither of them have any idea who it will be, this bud of a person that he planted in her womb, now that this baby isn't torturing his wife anymore, now, now, she is so fuckable. Her skin seems powdered with stardust, it's *moist* dammit, and sparkling at him, he swears, and her eyes are wet like a healthy cat's, glowing at him in the dark, open now, looking at him while their tongues stroke the insides of their mouths like they've never tasted each other before.

How could kissing this woman be anything that ever happened again? After years of marriage, years of just fucking, not that anything's wrong with that, but years really where they would never, ever have kissed, preferring to get straight to the part that matters, kissing having bored them, kissing having been something of the past. Kissing not being on their minds, but they still needed to get off. His balls would fill. There's the nice lady next to him who empties them for him. He always felt gratitude, but he had stopped feeling wonder. Excitement. Urgency. Except during these precious months when she was pregnant with their first son. And their second son. And now, again, this gift. This time, this fleeting moment in their lives.

Here he is, his hands on her breasts, which are so swollen, so sensitive she moans and pulls away slightly, and he just can't believe these are his wife's tits because these were not his wife's tits a few months ago. His wife's tits a few months ago were dried out, tired nipples that lay nearly flat against her ribcage. His wife's breasts, when she's not pregnant, were never as fleshy as her upper arms. It would be jangly arms and flat breasts. Now he can't even see her arms. His wife has breasts! Serious breasts. Not yet full of milk, but swollen and ready for what's to come. He has one in his hand and another in his mouth and she's shaking now, because all those hormones that are making her breasts grow into these beautiful flowers are making them raw with nerves. He has to be gentle. He doesn't want to be gentle, precisely because he must be in the face of her painful, swollen breasts. He squeezes and sucks them and she can't stay still, she's just squirming, he can tell it's uncomfortable, hears her breathe out the word *ouch,* and she puts her own hand on them to protect herself, but also to feel them herself. Because these breasts are a gift from God, the God who gave humans the ability to reproduce, and to feed their young. These tits are blessed and she wants to hold them too.

What can making casseroles teach us about making love?

A casserole takes a lot of prep work before it's ready. It's more about the anticipation of eating the casserole than about the act itself, sometimes. And if it's too hot out, both are kind of gross.

What casserole can I make to impress the new guy I'm seeing?

I make a casserole I call "Seduction." It's a twist on my signature mac-and-corn casserole, made with onions, five different cheeses, and tomatoes on top. I made it one night for a friend and he was definitely seduced by it. Or maybe it was the whiskey. Or maybe it was my hotness. But I'd like to think it was the casserole.

I'm buying my first dildo. Any advice?

When it comes to dildos, there are two categories: Ones that look like animals and ones that don't look like animals. I highly recommend ones that look like animals.

What casserole can I make to impress the new guy I'm seeing?

Breakfast casserole.

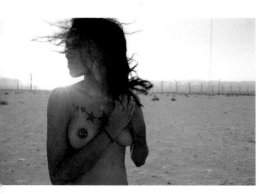

He arches his entire body over her now, he's up on his knees, not leaning his body on hers, no, he wants to see her, and he locks his mouth on hers again and fuck, he's kissing his goddamn wife. He wants to lick out the inside of her fucking throat. And then he puts his finger in her pussy, just like that, and it's as warm and wet as melted honey. He nearly comes right then. But he pulls away from her and takes a deep breath. On his knees now he grabs his dick hard and pushes at it. Down boy. Not yet. Breathe in, breathe out. Oh, man. Her skinny legs are splayed out from the bowl of her small hips, and in the dark he can just make out her glistening pudenda. Jesus. He can't look at it. He looks away. If he puts his dick in there now, he'll just come right away and that is not what he wants to do. But what else can he do now? He could eat her pussy, but he doesn't really want to. It's about his dick tonight, about the effect this bitch that is his wife is having on his dick. He could get back on those tits, but he'll probably fucking come right away doing that, too. So what he does is turn her over and there's her ass, which he loves, he loves his wife's ass. But it's calming him a bit, he loves it but it's familiar, not strange and new like those breasts and it's not her fucking wet pussy staring at him either, and he feels calm. But oh God, she's lifting it up at him and there's no hiding from what's underneath it. And so he leans over her to not look, and, anyway, his dick has been safely calmed, it's still hard as rock, but not as near to bursting, and he rubs it on her like a cat in heat and then she's rubbing her ass back at him, her ass is asking him to stick it in her, which he does—sticks it into her like a knife in butter—and he leans over her and takes each one of those breasts in his hands. And then he grabs both breasts in one hand, smashing them together hard, and she lets out a short cry, and with his free hand he grabs her head and twists it around, back toward him, so that he can shove his tongue down her mouth again. Damn. Damn.

Oh, if his wife were always pregnant! Oh, if his wife were always four months, five months, even six months pregnant! Not one or two or three! And not seven or eight or nine! But that middle time, this middle time, how he loves her, how he can't believe it's her, how ripe she is, how womanly, how soft and precious and giving and forgiving she is! Oh, if she could only stay this fleshy, this wet, this ready. If only she were always in a dark room, if only her breasts were always like this in a dark room. Then, then his life would be perfect. His wife, locked away in a dark room, a room which only he had the key to, permanently four months pregnant.

This whole putting things off is not working. Or, rather, it is working and Dick has changed his mind. He turns her over again, and his wife's breasts flop around in a good way, move like Jello, loose and real, and there are her hip bones, her splayed legs, and he gently thumbs her clit but she pushes his hand off of her pussy and arches up to him, her own hands on her tits, moaning, and he grips her hips and thrusts in there deep and he's just gonna come. It's just

gonna happen. Her head is twisted to the side and her own hands smash her breasts together—they touch! They're so big they touch each other!—and he thrusts again but he's going to come and he can come inside her if he wants, she's already pregnant, it's not going to make her more pregnant, and he loves everything about this, the no condom, the no cervical cap which he used to bang up against, the no smelly spermicidal jelly, just the thick, tangy smell of his dick in her pussy and he can come inside of her if he wants. But he wants to come on her face is what he wants and he hopes she's up for it, and really he knows she is because that's why he married her. Not because he needed someone to cook him dinner, not because he wanted her to raise his kids, mop his floors, and put his underwear in the dresser drawer. No, he married her because she's the kind of woman who likes to pretend she's a porn star. He wants to lift his dick out and hold it over those breasts and that's exactly what he does, his knees up near her armpits now and one hand is on his pulsing cock, and the other is grasping her round, fleshy breasts together, and he shoots out come all over her tussled, beautiful face, and her round, round breasts, banging his cock against one nipple, then her chin, tap, tap, tap, knocking out every last drop of himself onto her, his wife. And Dick is, in no small way, the happiest man on earth.

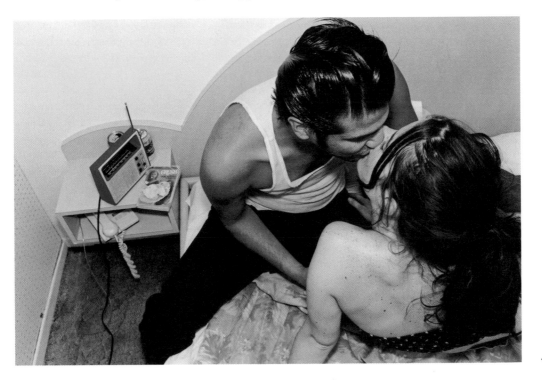

‹ MIA DONOVAN

LYING WITH MY FATHER

BY LISA CARVER

When I was 15 I left my mother's all brown-and-white apartment in New Hampshire against her wishes for my father's California digs. He called his place "the chicken coop"; it was two rooms and the roof was falling in. My stepmother had left him and he'd sounded a bit suicidal on the phone. I got off the plane and he was loping through the crowds like Moses through the parted sea, a head-and-a-half above everyone else, chicken-like hairdo and erratic beard, mismatched pants and shirt. He walked towards me like he owned me, like I was a parcel he'd set down for a minute instead of eleven years. I wore a new corduroy blue dress over a white turtleneck, and except for being unusually gangly even for my age, there was really nothing to notice about me. I had just lost my virginity (didn't like it at all), was the third best drawer in my class, and hoped to be a writer someday. My father stuffed me in his battered car and we each put an arm out the window, pretending to fly over the highway.

My father acted younger than I did. His unorthodox lifestyle appeared unbelievably cool. Friday night was poker night. Sunday he'd cook a huge meal and invite street people over (he preferred voluntary charity to the government-mandated version; he was a tax evader). His friends had names like "Black Vic" and "Reverend Bruce." Things were regularly stolen from the house. One visitor casually mentioned he'd just thrown a brick through his TV because Stevie Nicks told him to. Another advised putting a beer in your baby's bottle at night to make him go to sleep. My father would do anything. He applied for welfare "as an experiment." Once we got on it, he'd do things like write them a letter saying he was planning a lobster dinner for six and needed fifty extra dollars in food stamps. And it came. My father was glamorous.

On a trip to the beach with the neighbor's toddlers, he let me drive the van down an extremely steep, winding cliff. I'd never driven before outside of a parking lot, and nearly killed us all about thirty times. While the kids screamed and cried, my father sat calmly in the passenger seat, not asking me to slow down. I don't think he cared if he died. There was something so free and enticing in that—you felt that if you just stood close enough to him, some of his daring would transfer to you like static electricity. His bright eyes and lithe body seemed to say: "I'm a daredevil. I'm outside the laws of acceptable behavior. Are you, or are you one of them?"

My father never touched me and he never said "I love you." He didn't shake hands or pat backs. Having been abused as a child and then spent years in prison, it was as if there were signs all over his body: DANGER! DO NOT TOUCH! He'd sit with his back to the wall to have a clear view of all doors. His invisible enemies crept into my world too, and turned it all very, very exciting.

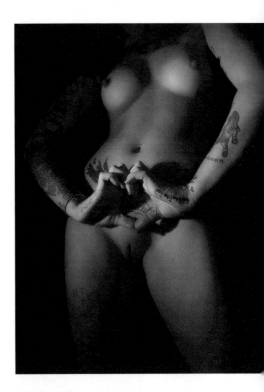

^ CHASE LISBON

He never asked what he wanted to know outright. He set traps, he did experiments. It kept me on my toes. I never knew when something he said was a simple comment, or a test, which I was loath to fail. I wrote in my diary to him all the sentiments bubbling up my throat and stopped by a cork-tongue: All the candles in Rome could not outshine the burning in my heart for you!!! My admiration is a monument enormous, my devotion knows no end!!! I feel for you not only as your daughter, but as your fellow thinker. But outwardly, I was quiet. Not surprisingly, he was disappointed in my development thus far: a dreamy, bookish personality wrapped in corduroy. I was a mouse. It was hard for him to believe his blood ran through my veins. When he pronounced me "wishy washy," I thought I'd die. I thought I'd do anything to change that about myself.

I never knew when or how he'd be near me. He didn't observe normal patterns of behavior. When I hurt myself and cried, he'd just sit there and laugh. He liked to walk in the bathroom when I was taking a shower. I became perpetually aware of the nakedness just under my clothes and the mental helplessness just under my preternaturally large vocabulary. My senses sharpened. I looked for clues in everything. I was unsure all day long, and all night.

There were only two rooms in the apartment and almost no furniture, so we slept together on a fold-out couch. Lying there with our long blond bodies side by side, stiff and straight, never slipping into the three-inch gully between us, we'd talk about sex. Mostly he talked, since I only had about seven minutes of experience to contribute to the conversation. He taught me lessons. There are three things you have to say to women to get them into bed, he said. They light up the room; they're different from other women; and you've never felt like this before. It felt like my father and I were in a conspiracy against the world, there in the dark in our creaky bed—against my mother and stepmothers and my silly school friends. We had our secret language, and we knew what was what in this backstabbing world. I think I would've done it with him if he'd made a move. The only way anyone ever seemed to impress him was by spitting in the face of convention. How better to prove I was rebellious than to break the greatest taboo? Besides, he was hot stuff. He knew all about geography and Napoleon and bull markets and systems of government and smuggling and why my mother back home was so pathetic and ridiculous. He could make about fifty different animal calls and introduced me to punk rock. Sure I would've fucked him. Everyone else did.

My father's women were all around. He favored wizened little degenerates with pouches of fat in unexpected areas, whom I couldn't picture surviving under the weight of someone as big and strong as my father. They didn't complain when he made fun of their logic, and they didn't think it strange that he had a whole stable of drunk floozies. He enjoyed the dirty, clingy, untamed, manipulative broods of children that went with them. Chaos felt right to

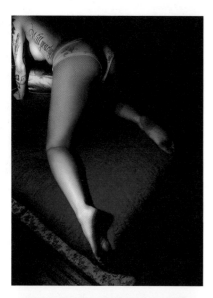

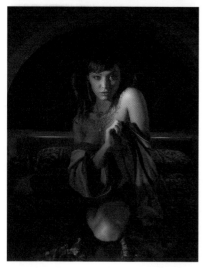

^^ ^ CHASE LISBON

him—he sought it out and then he encouraged it to grow. He never referred to all the broken bones and silent treatments he'd received as a kid (I had to learn about it from the rest of the family)—he had no use for self-pity, or any other kind of pity. He reacted to one woman's depression, which rendered her unable to leave her bed, by having sex with her twenty-five times in five days. He then complained about the cost of rubbers, suggesting the woman was taking advantage of him. "We each of us have our own highway to hell," the desperate woman intoned. "Not me," rejoined my dad, "I'm a hitchhiker on someone else's highway to hell. Too much work paving my own." Everything was a joke, and if it wasn't, then it was something to be laughed at. That's how I knew when he was serious: he laughed. Because he never laughed at jokes.

That man would part the thighs of anyone who somehow fit into a category he'd never explored before: a different race, weight, height, or age bracket; anyone willing to be in an orgy, do it on LSD, and so on. I think that's how he got mixed up with my mother—he'd wanted to try out the prude. My mother, a private school teacher, only gave my father one blowjob. Her only blowjob ever, after which she had to go rinse her mouth out or throw up—the story varied, according to whether it was my father or my mother telling it.

I didn't want to be like my mother, careful with her experiences. I wanted to try things out carelessly, ruthlessly. I would transform myself into the one who takes, and the one who leaves. I became an experimenter and a feminist of the loosest variety—very independent and fucked-up and free. I wanted to out-screw the men. And I did! By the time I turned 16, I was like Clint Eastwood—I roamed alone. In my mind's eye, I wore a hat. One that eternally cast a shadow over my eyes. I sat with my back against the wall. I set traps. I even seduced women, using the tricks my father had taught me: telling them they lit up the room, they were different from other women, and I'd never felt like this before. It worked every time. All around me piled the rubble of my experiences: a variety of broken hearts, suicide threats, hangovers, fights, poor eating habits. I never cleaned up, just moved on.

Unknowingly, I was trying to get my father out of my system by becoming him. When that didn't work, I had an affair with an older man who looked like him. I was 17 and high most of the time. I imagined it was my father every time. It was dizzying! I'd look up into his eyes, blue and myopic like Dad's, and say, "Dare I? Dare I?"—it was like standing at the edge of a ravine, wanting to throw myself down just because it's so deep—and then I'd allow myself to let my vision blur, let my mind smear this man's features into my father's. "Who'll ever know?" I'd say to myself, and did it again and again. But this guy was too easy. He fell in love with me almost immediately, and he whined.

Then along came the man who would become my son's father. A magister in the Church of Satan, he was cruel, oversexed, and he demanded extreme

loyalty. I found this combination of qualities knee-wobbling. I didn't leave the bed for five months. By then I was pregnant, and it was too late to wonder what I'd done.

Everything changed once I had my son. Not immediately. At first I was the same: predatory, virile, chaos-seeking. I had to consciously think through why I should not molest him. Why it was not okay to talk sexually with him. I don't mean explaining the birds and the bees—I mean bringing something sensual and dark into every conversation. Part of me wanted to be like a girlfriend to him—no, a fantasy half-realized. I resisted out of respect. I had to let him discover the world of sex and temptation on his own. That power over him belongs to some other lady out there, probably unborn. My father never gave up that power over me.

At the age of 29, something happened that made distancing myself from my father a possibility. I fell in love for real for the first time. Now, instead of looking glamorous in his abandon, my father looked sad to me. First with my son, and now with my new love, I was learning that conspiracy and dominance are not the only ways to be close to someone. I was coming to believe people really can cast light; you really can feel like you've never felt before. That was the ultimate betrayal to my father. He'd thought I was the one person who would never leave him, never discount his carefully constructed reality—I was his creation, after all. And now I was ruining everything.

I decided to stop responding when he talked about sex. He pushed harder, exaggerated his role, desperate for my old response.

He said the 18-year-old Russian bride he ordered in the mail was having second thoughts about coming, because she worried he would beat her. Just from a couple phone conversations.

He said, "I'll have the five-by-five clean your house while you're out of town making that CD." The five-by-five was a fat woman he'd met through a newspaper ad. He said he wanted my place clean so he could bring Darla over—the woman who liked to draw blood during the act—"and screw her facedown in your bathtub."

"Um . . . uh uh," I mumbled. I was almost half a lifetime old, successful, in love, a mother, but in his presence, once again, a mouse.

As an experiment, I decided not to talk about sex for that entire summer. I found I had to stop myself at least every other sentence. I learned that I talked about it constantly, no matter who I was talking to. It also became apparent that it made people uncomfortable, and that I was not comfortable unless no one else was. Just like my father, I needed to keep everyone around me off-kilter, so I could control and direct the situation. I had become a monster.

But realizing what you've become doesn't necessarily undo it. This New Year's Day, wanting to show off to him, I brought the two people I'd spent the last

thirty-six hours fucking to my father's house. After the visit was over, and my boyfriend was driving us away from there, the girl said, "I don't mean to freak you out, but that was the weirdest, most extreme yet subtle sadistic power play I've seen between anyone and anyone! Around everyone else you're this cool empress, but he makes you all shook-up and desperate."

I felt horrible. If anyone should have influence over me, it's my boyfriend, whom I respect and love and trust and adore. Not that man whose house I left thirteen years ago. But here I am, importing sweet gals from Illinois just to have sex with on New Year's Eve.

Maybe my father was right, maybe everything we do is about protecting our genetic code, and the only faith that is real is bad faith. Maybe the only way to be safe is to always be one step ahead of everyone else. Maybe God and love and friendship really are only tools. And maybe my father is funny and smart and I'm just a big drip, fearful and disapproving. Maybe it would be better to have some fun and quit trying to make myself over. Maybe this article should have been a knee-slapper, a full-bodied, full-of-life laugh at the expense of nice people like the one I'm trying to become. I've written those before. They were enjoyable. I miss them. But here I am, and even if I haven't broken into the place of the good people, I know for certain I've ripped myself away from the place where I know the rules and they are his. I'm all alone and I don't know where. I'm blinking and turning around, wondering, What do I do next?

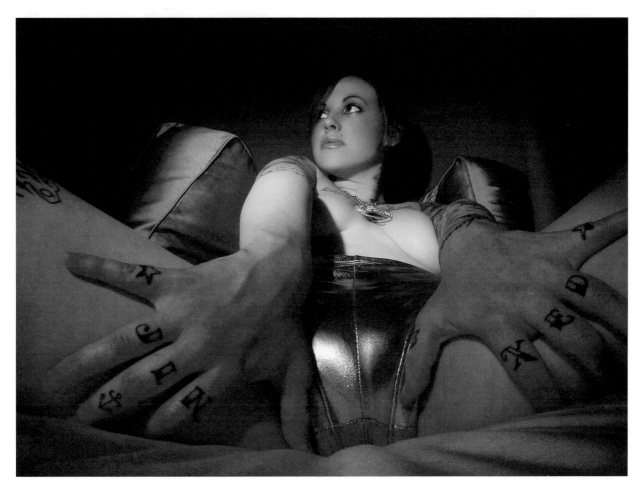

^ CHASE LISBON

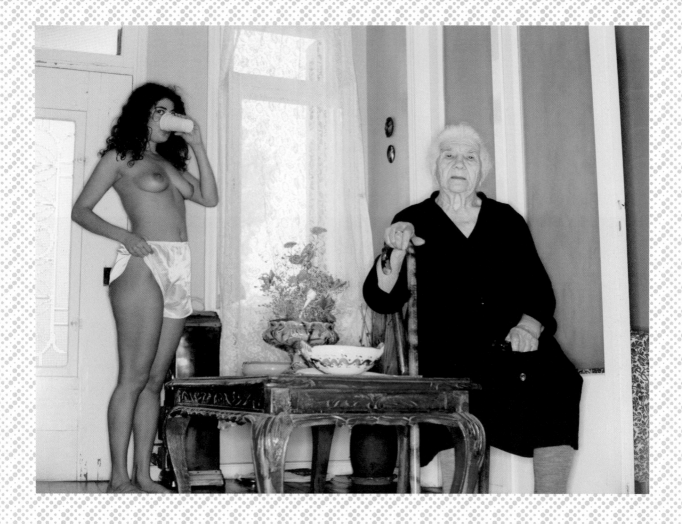

2002

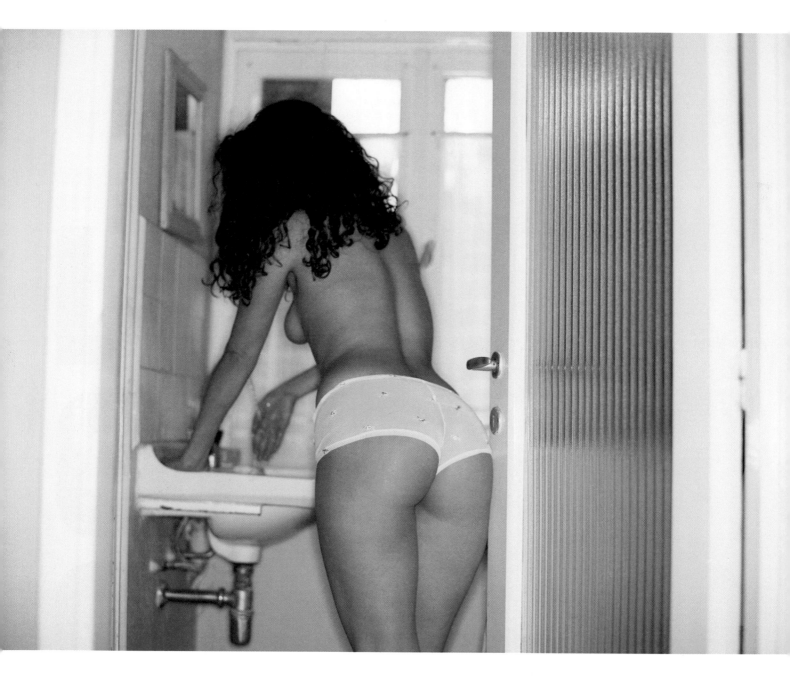

PHOTOGRAPHY BY
NATASHA PAPADOPOULOU

I initially found the juxtaposition in these pictures jarring—a tradition-ally dressed, elderly Greek widow pictured with a languid, beautiful, naked woman in her twenties. Then I learned the backstory. The young woman is Natasha herself; the other is her grandmother and name-sake. The photos are set in her grandmother's house in Northern Greece, where Natasha lived from the ages of two to twelve. Although she considers her grandmother the closest person in the world to her, Natasha has always enjoyed antagonizing the older woman, testing her limits. As a young girl she would pluck the hairs on her chin; later, she doggedly tried to teach the matriarch some words in English. Here, we see a naked Natasha attempting once again to vex her very clothed grandmother, who's laughing—a young girl's sparkling eyes defy the years that have caught up with the rest of her body. She seems not to care about her granddaughter's nude challenge; at this point, she's seen everything. —GRANT STODDARD

< ^ NATASHA PAPADOPOULOU

THE GUIDE TO BEING A GROUPIE

BY LISA GABRIELE

★ Be a girl. Be born sad. Be from a big family, or be an only child. Either way, make sure your parents are distracted and over-whelmed with life. They should hate your moodiness and scoff at any discussion of fresh and freaky ways to wear your hair. Notice that as your parents' arguments, debt, and beer bottles pile up on the kitchen table at night, the volume on your radio dial rises. Through a process of elimination, rock and roll, loud, is the only thing that drowns out the downstairs cacophony. You are 12. You learn to stay out of the way of what's going to happen.

★ Don't panic when lyrics to songs by Van Halen, Aerosmith, Led Zeppelin, and Journey fill the space in your brain previously reserved for algebra problems, figure-skating schedules, and your dad's new phone number. Realize that you can memorize a song after hearing it only three times. Trace a Rush album cover onto the title page of your English composition binder. Ask your mom if you can take guitar lessons. She tells you to dry the dishes, and when you're done, to take the garbage out. Drag the flimsy bag over the gravel, check to see if any neighbors are around, then sing into the dark suburban sky: *She's just a small-town girl . . . She took the midnight train going anywhere . . .* Wonder if Steve Perry wrote that song after he peered behind your homemade curtains into the 3-bdr, 2 bath, crpt, frplc, wtw shag, split-level and watched you, alone at the kitchen table, illuminated by the light over the stove, waiting for the avo-cado phone to ring.

★ Get a job at a jeans store in the mall. Go to Faces for a free makeover on your lunch break. In between sips of your Dairy Queen shake, watch as a 21 year old's face is smeared atop your 16-year-old features. Notice how that girl in the mirror looks old and young, wary and naïve at the very same time. Ask yourself, *Where did she come from?* Memorize the combi-nation of shading and shine before scrubbing it off in the washroom after shift. Your mom's picking you up in front of the mall. It's important that she recognizes you, for now.

★ Become best friends with Linda G., the assistant manager of the jeans store, who is four years older and has tits and money in spades. Plus a driver's license. Plus knowledge of radio-station concerts and the names of doormen at the Alexander Tavern and the Riviera by the expressway. Diamonds Lounge is okay, she says, but you go there last, because it's the

easiest to get into. There, let an older man dance with you. Make casual movie conversation. Ask him what he does for a living. When he tells you he's an accountant, pretend you know what that is. He asks you the same. You say student. *What's your major?* You say English. He asks for your number. Give him the wrong one. You mom's home all the time now, so it's likely she'd answer. Plus, he's her age, and that creeps you out. You're not here for the men; you're still here for the boys. But they have a hard time getting into these places without the benefit of scaffolded hair and three-inch feather earrings, which brush your collarbones and complement your Heart jersey perfectly.

★ Be certain that the first time the lead singer from Hustler makes eye contact with you, he's addressing his song to the sky-high blonde on your left. The CanAm Tavern is dark; it's an easy mistake to make. Feel Linda nudge you in the ribs the second time he finds your eyes. When she says *he's looking right fucking at you,* there's only the tiniest bit of jealousy in her voice. Because no one has searched you out or locked eyes with you so intently in so long, return the gaze with the kind of intensity you're sure will make the bar spontaneously combust. Feel joy and fear, like you've done something beautifully bad. Then recoil your attention, smack the love off your face, and enjoy the drinks he's sent to your round, tippy table. Be unaware this is the last time you act coy by accident.

★ Nod intently when Dale tells you that Hustler is just a starter band. As soon as he gets his shit together and buys a new amp, he's going to find a better band that will launch him into the stratosphere. Realize that the fact that he has a plan for tomorrow turns you on like nothing else. He puts his tongue in your ear and his hand on your thigh, near your crotch. He tells you he writes his own songs. Maybe one day, he'll write one about your brown eyes, which now reflect blurry love. Suddenly you have a plan, too. You will be the girl in his songs. That job will require you simply to show up and satisfy his needs. This is easy, because you've never really discovered any of your own. But showing up is something you've mastered.

★ When Linda gives you a look that says *your fucking ride's leaving,* say goodbye and promise to see him tomorrow. Be careful to keep the word "curfew" out of your new rock vernacular.

★ When the new doorman questions the veracity of your fake ID, say *I'm with the band.* Demand that he get Dale; Dale is expecting you. Dale

"IT SEEMS TO ME THAT S&M IS ABOUT TWO THINGS: BEING BRAVE ENOUGH TO PLAY WITH POWER AND REALIZE IT'S MOVEABLE AND MALLEABLE, AND ALSO THE DESIRE TO BE OVERWHELMED AND TO BE OVERWHELMING. WHICH IS NO DIFFERENT THAN ANY OTHER KIND OF SEX IF IT'S ANY GOOD."

—MAGGIE GYLLENHAAL, 2002

makes it good with the guy, then parts the sea, guiding you to a table by the stage. The drummer's wife is there. She excuses herself to check with the babysitter, respray her crimped hair, and shove cheap coke up her French-Canadian nose. Swear that she and the drummer are brother and sister. Dale kisses you fiercely, gratefully, expertly, draping his skinny tattooed arm around your bare shoulders like an owner. Feel marvelous to belong to something. For the first time in your life, feel proud of yourself and the things you do and the people you know.

★ Stack your spare cans on Friday morning to accommodate your new lifestyle. Find it difficult to remember the last time you made it to afternoon gym and drama. Realize that being in a classroom Monday to Thursday is like living between concrete brackets. Exist only for Thursday, Friday, and Ladies Nites when Dale's on stage, when you can finally, fully look at him. Imagine how you would fit into his big life, which is sure to get bigger than this tavern. Between sets, when Dale sits with you, he eats up all the oxygen. Find it hard to breathe, which has something to do with the fact that his mouth is constantly smothering yours and the broom closet in the backstage area of the Riv is only big enough to do it standing up. Enjoy the furtive sex, but prefer this open-air affection, when everyone in the room is reminded of who you really are.

★ Act positive that at some time or another you probably told Dale pretty much exactly how old it is that you were, or maybe that it never really came up. And whose fault is that? Try to remember the last time Dale ever asked you questions about yourself. Fucker doesn't even know your last name. Fucker never bought you a burger or phoned you at home. True, you told him not to, but fucker only ever *really* expected you to show up where he was playing, and to sit your sweet ass down on the vinyl chairs to watch. He didn't know about your strep throat or that your mom's been crying more than usual. Fucker didn't even write that song about your eyes, which are now brimming over with Great Lash Ebony and Alice Coopering down your Maybelline cheeks. You want to be in a song, but not this song. The last thing you ever wanted to be was the girl who bawls drunkenly in public washrooms because no one ever writes about her. Unless they're punk. And that's not your bag yet.

★ Be fashionably late when Soldier, Stripes, and The Look are playing the RockFest bandshell. Know almost everyone there. The drummer's wife, who is smoking and teetering on her heels in the rain, lets you into the backstage area behind the Port-a-Pottys. Fail to spot Dale, but catch a

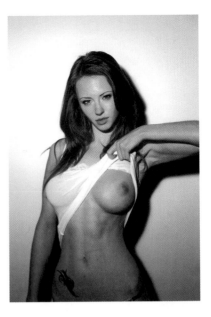

glimpse of Angelo from Soldier. He sees you too. Feel his big hug as he pulls you into his skinny body and fat bulge. Hear him tell you it's good to see you, that he's heard about you and Dale. He tells you Dale's an asshole and his band's crap and why don't you and Linda make yourselves comfortable on the picnic table and watch their show from there. Feel the click of comfort, of belonging to a place with these people, how things seem normal again. See Dale with that redheaded bitch from the Riv, the one who always hovered near the tippy table acting like she was total friends with everyone. Don't let it bother you. She is older than you by a lot, and Dale's totally fucking welcome to her.

★ Don't give a shit when Angelo ignores you after their set, because the keyboardist doesn't. It feels like musical sluts the way the two of you wound up side by side on the least crowded picnic table. Have a deep discussion about horoscopes, dogs, and divorce, which makes you feel gorgeous about yourself. Watch as Jay Jr. circles your nipple with the mouth of his sweaty Black Label.

★ Ignore your mother when she starts in on you again as you're on your way out the fucking door. Run toward the honking until her yelling disappears in the hum of Jay's IROC-Z. At the club, smile as he whisks you past the doorman, past the crowded stage area, and into a real green room. This is where you keep other bored girls company while boys play. Some girls you know, the rest you don't really want to. Get high. Watch Jay come backstage after a set you didn't bother to watch. Be unimpressed with a few songs he wrote, all which seem a bit gay. You knew which words were coming, even before you committed the lyrics to memory. When Jay asks you to shove over on the ratty couch, get up. Someone else's ex-girlfriend drives you home in a dark-blue van.

★ Notice a guitar leaning up against the console in the upstairs hallway. It's small and used and untuned. Ask your mother whom it belongs to. She says you, if you want it. Reply that you don't know how to play guitar. Try teaching yourself something new for a change, she says. Try making up your own mind about things instead of accommodating these fucking guys who keep pulling up our goddamn driveway but never bother to come to our front fucking door, she says.

★ Laugh secretly at the guy on the cover of *How to Play Guitar in Ten Easy Steps:* a gaylord with a red, fuzzy Afro who's smiling idiotically. Hide the book in your purple satin bag, the one you made in Home Ec for which

NERVE: THE FIRST TEN YEARS / 2002 / GABRIELE

you received your first A-. Learn a song, sitting cross-legged on the bathroom vanity. It's "Leaving on a Jet Plane." Picture what it must feel like to do that. Realize you can't, because you've never been on an airplane. Consider writing a song about that very real dilemma. When your brother pounds on the bathroom door saying hurry up, that he has to use the bathroom, tell him to fuck off and use the one downstairs, because you've got the room right now. Tell him all eyes are on you, and both of them are wide fucking open.

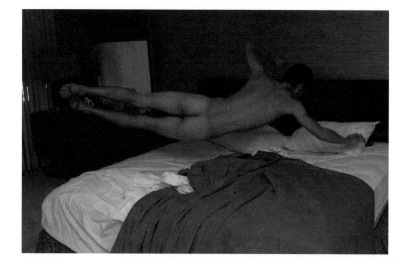

^ BRANDON HERMAN

› MIKE DOWSON

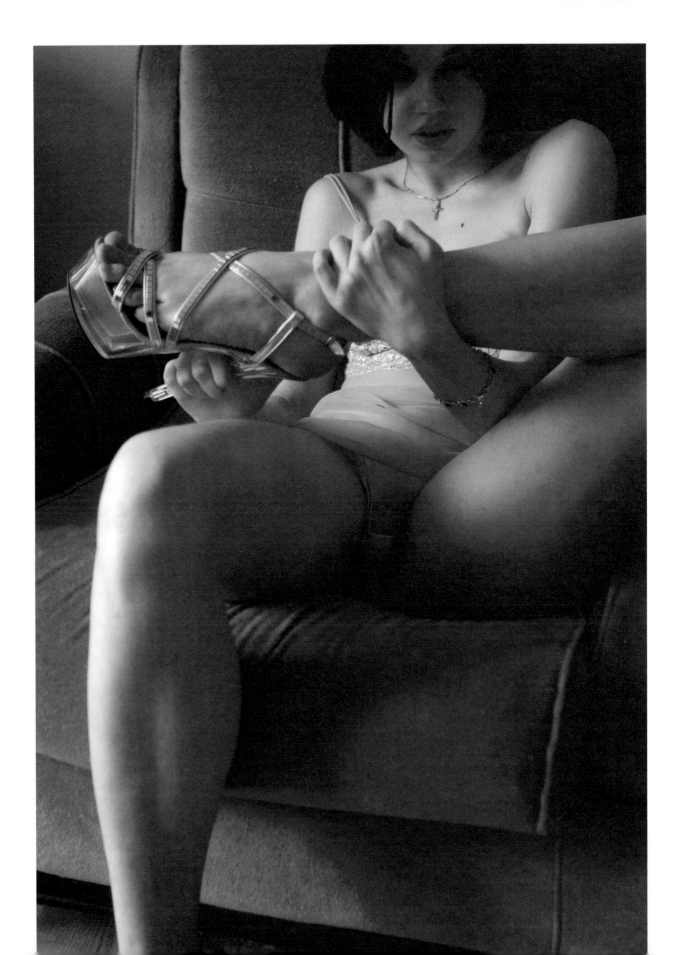

TRIALS OF A GAY-SEEMING STRAIGHT MALE

BY LEIF UELAND

I am sitting on her lap as she plays with my hair. I've got a longish late-'70s 'do, and the strands are blond and baby-fine. She runs her fingers through them, massages my scalp.

She is a beautiful girl, probably 16, with white poreless skin, full eyebrows, a disarming stare, and the naturally red lips for which Snow White was famed. At our performing arts school, run by a renowned theater in the Midwest, we wear black karate pants and gray T-shirts with a bluebird on the front, but she has cut a small V in the neck of her shirt. It's thanks to the V and the way her arms are raised to work on my scalp and the angle at which she is holding my head and the fact that she isn't wearing a bra that I can see her breasts, study them, without worrying that I'll be caught.

Her voice is smoker-gravelly and she speaks with flawed grammar and an ease with profanity that to my suburban ears is very cool.

"Leif, you're not going to be one of them, are you?"

I laugh, it tickles.

"Huh? Are you? Leif? Listen to me. Promise me. You're not . . . won't . . . be gay. Promise me."

I turn back to her. Inside the shirt, her nipples have stiffened, extended.

My cheeks flush deeply, feverishly.

"I promise."

I am apparently not the straightest-seeming guy you could ever meet. I don't know what it is about me—my pierced ears and pageboy haircut, perhaps, or maybe I'm just too clean. For whatever reason, my heterosexuality is frequently called into question. It happens all of the time. A total stranger will approach me, usually in a straight bar, and say, "My friends wanted to know if you're gay or straight?" I feel like I'm in a Kafka novel as adapted for the screen by Woody Allen. How am I to respond? If I say I'm straight, isn't that exactly what George Michael used to say? And if I indicate that I am a practicing heterosexual, won't they then assume that I am headed toward an inevitable sexual epiphany, akin to the great John Cheever's? Most recently I joked, "I'm totally straight, but I can't resist sucking the occasional cock." It certainly ended the conversation.

When I told a good female friend I was writing about the topic of my misunderstood sexuality, she said without a second's hesitation, "Oh yeah, everyone thinks you're gay." To the best of my knowledge I'm straight, but the question is hurled at me so frequently that I'm beginning to think everyone knows something I don't.

Sometimes, if there's a point, I'm willing to go along and play gay. Last summer, I was doing research in a Carnegie library in a small Midwestern town,

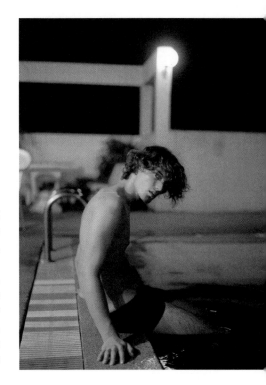

^ OHM PHANPHIROJ

a place best known for hosting the national lumberjack championships, when I noticed an adolescent boy between rows of books fixating on me. Taking in his delicate features, ivory skin, and black clothes, I thought to myself, "Town loner, doesn't yet know he's gay, feels a connection with the effeminate stranger."

Not wanting to interrupt my work, I was relieved when he disappeared. Fifteen minutes later, though, he was back and bearing a gift. Blushing to his ears, he presented me with a scalding café latté from the town's new and only gourmet coffee joint. There was no point in explaining the misunderstanding, so while I drank the coffee, we cryptically discussed the difficulties of being different, talked around the terrifying subject. Gay-and-understanding-me encouraged him to hang on until 18 and then get the hell out of town.

Until being sworn to heterosexuality by that suburban Snow White, the possibility that I might be gay never even occurred to me. I'd always had girl-friends—from the vixen in first grade who, after some discussion, let me go so far as kissing her index finger, to the girlfriend in seventh grade who sanctioned a visit to "second base." I spent more time wondering if I was a vampire.

Only in high school, when a trusted older friend and homosexual told me, "One morning you just wake up and you know," did I start to suspect that homosexuality was not a question of choice. This was an explosive, frightening thought, with one unavoidable implication: I might be gay! Me, the kid with all the girlfriends, the reacher of second base, the suburbanite with loving parents and a great family, I might be, I might . . .

That was the beginning of a lot of adolescent soul-searching. But even now when I replay every kiss, grope, or penetration of my first thirty-two years, all I see are females. Even leafing through the scrims behind my count-less solo sexual efforts, I only come up with women, just one depraved fantasy after another. Granted, throw dreams into the mix and we may have something there; I am willing to concede that I may have had a handful in which it sud-denly dawned on me, "Hey, that's no woman, that's the guy who fixes my car!" just as I would have to admit there have been relatives, minors, family pets, inanimate objects, and a brief but very kinky cameo by a genderless character who called himself Satan.

The doubting continued until one morning in tenth grade when I woke up soaking in what I initially misdiagnosed as a bed-wetting relapse. As the dream came back to me I felt something akin to what Zora Neale Hurston described as the pride of finding a first pubic hair when I realized that though the vision had not been Farrah, it was a woman, and a relief on so many levels.

Finally, at 17, I had a serious girlfriend. Fellow neophytes, we would fall deeply, crazily in love, lose our virginity together, and be a couple for the next seven years. Like all males, I couldn't wait to tell my friends after the first time, and was thankful that the issue was apparently settled, but mostly I was just

"AMERICANS ARE REALLY UPTIGHT ABOUT 'CUNT.' IN ENGLAND, YOU CAN SAY, 'OH, WHAT A SILLY CUNT.' IT'S A FRIENDLY TERM."

—MALCOLM MCDOWELL, 2002

overwhelmed by the power of emotional and physical love that converged when I was with her. It seemed it would vaporize me. I have to think that those feelings at least make me bi.

To be frank, I am sick to death of this topic. I have been suppressing my homosexuality for so long it cuts too close to the bone. Just kidding! The fact is, I don't particularly mind that what everyone's really trying to say is, "Leif, you are a gay man in denial." What drives me crazy is that they say these things with an air of not having their own secrets, aspects of their own sexuality that don't conform to whatever the cookie-cutter conception of normal sex is.

I feel a strong bond with my fellow gay-seeming straight males. I especially treasure the virtual queens who exhibit the mating habits of the Homo sapien heterosexual. Strange as it may seem, there is such a category. I'm tempted to propose we all start a club or a support group and print up T-shirts that scream, I LOVE THE VAGINA EXPERIENCE!

I prize my gay-seeming straight male friends so much that when one of them crosses over to gay-seeming gay male, as not infrequently happens, I go through a little mourning, realizing as I do that they have just made it a little harder for the world to buy my sexuality. Most recently it was an old college friend. Talk about gay-seeming—tall, handsome, former male model, voice well-suited for the fading matriarch of a clan in a Tennessee Williams play. . . . He announced recently that he was divorcing his wife and was not, in fact, straight. In hindsight, there was always something forced about his collegiate stories of female conquest, like a teenage boy feigning enthusiasm for the taste of beer. I think I wanted to believe almost as much as he did.

I feel the same way about the other side: straight-seeming gay males. I sometimes go to a dance club where they are everywhere—young guys I could swear were straight, except for the fact that they are all kissing each other. A woman I'd brought once cut in on such a couple and started making out with one of the guys. He took a pause and said, "You know I'm gay, right?" To which she responded, "Of course."

The shocking thing is that I think of myself and all my mixed-signal comrades as the normal ones. I wonder about everyone else, all the people who seem compelled to keep their mannerisms, interests, and selves marching in step with the mores expected of their sexuality. How scary is that? And to be honest, I harbor the sneaking suspicion that my team represents the future, when the masses, including homosexuals, come to honestly accept the full range of sexual nuance.

In the meantime, I think I know what might help. There's a scene in a movie, or perhaps it was a comedic sketch, where the obviously gay character is accused of being gay. He nervously laughs, "Well, well . . . if I'm gay, well, they're going to have to change the definition." Maybe what my people need is a

new definition, a nice user-friendly label. Something that says, "not gay, but not straight in the way to which you're accustomed, and maybe not even willing to rule out the possibility of being gay in the future." I've been using "gay-seeming straight male," but since that's unwieldy, perhaps we could go with the abbreviation: GSSM. I guess that would be pronounced "jism," as in "No, I'm not gay, but I am jism." On second thought, maybe labels are not the answer.

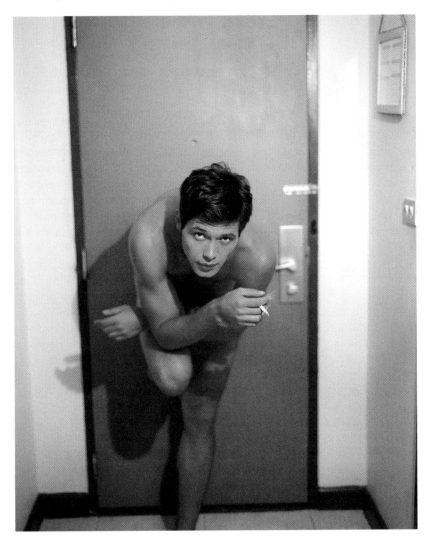

^ OHM PHANPHIROJ

SEX ADVICE FROM . . .
. . . COWBOYS

What sex tips can city guys learn from the men of the West?
Mostly manners. Some real fuckin', probably. I can't say for sure.

What's a no-fail seduction line?
Tell 'em you got a big truck and a big dick.

What should men do to make sure they last all night?
Don't drink too much, and don't drink too little.

Where's the best place to have sex outdoors?
Anywheres no one can see you.

What's the best way to initate a threesome?
Buy 'em some drugs.

A male friend of mine is having a hard time making his girlfriend come. What would you suggest to him?
Try lickin' her a little longer, she'll come a lot quicker.

What's the best way for a man to maintain his virility?
Exercise.

Would you be cool with bending over and getting fucked by a woman wearing a strap-on dildo?
Not in the least. I'd take the knife from my boot and cut the motherfucker off.

NERVE: THE FIRST TEN YEARS / 2002 / UELAND

HOW TO DATE YOUR WIFE

AFTER SEVEN YEARS OF MARRIAGE, SEX ISN'T THE PROBLEM—GETTING TO IT IS.

Hi Em & Lo,
I've been married for almost seven years now. My wife and I are coming out of a protracted rough spot (mostly parallel living). I don't think that new ideas for sex are the answer. Just getting to the sex is our sticking point. I think what I need to do is start wooing my wife again, but I'm so far out of the dating scene that I don't even know where to start. So I want to know, what nonsexual acts make you feel special? Loved? (Note: We have two adorable children and the discretionary income of an unsyndicated columnist.)
—Lo on Money but Not Lo on Love

Dear Husband of the Year,
Consider our heartstrings sufficiently pulled. With one short note you've reduced us to sniveling girly-girls who believe in the power of love, happy endings, and Shirley MacLaine movies. How could we not answer your letter? You make us want to be better people . . . you jump, we jump . . . you had us at "Hi Em & Lo."

So let's break it down, shall we?

Pencil Her In: The first thing you must do is plan time to be together, away from the kids. Planning, and sticking to the plan, is key—even if it means giving the kids a TV dinner every now and then (don't worry, they'll turn out just fine). Make dates to do datey things. Get dressed up, get sexy for each other. Wear that outfit you know she loves you in, or buy something you know she'll love on you. Replace your ratty boxers (or go commando). Think back on an early date you had and use that as inspiration for a new date: Relive that night, re-rent that movie, revisit places with fond memories (or just places where you did it really dirty). If you can't get a babysitter, then cook her a meal and rent a video. Fondue makers are pretty afford-able these days—we don't know why, but there's something inherently romantic and sexy about dipping a chunk of food on a long stick into a vat of hot liquid. Play hooky from work together and go to a museum (less crowded on weekdays), see a matinee (discounted tickets), or rent a Motel 6 room for a "nooner" (it's cheap and naughty). If you can't or don't want to go camping for a whole weekend, just get a tent and sleep in the backyard or on the apartment roof for a change

of scenery and some privacy (why should the kids have all the sleep-out fun?). Take up a hobby together: ballroom dancing, bingo, or basket weaving. On second thought, just stick with the dancing.

The Art of Woo: Write love letters and lust notes, whether it's via email, voicemail, or potpourri-scented handmade stationery. Leave billets-doux under the pillow for her to find after you've left the house for work or to run errands. Pinch lines from great poets and writers—Bartlett's is a good source for inspiration. Write her a song. If you're not musically inclined, then take her out to a karaoke bar and croon her a love song. (If she embarrasses easily, get her liquored up first.)

Be Mr. Nice Guy: Never underestimate the romantic value of being a gentleman. Surprise her by showing up at her office for lunch or to walk her home. Have a bath drawn for her when she gets home, pour her a glass of wine, light some candles, check in to wash her hair and suds her back. Give unsolicited back rubs, foot rubs, all-over-body rubs—any kind of rub will do. Next time she has a big day at the office, secretly set her alarm an hour ahead so you can enjoy a leisurely breakfast together first. Or serve her breakfast in bed just because it's Saturday. Buy her flowers, or just steal some from the neighbors (when's the last time you did that? Trust us, no matter what they might claim, ladies always dig a bouquet, even an illicit one). Fix something for her—organize her closet, hang shelves, sew buttons on that nice blouse of hers she's never gotten around to mending. Get a book you know she'll love and read it aloud to her while she lies on your chest. (Avoid anything found in the Politics, Cooking, or Self-Help sections of the bookstore.)

Show Off: Be one of those goofy young couples you see on the street who annoy the hell out of most of us (but whom we all secretly envy). Make an effort to engage in more PDA—we're not talking lewd acts with lots of tongue and saliva (so tacky), just more hand holding, butt patting, ear nibbling, and tickling. Plan make-out nights where you kiss, neck, and grope over the clothes—and that's it. No sex. And pay her compliments—don't force it, but force yourself to notice those little things you're inclined to take for granted. You know, like her eyes and her boobies.

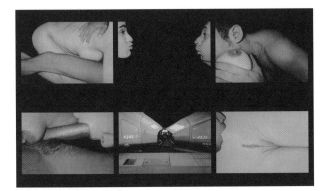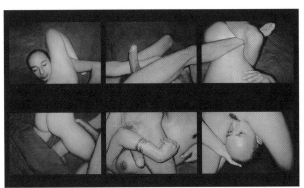

Do It Up: Romanticize the bedroom, feng shui it, *Trading Spaces*-it; paint the walls a warmer color; get softer, sexier sheets; add some throw pillows; get some cool candles and actually light them from time to time; dig up a great old picture of the two of you, take it to Kinko's to have them enlarge it into a nice print, then have it framed and hang it in your room. Or just put an old wedding snapshot on your fridge next to the kids' report cards.

Give It Up: You know that annoying habit of yours that drives her crazy but she's just learned to live with (smoking, swearing in public, biting your toenails, calling your dad "Man-tits")? Make an effort to give it up for her, in her honor. Warning: She might not notice. So subtle hints are allowed. However, if they don't result in you "getting to the sex," you are not allowed to pick up that bad habit again.

Do It One More Time: Propose all over again with a fake plastic ring or a little daisy. Renew your vows. Celebrate the anniversary of the first time you got it on—if you don't remember the exact date, chances are she doesn't either, so make one up.

Go Public: Profess your love to the world. Skywriting or placing an ad in the paper is pretty romantic, but a wee bit pricey. Call up a radio station and dedicate a song to her: It's hard to get through and a little tricky to coordinate so all parties are listening at the right time, but still worth a shot. There's something about Casey Kasem's Top 40 dedications that get us every time—it's just retro enough

not to be cheesy. Take out one of those "I saw you" ads in the backs of alternative weeklies and make sure she sees it. You know, something like: "I first saw you fifteen years ago on Delancey and immediately fell in love. I just saw you this morning beside me when I woke up and I'm still in love. Let's meet for coffee sometime." It's got all of the romance of the "Piña Colada" song and none of the weird "we almost cheated on each other" subtext. Tell you what: If you write an open love letter to your wife and send it to us, we'll publish it here in a few weeks and you can send her the URL.

Hope that helps, Romeo.

We believe in love,
EM & LO

MARY GAITSKILL

BY MICHAEL MARTIN

I lost my innocence to Mary Gaitskill; I think a lot of people did. Her first story collection, *Bad Behavior,* was full of high-concept naughtiness: women turning tricks in New York City, doing Dexedrine for days, getting spanked by the big bad boss and getting a big fat check to keep quiet. (The latter story became the film *Secretary,* which was a comparative Disney cartoon.) Her stories were told the way Debbie Harry delivered lyrics: matter-of-fact, offhand, but with sparks everywhere. Like Harry, Gaitskill's net effect was hard to process and easy to categorize. Maybe it was her openness about her past as a stripper, maybe it was her later role in discovering J. T. LeRoy, but somewhere along the line she got this reputation as the Queen of Sexual Transgression, which sells her way short. Yes, her stories were about explicit, non-PC sex, but *Behavior* was more *Catcher in the Rye* than *Catherine M*—it was about being young and doing things because you need to and you can; time has made the acts less shocking but the humanity more evident. Her second collection, *Because They Wanted To,* achieved this from the start. Its highlight is the story "Tiny, Smiling Daddy," in which a man contemplates his daughter's lesbianism while he's waiting for his wife to bring the car back from the mall. In a half-hour monologue, it becomes clear that his outrage masks an entire life's worth of betrayals.

Gaitskill's new book, *Veronica,* is her first in five years. Set in 1980s New York City, it's the story of a former model named Alison who develops a friendship with a middle-aged proofreader who was infected with AIDS by her bisexual boyfriend. It's as much about AIDS and the '80s as *Bad Behavior* is about bondage: instead, it's about friendship and loyalty and sex and power and death. The reviews have ranged from terrific to glowing, and it has been nominated for the National Book Award.

Recently, Nerve took Mary out for coffee. The thing about Mary Gaitskill is that, when you've been open about your experience with sex work and abuse, and you say things like "masochism is normal" to the *Wall Street Journal* in 1992, people try to run you down with the same narrative shortcuts you avoid so assiduously in your work, and depict you as shifty and weird. In person she's warm and very funny, and impossible to look away from.

ONE OF YOUR BIOS READS, "MARY GAITSKILL'S FICTION EXPLORES THE MEANING OF SEX IN AMERICAN LIFE. FOR GAITSKILL'S CHARACTERS, SEX REPRESENTS A DESPERATE AND UNSUCCESSFUL ATTEMPT TO BREAK OUT OF SOCIAL ISOLATION. HER FICTION OFTEN EXPLORES THE THEME OF HOW PEOPLE SEEK INTIMACY BUT DON'T KNOW HOW TO ACHIEVE IT." HOW DO YOU FEEL ABOUT THAT DESCRIPTION?

Well, that suits some of the stories I've written. It certainly doesn't suit my work overall. But those descriptions are written by people who are trying to come up with something that sounds interesting, and that's the best somebody could do.

AND WHAT'S YOUR DEFINITION OF INTIMACY?

[Laughs] Well, I know it when I feel it. Me and my husband have a joke. It's not really a joke, it's a preposterous idea. I actually shouldn't . . . well. There's this place in Rhinebeck *[New York, where she lives]* called the Omega Institute, and they have really ridiculous workshops there. We imagined one where some guru is leading one on intimacy called "Into Me See." At the end of it, people would take turns being naked and put their heads on the floor and their butts in the air and that's when you were really going to experience the reality of Into Me See.

The joke came up because we were both experiencing the yuckiness of talking about intimacy. It just seems so repulsive, the way people talk about it—it's the Holy Grail or something. You know . . . *[musically]* intimacy. The tone is always so solemn and sticky. And kind of damp, in an unpleasant way.

IN AN INTERVIEW BACK IN 1994, YOU MENTIONED YOU WERE WRITING *VERONICA*. WHY THE LONG GESTATION?

I wrote it in about a year. It was a short draft. Things were described in a very general way, instead of the way I like to describe things: sharp. If you had shown it to me and said it was the work of a 23-year-old writer, I would have thought they were brilliant, but if you told me it was the

work of a 36-year-old writer who had already written two books, I would have thought it was awful. So I would take it out and look at it every two years or so and I just didn't know what to make of it. Then I looked at it again in 2001 and something clicked. I knew exactly what I was doing, and I was somehow able to pick it up.

THE NOVEL'S ELEMENTS OF MORAL JUDGMENT AND SEXUAL GUILT ARE RELEVANT TO WHAT'S GOING ON POLITICALLY NOW.

I started it in the early '90s, when the face of AIDS was changing already. It was becoming less deadly and people were understanding it more and learning how to deal with it. But still there was that feeling of terror and judgment. When it first appeared, it was terrifying. Like a medieval plague, like nothing anyone of my generation or younger had experienced. And people really had a primitive response—there was terrible guilt, I think.

For example, I just assumed I had it. I think a lot of people did. It was like an alien, like this huge maw with teeth just appeared out of the darkened room. So that mentality very much influenced me when I was writing it at the time. When I picked it up again in 2001, things had changed quite a bit. But I thought I had to have both that mentality—the extreme fear—and the more pragmatic and understanding point of view that exists now. I wanted both of those to be present.

IN THE BOOK, ALISON, WHO'S YOUNG AND BEAU-TIFUL, STICKS WITH VERONICA, WHO'S OLDER, UGLIER, AND SICK, PARTLY BECAUSE SHE PITIES HER. PITY HAS SUCH A NEGATIVE CONNOTATION, BUT YOU SEEM TO COME OUT IN FAVOR OF IT.

I think pity, if it's genuine, is deeply felt. I mean, we're all to be pitied. We pretend that we're not. We strut around like we're a big fucking deal, but we're all to be pitied, unless we're very lucky. Some of us will drop dead rather pain-lessly or have easy deaths, but many of us will die slowly, with all the things we love stripped away from us, quite possibly alone, quite possibly in a great deal of pain, not even able to talk, shitting in our pants. I think that people,

when we're young and healthy, tend to forget that we are all on some level to be pitied, and if you have that feeling for someone, and you see their suffering, and you feel for them, that does make you more human, and it acknowl-edges their humanity.

HOW DID THE ONSET OF AIDS AFFECT YOU MEN-TALLY? YOU LIVED IN ONE OF THE EARLY EPICEN-TERS, NEW YORK CITY.

It was like everything we thought we had triumphed over came roaring back. As a teenager, I got very indignant over what I perceived as a kind of Dark Ages, supersti-tious, particularly anti-female attitude toward sexuality that was linked with death. The level of fear and awe that I saw in people of my parents' generation just seemed really ridiculous. It wasn't that I didn't know sex could be powerful, but I didn't see it as being quite such this mon-ster that they did. Gonorrhea and syphilis could be cured. If you got pregnant, you could have an abortion. One hun-dred years ago, if a girl got pregnant and she was unmar-ried, she was dead. Her choice was to become a prostitute or . . . well, that was pretty much it. If you got something like syphilis, it would kill you.

That threat went away, then AIDS happened. It was like a death figure just slammed a hammer down on everybody. Like, *Oh yeah, you thought I wasn't here?* I'm not saying that's what I really think, but it had that feel-ing to it. There was a period of ten to twenty years where you could have sex with impunity, with basically anyone you wanted, without feeling horribly ostracized—in New York anyway—without feeling like you were risking your life. That was very different than the rest of history, and sud-denly everything was changed. We thought we were living in a world that was totally remade, and it wasn't.

HOW DID LIVING THROUGH THAT TIME OF SEXUAL FREEDOM, THEN INTO THE AIDS ERA, CHANGE YOUR SEXUAL BEHAVIOR? DID IT EVOLVE OR FREEZE IN ONE SPOT?

Well, I'm in a monogamous relationship now; I've been married for four years. Frankly, this is terrible, but in my

30s and through my 40s, I didn't much think about it. If I knew I was going to be sleeping with someone, and it was a guy, I would ask him to get an AIDS test, and I would get one too. And we would do that and it would come back negative. I did use condoms sometimes, but I still often behaved like it wasn't an issue. I think a lot of people did. I wasn't a person for lots of one-night stands anyway, not since my 20s—not even then, really. It was something I did occasionally. I remember I almost had one when I was 40, and it wouldn't have occurred to me to ask the guy to put a condom on. So my behavior didn't actually change that much. Which I know is terrible, but I also know a lot of people my age were that way.

DO YOU MISS LIVING IN NEW YORK CITY?
I haven't lately. I do sometimes. It could be because I'm older; I'm not sure. It's so different now than what it used to be, even fifteen years ago. It seems like a much colder place. It's always been an ambition-driven place, but . . . maybe it's just because I was younger, but it seemed like in the '80s and the '90s, the ambitions made sense to me, or I could connect with them more. Maybe that's just because I was closer to them, but it seems colder, and definitely more about money.

HOW WERE YOU INTRODUCED TO SEX AS A CHILD?
I had very early a sense that sex was very complex and potentially violent. And I don't mean violent in a terrible way, but that it involved a very powerful clash between two people—powerful whether they were male and female or of the same gender. There's a kind of oppositional meeting taking place. I got that from watching cartoons. Mighty Mouse, Popeye and Olive Oyl. Mighty Mouse was my first crush. I thought Mighty Mouse was really virile. And he was. He was always saving some helpless female. I remember one cartoon in which he was saving a female mouse that had been hypnotized by a villain and she was singing in a high voice, "Don't You Remember Sweet Alice," and the villain had placed her on a conveyor belt that was heading toward a buzzsaw. Mighty Mouse came along at the last minute and rescued her and carried her

off, still singing. I just thought that was so erotic! And I was probably like 8.

And then on *The Three Stooges*, women were always getting shot in the butt with nail guns or something. And Olive Oyl was always having incredibly humiliating things happen to her, but being rescued by Popeye in the end, so Brutus would be put down. But it was clear that you needed Brutus. There would be no story without Brutus.

But I also did experience sex as being a really wonderful thing. When I got into puberty, it just made the world more interesting to me. I was aware of the incredible intense energy and the pleasure of it. I went through a phase when I was considered ugly. But something happened between the ages of 12 and 15. For one thing, fashions changed. It became very fashionable to be very thin and pale. To suddenly have the identity of a pretty girl was certainly preferable to the identity of an ugly girl. And suddenly the songs on the radio—which previously I couldn't relate to at all, they just sounded scary and tough and mean and I just didn't get them—at a certain point they were all about sex, and I totally understood. It was like suddenly I was on the same page as everybody else.

YOUR INTRODUCTION TO OUR FALL FICTION ISSUE TWO YEARS AGO WAS TITLED "BRING BACK THE SLUT." TODAY, IT SEEMS THAT MANY YOUNG WOMEN WRITERS—WHO ARE THE AGE YOU WERE WHEN YOU WROTE *BAD BEHAVIOR*—ARE CALLING FOR A RETURN TO A CERTAIN PRUDISHNESS. FOR EXAMPLE, IN *FEMALE CHAUVINIST PIGS*, ARIEL LEVY ARGUES THAT WOMEN ARE COPYING MEN'S IDEAS OF HOW WOMEN SHOULD BE SEXUALLY BRAZEN AND INFLICTING THAT ON OTHER WOMEN.
Yeah. I don't know what I think of that. Actually I do know what I think of that. It's kind of complicated. When people make those kinds of sweeping statements, it's some impulse to adjudicate what Women—with a capital W—should be doing. And it really so much varies. The problem for me with some of the seeming brazenness that was fashionable for a while is that it can be forced also. Because if a person doesn't feel like being brazen or doesn't want

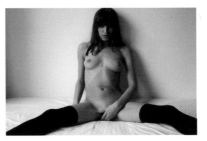

to do that, they shouldn't. I think a lot of times women who really display sexually are covering up a lot of fear. A confidently sexual person doesn't have to announce it all that much. But if it's who you are—if you love to get dressed up in the big heels and the tiny skirt and the wig and the whatever, why not? But I don't feel like that should be idealized any more than the modest, demure person. The same woman can feel both ways on different occasions.

For example, I was a stripper in my 20s, and I got naked—very naked—in front of people regularly. Yet about a year later, I was getting undressed in my bedroom at night and I saw something outside. It was a peeping tom, and it scared me. Partly because I thought that he was not simply looking, he was squatting and planning and waiting for me to go to sleep and come in. And that was not okay with me at all. And the fact that I was dancing naked a year before didn't have anything to do with it. I mean, it's all a matter of context and how you feel at the moment and who you're with. But my guess is that there will always be a need to define women in a way that we don't with men. There isn't a strong need to define what kind of man he is sexually, aside from the gay/straight question. It's something that's been true since the beginning of time.

I think the writer you're talking about, the phenomenon she's describing, and her argument against it are two sides of the same coin. The *Sex and the City* thing of, "Oh, women want sex and sex is great and women are just as horny as men and they love to watch gay porn!" . . . there's something about that that rings false to me, too. *Sex and the City* always seemed ridiculous to me. You would never have a show about men like that. It's too insistent, it's too reactive.

But I don't think there's a solution. I think some women have to find their own way of being where they'll feel the right to be very sensitive and shy and they don't want to have sex or take their clothes off and whatever, and some women will feel like ripping their clothes off and dancing around, but I think that's something people need to come to terms with individually, and I think that writing books about it and announcing that this is how people should be isn't going to do anything.

ONE OF OUR EDITORS SUMMED IT UP WELL: THEIR ARGUMENT IS THAT THE THONG EQUALS THE DEATH OF FEMINISM.
I once wrote a story that I never published, but I just looked at it again recently. It was about how in the '90s the criticisms were, "Feminism is bad because it's made women into neurasthenic asexual babies who are afraid to have intercourse!" or, "Feminism is bad because it's made women into sluts who only think about sex and don't have any sensitivity or desire for motherhood!" Whatever it was, it was feminism's fault.

ANDREW SULLIVAN PUBLISHED AN ESSAY A FEW WEEKS AGO ABOUT "THE END OF GAY CULTURE," AND ARGUES THAT THE IDEA OF GAY AS A SEPARATE IDENTITY HAS TO FADE FOR GAY MARRIAGE TO BE ACCEPTABLE TO THE MASSES. DO YOU THINK THAT'S PLAUSIBLE, AND WOULD IT BE A GOOD THING?
I still think it will be a long time before it is totally accepted by most people. I'm not sure it's a good thing. I think it depends on the person. For some people, it's really important for them to be part of the mainstream and get married and be just like everyone else—and I understand that feeling—but other people, they really don't want that. They prefer the identity of the outsider and will maintain that identity. If you had asked me ten years ago, I would have said that it was a good thing that gay culture ended because it perpetuated an idea of outsiderness that I thought was artificial. But I don't know what I think about that now. I think maybe that what I considered artificial at the time was to some people necessary.

YOU ONCE WROTE IN A BOOK REVIEW THAT YOU WEREN'T SURE WHAT MENTAL ILLNESS WAS. I THOUGHT THAT WAS INTERESTING, BECAUSE I READ IN ONE OF YOUR BIOS THAT YOU SPENT TIME IN MENTAL INSTITUTIONS.
I spent two months in a mental institution when I was 15. I know the essay you got the misinformation from, I think Ann Carson wrote it, and I don't know what her problem was. She makes it sound like it was something that

happened often over the course of ten years. Maybe she wanted to make me sound more pathetic than I ever was. Not that I haven't been pathetic at times . . .

SO WHAT'S YOUR DEFINITION? I'VE BEEN TOLD THE BASIS OF MENTAL HEALTH IS FLEXIBILITY.

That's not bad. I think I've gotten a little more conventional about it than I was when I wrote that article. I do use the term "mentally ill," and I used to avoid it, almost as a matter of principle. I used to think people got called mentally ill when other people didn't know what to make of them—they were just on a different wavelength, and if you could just look inside them, what they were doing would make a lot of sense. And that may be true—in fact, I'm sure it is true. But at some times, at a certain point, you just have to say, "This person's fucking crazy."

And I hate to say that, because I hate to subscribe to that utilitarian definition. It doesn't allow for time to slow down and look through the other person's eyes. But sometimes there isn't time, and sometimes it seems that however you slow down and how you look, you're never going to be able to connect with them anyway. But I still couldn't really define it. And I do think the diagnostic manual is mentally ill itself. It's so eager to classify so many different mental conditions as disturbed or problematic that you wonder what's left.

ABOUT THE J. T. LEROY STORY IN *NEW YORK* MAGA-ZINE. I HAD HEARD THOSE RUMORS FOR A LONG TIME, SPECIFICALLY THAT J. T. WAS SOMEONE YOU HAD CREATED.

That *I* had created? Gee, I wish I were that, uh . . . I only create people on the page, I don't have them physically walking around.

THERE WAS ALSO A RUMOR THAT HE WAS SOMEONE YOU AND DENNIS COOPER WERE COLLABORATING ON.

That is such a kooky idea. Whoever believed that, I don't think they know how to read. The three of us, Dennis, J. T., and me, we do not write at all alike. I mean, Dennis Cooper and I—it would be almost impossible for

us to collaborate, and if we did, it wouldn't come up with J. T. LeRoy.

SO IS HE REAL?

He's a real something. I'm not totally sure what he is. And I don't mean that in a bad way. I don't really know what he is or who he is. But I don't care. I like him a great deal and I think he's wonderful. I don't care if he's a hoax.

YOU WROTE A GREAT REVIEW OF THE GARBAGE ALBUM FOR THE *VOICE* IN 2001. SOMEONE SAID TO YOU, DISMISSIVELY, "OH—SHIRLEY MANSON, SHE'S JUST A SECRETARY." AND YOU WROTE, "MUSIC COULD USE MORE SECRETARIES RIGHT NOW." YOU PRAISED THE SHANGRI-LAS AS "GENERIC CON-TAINERS FOR PURE FEMALE ELECTRICITY."

That is something you don't see anymore. It seems like something that isn't possible anymore. As soon as someone emerges they're seized and groomed and controlled so much that whatever ordinariness they have is immediately obliterated or marketed so aggressively that it's not remotely anything ordinary. And I'm not necessarily, you know, a champion of the ordinary, but it's a good feeling to have in music.

HAS TIME SOFTENED YOUR VIEW OF THE FILM ADAPTATION OF *SECRETARY*?

I haven't thought about it. My reaction to it, when I saw the rough cut, I thought it was the stupidest thing I'd ever seen. But I just thought, *Well, whatever.* I felt sorry for Shainberg [the director]. I didn't feel sorry for myself. I thought, the poor son of a bitch went through so much trouble, he's never going to find a distributor, that's really sad. But then there became this whole thing with money. I didn't get paid when I was supposed to, and I was concerned that they were going to cheat me, and a lawyer told me they very well could. That was what upset me. I didn't give a fuck about anything else. I just thought, if I don't get my money, I'm going to have to kill somebody. So I didn't see it for a long time. I got paid, and as far as I was concerned that was the end of the story. Then my

sister came to visit, and she wanted to see it. It had been out for some months at that point, and we went to the theater, and I enjoyed it! It's not what I would have done, but it's kind of sweet. My actual character in the story, Debby, she would have loved it. It was too cute and ham-fisted, too "wanting to create a positive image." It wanted to make people feel good about themselves. It was so odd, because I read an interview with the screenwriter, who was sort of blathering about political correctness and how awful it was—well, the movie is the epitome of political correctness! *It was a positive statement about people who are into S&M, and those who don't understand.* Which

I find icky. But bottom line, it's great to have a movie of your work no matter what; it's a no-lose situation.

Have you ever read what Nabokov said, that Chekhov wrote sad stories for humorous people, and in order to understand their humor you have to understand their sadness, because they're connected? People don't get that now. To me, *Secretary* was a sad story for humorous people. It's actually very funny. But you have to feel the pain of it before you can laugh at it. I think you can certainly like the movie and like the story too, but I think a lot of people whom the movie would appeal to would not understand that.

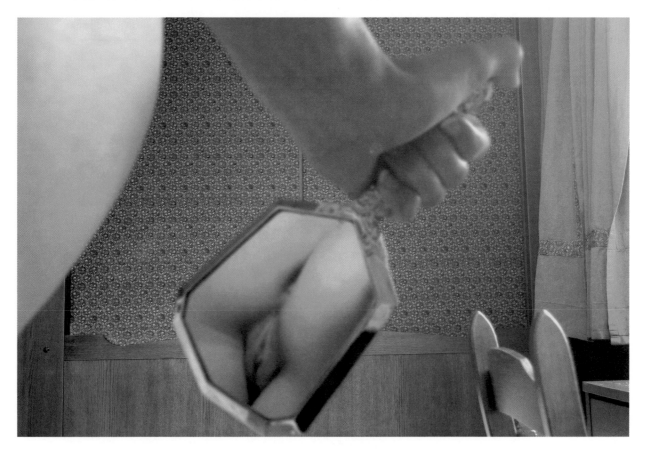

▲ PETER FRANCK

MY BEST FRIEND'S GIRLFRIEND

BY SAM LIPSYTE

It wasn't what you'd call a four-way. It was more like a two-by-four. It was high school in New Jersey, and whatever that means to you. We were parked in my Dodge Dart up on some hillock,

some ridge, some parking lot precipice, one of those places people go when they have to have their happiness in cars.

It was my senior year, and what that meant to me was I was finally getting out of here, this goddamn town, where everyone was so narrow-minded and small-hearted, where the purpose of life was to crush the life out of you. Later, of course, I realized I was the one who was narrow-minded and small-hearted, but how could I know that then? That's what the crushing's for.

Anyway, we were parked up there on make-out monticule, humper's hill, whatever it was called. It was me and my girlfriend in the front seat, my best friend and his girlfriend in the back. We had the radio on and I'm sure some by-now-resuscitated pop monstrosity was pumping through the speakers, drowning out our grunts, our sighs. Everything was going swimmingly except for one hitch: I wanted the other girlfriend, and I knew she wanted me.

See, my girlfriend was sweet and smart and sexy. I'm sure she still is. My best friend was sweet and smart and had good pot. I'm sure he still does. But his girlfriend, the one in the back seat, she was the one I wanted, the one I used to conjure whenever I did my bedroom conjuring act with hair gel, a tube sock. I'd been lusting after her a long time. Sometimes, I was certain, she sent me little lusting looks, too—not come hithers, maybe, but not get losts, either. My girlfriend sat behind her in homeroom, so all these looks, they got complicated sometimes.

Plus, she was my best friend's girlfriend. There is a by-now-resuscitated musical ode to this predicament, this precipice, isn't there? I was small-hearted, but not that small-hearted. I tried to leave all these thoughts behind in the tube sock under my bed, concentrate on this sweet girl in my arms.

Making out is one thing, but the first time you have sex in front of other people (assuming there is a first time), or at least in the vicinity of other people, with only a torn-up car seat between your coupling and, say, another coupling, a strange thing occurs. Something goes dead inside of you. Then something comes alive. Maybe some odd exchange has taken place between different kinds of holiness. Or maybe it's just that things have gotten really complicated.

Here I was on top of my girlfriend, inside of my girlfriend, us rocking gently together now. I heard these breathy woman-y moans from the other side of the seat. I glanced over my shoulder and saw my best friend's girlfriend with her head thrown back, her shoulders rolling as she rode my best friend.

I was going to come.

Go ahead, say I was going to come because I really wanted to fuck my best friend. Probably, but not that night. That night I wanted only her, even if it could only be a little part of her, even just a little symbolic part of her.

"I'm going to come," I said.

My best friend's girlfriend moaned and nodded to me. Come hither, come hither. I put out my hand and she took it, our fingers laced together near the headrest. We came at the same time.

A year later my now ex-girlfriend phoned me out of the blue to tell me what a shit I was. Shrink's orders.

"You're right, you're right," I said.

This was about the time I'd finally gotten together with the other girl. She was beautiful as ever. We got too drunk and I spent the night pulling on my softness, apologizing.

I run into my ex-best friend every once in a while. He doesn't need a shrink to know I'm a shit. I want to ask him if he saw me holding his girlfriend's hand that night, and if anything changed for him, if anything went dead or alive or if any holiness was exchanged, if he's been feeling the long crushing, too, but we'd need good pot for all that. We'd have to still be friends.

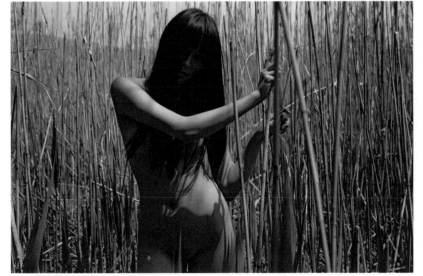

^ MARC BAPTISTE

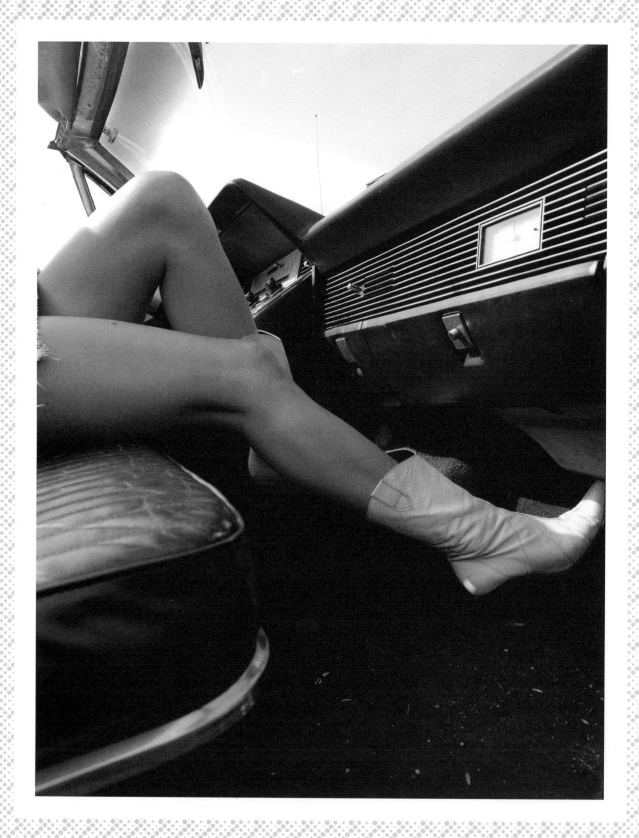

2003

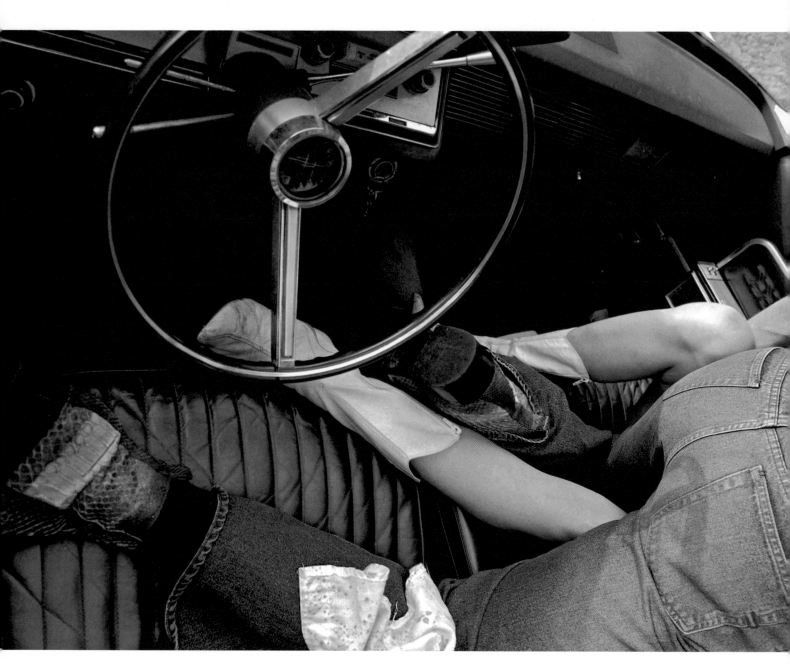

PHOTOGRAPHY BY
GLENN GLASSER

A car is meant to hurtle assertively down a highway, to envelop its passengers in the silent, protective nowhereness of travel. When appropriated for sex, it's very much a third partner. Glasser's close-cropped shots emphasize this insularity. In my favorite, she's going down on him. He's kneeling on the seat, feet braced against the dash-board, sun-flap folded up so as not to hit his back, and they just belong there. In the foreground, the shot opens up, and it's like you too are cradled in those deep seats, that charged space. It's like the right kind of drive—road open, music on, everything moving and perfect. You never want to get where you're going. —CARRIE HILL WILNER

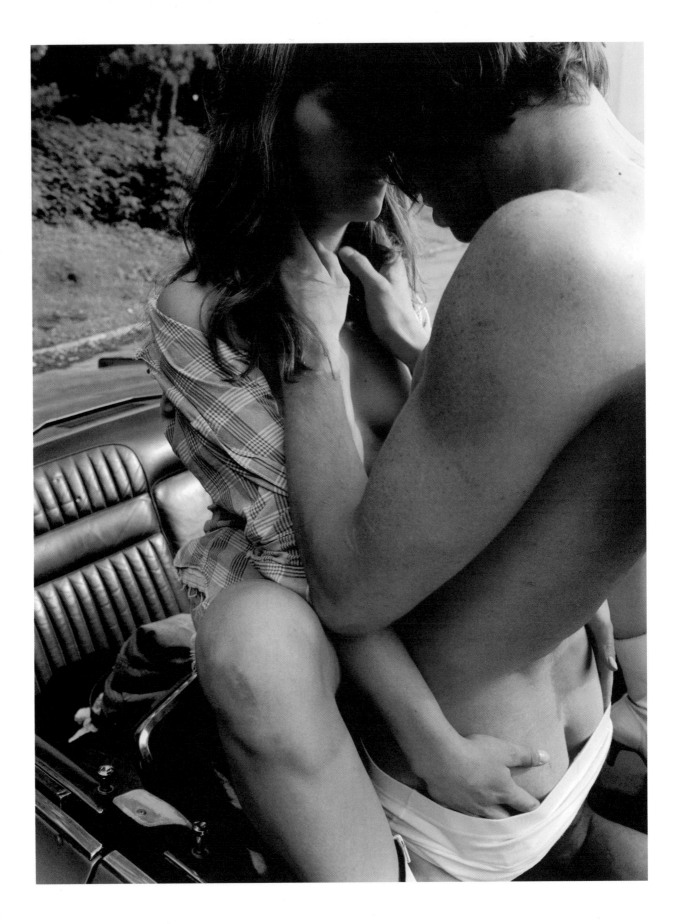

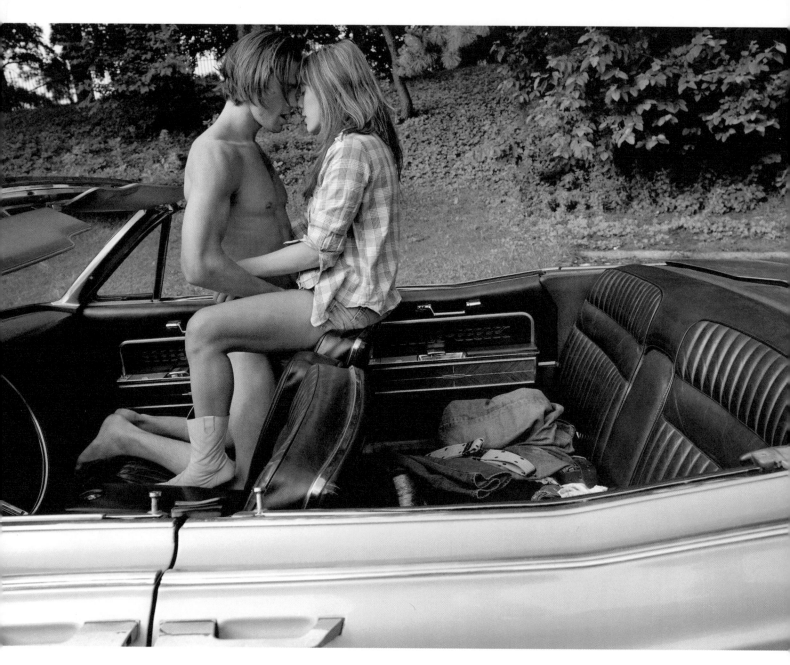

^ > GLENN GLASSER

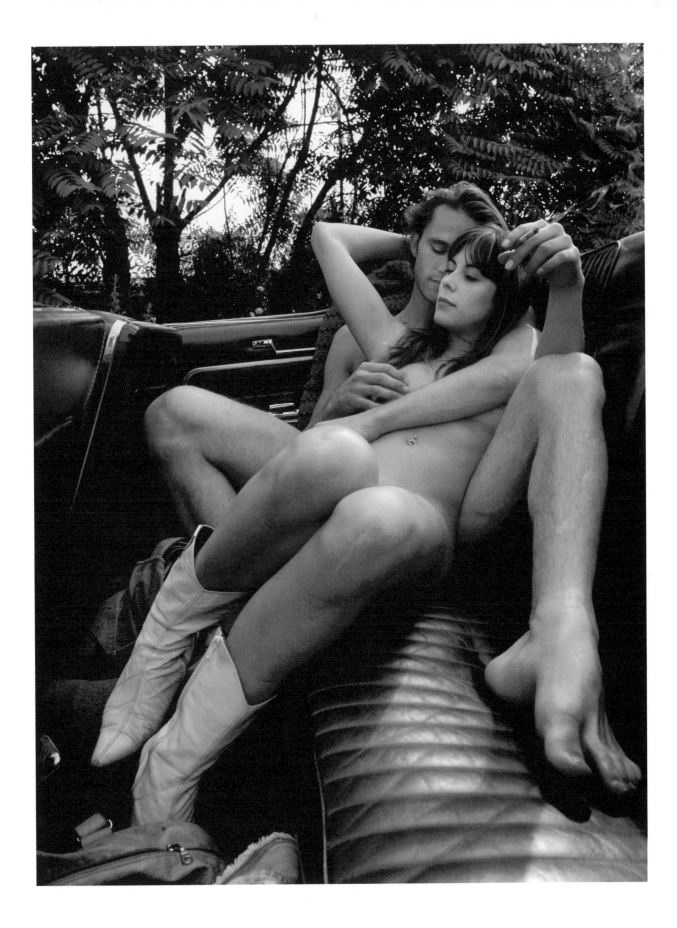

THIRTEEN ONE-NIGHT STANDS

BY LISA GABRIELE

KEY TO SYMBOLS

&	we did it
*	we just made out
0	nothing happened
000	he had three nipples
=	we only slept together, like babies
+	it was great
___/	we woke up on the lounge chairs surrounded by families eating buffet
['=']	he fought robots for a living
^	it was okay
-	it was bad
(((())))	he lived in a tiny space ship for four days, with cutouts for his legs
?	weird things happened
???	I can't remember the specifics
/	I was drunk
_	I was wasted
(_)	I can't remember his name
(----)	I remember his name but am not telling you
```	he cried
)	he called me
{	he didn't call
%)	I drew clown cheeks on my brother's girlfriend's face, with lipstick, after she passed out
(*)	I gave my date a hickie on his forehead while he slept
~	he passed out sucking on my pinkie
:0	he told me he sees spirits who write things on the wall, like, "Oh my soul!"
0	I left just after the sun came up
:<	I was so embarrassed for him, I couldn't respond
$$$	he left a lot of money (American), on the night-stand of a Mexican hotel room
!!	I was shocked and hurt at first
%	but then I split it with my friend

## 1. CHAS, STUDIED HUMAN KINETICS

We met at a bar in Detroit. We knew a lot of the same people. We left to go to another party in a bad part of the city. He seemed fearless, until two black guys started to kick cans at his ankles while he was trying to open the door of his car. He said to me, "For fuck sakes, get the fuck in the fucking car!" My sister picked me up at his parents' house before sunrise.

* / ^ {

## 2. THE JANITOR

He told me he was in marketing for a large whiskey company with a famous billboard the size of an airplane facing the river. He borrowed his dad's Cadillac for what was to be my first real date. After giving in and letting me drive, he reached into the glove compartment for a mickey of peach schnapps. He put his tongue in my ear at all the red lights. I did a good job parking the car at the mall. I also practiced driving backwards, both fast and slow. When I hadn't heard from him, I called the marketing department at the whiskey company and they put me in touch with plant maintenance. I said, hello, it's me, and he hung up.

* / ~

## 3. THE OKIE

I met him at a cheesy bar in Acapulco when I was 17. He looked a lot like my boyfriend back home. I kept saying that over and over again, until he said, "Yeah, but I bet your boyfriend don't got an extra one of these."

___/ 000 & ^

## 4. GREEK WAITER AT THE STEAKHOUSE

Eight of us were celebrating a friend's birthday. After steaks, we moved to the lounge for more drinks. Our waiter joined us when he got off his shift. He told me he got married when he was 18. I told him too bad because he could've been an actor on soap operas. If his English had been better.

/ + (_) {

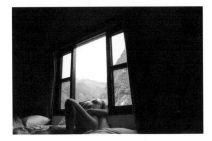

### 5. PETER, PHILOSOPHY MAJOR, THIRD HOUSE FRAT

All through university he had a perfect girlfriend who wore black leggings before they were "in." She wasn't nice, but she wasn't not nice. She got a scholarship to study French in France and was gone for a total of four months. Peter and I started to go down to the cafeteria together. That turned into going down to the pub together, then, this one Thursday after a "Crush Night" dance, back to his room. He put on Lou Reed records and asked me to hold him super tight, and not to laugh while doing it.

` ` ` = { -

### 6. TODD, PETER'S BEST FRIEND

Todd was unattractive. I was only with him to get back at Peter. Todd was studying political science and had become a committed Marxist. He kept his dorm room barren. Everyone said it was for the attention because his parents were rich. He joined the Peace Corps. Before he left, he said he'd definitely remember me when he was out in the middle of nowhere, battling black flies. Then he said, no, wait, that didn't come out right.

&&&& (we were 19).

++++ }}}} (yeesh)

### 7. THIS AUSSIE WHO BROKE INTO MY TRAILER

I was working as a waitress at a northern resort when I met him. He took me out; he drove me nuts; his accent was thick, so—I left. (Stop singing the song for this part.) I woke up in the middle of the night to him straddling me. He had a jug of Red Robin red wine and was yelling, "Lits git a paddy goring!" He broke into my trailer with my own keys, which I had forgotten, which reminded me how I needed to be more careful.

& _ + ? ??? { (_)

### 8. MURN

He was from Romania and jumped out of airplanes and into fires for his job. He was twenty years older than me and had wrinkles under his bum like a Sharpei. He smoked naked while talking about dying. He made me a paper airplane, lit it on fire, and sailed it across the room, saying, "That is going to be me one day."

& / + :<

### 9. FAMOUS AMERICAN

I was in Los Angeles for a conference—four long days. The only person I knew was this famous guy, who a friend of mine once dated. He always said, any time you're in L.A., you should call. So I did. We met on Sunset, and everybody looked at us as we walked into a restaurant. He ordered a lot of oysters and talked about his work. Because of the new smoking laws, we had to take turns going outside for a cigarette, which I was sad about because a lot of people who were walking by missed seeing me with this famous guy.

= - ` ` ` {----} {

### 10. BURNING MAN, 1997

In the middle of a windstorm this really cute guy and I climbed the highest scaffolding. The windstorm switched to a lightning storm, and this guy began to twist a piece of tin foil into a fat stick. He held it aloft because he wanted to see what it would be like to get struck by lightning. I peed my pants a little while scrambling down fast. He scared me, so I couldn't sleep with him.

{{{{}}}} {'='] "..." _ & = + ? ??? / (_) {-----} {}

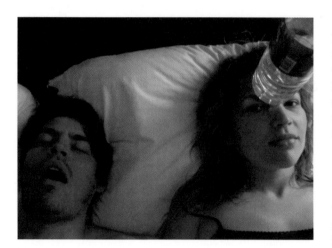

### 11. CLAUDE FROM QUEBEC CITY

I speak Spanish. So does my friend Lori. Years ago, we went to Isla Mujeres. We met these Canadians and pretended we didn't speak English. Some guy offered to sell us some Ecstasy. No one but me had cash, so I bought four tablets after the Canadians promised they would pay us in the morning. I must have quoted what they owed me in pesos, totally by accident.

&  +  ???  $$$  !!  %

### 12. LOUIS, MY HIGH SCHOOL SWEETHEART

We never had sex in grades 9 and 10. Either he was too scared, or I was too scared, but our timing was off. After I got hit in the face by a hockey puck, he stopped calling. I ran into him in the hallways at school and asked him if he still loved me. He said, "Thing is, your face freaks me out." Last winter, home for a spell, I looked him up. We had dinner. He's divorced, and his bum is bigger than mine. His daughter, 9, changed her nail polish three times a day. He was worried the fumes were getting to him.

&  -  /  :O  O

### 13. MY YOUNGER BROTHER

Both of us came home for our older brother's wedding, bringing out-of-town dates, people we'd just met. We rented adjoining motel rooms and stocked them with booze and pot for the after party. His date really hit it off with my date, both of them passing out in my bed. She was so weirdly solid, we couldn't even budge her, so I had to sleep with my brother.

O  =  %)  (*)  _

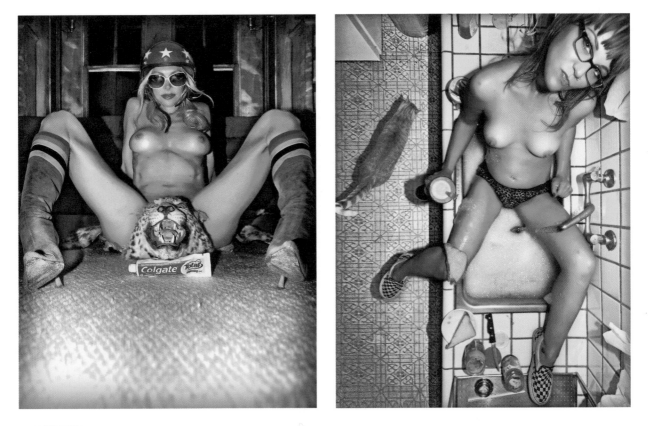

^ ^ MERKLEY???

# HOW TO WRITE SEX SCENES

BY STEVE ALMOND

Now that I am an internationally famous author celebrated for my graphic portrayals of *amour* (see "A Pervert Among Us," *New York Times Book Review,* April 2002, and "How Low Will He Go?"

*Us* magazine, January 2003), I am frequently asked how I manage to write such incredibly hot sex scenes. This usually happens at one of the many celebrity author venues I frequent, such as the Playboy Mansion Reading Room.

My general response to these inquiries is to laugh shyly and say, "Look, kid, ask Updike, he's even smuttier than me." But I must admit that the question is being asked so frequently these days, and with such delicious sycophancy, that I feel duty-bound to respond to my public somehow. Therefore, in the general interest of preventing more bad sex writing from entering the cultural jetstream, I am officially setting out this, my Twelve-Step Program for Writing Incredibly Hot Scenes:

STEP 1: NEVER COMPARE A WOMAN'S NIPPLES TO:

a) Cherries
b) Cherry pits
c) Pencil erasers
d) Frankenstein's bolts

Nipples are tricky. They come in all sorts of shapes and sizes and shades. They do not, as a rule, look like much of anything, aside from nipples. So resist making dumbshit comparisons.

Note: I am guilty of the last.

STEP 2: NEVER, EVER USE THE WORDS "PENIS" OR "VAGINA."

There is no surer way to kill the erotic buzz than to use these terms, which call to mind, my mind at least, health classes (in the best instance) and (in the worst instance) venereal disease.

As a rule, in fact, there is often no reason at all to name the genitals. Consider the following sentence:

"She wet her palm with her tongue and reached for my penis."

Now consider this alternative:

"She wet her palm with her tongue and reached for me."

Is there any real doubt as to where this particular horndoggle is reaching?

STEP 2A: RESIST THE TEMPTATION TO USE GENITAL EUPHEMISMS, UNLESS YOU ARE TRYING TO BE FUNNY.

No: Tunnel of Love, Candy Shop, Secret Garden, Pleasure Gate

Equally no: Flesh Kabob, Tube Steak, Magic Wand
Especially no: Bearded Clam, Shaft of Manhood
I could go on, but it would only be for my own amusement

### STEP 3: THEN AGAIN, SOMETIMES SEX IS FUNNY.

And if you ever saw a videotape of yourself in action, you'd agree. What an absurd arrangement. Don't be afraid to portray these comic aspects. If one of your characters, in a dire moment of passion, hits a note that sounds eerily like Celine Dion, duly note this. If another can't stay hard, allow him to use a ponytail holder for an improvised cock ring. And later on, if his daughter comes home and demands to know where her ponytail holder is, well, so be it.

### STEP 4: DO NOT ALLOW REAL PEOPLE TO TALK IN PORN CLICHÉS.

They do not say: "Give it to me, big boy."
They do not say: "Suck it, baby. That's right, all the way down."
They do not say: "Yes, deeper, harder, deeper! Oh, baby, oh Christ, yes!"
At least, they do not say these things to me.

Most of the time, real people say all kinds of weird, funny things during sex, such as, "I think I'm losing circulation" and "I've got a cramp in my foot" and "Oh, sorry!" and "Did you come already? Goddamn it!"

### STEP 5: USE ALL THE SENSES.

The cool thing about sex—aside from its being, uh, sex—is that it engages all five of our human senses. So don't ignore the more subtle cues. Give us the scents and the tastes and the sounds of the act. And stay away from the obvious ones. By which I mean that I'd take a sweet, embarrassed pussyfart over a shuddering moan any day.

You may quote me on that.

### STEP 6: DON'T OBSESS OVER THE RUDE PARTS.

Sex is inherently over the top. Just telling the reader that two (or more) people are balling will automatically direct us toward the genitals. It is your job, as an author, to direct us elsewhere, to the more inimitable secrets of the naked body. Give us the indentations on the small of a woman's back, or the minute trembling of a man's underlip.

### STEP 7: DON'T FORGET THE FOREPLAY.

It took me a few years to realize this (okay, twenty), but desire is, in the end, a lot sexier than the actual humping part. So don't make the traditional porno mistake. Don't cut from the flirtatious discussion to the gag-defying fellatio. Tease the reader a little bit. Let the drama of the seduction prime us for the action.

**THOUGHTS ON YOUR BAD SEX IN FICTION PRIZE NOMINATION? "WELL, THEY NEVER INVITE YOU TO THE FUCKING PARTY. THAT'S REALLY IRRITATING." —WILL SELF, 2003**

∧ WILLIAM HUNDLEY

NERVE: THE FIRST TEN YEARS / 2003 / ALMOND

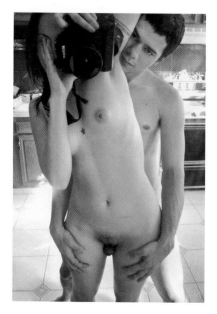

^ SARAH SMALL

### STEP 8: REMEMBER THAT FLUID IS FUN.

Sex is sticky. There's no way around this. If you want to represent the truth of the acts, you will likely be required to pay homage to the resultant wetnesses. And I'm not just talking about semen or vaginal fluid. I'm also talking sweat and saliva, which I consider to be the perfume of lovers, as well as whatever one chooses as a lubricant. (Sesame oil is my current fave, but it changes from week to week.)

### STEP 9: IT TAKES A LONG TIME TO MAKE A WOMAN COME.

I speak here from experience. So please, don't try to sell us on the notion that a man can enter a woman, elicit a shuddering moan or two, and bring her off. No sale. In fact, I'd steer clear of announcing orgasms at all. Rarely, in my experience, do men or women announce their orgasms. They simply have them. Their bodies are taken up by sensation and tossed about in various ways. Describe the tossing.

### STEP 10: REMEMBER THAT IT IS OKAY TO GET AROUSED BY YOUR OWN SEX SCENES.

In fact, it's pretty much required. Remember, part of the intent of a good sex scene is to arouse the reader. And you're not likely to do that unless you, yourself, are feeling the same delicious tremors. You should be envisioning what you're writing and—whether with one hand or two—transcribing these visions in detail.

### STEP 11: REMEMBER THAT, CONTRARY TO POPULAR BELIEF, PEOPLE THINK DURING SEX.

I know this is going to be hard for some of the men in the crowd to believe, but it's true. The body may race when it comes to sex, but the mind is also working overtime. And just what do people think about? Laundry. Bioterrorism. Old lovers. That new car ad, the one with the dwarf falling off the cliffs of Aberdeen. Sex isn't just the physical process. The thoughts that accompany the act are just as significant (more so, actually) than the gymnastics.

### STEP 12: IF YOU AIN'T PREPARED TO ROCK, DON'T ROLL.

If you don't feel comfortable writing about sex, then don't. By this, I mean writing about sex as it actually exists, in the real world, as an ecstatic, terrifying and, above all, deeply emotional process. Real sex is compelling to read about because the participants are so utterly vulnerable. We are all, when the time comes to get naked, terribly excited and frightened and hopeful and doubtful, usually at the same time. You mustn't abandon them in their time of need.

You mustn't make of them naked playthings with rubbery parts. You must love them, wholly and without shame, as they go about their human business. Because we've already got a name for sex without the emotional content: it's called pornography.

**BONUS!**
STEP 13: READ THE SONG OF SONGS.

The Song of Songs, for those of you who haven't read the Bible in a while, is a long, erotic poem that somehow got smuggled into the Old Testament. It is the single most instructive document you can read, if you want to learn how to write effectively about the nature of physical love.

I am not making this up.

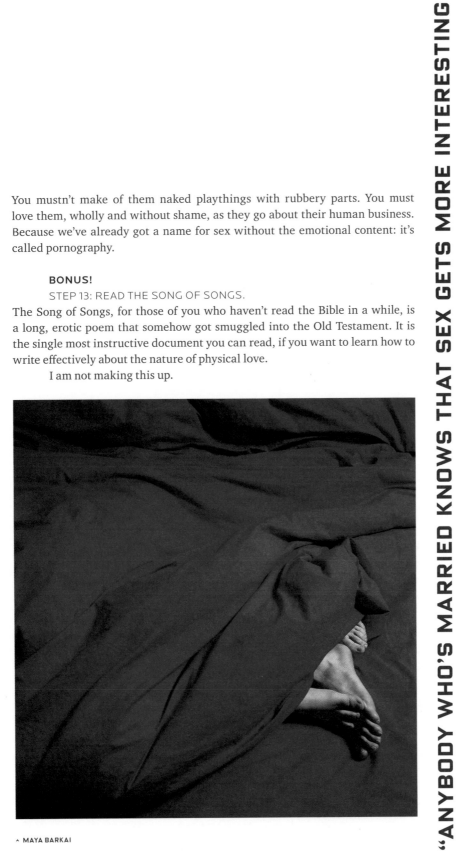

˄ MAYA BARKAI

# REQUIEM FOR A HANDJOB

BY KEVIN KECK

In all the time I've been sexually active with other people, I have achieved orgasm via the blowjob route only once. Some see this as my tragic flaw: here is a man who's obsessed with his penis,

yet he's unable to benefit from one of its great corresponding joys. Although I'm grateful for every woman who has declared, with soulful conviction, that she will be the first to fellate me with such professionalism that my head will pop off, it's just really not my cup of tea. After thirty minutes of pointless head-bobbing, a woman usually looks up from my crotch with a sigh, conceding total failure (more like annoyance, actually).

That is when I take her hand and school her in the gentle art that so many women have forgotten: how to punch the bishop.

The first time I demonstrated this technique to a girl, we were in college. She was totally offended by my inability to come from the ministrations of her mouth. When I tried to clue her in on strange concepts such as "friction" and "velocity," she barked, "Why would you want me to jerk you off? Can't you do that yourself?"

I pointed out that some men can actually blow themselves, yet it apparently doesn't abate their desire to have others do it. (I actually tried that once, after I saw it in a porn film: a guy, who was getting head from a girl, suddenly rolled onto his back and sucked himself off. This seemed like a novel idea, but I just wrenched my side and developed a keen respect for keeping semen out of a girl's eyes.) Nevertheless, I could not convince her that any guy capable of ambidextrous whacking can expound on the mystery of the difference between his left and right hand. Nor could I persuade her that when that hand belongs to someone else, it's almost as if you've rediscovered jerking off for the first time. Having failed to persuade my partner to add a new arrow to her sexual quiver, I was left to rediscover myself once again.

In graduate school, another girlfriend, Bridget, declined my request for her to stroke the Maypole on the grounds that she found it "boring." I can't fathom how a handjob is any more or less boring than giving head—at least when you're giving a handjob, you can carry on a conversation if the time is passing that tediously. Bridget argued that giving a handjob yielded her zero pleasure (though she was raised Buddhist, that whole "selfless" thing hadn't really taken hold too well). We eventually compromised: she would use a strap-on while employing a technique she charmingly called "the reach-around." It was a one-time thing. I don't love being stroked off that much.

Why is the most benign sexual encounter also one of the most difficult to come by? Years ago, I was a guest lecturer in a high-school class taught by my friend Allison. At lunch, she and I went out to her car to smoke, and we ended

up pawing one another. Since I got little action in high school, nothing was more appealing than a handjob from a teacher in the school parking lot. And of all the women I knew, Allison was the most likely to oblige, particularly because the two of us had a long-standing, unconsummated flirtation. (I was also fairly certain that Allison would oblige because she loves cock—both word and entity dominate nearly all her conversations outside the classroom.) Kissing her ear, I made my request in my most seductive tone. She recoiled from me in horror.

"That's ridiculous," she told me. "What am I? Some little dink from my class who's never seen a dick before? I'm not afraid to stare it in the face. I'm 25, for God's sake." Allison, who is actually 29, seems to have gotten part of it right. It does seem sort of juvenile for a woman to perform an act that usually occurs under a blanket, while the threat of your parents' arrival looms.

Of course, not all my partners have been so averse to "trying their hand at the slots," as one called it. I've had several relationships with women who seemed not only to like giving a handjob, they adored it. My first serious girlfriend, Cathy, said it made her feel more in control. (Although she could take this too far. In one aborted role-playing incident she said, "I'll be the vet—pretend to be a sheep that I have to collect sperm from.") Carol, whom I dated my last year in graduate school, would lie on her back and use a two-handed grip as I straddled her. She said she liked to "see it shoot." Carol, in particular, was a trouper, perhaps because she was also a virgin. If I was having trouble coming, she would stroke me until I thought a small blaze might begin in my pubic hair, only stopping to declare, "Keck, I can't take it any more—my arms are going to fall off."

That's the one truly great hurdle of the handjob: if you're not used to that activity, it can get really old, awfully fast. If my male friends have ever agreed on one thing, it's that many women beg off handjobs with the excuse that they feel more like a workout than a good time. When I stop to consider how much time I've spent laboring over my dick, doing that stupid, international motion that everyone understands, it is a wonder that I don't have the forearms of a gorilla. Or at least one forearm like a gorilla. But it doesn't take a decathlete to properly execute and appreciate one of the most underrated sexual acts in the whole erotic oeuvre. On the surface, the handjob can appear trite and prudish—the type of thing a "nice girl" might do in 1951 when you've finally given her your fraternity pin after going steady for eight months. And yet the coyness associated with it is part of the appeal. (A lesson might be learned from the Victorians, who knew a thing or two about heightening sexual pleasure by restraining themselves.) The handjob also lacks the inherent power trip that's built into the blowjob (if you're one of those people who tends to really think a lot about the rhetorical implications of what's happening to your penis).

Judging by the popularity of "facial" Web sites, I'm not the only man who hankers for a handshake. Women of the world take note: in spite of all your

NERVE: THE FIRST TEN YEARS / 2003 / KECK

## SEX ADVICE FROM . . . . . . COWBOYS

**What's the best way to coax a woman back to your place for sex?**
You just tell 'em, "I got a bigger truck than the next guy and more money."

**What's the best way to initate a threesome?**
The most important thing to remember here is that you got to take care not to make the other one jealous. Believe me, that'll happen. Oftentimes it's a recipe for disaster. Still, a lot of goddamn fun, though, I can tell you that for shit sure.

**What's a no-fail cunnilingus technique?**
Give a few minutes of the long licks. Ass to belly button. Then spread her a little wider, lick her a little quicker, making sure to keep a constant motion. Maybe dig your chin in her pussy a little bit. Make sure you shave, though.

**How would you react if a woman asked to penetrate you with a strap-on?**
Don't listen to those other guys. They'd never admit to it, but I'll bet that if a good-lookin' woman wanted to stick 'em they'd say, "What the hell?" They ain't telling you the whole truth! These motherfuckers lie all the time.

**There's the truth, and then there's the truth you wouldn't tell in front of your drinking buddies.**
Ain't that the truth!

miraculous assets, men will never lose their fascination with having a hand—preferably someone else's, because we're lazy—on Mr. Dangly. When my partner takes me in hand, gripping me like a debutante holding a squash racquet, pumping her hands furiously while she looks into my face and kisses me and talks to me—little delicious sacks of joy explode in my head like Pop Rocks in a mouthful of soda. That thrill of an unknown hand, the fact that she really is doing it all for me, carries me back to a more innocent time.

When was the last time you and your partner just made out? Where did those teenage tongues go? Don't you remember that pleasure of little muscles in moist mouths straining against one another, the days and weeks of fooling around, of getting past the embarrassment that no matter how much you practice, the bra is an elusive and clever adversary? Breasts are groped like fruit being tested for ripeness, and finally a hand strays below the waist, then retreats, then strays again . . . testing . . . testing . . . and when the zipper is finally drawn, your stamina seems to collapse under those hundreds of hours of foreplay and before you know it, your partner presses her body against yours and squeezes your cock tightly and you feel her breath and the hotness of it against your neck and ear and the hair stands up on your skin and you're waiting for her sweet words of urging and pleading, the way she'll cheer you on just like the girls in the porn movies do . . .

And then she says, "My arm is tired."

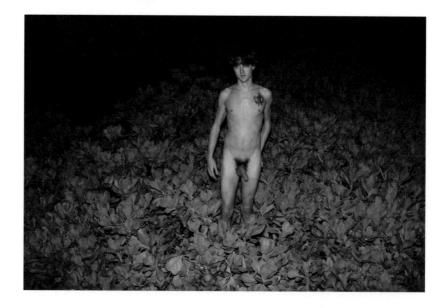

⌃ BRANDON HERMAN

# MUST BE THE MONEY SHOT

## HOW TO GIVE YOUR GIRLFRIEND AN AT-HOME FACIAL.

*Dear Em and Lo,*
*What would be the best way (if ever) to ask a woman to let you come on her face? Is there any gentlemanly way to broach the subject?*
*—Rainman*

Dear Rainman,
First off, kudos to you for spelling *come* without a "u." You obviously are a gentleman. But that doesn't mean you don't want to be a dirty bird occasionally. Facials are one of the last taboos—and taboo-busting sex is often the hottest, in that "so wrong it's right" kind of way.

However, in some cases, it's so wrong that it's just plain wrong. And you're right to assume that doing it without permission is one of those cases. Coming on a woman's face is a loaded act, like slapping her in the face (which can also be a "nice touch" in the middle of sex . . . but that's another question for another day). Projectiles aimed at one's kisser—a glass of water, a loogie, a cream pie, a fist—are rarely hallmarks of affection. They're usually thrown to insult and/or humiliate, often when there's an appreciative audience. Which reminds us of the above-the-neck money shot in porn, a genre in which women don't appear to get a lot of respect. In fact, its prevalence in porn is another reason why chicks averse to cheese aren't exactly begging for it. That, and the fact that man juice stings like a mother if you get it in your eye.

But there's a difference between porny-cheesy and porny-hot. Like eating fish eggs, it's all about context. If you're one of those guys whose mama didn't love him enough and consequently treats every woman who has the misfortune of crossing his genital path like she's a piece of meat, then the facial is a true act of degradation. But if you call your mom once a week, are in a cool relationship, and you both get off on it, then the facial is an act, period—a fun form of role-playing. If you mark your territory because you believe your girlfriend is your property, then you deserve to be evicted without notice. But if you mark the territory because you like the visual, then it's just a way to turn things up to eleven without waking the neighbors.

So how do you make sure you butter your baby's face "correctly"? First, don't assume she's doing you a favor, or that she'll have to swallow (or is that not swallow?) all her feminist pride to get you off; plenty of chicks dig it, too. Wait till the next time you're out together (so the sex isn't imminent and the pressure's off), have a glass of wine each, play a little footsie, get a little frisky, then lean in and say something like, "You're so sexy, you make me want to do dirty things. I'd really love to . . . I'd really love to . . . " Aaaargh, don't make us say it! Choose whatever euphemism you think she'll be most comfortable with. She may well ask you why you want to do it, so have an answer prepared (see the above paragraph for responses to avoid).

Or you could just wait until the next time you're in flagrante delicto. Make it part of the mid-sesh dirty talk: Everyone's more amenable to suggestion when they're in ecstasy. If you've never come anywhere but in the condom before, then consider building up to it: stomach, breasts, back, neck (a.k.a. the pearl necklace). Or simply ask her where she would like you to make your deposit.*

Once you've spilled your seed, remember these three points of etiquette: 1) For most women, ejaculate on the face becomes unsexy (not to mention chilly) exactly 5.3 seconds after the last orgasmic shudder: Be prepared with materials to help clean her up, or jump in the shower together. 2) Dude, it's on her face, so be willing to get it all over you too, especially if she hasn't come yet and is still feeling randy. 3) Nothing says "the pretend defilement ends here" quite like a good cuddle.

In your face,
**EM & LO**

**Here's the safer sex caveat: You still need to keep your snake in its latex skin if it's wriggling anywhere near Vagina Valley. And remember, semen can spread disease if it comes into contact with any mucous membrane, not just the vagina (i.e., mouth, eyes, open cuts).*

# LOVE AT FIRST BITE

## WHAT'S THE HARM OF HICKEYS?

*Dear Em and Lo,*
*What is your opinion of a hickey? Do you see a woman as a*
*slut with no self-respect when she has one? Personally, I do*
*not generally like to have them if they can be seen by the pub-*
*lic, but every now and then it gets a little rough, if you know*
*what I mean, and they just pop up.*
*—Once Bitten*

Dear O.B.,
The hickey is the sexual equivalent of a cat pissing on its
own corner of the lawn, and about as sexy as a chocolate
ice cream stain on a Calvin Klein original. Administering a
purplish-brown blood bruise (or wearing one with pride) is
a crass act of sexual braggadocio; it's a loud and obnoxious
answer to the question, "What did you get up to last night?"
that nobody asked. These broken blood vessels, which the
medical community terms *ecchymosis*, are in the same
league as mermaid tattoos, tight pants, budget-hotel kara-
oke, and going to the bathroom with the door open.

At least, that's what the anti-hickey brigade would
have you believe. Plug your ears, don't listen to their lies!
Those people have the sense of humor of a macrobiotic
yoga instructor; they can't stand to be reminded that
someone else is getting some while they're not; they've
never been swept up in the heat of the moment; and
they're probably still bitter that they never got one of their
very own in high school. You can spot the anti-hicks easily:
they're the ones who meticulously avoid any sexual activ-
ity that might get them in trouble or be considered indis-
creet—the doors are always closed, the blinds are always
down, and the noise is always kept at a level so as not to
wake the neighbors . . . or the mouse in the attic. Here's
the party; here's them pooping on it.

The passion purpura (its other, more romantic
medical term) is the scarlet letter for our generation—
and who's hotter than Hester Prynne? Without the taboo
appeal it has thanks to the anti-hickey brigade, it wouldn't
be half as fun or life-affirming. The love bite is the after-
sex glow times ten—the only thing (besides a shit-eating
grin) to give away your dirty little secrets. It's a saucy
reminder every time you look in the mirror of the lust you

recently inspired, you hot little popsicle. It's your little
bite-sized time machine that takes you back to a simpler
time, when making out was all that mattered. And it's
retro chic, just like those terrycloth shirts you used to wear
at summer camp. Then there's that popular, centuries-old
vampire fantasy—nuzzling into your luvva's pale neck for
a little life-force snack. . . . Giving or receiving a hickey is
like testing the temperature of the sadomasochism pool
with your toes: a little tickling here, a little nagging pres-
sure there, but nothing too hardcore in the pain depart-
ment. Territory-marking via a few burst blood vessels is
one more way to nudge open the doors of domination
and submission in the bedroom. Nobody wants to be
owned, literally, but it's fun to play pretend that your bod
"belongs" to another and that you've been branded by
love. And submitting to the sucking is a safe way to throw
caution to the wind in the throes of passion. Way safer
than fucking without a condom, for example—you won't
die from your average hickey,* unless you count dying
from embarrassment. You may well regret it the next day,
but that's sort of its charm—people don't blush enough
these days.

The hickey should not be administered (or accepted)
willy-nilly, however. There are rules of etiquette governing
the love bite, of which all ladies and gentlemen should be
aware. Only the hidden hickey (breast, back, shoulder, etc.)
may be given at any time and without permission, assum-
ing the person on the receiving end is thoroughly enjoying
it. The half-hidden hickey (e.g., just behind the collar) may
be administered with implicit permission. The blatantly
obvious hickey (neck!) may be planted only with explicit
permission, or when you know your victim well enough
to be sure that it won't get them fired/excommunicated/
laughed at for more than a day (and it won't get you fired
from the relationship).

If you end up the proud owner of a hickey, don't
make a big deal out of it (like a new watch you got on your
vacation and want to show off to everyone in the office).
But don't be ashamed that you're lucky enough to be get-
ting some hot, kinky sex, either. Besides, combing them
out doesn't work, so you'll have to wear blemish makeup

or a turtleneck, and who needs that in the middle of summer? Just accept it with grace and move on.

If you're a giver, please use discretion; hickeys should not be considered a "patented move," or something you absolutely need to give in order to climax, or anything weird like that. They are an occasional gift, like flowers and birthday presents. If you happen to spot one on someone else, give them the benefit of the doubt and don't be quick to judge, lest you come across as one of those uptight people who always keeps the shades down. However, it's perfectly acceptable to playfully interrogate a colleague about a blatantly obvious hickey. Half-hidden hickeys should be politely ignored by everyone except really, really close friends—the really, really close friend should feel free to ride their hickied pal's ass till the cows come home, but may choose to take the high road, because otherwise everyone will know that deep down they're just jealous.

Our bite is worse than our bark,
**EM & LO**

** We're talking about your standard hickey here; i.e., it's administered away from the genital area and no skin is broken.*

**2004**

CLAYTON JAMES CUBITT

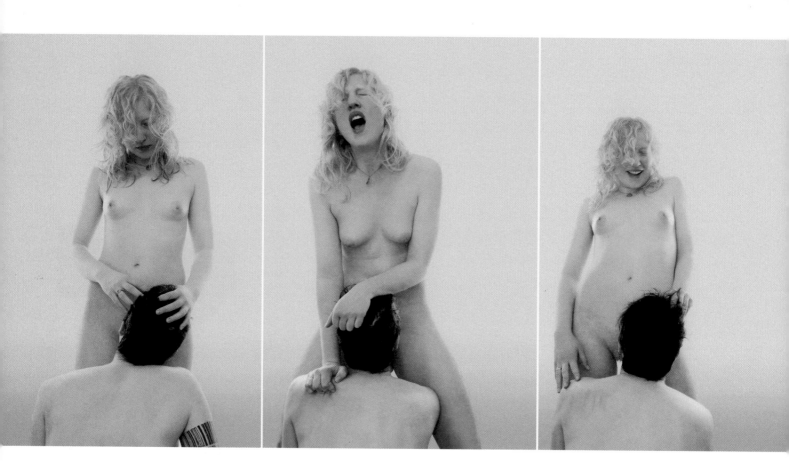

^ › CLAYTON JAMES CUBITT

PHOTOGRAPHY BY
# CLAYTON JAMES CUBITT

Single-named but multipartnered, Siege is a thirty-one-year-old photographer from Williamsburg, Brooklyn. With some colored gels, a few cameras and a harem of female friends, he created what he calls a "dreampod" in his bedroom, a comfortable space where Siege and his friends are free to express themselves sexually and artistically.

Looking at these pictures, I alternate between thinking, "These are some of the coolest images I've seen" and "I'll never be able to walk around Williamsburg again, knowing that above some Polish bakery, Siege or someone like him is getting away with murder."
—GRANT STODDARD

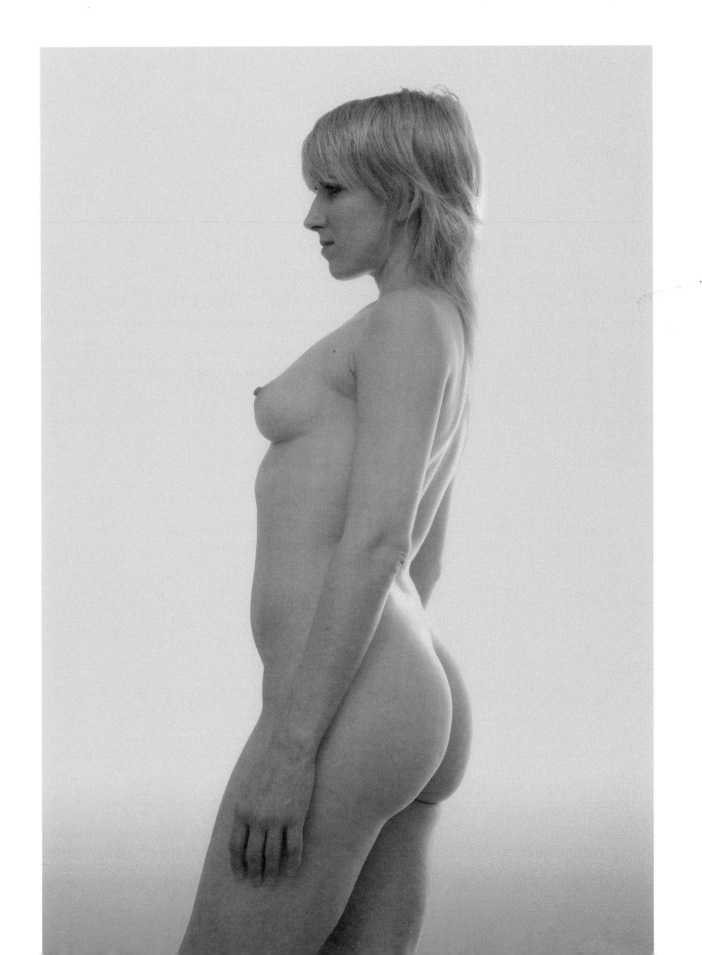

# FARMBOY RIOT

BY ALICE SEBOLD

In 1988 she looked around and realized that all her best friends, those she had contemplated the indiscretions of youth with, were dead or dying. By 1998 this event that had changed the lives of everyone she'd known seemed like ancient history in the sunny place to which she had moved.

Initially, Los Angeles had been a lark. That was what she told herself when, three weeks after Jimmy Balast's memorial service, she had agreed to ride cross-country with his younger brother. Jimmy had already been old by everyone's standards—nearly 40—when she'd met him after coming to New York to take classes at F.I.T. By the time Jimmy died most of his peers were already dead, and the memorial service was conspicuous for the number of single women shoring up the last vestiges of their coolness and straight men who had used their good looks in trade for Jimmy's professionally important nod.

Richard, Jimmy's brother, was not a designer. He was a shy, inward-turning academic who lived in Vermont and had been married until very recently to his college sweetheart.

After the memorial service she ended up near the door with him. She managed a few words about how incredible Jimmy had been when he interrupted her.

"Can you take me somewhere to get a drink?" he asked. "I've never been to New York before."

In a bar that looked more like a diner—blond wood, brass fittings, plastic ferns—they sipped at bad martinis. She felt hot in her stylish black dress, cut and sewn the weekend before. She liked to joke that mourning dresses had become her specialty.

He talked heatedly about someone he expected her to know—a man named Foucault—then realized she knew nothing about him when she asked him to write his name down on a napkin. "I will look him up," she said. "He sounds interesting."

Then there had been silence. The Muzak appeared to have bells in it. Unusual for Muzak, and they were so regular in their appearance that she began to hear them inside her head.

"Do you live near here?" he asked.

"I live five stops down on the 6 and three over on the double L."

"Oh," he said.

It was clear to both of them that they had nothing to say to one another. He knew nothing of the man she knew who was also his brother. His version of Jimmy stopped at stories of how he had always insisted on turning the waistband of his flannel-lined jeans down in high school—to show off the red plaid—or

how he had begged their mother to send all the way to Sweden for a pair of clogs when he was 13. She was expected to laugh and acknowledge that he knew his brother when he clearly didn't.

With the abatement of the bells, they were silent at the table. An offer of another round from a fresh carrot-topped waiter who could not have been too long in New York was deadly.

"Walk me to the subway," she said.

And on the walk she spied the familiar street, as she knew many of her friends—now dead or too ill to consider it—had done for years.

"Just unzip," she said.

She had grabbed his hand and led him quickly down a concrete stairwell outside the Home for the Blind. From where they stood she could see feet walking by above her head, but the angle at which they could possibly see her—she imagined—would have to be so oblique that they wouldn't gather much of what the moving object below street level was until they had walked on two or three paces. Then, she hoped, they wouldn't be the type to turn around.

"What? Here?" he asked. Lightly horrified.

"Or leave," she said, giving him the option.

He unzipped, and with a little massage he was inside her and the raw silk of her mourning dress was becoming rawer where her back pressed against the concrete.

He made rather too much of it. It was the Home for the Blind, not the deaf, after all, and soon a janitor came out to bark them back to ground level. By that time he had come in what she later thought of as his usual farmboy riot, and she had learned that he was not suited to fucking in stairwells or toilet stalls. She had not come. She didn't come a lot in those days, with friends dropping all around her like thin cavernous trees hollowed out of all previous pleasures.

But she said yes to the car trip across country because something in his farmboy riot way promised that if she were going to come, if she were going to escape, that it would only be with someone who was so far out of the milieu she had brought herself up to be a part of.

No matter how much noise he made or how wide he grinned in the silence that followed it, she never came. Not in any of the fourteen states they meandered through before they reached the Pacific.

To celebrate, she married him.

Two weeks later, unfamiliar with the brutal engineering required to drive on the freeways of Los Angeles—a sort of instinctive severing of the rational fibers of the brain—he was slammed into by a large truck bearing flats of garlic. He did not die, which was the bad news. But he would never again force her in the same way to encounter her loneliness—the dick's power-cord was severed—and this, she came to see, was the good news.

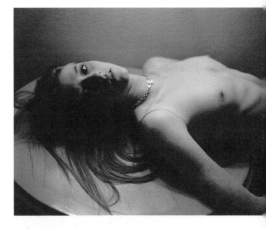

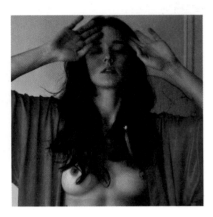

^ SAMANTHA WEST

By 1998 she had sunspots and had given up draping anything other than stretchy jersey knits with the occasional sly employment of newer techno fabrics as hidden joists and darts. Her clothes had the insubstantial quality of having seemed pulled from the junk bins, right out of Pic 'n' Save or the 99-cent store. They were the exclusive fad of exclusive celebrities and her name, abbreviated to its first syllables, began to appear in the pages of larger style magazines, attending like a bright feather or a lustrous false jewel the names of music stars that had appeared out of nowhere.

Richard was pulled out of the Canyon every so often to attend a social function. His ventilator and the noise it made both repelled and attracted clients to her business, and since he was unable to speak above a whisper, he smiled amiably as famous cleavage bent into his face to tell him how glad they were to meet him. This was the most ornate way to help him get off. The cheapest, and what occupied him day and night in a dark room in their house, was the porn he downloaded from the Internet. Occasionally, when he was loneliest, he would ask her to come and join him and she would sit beside him and place her hand on the back of his neck—where he still had feeling—while he scrolled through a new favorite series of images he had gathered while she was out late at night in West Hollywood, ripping off the impromptu street fashions of the transvestites that clung to the boulevard with the same inevitability as recurring canker sores.

Occasionally, she stripped for him. It was just the two of them and it was, besides the cleavages of the famous, the only live interaction he had with the female form. He had requests. He would ask her to turn certain ways and give her small tasks to perform on herself. Nothing that she really minded.

"Trim your pubic hair."

"Bend over and paint your toenails red."

"Face this way."

After all, he couldn't do anything about it, no matter how much he enjoyed watching her do the things he wanted. So it was something to do when she was bored or it was raining and even her muses out on Hollywood Boulevard would have sought cover or would be wearing hideous muffling layers that didn't look good on anyone. The leg-warmer pants she had tried once had summarily bombed.

And quite regularly, without being summoned, she masturbated in front of him to the soft, corrosive gasps of his trachy breathing.

At her studio one day, she got a call from Jimmy's oldest friend, whom she had met once out on Long Island, where he lived alone. Her only real feeling about this man—Lionel—had been that God had spared him by making him

too unattractive to ever get laid. He had spent fifteen years celibate by the time Jimmy introduced them and, in their world, that was his claim to fame. What he did for a living or what interests he had, she was never sure of.

"I'm calling because it may not matter, you may know all about it," he said, "but I've been led to believe over time that you may not unless you are a lot less vain than when I knew you."

"That mess is wrapped up in a load of insults," she said. "The potential antecedents could take years to track."

"Umm," he said, his breath pushing heavily against the phone.

"What are you talking about?" she asked. It was then she felt the scissors, still in her right hand. Pinking shears, the kind she had ruined over and over years ago by going from fabric to food with them. "They are not meant to cut pasta!" she could recall Jimmy snapping at her.

"This reveals a lot about me, too," he said.

She placed the pinking shears down on top of the sunny-yellow one-ply jersey that was so cheap you could run it like hose just by flicking it with a nail.

"What?"

"I saw you on the Internet."

It took her a moment and then she realized he must not have been aware of her career before. That, celibate out on Long Island, he had only recently become educated somehow that this former friend of a mutual friend was a trendy designer who was considering a bid on a glass-fronted house near the coast.

"Oh, yes," she said, "thanks." She was calculating in her head why he was calling. How could her success help him? "I'm very proud of what I've been able to achieve."

There was a pause. She felt his breath pushing against the receiver again.

"I've enjoyed it immensely."

"What?"

"What you've been able to achieve," he said. His voice had lowered a register and seemed gruffer somehow. "Letting everything show like that. A total lack of self-consciousness. It's very appealing."

"Who have you seen?" she asked. She was walking across her studio. The sun had already slanted past the awning and down the slope outside. The sky she looked out on was violet—a loveliness she could never hope to capture and slap onto the singer she was working the yellow up for.

"Why, *you*, of course," he said, his voice veering to a more regular pitch again.

"But I don't model my own designs," she said.

She heard his breath again. The rasp. And then the click of the receiver.

"IN SEXUAL CONTACT, WHICH IS USUALLY—BUT NOT EXCLUSIVELY—BETWEEN TWO PEOPLE, YOU DO RETAIN SEPARATE PEOPLE. VERY, VERY OFTEN IN MOVIE SEX YOU SEE THIS FICTION ABOUT UNITY. A UNION. AND THEN YOU CUT TO SOMEONE HAVING A CIGARETTE. AND IT'S ALL SO MUCH NOVOCAIN."

—TILDA SWINTON, 2004

Her brain was cloudy and the violet sky seemed shut off from her. The call, first a garbled sign of her own incipient fame, had become something else. What had Lionel done again?

She remembered how Jimmy and she had met. An exhibit of Judy Chicago's *The Dinner Party* had come to F.I.T. They had ended up standing on either side of it, strangers, sickened by the size and variety of vulvas in the room.

She tried to put the call out of her mind. When her unpaid assistant arrived—an inconceivably pimply fashion-boy named Jedediah—she sent him out for cigarettes and told him to take his time. The violet sky turned to highway lights against black as she tore at the yellow fabric, making so many runs in the cloth that when it was worn two days later to the MTV Awards, the young wanna-be who had commissioned it using her father's money became somebody overnight. Her nipples were radiant, peeking indiscriminately out onto the stage whenever she giggled and they shifted inside the paltry cloth.

When Jedediah returned with her cigarettes, she sent him home. She sat in her studio running bolts of yellow and began to cry for Jimmy. She had never done this, she realized. She'd been so cried out by the time his turn came that she had only draped a dress and fucked his brother.

At home she found her husband asleep in his wheelchair. On the screen of his computer was the kind of image she couldn't help but find beautiful. A black and white portrait from a series of the figure skater Katarina Witt. He had asked her to scan them onto his computer from the *Playboy* where they had first appeared. This way they became part of the library he could access himself. He could not turn the pages of a magazine, but with a muscle in his chin he could flick through nations of porn.

Once he was asleep he was hard to rouse, and useless anyway. In his paralysis she had almost forgotten the farmboy riot and the distinct feeling of loneliness afterwards. The accident had brought them closer together, and so had the porn.

Tired, her eyes puffy from crying, she lit a cigarette and began to scroll through the images. She remembered going to buy the magazine, as she went to buy them all—it was not something you could ask a homecare attendant to do—and how she had turned each page and held it up for her husband to see. He had whispered his approval and then asked her to do something, she couldn't remember what it was specifically, but she remembered enjoying it—being suspended above the dark room where they both were, just long enough to forget it.

After Witt, she clicked through the ceaseless jpegs—of the tasteful Olympians that had succumbed to more money than they had ever made as jocks, supermodels past their prime, and long-in-the-tooth former senators'

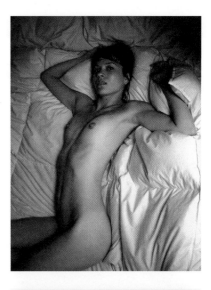

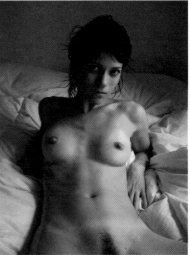

mistresses—until she reached the ones that hurt. The ones where women had ball gags in their mouths and did things with their legs and arms that even the most plastic of ingenues—the ones she designed for—were unable to do. It was here where she began to feel excited.

Always a fan of her own designs, she used one hand to unsnap her bra and could feel the pinch easily through the blue jersey fabric. She scrolled further and let her cigarette burn itself out. Small moans escaped her as she watched two girls together—ignoring their ridiculous nails and hair. Fashionable porn was still criminally rare.

"Will you take my instruction?" she heard her husband's voice whisper behind her.

"Not now," she said. She was chasing a climax by scrolling down into the caverns of images where there was more and more pain, where the aesthetics of the women themselves didn't matter anymore.

"For an image," he said, "scroll down all the way and hold the arrow down."

She did. It was like being alone in the house of your grandparents and discovering a secret drawer in a chest inside a room in which you weren't allowed. A pop-up menu expanded to the side and on it, she saw her name in capital letters.

SAMANTHA.

She clicked on it. A small shot of her face in ecstasy multiplied across the screen. He had used it as an icon for all the short clips he'd filmed.

She was jarred but she wanted it. She leaned in and cruised.

"Where?" she said.

"Try out Sam.Trim.06."

She clicked, dutifully.

And there she was, what—or a version of what—Lionel must have seen. What, she realized, as she absented herself from the room in a dark undulating crest and wave, the whole world must be somehow able to see.

She had done it. She wished she could have told Jimmy. She was a celebrity.

# A SORE SUBJECT

## WHEN YOU'RE HORNY WITH HERPES.

*Dear Em & Lo,*

*Before I picked up genital herpes from my then-girlfriend one year ago, sex was a natural part of a developing relationship. Now that's gone, and I don't know what to do.*

*I've had the herpes conversation three times now in response to a potential partner's natural desire for sex and intimacy. I have tried to be as open and honest as I can about herpes, about my feelings for my partner, and about how we can be creative about sex with a minimum of risk. But that conversation has always marked the end of the potential relationship. (Twice with a depressing passive-aggressive fadeout.)*

*I don't blame anyone, but I do feel sad that this important part of life is not working out for me. Do you have any advice for approaching intimacy with herpes or any other STD?*
*—Got Herpes*

Dear G.H.,

First of all, we'd like to give you a Golden Dildo Award for bravery and honesty in the face of danger (or, at least, in the face of temporary chastity). If only everyone felt as compelled as you clearly do to offer up the full scoop on their sexual histories. We almost didn't publish your letter in case it scared some readers into continuing to conceal an STD out of fear of loneliness (or horniness). But then we figured a virtual spanking in this column would convince them otherwise. So bend over, people: If you've got something, you gotta tell. Fucking is not a right, it's a privilege, and you've got to earn that privilege via honest communication about your bod and where it's been.

Unfortunately, honest communication isn't always the quickest route to the most sex. (Hence, so many liars . . . who will eventually get theirs in hell.) But there are ways you can approach the dreaded conversation so it doesn't feel like you're dropping a bomb on helpless Iraqi civilians (sorry—wrong column). Don't make too huge a deal about it, but don't gloss over it, either. Give her the basics—because despite the fact that this culture is soaked in sex, most people are still clueless when it comes to STDs. And don't assume just 'cause you've got

it, you know how it works across the board: do your homework so you can accurately answer any questions she might have. The National Herpes Hotline can be reached at 919-361-8488 (every operator we spoke to there was sweet as pie). The American Social Health Association has a great Web site as well. Other nice, helpful people can be found at the Planned Parenthood Federation of America (1-800-230-PLAN or www.plannedparenthood.org).

After you've dropped the mad science, explain to her the many ways in which you can reduce risk. During an outbreak, you'll keep your pants on, obviously. You'll embrace your inner sensualist and indulge in a lot of lovey-dovey hand-holding and deep eye contact. At all other times, you'll use protection. (Because for a few days each year—and there's no way to tell which days—most herpes carriers will be contagious in the absence of an outbreak. It's called asymptomatic shedding, and occurs in the area where you usually get sores.) She may be better protected by the female condom, as you could be shedding the virus from your balls, bum, etc., and the female condom offers a teeny bit more coverage. You may even choose to keep your boxer briefs on during sex so only your sheathed member is exposed—it's not official protection, but hey, it couldn't hurt. And like we once told Cockzilla: Sex doesn't always have to mean penetration—we see a lot of cunnilingus and mutual masturbation in your future.

Next, give your girlfriend space to digest the news. Point her in the direction of the resources mentioned above so she can do her own research and come to an informed decision. Remember, don't ever pressure a partner into an answer, don't tell her how she should feel about it, and don't try to sucker her into falling in love with you before you make your confession, either. However, hoping with every fiber of your being that she falls in love first is okay by us.

By the way, you might be interested to know that with more than one in five Americans infected with herpes (less than a third of whom know it because they never have outbreaks, lucky bastards), chances are at least one of those women who rejected you has already slept with a herpes carrier—either because the guy didn't know, or

didn't feel compelled to share. (Again we return to that ROT IN HELL thing.) If more people fessed up to herpes, then we'd all know a little more about it—and probably not be so freaked out. Knowledge is power, and power is sexy. Of course, you might not want to mention this when first telling your partner about your sitch—it could come across as a little defensive. ("Oh yeah? You're dumping me cause of herpes? Well, I bet all your exes were infected AND lying assholes to boot.") It's just a little something to remind you that you are among many of the totally cool and probably very good-looking people with herpes.

But the main thing to do—and excuse us while we get all Dr. Phil on your ass—is to take care of yourself, both physically and emotionally. Repressive drug therapy (see your doc) can speed recovery and lessen the severity and frequency of outbreaks, as well as possibly reducing the number of days when you're asymptomatically shedding. Boosting your immune system will also help: Take multivitamins (focusing on B complex, C, E, A, zinc, iron, calcium, and, during outbreaks, vitamin E) and lysine supplements, and avoid junk food or foods with arginine (chocolate, soda pop, nuts [especially peanuts and almonds], rice, coffee, tea). No tanning in the sun, no scratching the area (even when you've got no sores), and—here's the tricky one—no stress. Get yourself a therapist or a support group—in a couple years, herpes will not be that big a deal to you, but now, having gotten it so recently, it's the weight of the world. You deserve to have someone to vent to. And while we're loath to send people away from our Personals, you really should check out the site Meet People with Herpes (which wins the Golden Dildo for Most Unapologetic Web Site Name). Even if you don't necessarily meet the love of your life there, you can probably find consolation/empathy/advice regarding "the big talk."

And please, if any of you happen to be on the receiving end of a conversation like this, be cool about it. Honest Abes like our friend here should be rewarded for their behavior—not with unprotected genital-to-genital contact, natch, but at least with a polite, considerate, and sympathetic response. Of course, it's your right to walk

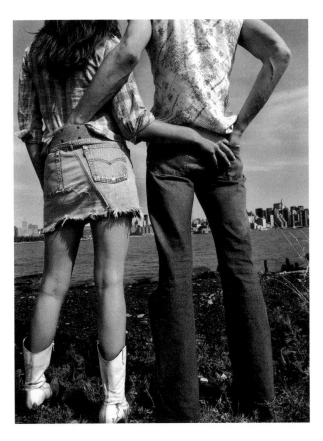

▲ GLENN GLASSER

away (just don't run). But know this: you could be turning your back on your one true soul mate and walking into a future of eternal solitude.

By the way, our first book, *The Big Bang*, has a humongo chapter on STDs, including herpes. It focuses on straightforward, practical information you can't always get from those clinic pamphlets.

Crossing guards,
**EM & LO**

# SHALLOW GAL?

## U-G-L-Y, HER BOYFRIEND'S GOT NO ALIBI.

*Dear Oracles of Sex-Related Wisdom,*
*I am in the midst of what might be termed a moral conundrum, although applying such fancy words to a form of cowardice on my part does not seem entirely kosher. Recently, to my great delight (and through the Personals, no less! Thank you, Nerve übermatchers!), I have met a 26-year-old male who has many things going for him: absolutely amazing in bed (quite cunnilingually gifted!), intelligent, and possessed of a razor-sharp wit. Of course, the reason I'm writing to you is because he is, to put it delicately, UGLY. I think I could put up with him being overweight more easily (which he isn't—he doesn't have a bad body). I cringe whenever I look at his face, even after six months of dating (though I am far from repulsed with my eyes closed), and for this reason have been too sheepish to introduce him to my friends or family. I feel horrible for using these superficial standards, but I can't bring myself to let anyone I know catch a glimpse of him. I feel like I'm going to be judged by who I'm with, and most people would classify me as waaaaaaay out of his league (I tell myself I want to protect him from rude thoughts and quips, but who am I kidding!). How can I be so physically attracted to someone whose face is so aesthetically displeasing? I'm getting more serious with him, and he has asked more than once to meet my parents, and I keep making excuses. I don't know how I should handle this, although my instinct is to keep the relationship secret. Help me get over my idiocy, please! What should I do?*
*—Shallow Gal*

Dear Shallow Gal,
If it's such an issue for you, how on earth did you end up in a six-month relationship with Funnyface? Is good cunnilingus really that hard to find? Never mind six months—how on earth did you end up in bed together the first time? Either you were wearing some serious beer goggles, or your boyfriend should take his "razor-sharp wit" to Hollywood and cash in.

Regardless of what Jedi mind tricks got you there, this is the deal on where you're at right now: It's okay not to be attracted to this man aesthetically speaking, but it's not okay to be ashamed of him. It's okay for you not to find him good-looking, but it's not okay to be so concerned with what others think. It's okay to think you're out of his league in the facial features department; it's not okay to assume that means you're out of his league in general. It's okay to judge his appearance; it's not okay to judge his worth by his appearance. It's okay to enjoy the hot sex (and his company) without wanting a serious relationship; it's not okay to let him think you want a serious relationship just to keep the good head and great jokes flowing.

Which means that if you want to be "okay" in our book, you've got to make a decision: Either you fess up to your friends and family, or you fess up to him. If you really can't stomach the awkward introductions and you're not prepared to give up on this guy—or if you kinda get off on having a secret luvver—then you're going to have to be honest with him. Not too honest, mind you—no need to tell him he jumped out of the ugly tree with a bungee cord and hit every branch on the way down . . . and up . . . and down. Rather, explain that you don't see this relationship going anywhere, or becoming any more serious. Tell him that casual dating and great sex are quite enough for you, thank you. If you say all that and he still sticks around for dinner, then you have our full permission to shag him behind closed doors/in seedy motels on desolate highways/when your roommate's out of town/in a blindfold whenever you want. You can close your eyes and picture Jake Gyllenhaal for all we care.

But we have a feeling that deep down you want to give it a shot. You're poised to be the better person—to live the feel-good romantic comedy of the season. You've obviously seen *Shallow Hal*—don't you remember the moral? What about *Shrek*? *Rudolph the Red-Nosed Reindeer*? Everyone knows the ugly duckling is your best shot at a happily-ever-after ending. At the other end of the beauty's-only-skin-deep spectrum, there's *Are You Hot*? What lessons can we glean from this car crash of a TV show? Probably that most intelligent beings would rather put a staple gun to their eyelids than be forced to hold a five-minute conversation on the situation in Iraq with any of those contestants. There's a reason why so many überhotties couldn't tell a joke or argue a point if their nose job

depended on it—they've never had to work hard to hold someone's attention, and unlike your boyfriend, they've never had to woo someone with their wit. Listen, everyone has a flaw: Your boyfriend's is his face. Your hamartia is that you're a secretly shallow, superficial scumbag. And George Clooney's? How much do you want to bet he has weird, mutant-looking balls? There's no such thing as the total package, but amazing sex, fiery chemistry, and a sparkling personality is about as close as it gets.

Anyway, there's something to be said for dating an anti–Brad Pitt who's great in the sack. It's like finding treasure stashed where no one would think to look for it, like discovering the best burger in town for three bucks at the greasy spoon, like being the only person who knows where your local library shelves all the porn. Some would even say that with your boyfriend's decreased market value, he'll be less likely to stray than more handsome (read: cockier) dudes. Or at least less likely to be hit on constantly by scavengers. And as the hot one in the relationship, you have so much more freedom than you might with an Adonis: You don't have to worry about what you look like all the time (a disorder that causes too many women to pass up a great date because they don't have the "right" outfit, or to pass up great sex because they haven't shaved their assholes that day). Being liberated from fascist beauty standards means you'll feel less inhibited, which means even better sex! You can truly be yourself—well, yourself once you drop the shallow act.

Once you've made your peace with his pizza face, you've got to deal with your friend issues. It's a little condescending to want to protect him—this is your problem, not his, especially since he's gung-ho to meet your family. And what kind of jerkfaces do you have in your life that you're so sure they'd give you a hard time about his face to yours? It's only the lame-o's who will make fun of you for being with him; the cool kids will assume he treats you exceptionally well and has an enormous *schwanzstucker*—they will think only the best of you because you're obviously not a shallow prick. At least give your friends a chance to be cool. No pre-coming-out-party qualifiers behind his back; just introduce him with a thumbs-up to give him a fighting chance. Your friends don't have to find him sexy (they're not going to be sleeping with him), they only have to enjoy his company, or at the very least, be happy for you that you've found someone who gives you explosive O's.

Maybe your friends will surprise you, and they'll welcome him with open arms. Maybe you'll surprise yourself, and realize it's not such a big deal. Or maybe he'll surprise you, and grow into a very distinguished-looking older man . . . who ends up dumping you for some 18-year-old hottie who'd beat your conceited ass in a beauty contest any day.

Looks fade, personal integrity is forever,
**EM & LO**

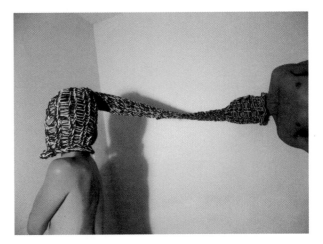

▲ WILLIAM HUNDLEY

# MIDDLE GROUND

BY ADA CALHOUN

When I was a teenager, Frank Bascombe, the 40-year-old man at the center of Richard Ford's *The Sportswriter,* was my kind of guy. He's "in the deepest depths of my worst dreaminess." So was I!

He feels "a swirling dreaminess." Hey, me too! The symptoms of dreaminess "can be a long-term interest in the weather, or a sustained soaring feeling," he says. And that's what I felt: a disoriented, *is that all there is* torpor. At 15, I was having a midlife crisis.

Young women and the Richard Ford brand of middle-aged men have an awful lot in common. Both are alone in a crowd, too smart for the room. Both feel trapped—by school on one hand, suburban obligation on the other. Both are uneasy with responsibility, newly unsure about what they want to do with their lives. And both confuse sex with love. In short, both are fantastically lonely. So is it any surprise that, in spite of progressive society's disapproval, they so often fantasize about—and even occasionally wind up with—each other?

These days, older men are not supposed to want to date young women. As we know from Demi-Ashton and *Something's Gotta Give*, when older women score young studs, a collective societal wink of approval is in order, while for men, the convertible and half-his-age girlfriend are signs of moral bankruptcy. Men dating women young enough to be their daughters is frowned upon. While it's hard to condone older men dating women who in fact are their daughters (Woody Allen), I absolutely defend Jack Nicholson's right to arm candy, not for his sake, but for the candy's.

Being the younger girlfriend isn't exactly a prison sentence. It typically involves travel and being fussed over. And, as a rule, that pretty, smooth-skinned young thing in the passenger seat isn't in it for cynical reasons. Sure, maybe sometimes it's about what people always say; he wants to stave off mortality with a wrinkle-free trophy, she wants money and power. But I think a lot of times their neuroses just happen to be in sync; sometimes they just get each other.

Throughout my life, I have known plenty of girls who wound up in various relationships across the intimacy spectrum with men twenty years older. Maybe it was socially awkward at times, but they didn't die and few of them felt then or feel now that they were being exploited.

Maybe if one of my 30-year-old male friends started fraternizing with an 18-year-old girl, I would be scandalized, but I don't think so. In any case, I certainly wouldn't question the young lady's motives. I have smart, nice friends who would have a lot of neat stuff to teach any girl who's like I was ten years ago.

Besides, even though my friends and I fraternized with older men out of a sense of adventure or friendship rather than what people always say younger

women are after—money and power—I refuse to believe that money and power are such terrible things to want. Both are in short supply when you're a teenage girl with ambition beyond the limited life to which you've been sentenced by your age. Mutual, life-improving arrangements that happen to involve one person being rich and the other being pretty certainly aren't any worse than those unglamorous couplings of similarly endowed and aged people who combine to synergistically create a perfectly healthy, fantastically boring dyad.

And healthy, boring dyads seem to be what sanctioned teen entertainment is all about. In the '80s, you had Judy Blume's training-bra classics and softcore porn like *Do You Love Me, Harvey Burns?* In the '90s, you had Francesca Lia Block's L.A. fairytales. Now, teen girls have Louise Rennison's books about the engagingly pouty heroine Georgia Nicolson (*Angus, Thongs and Full Frontal Snogging*, etc.), which, while charming, are about pretty standard stuff: fights with Mom, kissing boys, feeling ugly. Then you have Sophie Kinsella's *Shopaholic* series, pure proto-socialite drivel about a ditz who just can't stop buying accessories on credit. From the Amazon summary: "Becky's ten-month globe-trot with hubby Luke was a shopping spree disguised as a honeymoon—heck, Becky will walk across hot coals for an aquamarine necklace . . ."

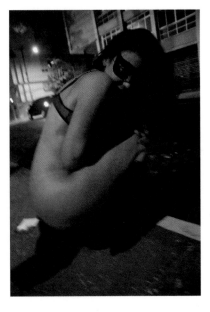

Girls: reading these books is a BIG MISTAKE. Not only is this soulless genre, with its "look how unsexy sex can be" posturing, way too shallow for a growing mind, it only expands the chasm between you and men. What one needs from a boyfriend or husband, at any age, is empathy and companionship, and the more *Women Are from Venus* bullshit one indulges in, the more difficult it is to bridge the gender gap. Whenever you're setting up human relationships as a game (*The Rules, He's Just Not That into You*) or a glamorous lifestyle choice wherein you dress up and spend most of your time talking with your girlfriends or your journal about how exasperated men make you (*Sex and the City, Bridget Jones's Diary*), you're never going to see men as fallible, mortal beings looking for understanding just like you are.

Chick-lit heroines are like the pettiest and most practical characters in a Jane Austen novel come to life, minus charm or patience. It's all frantic screwing-cute with no time for anything to steep, whereas Ford and company—they know from steeping. *Everything* is mystifying for these confused, angst-ridden heroes—even getting up in the morning, which is why these books stop being good reading once you hit your 20s and need to stop stewing and get on with things.

As a 10-year-old girl, my first cassette tapes were (and how this happened I'll never know): Huey Lewis, Phil Collins, and Weird Al. Hipper friends quickly swooped in with Depeche Mode and the Violent Femmes, but the damage was

done: from an early age, I deeply identified with the cultural output of that demographic. And after the obligatory Jane Austen and Brönte sisters phase, I got obsessed with random older male authors I found purely by chance at used bookstores (if the back cover referred to its aging hero as "tortured," my baby-sitting money was as good as spent):

Richard Ford, Tom Spanbauer, Joe Coomer, J. D. Salinger, Lewis Shiner, Philip K. Dick, Denis Johnson . . . I was smitten. I even liked Harry Crews, whose genuinely terrifying Southern Gothic books—getting tattooed when you're blackout-drunk in Alaska, accidentally killing a hawk you're trying to train, watching a cockfight—taught me everything I needed to know about the darkness of the soul. And it sure put not being invited to some cool-kids party in perspective. *Hey, I may be sitting at home alone,* I could think, *but at least I'm not an alcoholic living in a shack in the woods with a dead bird in my closet.* I just sort of wanted to date one.

As refuge from perpetually disappointing teenage boyfriends, I pined in a romantic fashion for dozens of older male authors, alive (Sam Shepard) and dead (Tolstoy). Falling for a narrator is weird. It entails a curiously absorbing sensation of wanting to simultaneously be and sleep with the person who owns the voice that's entered your head. When you already share so much intellectual bandwidth with someone, you lose yourself a little. But when your life consists of baffling social scenarios, pop quizzes, and drug experimentation, I'm not sure that's a bad thing.

Think *Lost in Translation* Bill Murray, in narrator form, whispering his frustrations into your ear while you stay up all night, thoroughly at sea in a twin bed in your parents' house. Is it any wonder I wanted nothing to do with the young-adult novels and feminist literature calculated to make me a well-adjusted young woman? Sure, I skimmed *Possessing the Secret of Joy,* but joy gets old; I was interested in other secrets—secrets like what it feels like to walk up to the door of the home where you live with your wife and children and not want to go inside.

Ultimately, I have a healthier idea of the difference between men and their books. When I interviewed Sam Shepard for *New York* magazine, he did not insist we go on a road trip immediately, but instead hung up on me after a few perfectly normal questions. At nearly 30, I'm too old for all my older men anyway. But my emotional affair with that demographic has left me less judgmental. Whenever I read a middle-aged author's overwrought piece of self-indulgent fiction, even if I don't enjoy it, I can picture my younger self reading the same story and under-standing it exactly. If my husband goes through a midlife crisis twenty years from now, I hope I'd be able to channel my teenage self and remember how to be the refuge-girlfriend rather than the wearying spouse.

The only thing *The Sportswriter*'s Frank Bascombe said that I disagreed with was this: dreaminess when you're young is pleasurable, and when you're old is not. In fact, it can be torturous for the young and pleasurable for the old; it's just a question of finding someone just as dreamy as you are to see you through. But I have no doubt that—driving around in his shiny new car, all intense longing and existential angst—Frank and I would have worked it out.

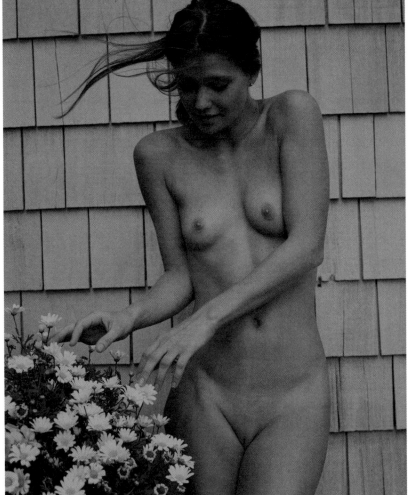

▲ MARC BAPTISTE

**"I'M NOT INTERESTED IN LOOKING AT PARIS HILTON'S VAGINA. NOTHING PERSONAL. I DON'T WISH HER ILL, BUT SHE'S NO EDIE SEDGWICK."**

—JOHN WATERS, 2004

# GOODBYE, METROSEXUAL

BY JANE ROSS

Remember when what women hated about the modern urban male was his obsession with his career? The "working late at the office guy" has been a pain in the ass forever, but was turned into a caricature of chilly ambition in the '80s, when the first generation of women bred to work hit cities. Once there, they were forced to fish from a dating pool stocked with careerist louts. There may have been perks—the cool rush of being half of a fast-moving power couple, the super-swank array of stainless-steel-juicer-toaster-microwave devices that served as evidence of success. But there was a constant whine of complaint. Whatever pleasure had come with the early flash and buzz of a relationship with a workaholic boy evaporated as soon as the relationship settled and became committed, domestic, or reproductive. Then it was the ladies who were stuck right back in the domestic sphere, while their men catapulted out of bed every morning and hit the treadmill, the juicer, the boardroom.

Well ladies, the good news is that those days are over.

New York City—home of Michael Milken, Donald Trump, and the fictional Gordon Gekko—has been taken over by a new generation of men who are decidedly not hot for work. The faded economy, coupled with distance from the anthropological notion that men are supposed to provide anything for anyone, has played havoc with expectations for vigorous masculinity. These days, a pride of twenty- and thirtysomething young lions emerge from their dens each day, stretch their sinewy backs and shoulders, give a mighty roar, nip out for a coffee, and then return to curl up and snooze for the rest of the day.

During a particularly bad moment—bad because of the economy and a painful breakup—I rebounded with an unemployed man named Jake. Jake had sped directly into the dot-com fast lane straight out of college and cruised there for about eighteen months. He'd founded a Web site that had something to do with simulcasting something, appeared in a couple of magazines about it, purchased a two-bedroom apartment in the East Village, become a nerdy little celebrity in the Web world. When the tide turned, he lost his company, his income, and his insurance. But he'd had the confidence of a guy who'd found success easily: it would surely come round again. So Jake settled in, confident that his ample savings would see him through to the next management offer.

By the time I met him, at least a year later at Bleecker Street Records, he had begun to come to terms with the fact that his unemployment was more than an extended vacation. But in many ways, he was still treating it like one, devoting himself to tasks like expanding his record collection and deejaying at his local East Village restaurant/lounge on the odd weekend night. He was learning to play guitar, had traveled to Europe with his family, and was toying with

the idea of starting a novel. His savings had dwindled, but he got by on a couple of stray bartending shifts, the rent he collected from the two squatters who'd moved into his second bedroom, and though I didn't know it when I first saw him—a string of soft-hearted, gainfully employed girlfriends.

Meet the new man. He may have been—for one brief, halcyon moment—an absurdly young master of the universe, running his own company at 21 and buying raw loft space in Williamsburg leveraged against his gajillion imaginary dollars in stock options. He may have experienced dismay and a vague sense of something grim—was it emasculation?—when the bubble popped and took with it his money and prospects for immediate employment. But now, after years of half-hearted temping, bartending, "working on his music," and possibly starting that novel, he's come to grips with his own level of inactivity. He's gotten used to the fact that he doesn't have anywhere to go during the day. He's settled in, even warmed to it.

^ BRANDON HERMAN

Jake used to tell me that his life improved dramatically after he lost his job: he had had time to learn about himself, spend time with his friends and family, tend to his own psychological and emotional health in ways he compellingly argued he'd never have gotten to if he'd kept drawing a fat paycheck. And though I gathered that his career had never been of the jacket-and-tie-power-lunch variety, I got what he was talking about and on some level, appreciated it. In New York, our definitions of selves revolve around our careers. Without jobs, men and women (but mostly men) have been forced to go deeper.

And incidentally, let's not pretend that women haven't spent portions of recent decades practically begging for men who were less, well, professional. We have had a hand in creating these monsters of lethargy. We've campaigned for male sensitivity training, prayed for guys who were more interested in the details of domesticity, who would spend more time at home. We have made public our longings for a gender scale balanced so precisely that the notion of a house-husband wouldn't be exotic and wished that there were more stay-at-home dads who could pry open a juice box and raise hell at a PTA meeting so that we wouldn't have to.

It's sort of like these guys have heard our pleas, and then wildly manipulated them for their own lazy purposes. Because for all his talk of self-knowledge and closer ties with family, it wasn't long into our relationship that I realized that Jake was mostly sitting on my couch and enjoying the take-out that I paid for every night after I got home from work. I was happy to see him of course, pleased to have a boyfriend I could count on to greet me at the door. He was always up for movies, and I never worried that he'd have to work on a weekend when I wanted to go to the zoo. But the fact that he could not afford to go anywhere else made me feel like a patron, supporting his artistic ambitions by showing up for his deejaying and talking to him about his desires and ambitions,

without really respecting him that much. Mostly, I was in it for the affection and the sex. I was dating a "himbo."

In fact, while they may be aping—and by that I mean genuinely mocking—the very qualities that women always said they wanted—an interest in life outside of work, lessened focus on material wealth, and a commitment to spending time at home—there is something curiously regressive about the behavior of these himbos. After all, the desire for all of the above qualities in a man has traditionally been linked—in our shared female imagination—with notions of commitment, and in turn with notions of maturity. We've been asking for men so sure of themselves that they do not connect their sense of worth to their stock portfolios, do not need to replace flagging penises with cars, are capable of fulfilling household responsibilities, respecting their partners' work and time, exhibiting confidence and honesty in bed, all while keeping their own identities, passions, and friendships intact. In short, what we've been asking for are grown-ups.

What we seem to have on our hands are overgrown teenagers, without the sex drive. The himbos we allow into our homes have returned to their primal age—19. You remember them—probably some of the same guys, actually—from when they were chronologically 19. They were long-limbed puppies who'd spent a year at college, where they'd discovered that food costs money and requires preparation and that clothes get gross unless you perform some elaborate and mind-bending procedure involving detergent and coins. When they came home for the summer they practically rolled over on their backs in joyous anticipation of the fact that Mom was there to take over all these jobs herself. Sure, they love Mom, and even throw a little affection her way sometimes. But mostly they sit on the couch and eat sandwiches and watch *Days of Our Lives*, secure in the knowledge that she is taking care of the details—working and providing and making sure that everything is clean and that they will have full bellies by the time their friends come over to drink beer.

Guess what—we're Mom. When I began to occasionally point out to Jake that I felt like a caretaker more than a girlfriend, he was smart enough to own up to it. He'd slap my ass and tell me to get over it. "You've got a husband to support!" he'd chide, with weirdly swaggering self-effacement.

At the time, I only half-understood that part of what he was experiencing—along with free meals and cable—was self-loathing. When the jobless period descended, a lot of these guys, like Jake, could not get it together to pound the pavement. It was humiliating. They'd been to good schools, come from comfortable homes. They'd been promised, and in some cases made, lots of money without having to do the drudge-work of dues-paying. And then—suddenly—there were no jobs? They didn't have marketable "skills"? They had to beg for counter jobs and entry-level positions? *No way, man, that's not cool,* you could hear them

muttering to themselves. *I'm a fucking artist. I'm a poet, a musician; I've run a fucking company; I've been to college; I don't need to work as a fucking consulting assistant; they can come to me with offers, I don't need to beg anyone for a job.*

So they didn't. And that's where we found them—sitting in a coffee shop or record store, thrift store clothes, tight jeans on their hollowed-out bodies. They were great. They liked the attention, flushed at the thrill of having someone want them. The thing is, most of them are really pretty, and sweet, and boyish in the way that men are before—frankly—they get ruined and made brutish by their big-dick jobs. And we—the ones who still feel impelled to drag our asses to work every day so we can get paid so we can make rent and feed ourselves—are pretty lonely. We need to get laid. We'd like some companionship. And this is what we've got to choose from. So even though we know they're expensive to keep around, even though we wonder why when they're home all day they'll never bother to cook a dinner, even though we suspect that they really aren't the brilliant guitarists we want to think they are—we still support them, still jump back in their arms when we get home at night, still curl up warm and snuggly next to them on a Saturday morning, safe in the knowledge that we don't need to go to work this morning so that, like them, we can sleep in. In some ways, no matter how aggravatingly impotent we realize these himbos are, the ultimate irony is that they've got us by the balls. In a universe drained of money and leverage and power, they can still exact a certain toll by insinuating themselves into our lives. They manage an upper hand with no cards to play, and if that's the only heady rush they get during the day, it's still pretty satisfying.

But when it comes to the sex, the resentment and power imbalances really get in the way. At first it's great. There's nookie waiting for you every time you come home—because your boyfriend never needs to be anywhere else! But at a certain point, it begins to transform. Jake was great in bed—lanky and energetic at first, eager to go down on me, to hug, touch, cuddle. It was refreshingly warm, youthfully exuberant sex. But it didn't last long. Pretty soon, he was actually going down on me way too much. It felt like he was doing his chores, rather than actually having much fun with me. And soon even that dwindled off. There was too much hugging, too much petting, too much nuzzling. Not enough fucking. It felt as though he couldn't get it up—even though that wasn't actually the problem. There was something damaged about his masculinity and it got expressed in a psychosexual way. It was as if bed was the place where he was forced to concede that I was the hunter-gatherer-breadwinner; but of course it was the place where it was most important to me that he not acknowledge it.

I eventually threw Jake out—more or less. I was passive-aggressive about it—complaining more and more about footing the bill, fretting about finances in front of him, goading him into job-hunting. He got increasingly moody, less eager to please me; I was trouble now. By the time I told him that I thought we

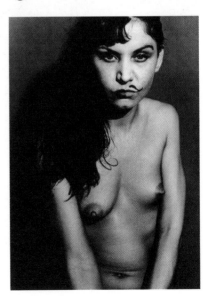

^ KATRINA DEL MAR

shouldn't see each other anymore, he had managed to make it feel as if he were rejecting me: like I was too uptight and money-obsessed for his free and easy, artistically driven vibe.

I'm sure it wasn't hard for him to rejoin the ranks of the other temporarily dispossessed himbos. He probably just slunk back into a bar or café or back into Bleecker Street Records and waited patiently for someone else to come in and adopt him.

And as for me, well, we go on, don't we? We go to work, keep our crazy schedules, pay our debts, and go long stretches without sex until the next puppy catches our eye on the subway.

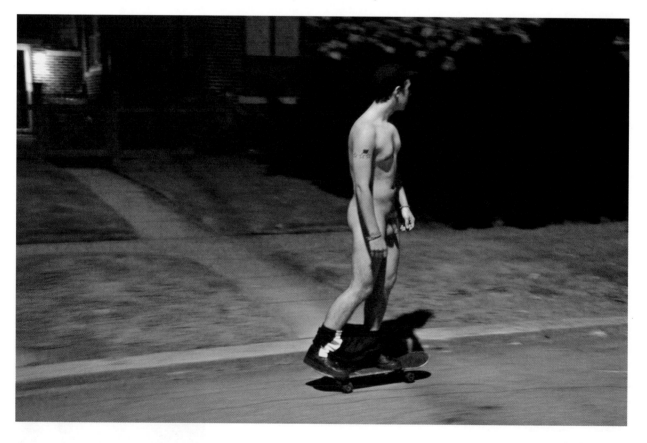

^ › BRANDON HERMAN

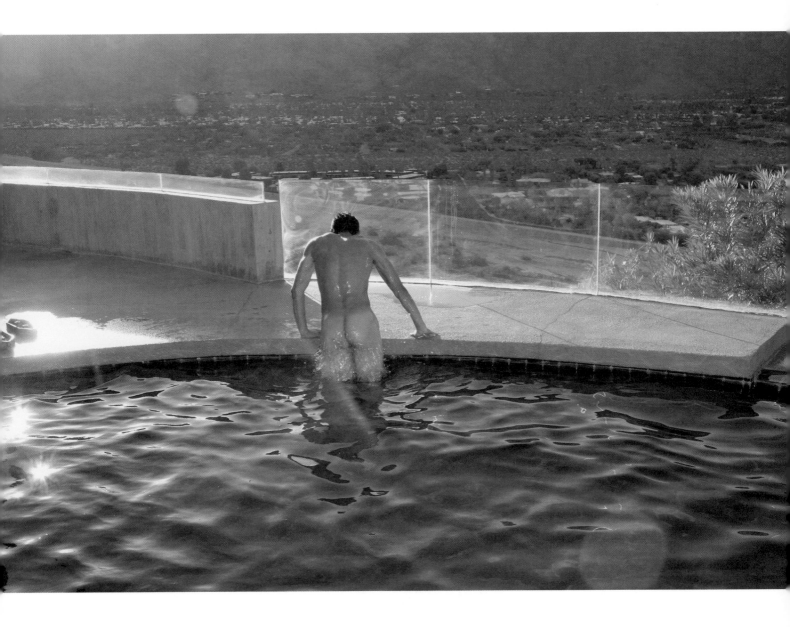

# SLAP

BY JACK MURNIGHAN

There was no blood, just a low whimper. Adumbration of tears. Guilt, my guilt. I pulled out of her and reached my stinging hand down to her pussy, looking for answers. She arched high, asking, wet to my touch.

I hit her, my girlfriend, in the face. I hit her in the face during sex. Smacked her hard, while fucking, with no warning and no permission. It was the first time I had done it, the first time I had done anything like it. My palm shot with pain and her cheek blushed deep, trembling. It wasn't like me; I'm a permission guy—I ask first. This time no asking, no prompting, no security that it was the right thing to do. The police could have been called; instead, it seemed like she liked it.

Of the many things I've asked or not asked to do in bed, slapping a woman's face was the strangest, the most counterintuitive, and easily the most ambiguous. It felt impossibly illicit, a thing never to be sanctioned, an octopus in the pasture of my politics. And yet I did it, guided by an elusive, dubitable, shimmering sense that it was the appropriate act for the moment. Hands tied behind her head, Air France blindfold over her hazel-green eyes, she never saw it coming. Then the noise, much louder than expected, the prickly needles of pain in my hand, the shapes of my fingers traced in rouge on her cheek, and her quivering mouth, jaw, lips.

There are things I do with women almost exclusively for the sake of demonstrating our alliance, proving we are fully open to each other. Things I ask for, things I give. Rarely, though, do I feel fully trusted, fully empowered, free.

In truth, I'm a little afraid of the id set free—mine, anyone's. But part of me knows that sex doesn't, shouldn't, work that way. If she and I agree, if we both want it, it's good.

Various women over the years have taught me that hard lesson, slow pupil as I am. So there I was, trusting my intuitions, deep inside her, hard-bucking, the intensity dial waiting to be turned to maximum. With my left hand bunched in her hair, I lifted myself with my right, looked at her one last time, and hit her hard across her face with force behind my fingers.

You might know you're approaching a line, but how do you know you can cross it? I don't want to ask myself this question, but I can't help but do so. One part of me says that you know when you know, that old lovers are smart that way, but at the time I almost wilted with the terror of my wondering. I'm sure for some of you slapping or being slapped is unimaginable, while for others it would be no big deal. But I was doing something I never thought I could do, that I thought I could never believe in, and that I couldn't imagine anyone would ever want. And then I found out that she liked it—and that I did, too. Not enough

to become a habitué, but enough to know I could do it again. Another gone, I thought, in the libido's dance of a thousand veils. It was a strange moment, feeling like I had discovered something in—and perhaps about—myself, and yet I felt so much unlike me. And then I heard her moan; it seemed like a call. So I slipped back inside, trying to recapture the rhythm. Three thrusts, perhaps four, and then with the left hand. Another moan, but no tears. The unthinkable had become real, a matter of trust.

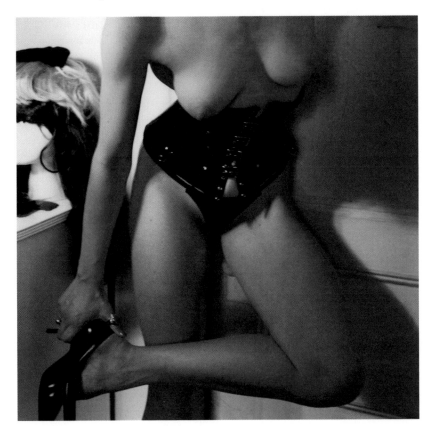

▲ GEORGE PITTS

**How can new parents keep their sex lives active with all the exhaustion, responsibilities, bodily changes, and spit-up that comes with a new baby?**
A lot of tender hugging and kissing, if you're too tired to have sex. Maintain that affection. And oral sex is a good thing to do, man on woman obviously, because it's really healing. Porn. We definitely watch a lot of porn. And when you first start breastfeeding, your boobs get humongous, so do some titty-fucking.

**Is there anything your husband can do with your breasts while they're sore from breastfeeding, or are they totally off-limits?**
Well, the titty-fucking was far from the nipple so it wasn't so painful. You get these porno boobs, which was so bittersweet because my husband just wanted to grab them and play with them, but they were so painful it was like this cruel joke. So I just let him look at them while I masturbated him.

**We keep our two-month-old's crib in our bedroom. My wife says we can't ever have sex while the baby is in the room. She's worried the memory will stay with him and land him in therapy later. I say he's not nearly aware enough of the world to know what we're doing. What should we do?**
Have sex on top of the dishwasher. Yes, the baby probably doesn't notice any of this stuff, but if your wife has a hangup about it, why force it? Work with it. Capitalize on it. You always have sex in the bedroom. Take this opportunity to have sex elsewhere in the house.

# FEAR FACTOR

BY PAUL FESTA

The first time I had sex with someone I knew was HIV-positive— past midnight, in a hammock on the beach—I felt as if I had slain an abuser who'd had complete and unsupervised access to me since my sophomore year of high school.

I was nearly 30 and had lived under the abuser's watch for fifteen years. I'd started coming out as a gay adolescent in San Francisco in the early 1980s, just as AIDS was revealing itself, and it quickly became impossible for me to dissociate myself from the epidemic. My tormentor was AIDS anxiety, but AIDS itself was like a fraternal twin. We competed for resources and wished the other were dead.

Through high school and college and into my late 20s, I was in a constant state of morbid anxiety. Depending on the course of my disease (officially diagnosed later as acute hypochondriasis, and more casually identified before then as survival guilt), I was convinced either that I had AIDS or was in imminent danger of getting infected.

I was much too smart to take comfort in my annual negative HIV test. I'd read a news story saying HIV antibodies could hide in the macrophage of the cell, escaping detection for years or decades. I was also a sufficiently critical consumer of medical information to notice, as the years of the epidemic passed, that AIDS "facts" had a tendency to evolve.

Unstable medical information is mother's milk to the hypochondriac. Take the term "safe sex," for example. At some point, they added a consonant to it, an "r" tacked onto *safe*, and out of that one-letter revision I composed cantos of infection, epics of fear. Oral sex commuted (as it still does) back and forth from one side of the safety border to the other, depending on the study, or the interpretation of it, or whether the interpreter's interest was in paring down infection rates by luring populations of gay men away from anal sex, or in giving a single skeptical neurotic a straight answer.

Either way, the medical establishment's flip-flops led me to believe that I wouldn't survive the epidemic. From the start of my adult sex life at age 15, I was remarkably adept at convincing myself that this guy whose cock I was sucking *right then* was probably not infected. In later years, when this illusion began to crack under the weight of statistical absurdity, I started disclosing my own HIV-negative status in an effort to prompt a disclosure from my partner in return. This didn't feel particularly honest, because I didn't actually believe my negative test results to begin with, but the practice always succeeded—at least on the superficial level of convincing me that I'd taken an extra precaution, while permitting me to suck ever-increasing quantities of cock. In cities

where the proportion of gay men who were HIV-positive approached one in two, everyone's disclosure was always the same: negative.

Dipping into natural reserves of denial, I was far less afraid during sex than before or after. But these anxiety vacations inevitably came to an end. The next morning, or the subsequent week, the spider bite became Kaposi's sarcoma, the rediscovery of lymph nodes under my jaw—which were neither swollen nor tender except to the degree that I manhandled them like subcutaneous worry beads—an endlessly renewable moment of morbid speculation.

When I wasn't having sex, I felt anxious and guilty, unable to accept the fact that men just like me were dying gruesome deaths by the thousands and that I, by virtue of being a few years younger, had every prospect of surviving. To cope with this burden, I did my best to make myself suffer as much as I imagined they did.

Until that summer night I hooked up with Andrew Farley at Fire Island Pines. We'd encountered one another at a bar, out on the patio, and I'd had one of those alcohol-inspired re-evaluations of a college acquaintance. Andrew was not conventionally beautiful, but in a way that had eluded me in college, there was something lovely about him. He was tall, big-boned, with facial features I'm hard-wired to lust after: a broad mouth, thick lips, prominent ears, jet-black hair. His voice was low, musical and cigarette-gravelly, his conversation lively and intelligent. He put the moves on me in a way that was subtle enough either to ignore or enjoy. I found myself enjoying it, and shortly before the bar closed we left together.

Andrew beat me to disclosure. In the hammock where we'd been kissing for twenty minutes, as clothes began dropping to the sand, he told me that a few years after graduation he'd been infected. He thought he knew when, and by whom, but I was barely curious about the particulars. I was on the beach at Fire Island Pines with Andrew Farley, the two of us were in the hammock with AIDS, and, like all long-anticipated confrontations, this one had an immediacy and reality that seemed to exceed the dimensions of waking life. But it was not the nightmare I'd spent my youth imagining, because when the moment finally came, I was not afraid.

Andrew disclosed; I listened. And in a moment of unique clarity, I told Andrew that apart from being sorry he'd been infected, his being HIV-positive didn't matter to me.

I took a condom from my wallet and rolled it on, taking surgical care to keep sand away. AIDS aside, sex in a hammock on the beach is a complicated matter, and there were a few false starts. Most positions, for example doggy style, risk resembling a game of Twister on a moving, three-dimensional mat. After trying a few of these, I abandoned my place in the hammock with Andrew and knelt in the sand beside him. He lay on his back in the hammock and I swung

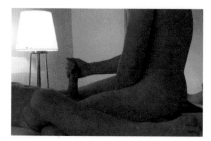

^ BRANDON HERMAN

him back and forth in time with my slow thrusting for a while, then held him to me and fucked him hard and fast while he jerked himself off until we came.

Orgasm famously puts things—one's partner, one's judgment, oneself—in a different light, and that is no less true when you know that the semen pooled on his chest contains a lethal retrovirus. *That's it*, I thought, in a kind of cowed reverence I felt again just recently when I encountered my first wild rattlesnake.

But this orgasm had not brought caution—that had been there all along. Nor had it brought depression or regret. I conducted a flash inventory of hang-nails and paper cuts, then reassured myself that Andrew, considerately enough, had not come on me. I knew, with a sureness I'd rarely been able to muster after other sexual encounters, that I hadn't done anything in kissing and screwing Andrew Farley that put me at high risk of getting infected.

Andrew and I laughed about what friends would say if they knew about our hook-up. We ran into the water and laughed again. Maybe my laughter was nervous, but after a kiss goodbye, I walked back to my room feeling high and safe, sensing that the tryst on the beach had shrunk an out-of-control anxiety into lasting, rational caution.

The first time I had sex with someone I knew to be HIV-positive was a liberation from the anxiety produced by growing up with AIDS all around me, but nowhere near me. Men died by the tens of thousands everywhere in the world, but in my bed, they were always uninfected. I will never know if that uninterrupted procession of HIV-negative sex partners was the result of igno-rance, coincidence, luck, or lies.

To this day, at nearly 34, I have never attended an AIDS funeral or memo-rial for a personal friend. The refusal of the disease to manifest itself directly in my personal life while it decimated the world around me produced an anxiety that reality never got close enough to constrain, one that virtually vanished in that hour with Andrew on the beach. Now I knew that, whatever this epidemic brought my way, at least I could face it with the confidence of having touched my adversary.

The first time I had sex with someone I knew to be HIV-positive was also my last. In several subsequent instances, twenty minutes of making out were followed by a disclosure of infection, but after that night at the Pines I could no longer say what I'd said to Andrew. It *did* matter that my partner was HIV-positive, not because I was irrationally afraid and didn't think I could have reasonably safe sex with him, but because after the age of 30 I lost much of my drive to have sex for its own sake. Now I was having sex in search of a boyfriend, and the one I hoped to find—the one with whom I hoped to spend the next six decades doing bourgeois, straight-aping things like making a home and raising children in it—was probably not going to be HIV-positive.

If I fell in love with someone who turned out to have the virus, that would be one thing. But I wasn't going to seek him out. Barring love at first sight, I wasn't even going to date him. It wasn't easy to admit this, to face the guilt of being not only a survivor but an avowed HIV-negative separatist. But I already had let guilt govern half my life. I had paid my dues, and I had paid them senselessly. Nobody had been cured by my misery; no one had even been comforted.

The next and last time I saw Andrew was the morning of September 11, 2001, as I hurried away from the corner of Seventh Avenue and Thirteenth Street. It took me a moment longer than it should have to recognize him. He had aged too much, and his color was wrong: dark, with an unhealthy orange tint. His skin was drawn, his cheekbones too sharp. And though that day was notoriously clear and still, he wore heavy fall clothes. Thoughts came hard and numb, delayed in a moment's stupor and then all at once, like ice cubes cracked out of an aluminum tray: *This is Andrew—he has AIDS—these are the side effects of his medication—we are going to touch.* He put his arms around me as I described what I had just seen, and though I could not believe the words I spoke he seemed unsurprised by them, almost unmoved. He only wanted to know if I was going to be all right.

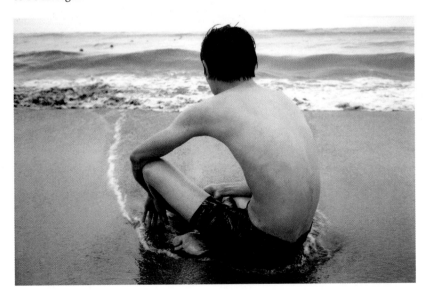

▲ MY LITTLE DEAD DICK

"THE ACT ITSELF IS ONE OF THE CLUMSIEST THINGS ANY ANIMAL CAN DO. IT'S GROTESQUE IF YOU'RE LOOKING AT IT. I THINK IT'S USUALLY GROTESQUE IF YOU'RE DESCRIBING IT."
—TOM WOLFE, 2004

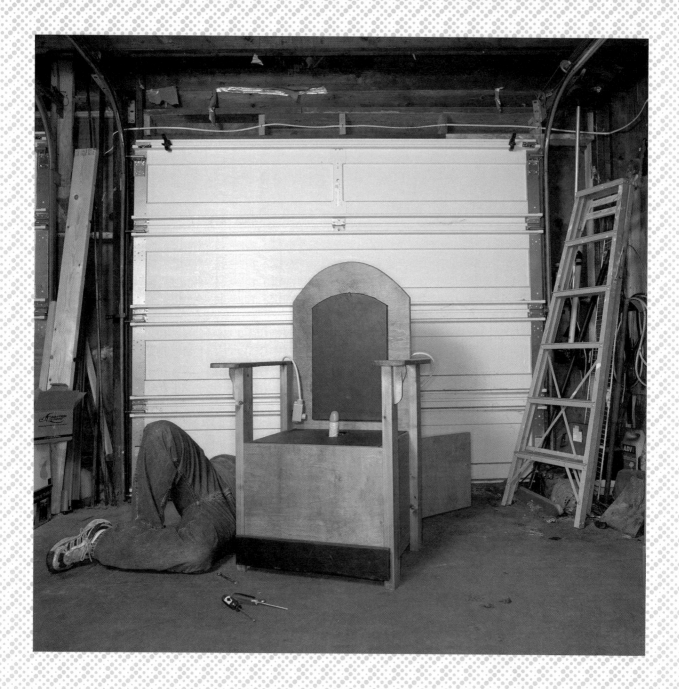

**2005**

PHOTOGRAPHY BY
# TIMOTHY ARCHIBALD

Ben Franklin probably never thought there'd come a time when amateur engineers would mount dildos on horizontal jackhammers. Not that such machines didn't exist in his day—a quick look at archives from the U.S. Patent Office shows many early designs for mechanical sex partners. Timothy Archibald discovered this in 2002 while researching a story about independent inventors; soon, he was talking online to Americans who'd built their own sex machines. He decided to meet some of them, and crisscrossed the country with his camera. The result is a surreal, almost dystopian visual survey of everyday people living in ordinary suburbs who just happen to like getting screwed by appliances plugged into wall outlets. —WILL DOIG

^ < TIMOTHY **ARCHIBALD,** *FROM SEX MACHINES: PHOTOGRAPHS AND INTERVIEWS* (PROCESS MEDIA INC. 2005)

^ < **TIMOTHY ARCHIBALD,** *FROM SEX MACHINES: PHOTOGRAPHS AND INTERVIEWS* (PROCESS MEDIA INC. 2005)

# SKULL

## BY STEVE ALMOND

My friend Jake stopped by for a few beers. We'd been pretty good friends in high school, had gone our separate ways for college, then wound up in the same city, more or less by accident. He was a sweet guy, eager and a little sentimental at times, which probably gave us something in common. We were sitting on my couch, drinking, talking shit.

"How goes it with Sharon?" I said.

Jake sat up a little. "She's amazing."

Sharon was his new girl, a tall, elegant redhead, a little older than us. She had the kind of voice you always imagine a phone sex operator would have, moist and soothing. The unusual thing about Sharon—she had a plastic eye. Or actually, it was a polymer. Jake had clarified this for me. ("It's a polymer, man. Get it right.") She'd been shot in the eye with a BB gun when she was a kid and they hadn't been able to save it.

"We're having a great time," Jake said. "I mean, this girl knows how to have a great time."

"Lucky bastard."

"You're not going to try to work things out with Lucy?" Jake said.

I'd broken up with my girlfriend a few weeks after Jake met Sharon.

"Nothing to work out," I said.

"You guys seemed crazy about each other."

"That one night you saw us, sure. I don't know. We drove each other nuts."

"Love does that sometimes."

"I don't know," I said. "I didn't feel like I was getting to the real stuff with her."

"That's not a problem with Sharon," Jake said. He laughed a little, as if at a private joke.

"What's that mean?" I said.

"Nothing," he said.

"Nothing?"

"Not really."

He got up to fetch another beer. That was one thing about Jake. He could make himself at home pretty quickly. He settled back onto the couch and we talked about making a plan. But we were both shitty at making plans. We couldn't decide anything. The only films around were based on comic books, and we knew all the cheap bars would be full of college kids. So we kept drinking and smoked half a joint and watched the Red Sox clobber the Tigers.

"What's Sharon up to this evening?" I said.

"Some dinner up in Auburn Hills."

Sharon did corporate fundraising for an educational nonprofit. This explained her clothing and her impeccable phone manner. It impressed me that someone could earn money attending fancy parties.

"How long has it been with you guys?"

"Nine weeks."

"Nice."

"She's special," Jake said.

"There's something about her."

He made an expansive gesture. He'd drunk four or five beers by now. It was hard to tell because he always put his empties in the recycling bin right away.

"Yeah," Jake said. "I lucked out."

"She's sexy," I said.

"She's sexy, all right."

I let this sit for a minute. As I say, it had been a while since I'd been with a woman. "Fucking Tigers," I said. Weaver had just given up a homer to some pigeon-toed bastard from the Red Sox, I didn't know who.

"Fucking Hello Kitties," Jake said.

We didn't say anything for a while, just let the announcers drone on. I was thinking I might just call it a night, though I was worried if Jake left I'd be tempted to call Lucy up and make an idiot of myself. There'd been some of that already.

Jake got up to get another beer. He was staggering a bit upon his return.

"You okay there?"

"Sure." He sat heavily. "This is your last malt beverage. You wanna go halfsies?"

"It's yours," I said.

"Thanks, man."

Jake took a gulp and swirled it around his mouth. He'd told me once that this was the best way to keep debris from settling between the teeth. His dad was a dentist, so he was full of such useful advice.

"Listen," Jake said. "You were asking about Sharon before."

"Yeah," I said.

"She's amazing."

"You mentioned that."

"There's this one thing," he said.

"What thing?"

'In terms of, like, our intimacy."

"Right."

"She likes to do different stuff."

"Different how?"

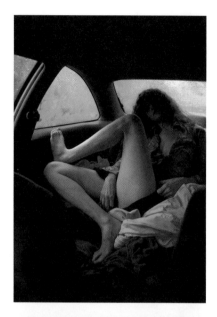

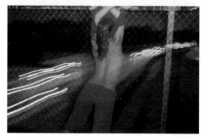

Jake glanced at the TV. It was a shaving commercial, some gorgeous idiot with the face of a Greek statue. "More *offbeat*, I guess. Offbeat might be a better word."

I remembered now what had always creeped me out about Jake, which is that he had a tendency to say a little too much when he was sloshed. One night, back in college, he'd mentioned that he was sort of attracted to certain short-haired breeds of dog. "Not enough to do anything," he assured me. Still, it had pretty much killed the evening.

"She's a big fan of the face," Jake said.

"Who isn't?"

"Involving the face more."

"As in, what, like facial massages?"

"Those too," he said. He paused and glanced at the TV. "I'm going to mention something here, Pete. Okay?"

"That's the whole point," I said. "We're talking."

He glanced at the TV again.

"You want me to turn off the game?"

"If you want."

His whole posture had changed. He was sort of hunched over. I turned off the game and put on the only album we could ever agree on, which was *Al Green's Greatest Hits*. "It would have to be, like, strictly confidential. No kidding."

"Scout's honor," I said. This was an old joke. We'd both been Boy Scouts back in high school, for about two seconds.

"It's just this thing," Jake said. "This sort of sensual play, involving the face."

"Sensual play."

"She loves to feel me, you know, rubbing against various parts of her face."

"Hold up," I said. "What parts?"

"That's just it," he said. "I'm not the most experienced guy in the world, in terms of sexually. I've kind of let her take the lead."

"Yeah?"

"I don't want to freak you out," he said.

"You're not going to freak me out," I said.

What I was thinking about, oddly, was depth perception. I'd discussed the fake eye aspect with Lucy—we'd gone out to dinner with Jake and Sharon that one night—and she mentioned afterwards that she knew a girl who was blind in one eye and that it had screwed up her depth perception. This had made the act of giving head difficult.

"She likes for me to rub her eye," he said.

"Her eye?"

"Not really her eye," he said. "The area around her eye."

"The socket?"

"Just listen," he said. "Okay?" He took a deep breath. "I didn't know about any of this shit, but you know she had a couple of surgeries. They've been able to make some real advances in ocular rehab." He killed the last of his beer, swished it around. "You'll notice, for example, that she can move the eye a little. It doesn't just sit there. That's because of muscles around the ocular nerves. She has to do these exercises, every night. To keep the muscles strong."

"Right."

"She does them, you know, with the prosthetic out. Most nights, I mean, by the end of the day, those muscles are pretty sore. So she removes the prosthetic."

"You've watched her remove the thing?"

"No," Jake said. "She goes into the bathroom for that. Then she comes out with this patch. For the first few weeks, she always wore the patch. But this one night we'd been drinking and she asked if I wanted to see what she looked like without the prosthetic, and I said yeah."

"Wow."

"It was kind of heavy," Jake said.

'What did it look like?"

"It's like, I guess, sort of like a little cup. There's some scar tissue."

"Yeah?"

"She has to rub this balm in, to keep the flesh moisturized. So this one night, a couple of weeks ago now, I rubbed the balm in for her. Does this sound creepy, man? Am I freaking you out?"

"Not really," I said.

"Because I'm not trying to freak you out."

Jake had his eyes fixed on the bouncing red lights of the equalizer, which were rising and falling with Al Green's voice. We could hear my upstairs neighbor, dragging something heavy from one room to another.

"I could see how much it meant to her, you know, to have me accept that part of her. And the flesh there, it's extremely sensitive, the way scars can be. It was kind of a turn-on for both of us. So it just sort of evolved from that."

"Evolved?"

"Well, the first thing, she would start to touch me while I rubbed in the balm."

"Your dick?"

Jake glanced at me. His eyes were glassy with the accumulated booze; I could see now that he'd been prepping himself. "It gave her great pleasure to have me touch her there. You know, anyone can love the other parts of her. You've seen her, Pete. She's a beautiful woman. But to have a man accept that part of her, it drives her crazy. That's what we all want anyway, to have our lover accept the most damaged part of us, right? Am I right?"

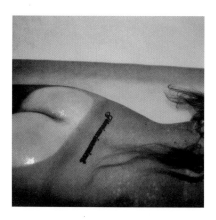

"Absolutely," I said.

"So from there, it was a pretty natural progression."

"What was a natural progression?"

"That she would want me to rub myself there."

"Like a massage?"

"Sort of," he said. "But not with my hand."

"Hold on," I said.

"This balm we use, it's practically like a lubricant."

"Get out of here," I said. "Get the fuck out of here."

But Jake was not the sort of guy who joked around. He lacked the imagination. And he wasn't cruel enough. That was maybe worst thing about talking to him: everything he said was the truth.

"I didn't understand what she wanted at first. I thought she just wanted, you know, to put me in her mouth. She likes to do that. And she's excellent in that department, by the way. But then she moved. She moved down a little and said, 'Do you trust me, baby?' I said, 'Of course I do.' It's true, Pete. I do trust her. 'I'm going to do something,' she said, and I told her whatever she wanted to do, that's what I wanted, too. So that's how it started. She took me and began to massage that area, very gently."

Jake was silent for a few seconds. Al Green was singing, *Here I am, baby, come and take me.*

"I don't want to get too technical," Jake said.

"No," I said. "You don't have to get technical."

"But to her, like I said, that's the most intimate part of her anatomy. So in that sense, what she wanted was just for the most intimate parts of our bodies to be joined, to be in contact."

"How much contact are we talking about?" I said.

"Well, at first, it was just, like, a massage. Using me to massage that area. But you have to remember, I mean, we were both naked." Jake was speaking quite softly now, fading in and out. He wasn't looking at me, thank God. He was on the other side of the couch, staring at the equalizer.

"I mean, it began as something more sensual. But at a certain point, it sort of pivoted over and there was a sexual component to it, as well. She was using her hand. She was using her mouth. I was all over the place. I couldn't always tell where I was, to be honest."

"Sure," I said.

"It's what she *wanted*," Jake said. "She wanted me to be turned on. She wanted me to get excited."

I was trying not to picture what he was talking about. But it was difficult. I kept flashing to this image of a skull and how naked skulls look, how terribly

stark and vulnerable. It was like an idea of what people really are, after all the pretty flesh has rotted away: white bone and black holes.

"The first time it was just sort of gentle like that, this gentle play. But since then, it's gotten more intense." Jake belched softly and excused himself. "There are times when I can feel she wants me to use more force. She wants me to take charge. It's not like she's issuing orders. But I can tell from the way she positions herself."

Jake glanced at me. It occurred to me he was waiting for me to say something, so he could go on.

"Wouldn't this be considered sort of dangerous?"

"Yeah," Jake said. "That's what I figured. I mean, it's a part of the body that's been traumatized. It's right near the brain. There's all this scar tissue. That's what sort of freaked me out. I was having these fantasies of, like, something bad happening. But Sharon kept telling me, 'It's okay. I like the pressure.'" He frowned. "It's not like there's any real penetration. The area we're talking about isn't that big. I mean, feel your eye."

I was afraid that Jake might really want me to do this, right there in front of him, but he kept talking.

"It's more like the skin rubbing against the rim, that sensitive part just below the tip, you know, rubbing, sort of up and over the rim. I don't even know what you'd call it. It's not like they hand you a manual on this stuff in sex ed. The thing is, Pete, it felt good. It *feels* good. Not the same as making love, but I guess it is a *way* of making love."

"Absolutely," I said.

"And Sharon, she's made it clear that she likes how it feels. She especially likes to feel me, you know, complete the act. I hope I'm not being too graphic here. Am I being too graphic?"

I paused. "It's sort of the nature of the thing," I said.

"Right," Jake said. "*Precisely.*" He let out a long, beery sigh. "Anyway, it's something I've been sort of carrying around. Not like I'm ashamed. But it's just fairly intense, in terms of early relationship issues." He leaned toward me and set his hand on my arm for a second.

"So, thanks for listening, man."

"Of course," I said. I felt honored that he'd chosen to tell me, actually, but also a little put upon and also worried that I wouldn't be able to resist telling someone else.

"I hope this doesn't make you feel any differently about me or Sharon. I mean, I'd hate to think—"

"Not at all," I said. "What people do in the bedroom, however they can find happiness, that's all good."

^ SAMANTHA WEST

"I knew you'd understand," Jake said. He stood, a bit uncertainly, and stretched his arms out wide. "Man, I've got to piss like a racehorse."

"Sure," I said.

Jake took his leak and shambled back into the room. He said he should probably go. I could tell he wanted to see Sharon. The beers and the talk had swollen his heart.

"You okay to drive?" I said.

"Fine," he said.

"I can call you a cab."

Jake cocked his head. "No," he said. "I'll do a quick lap around the block. If I still feel drunk, I'll come back up. Promise."

Jake had survived a pretty serious car wreck in junior high and it came out later that his mom had been drinking, so I knew he wasn't bullshitting. He paused in the doorway. "Listen man, Scout's honor on that stuff before, right?"

"You know it," I said.

"Cool. Cool."

I listened to him trundle down the stairs, the flap of sneakers on the damp sidewalk as he started his lap. I was kind of relieved that he was gone. And then, on the other hand, I sort of missed him. The Reverend was still singing *I'm so tired of being alone*, and *let's stay together*, all the things lovers should tell each other. It made me feel lonely, to be in possession of such a sudden intimacy. A secret can be a lonely thing to bear sometimes.

And I wouldn't have expected Jake to be the one. Of all my friends, I mean. He's not the one you'd pick out of the lineup and say, *Yeah, him, he's the one diddling his girlfriend's eye socket.*

I don't mean to cheapen the thing. It's no joke. This was something real. Sharon was a real person. Some kid, long ago, had shot her in the eye with a BB gun. And now she was carrying around this injury. She wanted her lover to touch her. There was something beautiful to the story. I could see that. But it still left me a little shaken.

Later on, I managed to convince Lucy to come by. There was a lot of coy begging involved, though she'd had a drink or two, which helped.

It wasn't like that night was some breakthrough in our relationship. That's not the point I'm making. It just felt good to have her in my bed again, the familiar shape and heat of her. Just before we fell asleep she set her head on my chest. I could see her face in the moonlight: the round cheeks, the swell of her mouth, the shallow well of her eyes, which were wet and delicate, as precious as rare stones. Then this awful thought flashed through my mind: the worms would attack her eyes first.

I didn't want to think about it, but somewhere across town old Jake was with Sharon and they were finding their own path to love. It was—whatever,

not strange or absurd, but human. Lucy closed her eyes and I let my fingers drift along her brow, her jawbone, the rim of her eyes. It was her skull I was tracing.

"That feels good," she said drowsily.

"Good."

"I'm glad you called."

"I wanted to see you."

"Keep going," she said.

"Of course," I said. "Why would I stop?"

^ WERNER AMANN

**Are you worried that those tight jeans will affect your man's sperm count?**
I think male country singers actually wear tight jeans so they won't have so many children floating around.

**I've been out on three great dates with a guy I really like, but he hasn't made a move on me yet. What's up?**
Six words: *He's Just Not That into You*—a book I've actually read. I found it in a train station on a bench. I read it and I was like, "Wow." You kind of only need to read ten pages, then you can throw the damn thing away. That's probably why I found it on that bench.

**How do I reacclimate myself to the dating world after a three-year relationship?**
The first thing you have to do is get drunk in a bar and make out with someone totally random. That's absolutely paramount. No negotiation. Otherwise you're going to go looking for romance and get yourself into another three-year relationship before you know it.

**How can I get a country musician to notice me from the stage?**
I'd like to think that it doesn't involve flashing your tits, but it probably does.

# ON A SATURDAY AFTERNOON

BY AIMEE BENDER

I have known them for at least three years, these two; we all went to school together and at one point I dated the blond, but it was brief. The timing was off and both of us were swept along by the river of another match. I have flirted with the brown-haired one for years.

I have this fantasy, I say one evening, when all of us are slightly drunk, sitting on my apartment steps on Gardner on a clear July evening. Would you come back? 4:00? Saturday?

Sure, they tell me, curious. The word marked by brake lights and bitten fingernails. Everybody facing out. We all hold hands at once, and we are all lonely when we go home, but this is helpful, this hand-holding, this sitting on the stoop of my apartment building, watching while other people look for parking.

I have recently broken up with someone whom I did not expect to break up with, and every morning, the earliest time I wake up is suffused with remembering. I can't seem to beat that moment, no matter how early I rise. I once thought that if I traveled in France, I would have a different brain, the brain of a girl who travels in France. I saw myself skipping through meadows in a yellow and blue print dress. But even with the old buildings, with the bright, bready smells, with the painted French sunlight, it was still my same brain in there, chomping as usual, just fed this time by baguettes and brie.

In the mornings I write long, circular journal entries when I wake up. Too early. Before work. But even though I am making steady proclamations about who I will go for next, and why, and how it will all be different, it is brutal to imagine the idea of meeting a new person. Going through the same routine. Saying the same phrases I have now said many times: the big statements, the grand revelations about my childhood and character. The cautious revealing of insecurities. I have said them already, and they sit now in the minds of those people who are out living lives I have no access to anymore. A while ago, this sharing was tremendous; now, the idea of facing a new person and speaking the same core sentences seems like a mistake, an error of integrity. Surely it is not good for my own mind to make myself into a speech like that. The only major untouched field of discussion will have to do with this feeling, this tiredness, this exact speech.

The next person I love, I will sit across from in silence. We will have to learn it from each other some other way.

On Saturday, there's a knock at the door right at 4:00, and I open it up. Hi! Hi, hi. We're all joking and nervous, and they brought beer. Me too. I usher them in. My apartment sometimes reminds people of a warehouse; the space is high and

elongated and feels empty. The living room is a stripe. It's too narrow to watch TV in, so I put the furniture on a diagonal.

They both look great, thriving out of control. These are solid men, with square kneecaps and loving mothers, who are still sort of awed by women. They have a line of fur instead of hair at the napes of their necks, sometimes dusting the hinge of their cleanly shaven jaws. Me, I'm clothed and workmanlike in overalls with many pockets. A red tank top, legs covered. They have had crushes on me at some point, and me on them, but everyone knew that friendship was best, and it is in this spirit that they walk through my door. They're good at the greeting hug routine. There is a wild fondness in the air. We grab beers, twist off, fling bottlecaps into the air.

They're friends with each other, too. Sometimes they play soccer together.

They said they would do what I asked them to. That's the agreement. It's a 4:00 afternoon and the July sun is lazy and inviting and it's a second floor apartment so it's always a little warm from the rising heat, and here are these two men I've captured, inside my house, wearing worn white T-shirts. One of them has a stain right in the middle from the peach cobbler he ate at lunch, leftover from the potluck he went to Friday night at Janet's. He is the type everyone gives their leftovers to at the end of the party because they know he will eat them, and he does. Somehow this makes me proud. Whenever these two walk down hallways, or through crosswalks, in their tall boyishness, I feel a surge of pride that is faintly motherly and also not. I want to fuck and birth them at the same time.

Today, they have another beer. Me too. We joke around. We play bottlecap hockey. I serve cookies on a chipped green plate. They eat them, fast. They have sweet tooths, they say. One prefers the chocolate chip; the other enjoys the texture of oatmeal. They're deep in the stripe, by the windows at the room's end, and I sit down in the chair that I've placed closer to the door. Stay over there, I tell them, as they swallow the last two bites off the plate. Alright, they say. They sprawl out on the carpet, hands propping up their heads, and they know how to own space, how to feel important without realizing it. They have never questioned their right to be alive; it is borne in them, and obvious. One is wearing shorts and has blond hair all over his knees. Like poured milk from a glass carton.

Okay, I say, after the third beer is finished. I bring out tequila. I give each of us two shots. Down, down, down.

Then: Just touch hands, I say.

One touches his own hands. No, I say. His. His hand. Touch that.

It takes until just now for them to realize I want them to touch each other. They have assumed they'll be touching me. I don't have shoes on, but I have the rest on, and maybe a ponytail. I'm in the day. Just touch hands, I say. Gently. Please. They look bewildered—not upset, just unsure. They will need my constant reassurance. This is why I will not feel left out.

It's okay, I tell them. Just feel his arm. Maybe the back of his neck. Just see what it feels like.

The sun slants through the curtains as their two hands reach over and they sort of grab at first but then relax. They explore the knuckles, the wrists, the elbows. They don't giggle but there is some nervous shifting, some more drinking from beers. Wet barley lips. One is from Oklahoma, and came out West to direct movies. The other lived in Oregon, in a clapboard house with an attic where he gathered bird nests from trees. They remember their first kiss with a girl, the years of masturbating in the shower before their sisters would bang on the door, yelling about hot water.

They are touching each other's arms now, with freckles, with downy hair. Touch his stomach, I say, to both. Four eyes beam up at me, frightened. It's okay, I say. It's for me, I say. Please. And their hands, shaking slightly, reach down under the loose T-shirts and just glance over their stomachs, which have tiny lines of sweat forming in the creases from sitting.

I am in my chair. They feel scared, even from over here, but not awful scared. They're open-hearted and they can stand it. They have untested liberal minds. They are also getting turned on. Their faces move closer together as one grazes the inner arm of the other.

Kiss him, I say, out loud.

The light through the drawn curtains is a dark red and partially obscures their clean-shaven faces. They lean in, and their cheeks bump at first and finally touch. Their lips, so soft. They are tentative and frightened, faces pressing gently against each other. Lips meet. Boy lips on boy lips. I love watching them. I could watch them for hours. Their heads leaning and listing, the lips learning what to do, how almost-familiar it all is.

One stops. Looks at me. Is this alright? he asks. His lips glisten. Why don't you come join us—

I'm watching this time, I say. Just watching. You're so beautiful, both of you.

The other turns to me, eyes overly brightened. Come on, he calls. Come over!

I shake my head.

Absolutely! they both say.

No.

I'm on the weird island, over here. They love me too; I'm not totally absented. We all know I'm in the room.

Keep kissing, I say. I can't tell you how much I love to watch you kissing.

Their big boy faces drink more beer and then lean back in and I see the erections, poking up from their pants, and they seem hopeful and nervous and vulnerable, and as they keep kissing, hands moving now down shoulders, to back, to stomach, I tell them to take off their shirts, and they do, because today they listen to me. I will not hurt them. I can only get away with this once. And

the shoes kick off, and the pants roll down, and there they are, nude and strong, poking each other in the stomach. More beer. More tequila. Eyes closed. The reddish light flutters on the floor and cars honk downstairs.

I tell the one on the right, the one with the brown curls in his hair, to lean down. To try it out. Please, I say again. Please. My voice is so quiet but we all hear everything. He bends down. The one on his knees now has a face combination of pained concern over what this might mean and utter joy too, and he opens his eyes and glances over at me, and I smile at him, my whole body awake. He can see how turned on I am. There's a furrow of worry in his brow so I reach over to the overall straps and unclip them and pull my shirt up so that there are breasts in the room. Visiting. His face lights up, in part because he likes them, but even more because he knows them, he recognizes the shape, they are a marking point for identity and memory.

^ BRANDON HERMAN

And then my overalls are back on and he closes his eyes again, I have relieved some knot in his thinking, and the first one is curled over and he doesn't know quite what to do but he has some ideas, and his mouth is earnest and effortful.

Their hands grip the carpet hairs. Look at the initial swell of a bicep, that bump after the dip of the inner elbow.

When they switch, they're laughing now. Everyone's drunk. No one has come yet. They kiss in between switching, and their hands move all over, into inner thigh, rounded curve of the ass, sweaty necks. I feel the tide fading from my feet. They look up—come with us, come join us, they say, but I'm over here, I say, for today—and they are at once disappointed and also we all know the rhythm has been set as is. Tight calves and legs lifting. Brown curls and blond knees. When they're kissing again, I could stare for hours. Men love to watch two women kiss, but how I love to watch two men. So clear in their focus. The amazing space created for me when there is nothing demanded or seen.

When they are sleeping I go into my bedroom. It is darker than the rest of the apartment, and only large enough to fit a bed and a dresser. I don't sit down, but I stand with the furniture, my whole body triggered. And it is only now that I feel the coldness of watching, the interminable loneliness, how the exit will happen, how they will hug me but something will have shifted, how our meetings will be awkward for awhile, and possibly never recover. I slow down my breathing, move away from the clawing inside. After awhile, I hear as they get up off the floor and let themselves out. They leave me a nice note, and one washes the cookie dish, and they even put the beer bottles in the recycling bin, but the rest of the evening is nothing but the trembling edges of something I am so tired of feeling and do not want to feel anymore.

# THE NERVE INTERVIEW:
# DAVID CRONENBERG

BY MICHAEL MARTIN

David Cronenberg is the H. G. Wells of horror films: over thirty years and a dozen movies, he's taken us to the fringes of the future to ask important questions about the present. Unlike Wells—no genre hack himself—some of Cronenberg's visions look a lot like reality. His first film, 1975's *Shivers*, depicted a parasite that invaded an upscale singles complex, making its residents sexually voracious and spreading via sexual contact. (HIV? Crystal meth? Both?) Since then, he's addressed the human power struggle with technology (*Videodrome, ExistenZ*), male sexual competition (*Dead Ringers*), scientific hubris (*The Fly*), and the search for sexual community in jaded times (*Crash*). Although intricately styled and infamously gory, his films are about humanity at its most basic: the body, our instincts, and our attempts to subvert them.

Maybe that's why Cronenberg's latest film, *A History of Violence*, has been called shockingly mainstream but feels like a story no one else could tell. Tom Stall (Viggo Mortensen) is a small-town family man who becomes a local hero after shooting three would-be robbers. But how did he become such a talented marksman in the first place? As Tom's secret past unfolds, he dodges shady characters, tries to protect his children, and has hot sex with a wife he loves passionately (Maria Bello, who delivers one of the most thrillingly fraught onscreen orgasms ever). Not just for that reason, it's the best film I've seen this year, from the completely real sex to the meaningful dinner-table silences to the suspense sequences that are almost physically intolerable.

Cronenberg's creepy oeuvre had better not hold him back at Oscar time. I will say that it did nothing to prepare me for the genial, toothy gent who showed up to chat about humanism in a soft Canadian accent. We talked about *A History of Violence* and his career-long fixations.

**PEOPLE ARE TRYING TO FIGURE THIS FILM OUT: ARE YOU CRITIQUING AMERICA'S HISTORICAL RELATIONSHIP WITH VIOLENCE? IS IT ABOUT LIFE POST-COLUMBINE OR POST-9/11? WHAT WAS YOUR INTENT?**
The first level of intent is to tell a good story. The movie has to work as a narrative suspense twist whatever. But I like a movie to have depth, to have a lot of levels to it, so the deeper you go the more things you find. You're not required to go that deep if you don't have a mind to.

It all started at Cannes, the discussions of, "Is it a critique of America and its relationship with violence?" Me being the contrarian that I am—because I knew the answers they wanted—I said, look, there's no country in the world that was not founded on violence or territorial wars or suppression of the indigenous peoples, so you can't lay all that on the U.S. But at the same time, I wanted it to have resonance. That whole iconic Americana element that involves American Westerns, gangster movies, and a family movie at the center of it. Politically, I can feel it, though.

**DID BEING CANADIAN GIVE YOU AN ADVANTAGE IN TELLING THE STORY?**
As I pointed out to the French, it's been the American critics who have been most eager to interpret the movie as a critique of America. I think that makes sense, because they're the most sensitized to what is happening in America right now. There are a lot of people who are critical, so they find this movie is a stick to beat America with. I'm the last one to say don't do that. But as a Canadian, I think I do have a subtle perspective shift on America. The saying is, is the fish a better creature to tell you what water is, or is the fisherman?

**IT AMAZES ME HOW LIBERAL CANADA IS. SO CLOSE, SO FAR.**
I had a discussion with Michael Moore about *Bowling for Columbine*, in which he portrayed Canada as this mystically different country. He was saying Canada has as many guns per capita as the U.S., but somehow we don't kill as many people as they do here. And I said, "That's

really misleading, Michael, because we have gun control in Canada, and those guns that you're mentioning are shotguns in the homes of farmers, they're not Glocks in the night tables of urban dwellers."

In Canada, you can't get a permit for a gun for self-defense. It's not considered a reason to have a gun. So people don't have guns in their houses, and that makes a big difference, because then the kids don't take them to school and shoot each other. He wanted it to be a strange, cultural thing between us, and I said, no, it's quantifiable. We didn't have slavery, we didn't have a Civil War, we didn't have a revolution, our disconnect from England was civil and sort of parliamentary. We never had the idea that taking the law into your own hands is the way to deal with an extreme situation and that you had the tool, i.e., a gun, to do it.

In *A History of Violence*, you have a man with a gun protecting his family and importantly, his property, from other men with guns, and literally taking the law into his own hands. In Canada, when you're threatened, you phone the police. You don't pull out your gun. It's a completely different attitude, which has historical antecedents.

**THERE'S A LOT OF BLOOD—AND DECONSTRUCTED FACES AND BRAIN SPILLAGE—IN THIS FILM. WHY IS THE VIOLENCE SO GRAPHIC?**

Well, it's not. It's not a lot of screen time compared to any garden-variety action movie. But it has an impact because it comes only at moments. It's not because I have this theory of cinema and violence that I've imposed on the movie. It comes from the movie. It comes from certain characters. Where did they learn to be violent, and what does the violence mean to them? In this case, they learned it on the streets, and what it means to them is business—if you have to kill someone, you do it and you move on to the next thing. It's not martial arts, and it's not even sadistic pleasure, it's just business, and that gave me the key to the tone of the violence of the movie.

And even though the violence seems to be justified, the human body doesn't know whether the violence visited on it was justified. The results are the same. And to me, that's what violence is really about—the human body. That's the violence we worry about the very most. There's cars crashing and buildings falling down, but really, if there's no damage to the human body it's still not what we worry about. So that was my other approach. It's all very body-oriented, very intimate.

**IN ALMOST ALL YOUR FILMS, THERE IS THIS FASCINATION WITH HUMAN FLESH AND TISSUE— THE PLACENTA IN *EXISTENZ*, THE VIDEOTAPE-SWALLOWING VAGINA IN *VIDEODROME*, THE FUCKABLE WOUND IN *CRASH*. EXPLAIN YOUR FASCINATION.**

For me, the first fact of human existence is always the human body. I'm an atheist; I don't believe in an afterlife. I think of myself as an existentialist humanist. As an existentialist humanist, you don't refer things to an afterlife or a superior being. You're saying, "Look, we're really all we've got, we've got to make things work here and now, not in some afterlife where all wrongs will be righted." To me, that's a positive philosophy. It does mean that I therefore look at the body in a very serious way. I think it's a universe unto itself and deserves further study.

**WITH *A HISTORY OF VIOLENCE*, DID YOU WANT TO ADDRESS SEXUALITY IN A DIFFERENT WAY THAN YOU HAD IN THE PAST?**

No, not really. Sexuality is of interest to me for all the obvious reasons—plus the body-specific reasons—but I have to forget about my other movies when I'm making a movie. The sexuality comes out of the characters and out of the plot. There are two sex scenes, which are interesting because they take place between a married couple that have children. You don't see that anymore. It's either adolescent sex or forget it, whereas anybody who's married knows that sex gets more interesting and more complex and deeper as you get older. So I was interested in that.

In the original script, there were no sex scenes. I added them. I felt in some ways you could call this movie *Scenes From a Marriage*. I have to know about the sexuality

involved in that marriage if I'm really going to understand it. Of course, it's a perfect before and after—there's a pivotal moment in the film which changes the sexuality, and in looking at that, it's very revealing of what's going on under the surface with these characters.

**I THINK THE SEX SCENES ARE REALLY REMARKABLE—THEY ARE INTRICATE, THEY ARE REAL, THEY ADVANCE THE PLOT. I THOUGHT THE SEX IN *CRASH* WAS EXCELLENTLY DONE IN A DIFFERENT WAY. YOU'RE REALLY GOOD WITH THESE SCENES. HOW DO YOU DIRECT THEM?**

Whether I was doing dialogue or violence or sex, my approach was always the same. It was never, "Okay, now we have to get tense because this is a sex scene, or this is a special moment because we're doing this violent scene." It's, "How do we choreograph it?" The actors are involved immediately, they're not manipulated like pawns, and that immediately takes the edge off. In a sex scene, as an actor, you're incredibly vulnerable—your own sexuality, your experience of sex is revealed in certain ways. But I don't do it that way. I encourage them to look at the monitors, so they know exactly what they look like—this goes for dialogue scenes as well—and what I'm seeing, and we use that to shape the scene.

**SOME MIGHT ASSUME, AFTER WATCHING *SHIVERS*, *DEAD RINGERS* OR *VIDEODROME*, THAT YOU'RE AFRAID OF SEX.**

I'm very comfortable with it, I'm not embarrassed, I'm not uptight, I'm not voyeuristic. When I shoot sex scenes, it's business as usual, in a way. That attitude relaxes everybody on the set. That's pretty much it, you know. I mean other than that it's just trying to figure out what would these characters do and how would they do it and why would they do it, and the resonances are quite nice, too. Maria and Viggo really wanted to know everything that's going on, for example, in the scene where she dresses up as a cheerleader to seduce him. These are role-playing scenes, and the whole movie's about role-playing, and they understood that.

**MANY OF YOUR MOVIES INVOLVE TECHNOLOGY AND HOW IT'S USED TO OVERRIDE SEXUAL REPRODUCTION OR SOME NATURAL FUNCTION. THIS FILM IS VERY PRIMAL. HAVE YOU LOST FAITH IN OUR ABILITY TO TRANSCEND OUR NATURE?**

Well, I don't know that we ever really do. This movie is not very much about technology, but my understanding of technology as expressed in other films is that technology is very human. And because technology is only human, it's an expression of ourselves, just as an artist expresses himself in a painting. It expressses all aspects of us, including the worst, the most destructive, the most sadistic, the most perverse. But it's still human.

I think of technology as worth examining from that point of view because of the things it says about us. It's like a magnifying mirror, and we shouldn't be afraid to look into it that way. I guess there's always a desire for transcendence, but I wonder if it's an illusion. Once again, if you're a humanist, you're not really looking for transcendence of humanness, you're looking to come to terms with what is human. Because even the desire for transcendence is totally human. I don't think there are any other creatures that could conceive of such a thing.

**_SHIVERS_ AND _RABID_ WERE MADE IN THE LATE '70S, AND THEY'RE CONSIDERED PRESCIENT IN TERMS OF THE AIDS EPIDEMIC. HOW DOES THAT SIT WITH YOU TODAY?**

*Videodrome* was considered to be prescient vis-à-vis the Internet and interactive media. Even *The Fly* was considered, well, not to be prescient about AIDS, but *actually about* AIDS. There's a branch of science fiction that prides itself on predicting the future, and takes great delight in it when it comes to pass. Arthur C. Clarke wants to say, "I predicted satellites thirty years before there were satellites," and so on. I don't see myself that way. I don't think prophecy is my game. On the other hand, if you are doing what an artist should do—that is, lowering all your defenses and having antennae to pick up all those slight signals in the air that are there for everyone to pick up, you'll inevitably anticipate something.

In *Rabid*, I invented a whole stem-cell research thing. The premise is based on tissue that's been neutralized to the point that it doesn't know what it should be, and that's what stem cells are. I actually did research that was available then, and I could see that the human body does produce these neutral cells that have the potential to be anything. I thought that was pretty fantastic. It's taken this long before it's actually manifested itself in medicine as a tool to be used, but I could anticipate this thing. I once thought that I could be a scientist, but I realized that I'd rather just invent the stuff than spend the thirty years really making it happen.

**WHAT INVENTION WOULD YOU LIKE TO SEE BECOME REALITY?**

Well, I like teleportation. I've already done that in *The Fly*, which of course was a remake of the original. You know, I read somewhere that some people are now thinking that maybe it is possible. Perhaps not in the foreseeable future with a creation as complex as a human being or a living creature, but with some more simple substances. It would have huge, huge repercussions.

**DO YOU WATCH TELEVISION?**

Not really. I used to watch it a lot as a kid, and that's where the idea for *Videodrome* came from. We had this rotating antenna, and when all the networks went off the air, you could rotate your antenna and pick up some strange things, like from Buffalo, Queens, Toronto, the Great Lakes. They'd be these fascinating, kind of shadowy and mysterious programs, and you weren't sure whether half of what you were seeing was your imagination or reality. Today, I watch sports. I don't really watch series TV anymore. I use my TV set basically as a DVD player.

**WHAT'S YOUR NEXT PROJECT?**

Nothing certain. There's a couple of possibilities; one that's been in the news a bit is *London Fields*. It's a challenge to try to get it on the screen, but there's a good script that was cowritten by Martin Amis. Another possibility is an original script that Bruce Wagner wrote. He's a brilliant novelist and a good friend, and I've been trying for years to think of something we could do together. *[Note: Forty-eight hours after our interview, it was announced that HBO had commissioned* Dead Ringers *as a series. Holdout!]*

**DO YOU THINK SNARK IS AN ISSUE IN REVIEWING? DOES IT SEEM THAT WE'VE BECOME A CULTURE OF CRITICISM AT THE EXPENSE OF CREATION?**

Yeah. Some of the reviews, you have to think—and I'm not talking about this movie—but you have to think, "You can't hate my movie that much." It's pathological. There has to be something else going on there.

**AND WITH BLOG CULTURE, THAT'S MAGNIFIED. A CELEBRITY WALKS DOWN THE STREET AND INSTANTLY—MUSINGS ABOUT WHAT THEY WERE WEARING AND HOW AWFUL IT WAS AND HOW MUCH THEY'RE HATED.**

The obsession with celebrity is another thing. I remember Pauline Kael was the first film critic to review an actor's persona, not their performance, and I always thought that was curious.

**WE RECENTLY INTERVIEWED DON ROOS, WHO DEFENDED THE HOLLYWOOD CLOSET. HE SAID, "I DON'T WANT TO KNOW ANYTHING ABOUT AN ACTOR'S OFF-CAMERA LIFE, BECAUSE IT INHIBITS THEIR BELIEVABILITY AS A CHARACTER."**

Yes, and it affects me as a director, when it comes to casting. Back when I was going to do *Basic Instinct 2*, I wanted to cast Rupert Everett as the male lead. Sharon [Stone] was fine with it, but the studio wouldn't allow it. They said no one would buy him as a heterosexual man. I said, "That's ridiculous—he's an actor." They said, "Well, he's *militantly* gay. He's made a point of being open about it." Can you imagine what will happen if people are cast entirely based upon their persona?

**YOU KNOW, I HAD FORGOTTEN ABOUT *BASIC INSTINCT 2*.**

Well . . . let's not get into that.

# A CHURCH OF STORIES
## CHUCK PALAHNIUK PROPOSES A NEW RELIGION

BY CHUCK PALAHNIUK

In 1998, while in Los Angeles for the filming of *Fight Club*, I went with friends to the Getty Museum. All those antiquities, the decorative objects, all the galleries of stuff being looked at by hushed tourists, my friends and me. That endless parade of masterpieces—it was too much. Grinding, the way a day of yard sales can be grinding as your eyes find a name for each object, a place in history, a story. Too many famous stories butted together on that hilltop above Los Angeles.

Of course, I turned that day into a story.

In the 1970s, during my childhood, museums were more hands-on. You went to galleries to destroy fine art. You took a sledgehammer and mashed the nose of the Pietà. Or you kissed a picture and left lipstick. You tried to spray paint the Mona Lisa, or planted a bomb that would trash some Mirós. These days, of course, the Getty had guards and Plexiglas and motion detectors.

So, wandering with my friends, I asked them: "Instead of stealing or attacking established art, what if some frustrated artist tried to sneak his paintings into the world's museums?" This artist would paint each picture, matte and frame it, put two-sided mounting tape on the back, and wrap the picture inside his trench coat. He'd arrive like us, then open his coat and stick his work on a wall, right there among the Picassos and Renoirs.

This little yarn became a short story called "Ambition" and a screenplay. The story, about an artist desperate to find his place in history, I wrapped into a novel called *Haunted*.

This May, "Ambition" and *Haunted* will be published.

On March 13, the Metropolitan Museum of Art found a lovely, gold-framed portrait of a woman wearing a gas mask stuck on the wall of their gallery. On March 16, the Brooklyn Museum found a portrait of an 18th-century military officer holding a can of spray paint. The Museum of Modern Art found a painting on March 17 depicting a can of cream-of-tomato soup. The Louvre and the Tate museums have found similar paintings stuck on their walls.

According to the *New York Times*, this is the work of a British graffiti artist named Banksy, who wears a trench coat and fake beard as he hangs his work among the masterpieces.

A coincidence? Or are we more the same person than we'd like to admit? My thoughts are so much your thoughts that they hardly qualify as mine. The darkest fantasy you keep buried, someone else will get rich singing about on the radio.

Is it better to hide your dark idea and hope that all other people do the same, or to depict and share that dark idea?

While writing *Fight Club*, I talked to friends about the idea of a movie projectionist splicing porn into family films. One friend told me not to use the idea, saying it would prompt people to salt porn into everything. When the book was published, countless people wrote to tell me they'd already been splicing sex into Disney films, pissing into restaurant food, or starting fight clubs. For decades.

Still, do we do more damage when we share our dark fantasies—when we explore them through a story or song or picture? Or when we deny them?

Stories are how human beings digest their lives: by making events into something we can repeat and control, telling them until they're exhausted. Until they no longer get a laugh or gasp or teary eye. Until we can absorb, assimilate even those worst events. Our culture, it digests events by making lesser and lesser versions of the original. After a ship sinks or a bomb explodes—the Original Tragedy—then we have the news version, the television movie version, the talk radio versions, the blog versions, the video game, the Franklin Mint Commemorative Plate versions, the McDonald's Happy Meal version, the one-liner reference on *The Simpsons*. Echoes that fade.

Then, like the funny story you used to tell at parties, the story that would always get laughs, about how you took acid and ate half a fur coat one night, we stop telling that story. *Not* because it stops making people laugh—but because we've digested the event. It's resolved, and telling that story in any form no longer serves the teller.

Maybe that's why Radiohead no longer plays "Creep" in concert.

Maybe it's why we dream—compulsively telling stories, processing our experience like the food in our guts, even while we sleep.

But the stories we're afraid to tell, to control, to craft—they never wear out, and they kill us.

At least this is what I tell my friends when they ask me to shut up. To not give people any new ideas. This is my story about telling stories about telling stories. My way to digest what I do.

I tell people: The sooner we can tell a story, the quicker we can wear it out and make it a cliché, then the less power the idea will have.

Until the past century, religions used to give us a place to tell even our worst stories. Depict our most-terrible intentions. Once each week, you could turn your sins into a story and tell them to your peers. Or to a leader, who'd forgive you and accept you back into your community. Each week, you confessed, you were forgiven, and you received communion. You never strayed too far outside the group because you had this regular release. Maybe the most important aspect of salvation is having this forum, this permission and audience, for expressing our lives as a story.

But as church becomes a place where people go to look good—instead of being the one safe place where they could risk looking bad—we're losing that

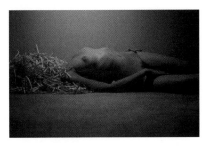

↑ ROSE AND OLIVE

"WOMEN HAVE RELEASED THEMSELVES FROM IMITATING MEN. NOW THEY HAVE TO FIGURE OUT HOW NOT TO BE CON- FUSED WITH HOOKERS."
—MAUREEN DOWD, 2005

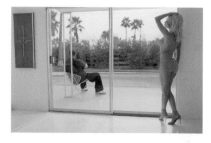

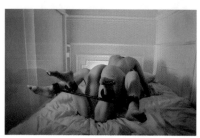

regular storytelling forum. And the salvation, redemption, and communion it allows.

Instead, now people go to therapy groups, twelve-step recovery groups, chat rooms, phone-sex hotlines, even writers workshops, to turn their lives and crimes into stories, express them, craft them, and in doing so be recognized by their peers. Brought back into the flock for another week. Accepted.

With this in mind: Our need to turn even the darkest parts of life—especially the darkest parts—into stories . . . our need to tell those stories to our peers . . . and our need to be heard, forgiven, and accepted by our community . . . how about we start a new religion?

We could call this the "Church of Story." It would be a performance place where people could exhaust their stories, in words or music or sculpture. A school where people could learn craft skills that would give them more control over their story, and thus their life. This would be a place where people could step out of their lives and reflect, be detached enough to recognize a boring pattern or irrational fears or a weak character and begin to change that. To edit and rewrite their future. If nothing else, this could be a place where people would vent and be heard, and at that point maybe move forward.

It would be a forum safe enough for you to look terrible. Express terrible ideas.

In modern history, frustrated, powerless people have turned to churches. During the last years of segregation, people found each other in churches and recognized they weren't alone. Their personal problems were not only their own.

This "Church of Story" would give people a forum for connecting. Here, we'd have a regular time and place and permission to tell stories to each other. Instead of ignoring this need or fulfilling it at Starbucks in the window of time created by a cappuccino—or wearing a fake beard and gluing our story on the wall of an art gallery—we could give people the permission and structure they need to gather. To tell stories. To tell better stories. To tell great stories. To live great lives.

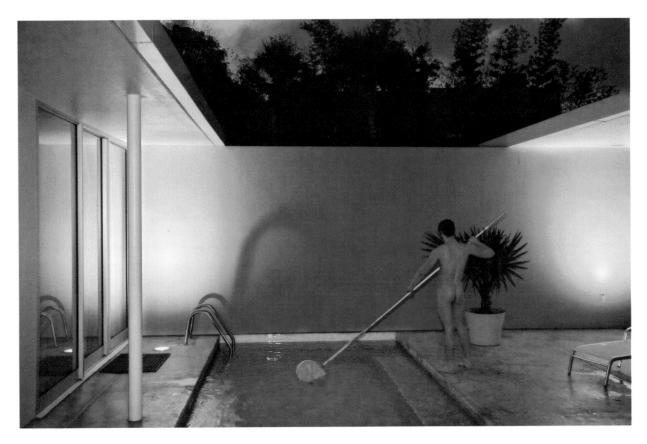

^ BRANDON HERMAN

# DONALD SUTHERLAND'S BUTTOCKS

BY JONATHAN LETHEM

"—Donald Sutherland's buttocks—" Those were the words that drew my attention from the other side of the table. My wife's friend Pauline was speaking them to my wife. What struck me

most wasn't the odd specificity of the reference, nor the muddled thrill of jealousy and delight that lurches through my heart as it does anytime I gather that someone is talking about something sexual with my wife (ensuring the instant obliteration of my attention to any topic I might have been discussing at my end of the table). What struck me then, and what strikes me now, is that I knew what Pauline was talking about, instantly. And so I leaned across and said: *"Don't Look Now!"*

No one who has ever seen it has forgotten the sex scene between Donald Sutherland and Julie Christie in Nicholas Roeg's *Don't Look Now*. The scene is characterized by a tension between Roeg's cool, artfully distanced camera and the (apparent) commitment to total disclosure on the part of the unclothed actors, which has led to the legend that what was filmed was something more than a performance. The borderline-explicit sex is edited, too, in a disconcerting series of cuts, with flash forwards to the couple dressing to go out afterwards. This deepens the meaning of the sex scene, adds a note of pensiveness, even sadness. The rest of the film—a supernatural melodrama both tragic and terrifying—seems to tug at the edges of that single scene, making the sex appear in retrospect more poignant and precious. Their beautiful, disturbing, uncannily real fucking will turn out to be the only moment of reprieve for the two characters, the only moment of absolute connection. Even the film's title comes to seem a reference to the intensity of the sex scene. The result is like a brand sizzling into the viewer's sexual imagination. We feel we've learned something about sex, even as we're certain it required every bit of our own previous knowledge of sex to be in a position to receive and confirm the scene's knowingness, its completely nonverbal epiphanies. And so, when I heard Pauline say, "Donald Sutherland's buttocks," I felt with a shudder my memory of this scene instantly recover itself, and I was touched and frightened and turned-on again. And I wanted to take my wife away from Pauline and the others and show her the scene, because unlike nearly any other scene of sex I'd ever watched, this one was like a piece of my own sexual past.

This, to put it bluntly, is what I want. Not Donald Sutherland's buttocks in and of themselves, but films that install themselves this way in my sexual imagination, by making me feel that sex is a part of life, a real and prosaic and reproducible fact in the lives of the characters, as it is in my own life, and at the same time make me feel that sex is an intoxicant, a passage to elsewhere, a jolt of the extraordinary which stands entirely outside the majority of the experiences of

the characters, as it stands in relation to my own experience. Do I contradict myself? Very well, I contradict myself. I want the paradox. I want it all.

Where and how this can come to happen in cinema's future is beyond my expertise—it occurs rarely enough in cinema's past and present that I suspect it is beyond anyone's expertise, that it instead must be discovered, perhaps even scared up sideways, in the midst of operations in pursuit of other truths. (Certainly *Don't Look Now* wasn't conceived, or received, as a "sex film"—and I've recently learned that the famous scene was in fact an afterthought, shot after the script was exhausted but the director unsatisfied). I didn't meet even a hint of it in *Closer* or *Y Tu Mamá También* or *Henry and June* or *We Don't Live Here Anymore*, but I did in the Israeli director Dover Koshashvili's *Late Marriage*, a slice-of-life drama both farcical and realistic. In *Late Marriage*, when the mama's-boy protagonist calls on his secret girlfriend, an older woman, the two unexpectedly devour each other in a long explicit scene that pinballs from annoyance to arousal to boredom and back to arousal, with a pause in the middle to sniff a used tissue for traces of bodily fluids—precisely the sort of Donald-Sutherland's-buttocks moment that makes a sex scene ineffable and lasting, a revelation. I met it for an instant in Preston Sturges' *The Lady Eve*, in the expression that crosses Barbara Stanwyck's face, so giddy it almost feels like an actor's lapse out of character, as she says to Henry Fonda: "Why, Hopsie . . . you ought to be kept in a cage!" (Oh, yes, I meet it often when I watch Barbara Stanwyck, and I wonder where our Barbara Stanwyck is hiding . . . might it be Maggie Gyllenhaal? On the strength of *Secretary* it seems possible . . . but then why aren't today's filmmakers making dozens of Maggie Gyllenhaal vehicles . . . what's their problem?) I met it, unexpectedly, in Miranda July's forthcoming ensemble comedy *Me and You and Everyone We Know*, where several child characters are portrayed with their sexual curiosities not only intact, but capable of setting up genuine erotic reverberations in the adults, with results that are not only disturbing and funny but also disconcertingly honest. (This is a matter that American films have been too fearful to take up, despite Hollywood's compulsive trafficking in child sexuality as an unacknowledged source of revenue, and as a source of energy in otherwise lifeless product.) I met it in Ralph Bakshi's pornographic animated films, a couple of times—most of all in the crude sequence of sex-in-a-moving-jalopy, set to Chuck Berry's frantic and bawdy "Maybelline." The scene somehow manages to convey a moment of sexual self-discovery in the autobiographical cartoonist character who is drawing the images, ratifying his lust by satirizing it. I met it, of course, in Luis Buñuel's *Belle du Jour*, when Catherine Deneuve, playing a wealthy housewife slumming as a prostitute, dares herself to look into the mysterious buzzing box presented to her by the enigmatic Asian whorehouse customer. What she sees there intrigues her, and her curiosity pleases the Asian gentleman. We cut to a scene afterwards, where

▲ WILLIAM HUNDLEY

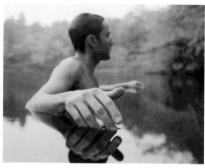
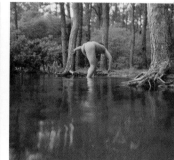

⌃ DAVID HILLIARD

› SAMANTHA WEST

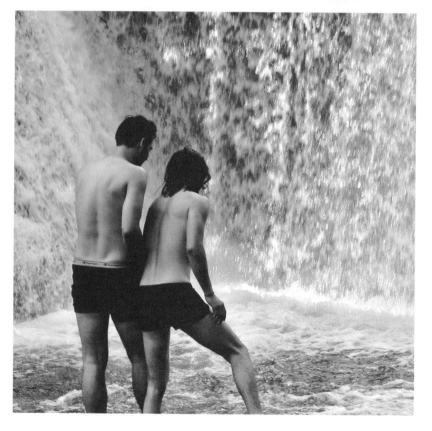

both have been gratified by whatever it was that occupied the strange, buzzing box—we never get to see inside it ourselves.

Am I calling for a return to reticence, to mystery? No. I'm calling for what I don't know to be calling for, I'm calling for surprise, for complicity delivered in an instant, I'm calling for filmic moments that lure and confuse me the way sex can, at its best. I don't want to choose between scrupulous, grainy, documentary realism (or the new and unsavory hi-definition nudity I've been warned about) and fantasy, imagination, exaggeration, cartoons—I want them both. Give me prosthetics, like Marky Mark's penis extension in *Boogie Nights*—give me even more like that, give me a whole cinema of actors in fake bodies, like Cindy Sherman's prosthetic pimply butts and swollen breasts in her still photographs. Give me the sex lives of animated characters, and of rotoscoped actors, like the ones in Richard Linklater's *Waking Life* and his forthcoming *A Scanner Darkly*—a perfect solution to marrying glamorous and recognizable actors to explicit bodies without disturbing us or the actors by disclosing the actual bodies of actors, a perfect way to keep from rupturing the dream. Give me real bodies, too, of actors I haven't met yet, in scenarios which are stubbornly unpornlike and only half-erotic, like Michael Winterbottom's forthcoming *Nine Songs*. Let me see what happens if Michael Winterbottom has to show his bottom, and Eliot Winterpenis his penis, and Carla Summertits her tits, and Lucius Spring-testicles his testicles, and Delia Solsticeclitoris her clitoris, and so on. And, for that matter, Donald Sutherland is still among the living: let's see how his buttocks are holding up. C'mon, show me something the mention of which will make my head turn at a dinner party thirty years from now. Try and make me blink. Try and make me keep from blinking.

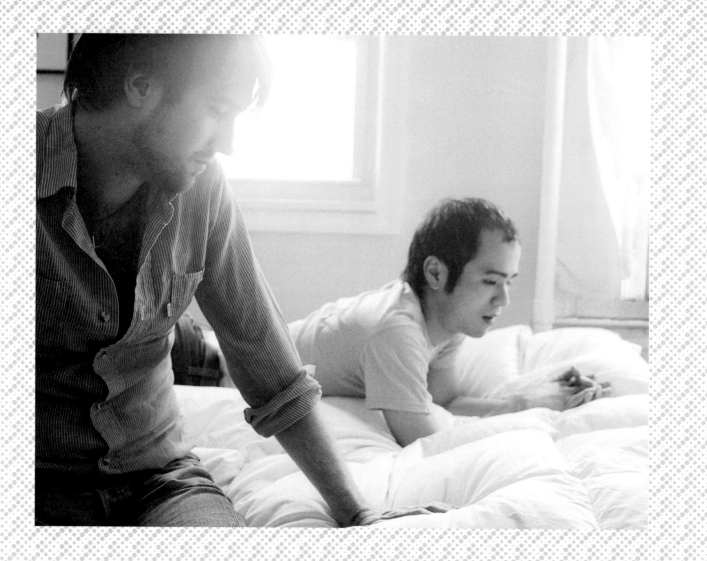

2006

‹ FUTOSHI MIYAGI

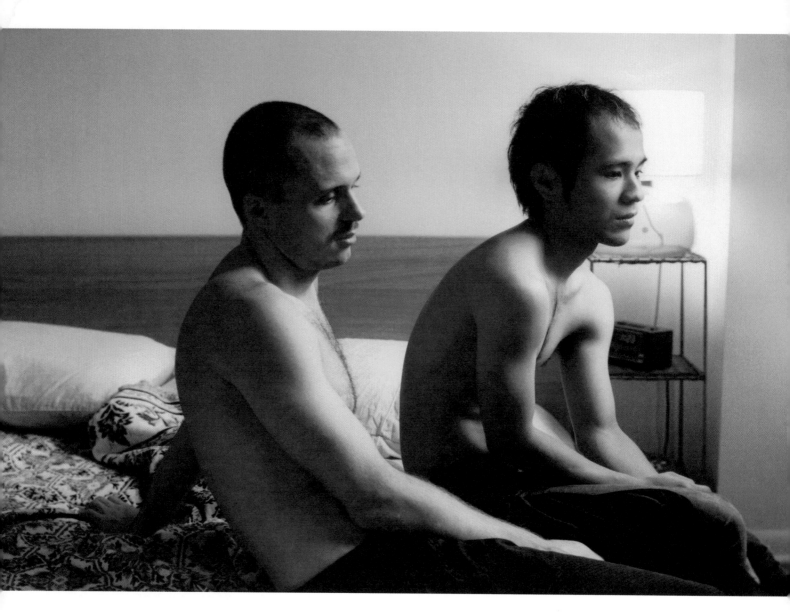

PHOTOGRAPHY BY
# FUTOSHI MIYAGI

Since 2005, Brooklyn-based photographer Futoshi Miyagi has been compiling a photo series in which he photographs himself in the homes of other men. In the photos, he and his subjects appear in poses that suggest pre- and post-coital scenarios. The result is a visual record of one-night stands that never actually happened: in one, a tall stranger clutches the diminutive photographer to his chest in front of a mirror reflecting an expansive loft; in another, Miyagi leans over a bathroom sink, bath towel around his waist, while an older, balding stranger stands naked in a sunlit shower next to him.

"It's such an instant intimate relationship that you establish," says Miyagi, a soft-spoken twenty-four year old from Japan who moved to New York four years earlier to attend City College. "To some extent, it's not real, but sometimes it lingers for awhile." So much so that he's even had sex with a few of his strangers in the days after the shoot, though never during the shoot itself. "The camera does make it sexual, but at the same time, it keeps this separation," he says. "It stops me from going too far." —SEAN KENNEDY

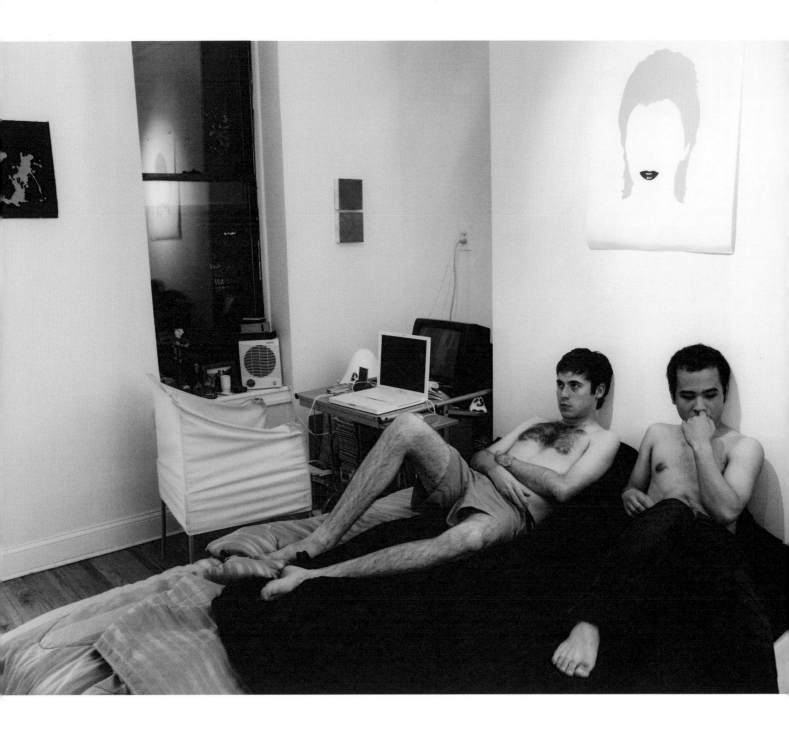

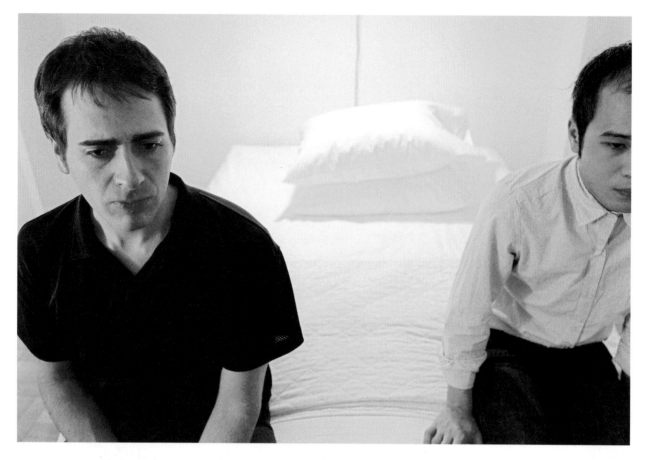

^ > FUTOSHI MIYAGI

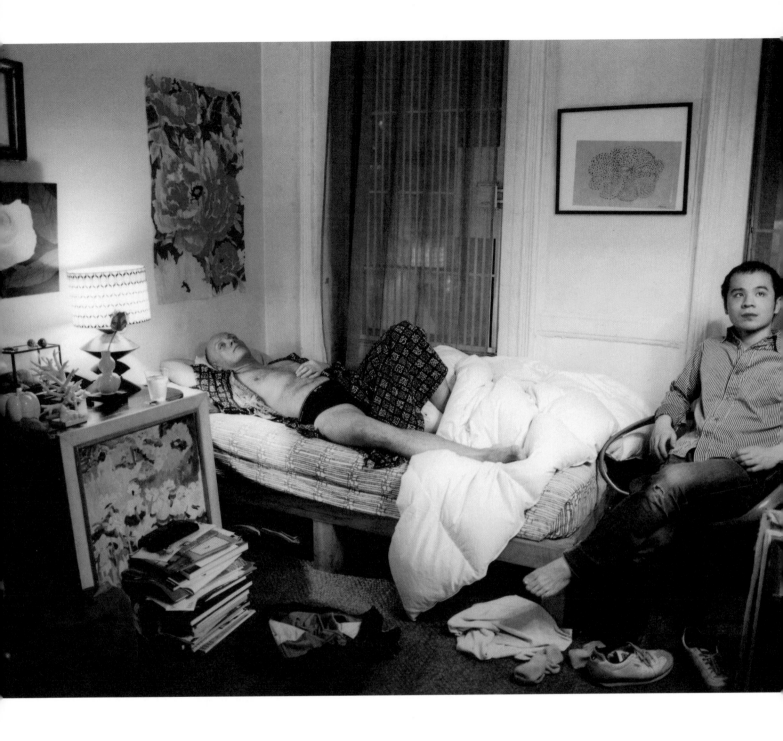

# MARATHON MAN

BY JONATHAN GOLDSTEIN

For some reason, when I was 18, on the rare occasion I was able to convince a woman to sleep with me, afterwards, as we lay in bed naked, I would become terribly depressed.

I still can't say what exactly it was, and as I got older the feeling left me alone. But at that time, I was very sensitive and had to tread lightly in the arena of sex. Blowjobs left me feeling lonely and vulnerable. Sixty-nines made me feel claustrophobic, like I was being buried alive. Even massages made me anxious, more conscious of my own blood-and-gutness than was to my taste.

The only sex act I found myself comfortable with was the handjob. There was something about it that felt easy and conversational. It was like going for coffee with a friend, but with your dick included in the chat. And I should say that even in the HJ department, I wasn't exactly laid back. So used to the way I handjobbed myself, it took me a good ten minutes just to acclimatize to another person's touch. Once we got going, I needed a lot of encouragement—reassuring talk, oils, balms, and constant repositioning. Plus, a decade of self-abuse had rendered my dick pretty much aristocratically indifferent. I had to practically slam it in a doorjamb to get it halfway turgid. So a typical handjob usually took anywhere between twenty to thirty minutes, with me shouting "harder!" and "faster!" like I was whipping a team of snow dogs across the tundra.

Of all the fist fellatio I received during that unfortunate period, the most grueling, soul-debilitating, and dehumanizing took place in my parents' basement. It was midnight. I was hanging out with my girlfriend, Amy, drinking beer and listening to the local classic rock station when she told me to lean back on the couch and take off my pants.

Tired, slightly drunk, and not especially aroused, I still did as I was told, and as I did so, she took off upstairs to look for paraphernalia.

"There's some ointment in the downstairs bathroom," I said.

"I never want to hear you use that word," she said. "It turns me off."

Amy was the kind of overachiever who prided herself on getting the job done, the type who made birdfeeders, baked complicated pastries, and taught herself to play the French horn. I was the kind of guy who used words like "ointment."

I'll never forget how hopeful and sweet she looked trotting down the stairs, her arms loaded with pharmaceuticals, so completely unaware of the handjobathon we were about to embark on. It was like the beginning of that Stephen King novel, *The Long Walk*, where all the kids show up, well rested and fresh-faced, about to embark on the neverending jaunt that would eventually kill them.

The start was pretty promising. Despite the three or four beers in me, I became erect easily. She pounded away, looking at me, looking at the ceiling, smiling, sighing. After fifteen minutes, she stopped to massage her wrist.

"You don't have to continue," I said.

"No, I want to," she said.

I guess she was still under the impression that leaving a job unfinished could prove a blemish on her sexual resume. So she carried on, as though getting me off were some kind of logic problem that could be solved through perseverance. She brought to it all of the overachieving eagerness she brought to all of her undertakings. It was like doing a thorough job on a bibliography or getting out a grape-juice stain. Nothing a little old-fashioned elbow grease and determination couldn't resolve.

She started up again, her fist pogo-ing up and down, her fingers doing fancy little French-horny things. I watched, unimpressed. Twenty minutes in, my mind began to wander: *Was this what that song from* Grease, *"Hand Jive," was really about? Is that what we were doing? Hand jive? Can there really exist an orgasm machine like the one from* Young Frankenstein? *Have my friends just been giving me a good time or am I really that great a dungeon master?*

Amy let go and rolled her hand around on her wrist, her mouth wide open in mock/real pain.

"Are you even enjoying this?" she asked.

"Of course," I lied.

*What exactly is head cheese? Who's next in line for president after Speaker of the House?*

After another spirited half-hour, she introduced her left hand to the equation, using it to manhandle my balls. It was like watching one of those science films of a Neanderthal trying to start a fire. Yet somehow I remained, all throughout, as hard as a ketchup bottle.

Two A.M. came and went. I started drifting in and out of consciousness. I'd have these quick two-second dreams where I'm riding a unicycle along a bumpy gravel road. I'd reawaken with a start to find her pounding away, no longer even looking at me, dropping the charade of eye contact and focused solely on my penis. It was as if she were enacting an age-old primordial tale. Like a sexualized version of *The Old Man and the Sea*, this had become a test of endurance between her and my dick.

"You are a worthy opponent, but come you shall."

The clock on the VCR read 3:00 A.M. Aside from a few cigarette breaks and a couple chats about "what the hell was the matter here," they had been at it, my penis and her, for three hours straight. I felt completely alienated from her, from my own penis. From life itself.

"ONE OF THE REASONS PEOPLE ARE GETTING KINKIER IS JUST TO GET A SNIFF. IN THE OLD DAYS, YOU COULD REALLY SMELL YOUR MATE. THE KINKINESS NOW, WHATEVER IT IS—BEING HUNG UPSIDE DOWN WHILE GETTING A BLOWJOB? THE POINT IS, IT'S ALL IN SEARCH OF A LOST SMELL."
—NORMAN MAILER, 2006

I decided to take a shortcut to the finish line. I closed my eyes and imagined myself in my 11th grade classroom being masturbated by Mrs. Velardi, our thirtysomething art teacher who wore tank tops and bandanas. Then, in the midst of it all, in walked Amy. I saw her, wearing the same thing she was wearing beside me on the couch, but instead of being flesh and blood, she was imaginary—entirely in my head.

Oddly, closing my eyes and imagining being jacked off by Amy was more titillating then keeping my eyes open and watching the actual thing. It made it more perverted somehow, and thus transported me to the next level.

"Faster," I whispered. "Harder."

The radio was blasting a Doobie Brothers retrospective. I reached over and turned it off in the middle of "Taking It to the Streets." The Doobie Brotherless silence was all I needed, and thirty seconds later I was an out-of-control garden hose.

I remember Amy raising her hands in the air, triumphant, like that freeze frame of Judd Nelson at the end of *The Breakfast Club*.

The next day, I would wrap my penis in toilet paper to keep it from rubbing against my jeans. It was bruised and battered, but also oddly naked—lonely without a hand wrapped around it, pole-dancing to classic rock 'n' roll. Eventually, of course, it would grow most comfortable in its aloneness, but just then it needed coddling.

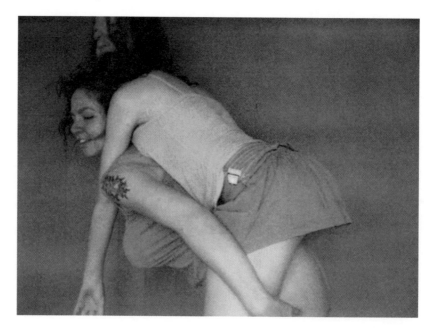

› ROSE AND OLIVE

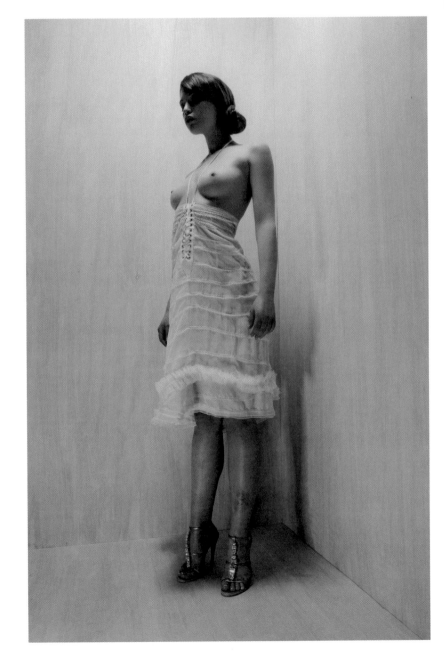

^ CLAYTON JAMES CUBITT

**How can I engage my boyfriend in a rough, sexy wrestling match?**
As soon as he walks through the door, throw a bag over his head and trip him. Once he's on the mat, have your friend ring a bell and start going.

**I want to wear something sexy and revealing for my boyfriend, but I'm a big girl. What'll work with my curves in a flattering way?**
A valkyrie costume (www.illusions gallery.com/Valkyrie-Arbo.html). You know, with the horns on your head and the cone bra and the long, blonde braids. Valkyries are always big, busty ladies. Or you could be a sexy cavewoman. Any sort of fantasy role-playing suits curvaceous body types. It shows that you have confidence in yourself, that you're willing to put on knee-high boots and a cape and be like, "Let's get it on."

**What's the secret to looking good in spandex?**
When you're in Jell-O, you look good in anything.

**What's the best way to pick up a wrestler?**
Tell her she can leave her mask on.

# SUMMER STORM
## REVISITING THE SADDEST, SEXIEST MOVIE
## I'VE EVER SEEN—*BETTY BLUE*

BY STEVE ALMOND

I was miserable the summer I saw *Betty Blue*, living in a dead college town without hope of action. By day, I was an intern at the *Meridan Record-Journal*, working solid waste and obits. Nights I

spent in a sweltering flat on Oak Street with my two goony roommates, Ben and James. We were going to be rock stars, but first we had to whack off.

The diet was pepperoni grinders and birch beer, the means of transport a Mercury Bobcat purchased for the princely sum of $250. The muffler of this vehicle came loose every third trip and scraped the road, producing a shrill aria and shooting sparks up behind the car. Such were the fireworks of my existence.

Into this dismal milieu came *Betty Blue*. James had a bootlegged copy, on Beta I believe, and we watched it in the basement of the house where the girl I had a crush on lived. She was upstairs blowing her hippie boyfriend.

The film opens with Betty (Beatrice Dalle) and Zorg (Jean-Hugues Anglade) clamped naked under a poster of the Mona Lisa. This is not some coy, choreographed encounter, but several minutes of congress, their bodies damp, exposed, ardent, a certain stunned pleasure to the eyes. Zorg is on top and at one point he reaches down between Betty's legs (I hadn't realized this was allowed!) and she begins to whimper. Then she reaches down herself and the tempo increases, her lovely breasts begin to vibrate, his thighs tense, she bites his chin, he growls . . .

To this point, just through junior year in college, I had never seen lovemaking in a movie. Porno sex, the jackhammer variety, sure. But nothing so flagrantly tender. Nor had I seen—let alone taken part in—a simultaneous orgasm. I was (to put it mildly) hooked, engorged, delirious.

But it wasn't just the sex that got to me; it was the emotional danger of the story, the sense of love as a preamble to ruin. The film was French (this may go without saying) and the director, Jean-Jacques Beinix, showed the good sense not to load us down with backstory. "I had met Betty a week earlier," Zorg informs us, as they lie in a ravishing heap, "and we had screwed every night." The next thing we know, Betty appears on the doorstep of Zorg's beach house wearing an apron and nothing else. She moves in, they drink tequila shooters, they go down on one another, life is good. Zorg works as a handyman to make ends meet. But one night, Betty finds an old novel he wrote, and becomes convinced he's a genius. Then Zorg's lecherous landlord appears, and we discover that Betty has rather serious anger-management issues. He makes the mistake of bullying Zorg. Betty throws paint on his car, pushes him off a balcony, and torches the beach house for good measure.

The two young lovers set up house in Paris, then a small village. But Betty keeps going postal. Her brief stint as a waitress ends when she stabs a rude

patron with a fork. With each outburst, she drifts further and further toward outright madness. And there is nothing cute or redeeming—nothing Gumpy, in other words—about her condition. Beinix refuses to romanticize the turmoil. His cinematography is achingly beautiful, but always tinged with the florid. In one shot, we see Betty staggering through the dusk in a flaming red dress, in another the sun has broken into fragments. Zorg refuses to abandon her. Loving her is clearly the most reckless act of his life, but he's utterly helpless to do otherwise.

And who among us has not longed to feel this way? So desperately, irrevocably in love? That was certainly how I felt twenty years ago, watching *Betty Blue* for the first time, in that sticky basement. I wanted to be wrecked by love, or at the very least assaulted for a few weeks.

Did it happen that summer? Of course not. Instead, I drove the Bobcat into submission and pounded out my somber obits and sweated pit stains into my Oxfords. But it can't be taken as a coincidence that, upon returning to school, I got involved with a woman who was a dead ringer for Betty—the same dark hair, the same lush, protruding lips and square teeth. Nor that she believed in me as a writer, long before I considered myself one.

This was the less obvious allure of *Betty Blue*: the movie was wish fulfillment for young writers. Zorg was like all of us literary schmucks, just waiting for someone to recognize our true calling. I especially savored the scene in which Betty (having read his manuscript in one sitting!) cooks him a celebratory dinner. "When I think that you wrote that," she says, adoringly. "I've never read anything like it."

Can you imagine hearing such words? Spoken by a pale, horny Frenchwoman? Then she feeds you turkey and chestnuts and kisses your whole body? The fantasy haunted me for years. Hell, I would have settled for a turkey potpie and a handjob. I still would.

But it doesn't stop there. Betty sets about typing up his manuscript—using only two fingers, mind you—and mails it to publishers. When one of them sends Zorg a nasty rejection ("I return this nauseating flower you call a novel"), she marches over and slashes the guy's cheek with a comb.

Zorg arrives at the police station to bail Betty out. The cop seems like a hard case at first. But when he finds out Zorg is a writer, his expression softens. He hauls out his own novel manuscript and a bottle of vodka. "Publishers are all fucking assholes," he declares. I loved the idea that the world might be filled with just such a secret fraternity of writers, bitter and dreamy and ready to forget the rules.

It all goes bad for Zorg and Betty in the end. Of course it does. And the final scenes are impossibly wrenching.

American audiences, for the most part, missed *Betty Blue* the first time around. This was the late '80s, after all. Our citizen-consumers were just

"THE HEAD GETTING CLOSE TO THE GENITALS IS, IN A WAY, MORE INTIMATE THAN LETTING THE GENITALS DO IT ON THEIR OWN. OUR SENSORY ORGANS, INCLUDING THE BRAIN, ARE RIGHT DOWN THERE, AND IT HAPPENS LESS FREQUENTLY IN COUPLES AS THE RELATIONSHIP AGES AND EVOLVES."
—JOHN UPDIKE, 2006

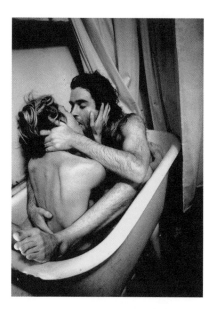

beginning their long plunge into the cinema of pornographic violence. Not even the upscale reviewers seemed to understand what *Betty Blue* was: a sustained meditation on the perils of love—no crazy ethnic family or gay best friend for laughs, no serial killer to goose the drama. I can't imagine that the 20th-anniversary director's cut will fare much better. It's an hour longer than the original, twice as dirty and twice as sad. As a nation, we have proven astonishingly adept at dodging the bad news of our hearts.

But I plan to watch the movie again (and again) to remember who I was during that summer, how sore with the need for love, how brutally alone, and how—like Betty and Zorg—I secretly wished the pain would never end.

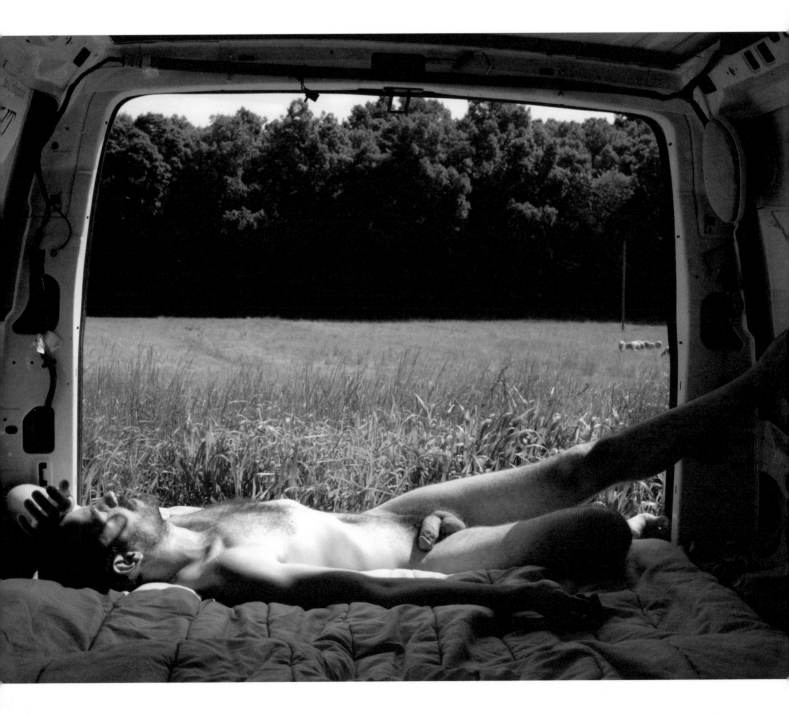

# NORMAN MAILER AND JOHN BUFFALO MAILER

BY WILL DOIG

It's been fifty-eight years since Norman Mailer's first publishers persuaded him to change all the "fucks" in his debut novel to "fugs," and he's been verbally making up for it ever since. Beginning with the publication of his first novel, *The Naked and the Dead*, when he was 25, the legendary author has steadily developed a reputation, true or not, as a hard-headed womanizer who picks fights with his critics. Meeting Mailer today, at 83, it's hard to imagine. Dressed in sweats and an old pair of boots that appear to be duct-taped, he stands less than a foot shorter than I am.

His Brooklyn Heights apartment sits high above the piers that were the borough's economic heartbeat in the '60s, back when Mailer was pioneering a new kind of journalism that combined facts, commentary, and novelistic elements. Those piers are now partially obscured by the upper deck of the elevated Brooklyn-Queens Expressway. In Mailer's living room, a large flat-screen TV peers down at earth-toned antique furniture. His son, 27-year-old John Buffalo Mailer, sits next to him, leaning forward in his chair. The sensation of the future running right alongside the past is everywhere you look.

The concept for Mailer's latest book, *The Big Empty*, was spearheaded by John. It's a series of transcripts from conversations they've had over the past few years, some that have previously been printed in magazines and some that they recorded themselves. It puts the perspectives of two generations (actually separated by fifty-five years) side by side on topics ranging from sex to politics to boxing, and finds that the world has only changed so much.

**Norman:** Let me warn you in advance, I used to be in possession of a reasonably good syntax. That's no longer true.

**OKAY.**
I'm also hard of hearing—particularly when I don't like a question, like a number of politicians.

**RIGHT, LIKE NIXON. WHENEVER HE GOT A QUESTION HE DIDN'T LIKE, HE'D SAY, "I'M GLAD YOU ASKED THAT," AND THEN HE'D CHANGE THE SUBJECT.**
Well, if you can't divert the incoming point of a tough question, you shouldn't be a politician.

**IT'S SCOTT MCCLELLAN'S SPECIALTY.**
Yeah. To say something truly mean about him, and maybe even unfair, he is the fat boy who wouldn't bend over. Though I guess that's actually a positive remark.

**YOU SAY IN THE BOOK THAT OF ALL THE PEOPLE IN THAT GANG, DONALD RUMSFELD IS THE ONLY ONE WHO SEEMS "REAL" TO YOU. WHAT DOES THAT MEAN?**
I'll give away a secret: my father and Rumsfeld have a certain physical resemblance. They weren't alike in other ways, but that gave me a certain sense of Rumsfeld being an interesting guy, at the very least. Not to defend him. It's just that he's the only one of those people who I think is real. Part of combat wisdom is to know who you're up against. Which enemies are you going to respect, and which are you going to despise? If you despise them broadside, then you're in the ranks of the politically correct, and in real spiritual trouble.

**YOU BOTH HAVE A SEVERE AVERSION TO POLITICAL CORRECTNESS.**
You could boil water with that aversion.

**YOU'RE ALSO VERY SKEPTICAL OF TECHNOLOGY. HOW ABOUT SOMETHING LIKE ONLINE PERSONALS?**
Let me get this straight. They meet up on the Internet? In other words, "I'm blank-blank-blank, I like blank-blank-blank . . ."

## EXACTLY.

I have no experience in that direction. The nearest I ever came was about sixty years ago. *[To John]* I don't think I ever told you this story. About sixty years ago, I got into a correspondence with this woman. When you're an author, people can send a letter to your publisher to get it to you. So we wrote and wrote and wrote. Finally, I said, "If you're serious and you're coming to New York, take a room at this hotel, and I'll come there, and when you open the door I want you to be stark naked." And it came to pass. That's the nearest I ever came to online dating.

So I did have a few romances by mail. It's not shocking to me. In fact, I can see where it has a libidinous edge, this idea that you can start with a lack of knowledge about someone and, step by step, move into more intimacy.

## IN THE BOOK, YOU BOTH AGREE THAT WOMEN "CONTROL" MEN. COULD YOU ELABORATE?

I think women are in control mainly because they see themselves from early girlhood as future coaches. They're in control the way a coach is in control. Coaches can handle athletes who are much more powerful than they are. You have guys who could kill you with a punch, and his little Jewish manager says, "Listen, you dumb fuck! How many times do I have to tell you to keep your right up around your ears? Do I need to tie a string to your fucking head?" And this big oaf of a guy is like, "Gee, okay boss. I'm so sorry." You could use that as a paradigm for marriage.

## BUT SURELY YOU DON'T THINK WOMEN ARE IN CONTROL POLITICALLY OR ECONOMICALLY?

**John:** I don't think women are dominating the workplace. To say that women are running things is just false. But I do see more female CEOs popping up, and I'm encouraged.
**Norman:** Well, look John, let's disagree to a degree. Men are running the economic machine, yes. No disagreement there. But the women who get the positions of power, they don't think as women, they think as corporate executives. There's no difference whether the women are running the corporation or the men.

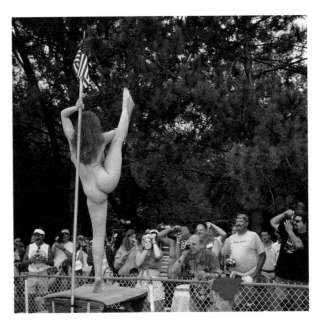

^ TOM TAVEE

**John:** Well, that's the shift I'm hoping to see, that if we have women in powerful positions, they'll lend feminine qualities to it.
**Norman:** Look John, being in power not only means you're able to affect the machine. It also means the machine takes you over. The arch example I can think of is astronauts. You've got astronauts who travel to the moon, and they get what they wanted: the glory of doing something with the machine that no one had ever done before. But the machine has huge effects upon them too, and I would say the same applies—on a smaller scale, of course—to a powerful woman who takes over a corporation. She will end up being more affected by the machine than she will affect the machine.

One of the reasons I love being a novelist is the only machine that changes you is the novel itself. The novel has its own logic, and that logic alters you in working on the novel. This longwinded speech is to one effect: disabuse yourself of the idea that women in power are going to make for a better society.

**IS IT WORTHWHILE FOR YOUNG PEOPLE TO NAÏVELY TRY TO CHANGE THIS MACHINE, EVEN IF IT'S IMPOSSIBLE?**

Absolutely, because the only real rule of character we can depend on is how much you can learn from your defeats. Victories are dangerous. All victories ever did was swell my ego.

**NORMAN, IN YOUR GENERATION, GETTING MARRIED WAS A GIVEN. IN JOHN'S, MARRIAGE IS QUITE OPTIONAL. IS THERE ANY REASON TO GET MARRIED ANYMORE?**

When I was a kid, marriage was still sacramental. Till death do you part, that sort of thing. A lot of that is gone now. When the sacramental aspects disappear, there's much less logic to marriage. Ninety percent of marriage is very mechanical. You're at breakfast and you say, "Hon, would you pour me another cup of coffee?" That's become part of the machine of interrelationship. In certain marriages, it's "Pour the fucking coffee yourself." That's not part of the machine, and no marriage can survive very long unless 90 percent of it becomes very predictable. In other words, you can't have a marriage where every time, the reaction is, "Pour your own fucking cup of coffee." There's a need in the psyche to have something that's highly predictable, and I think a great many people get married for that reason—literally, if you want to take it at its worst, for the *boredom* of marriage. Because at least when they're bored, they're not as full of dread as they are when they're free of boredom.

**ISN'T THAT BOREDOM ANTITHETICAL TO SEXUAL PASSION?**

Of course. But that's also part of it. When you're driving a car that has five hundred horsepower, you need some kind of brakes. All right, that's a crude image. *[Laughs]* All I'm getting at is that very often, highly sexed people get married in order to have an outlet. *[Pause]* Let me see, I can say something better than that. What a way to end up, huh? You could hang yourself with a sentence like that. *[Long pause, throat clearing]* People, whether highly sexed or not, often need a machine like a relationship, something like an accelerator and a brake. Marriage allows you to do that very well. It's the soft machine of society.

**YOU SAY THAT DURING THE SEXUAL REVOLUTION, SEX WAS "ENNOBLING." IS THAT OVER FOREVER? ARE THOSE OF US WHO MISSED THE SEXUAL REVOLUTION DOOMED TO IGNOBLE SEX?**

**John:** I think STDs are the biggest difference. A guy who gets laid with a different girl every week, that's scary to a lot of women. At the same time, I think people are kinkier than they've ever been. You can look to the Internet to see. The stuff out there is mindblowing. Me, I don't trust someone till I can smell them. You can feel the energy of a person, you can sniff them out. They can tell you all the right things, but in person you can still tell, "Hmm, this is a bad guy."

**Norman:** Alright, let me demolish your thesis. Your thesis is wonderful so far as it goes, but you're leaving one crucial factor out. When you meet the person, when she walks in front of you and you want to sniff her, she's wearing deodorant. And I would argue that one of the reasons people are getting kinkier is just to get a sniff. In the old days, you could really smell your mate, and smell is the animal sense that inspires you. It got you hot.

**John:** I hate to argue with you, but deodorant's been around for a while. It's not a newfangled invention.

**Norman:** In the old days, it stank so bad that a respectable woman wouldn't wear it.

**John:** But the deodorant mixes with your own scent. You put the same deodorant on two people, they're not going to smell the same.

**Norman:** That's true, but it's a huge distortion. Look back to the court of Louis XIV. They bathed every three or four weeks, so you got the raunchiest crotch odors mixed with some very special perfumes. And of course, they were screwing in every bush, not to mention every bedroom in Versailles. I'm just saying, the kinkiness now, whatever it is—being hung upside down while getting a blowjob? The point is, it's all in search of a lost smell.

**LET'S GO BACK TO WOMEN AND POWER FOR A MOMENT. IN THE BOOK, YOU SAY, "THE DESIRE FOR POWER IN WOMEN THAT'S REVEALED ITSELF IN THE LAST THIRTY-FIVE YEARS IS NOT ATTRACTIVE." I ASSUME YOU MEAN NOT SEXUALLY ATTRACTIVE?**

No, I meant politically attractive. They're not saying things we haven't heard before, not showing the way in which we could have a better world. Their critical abilities are often excellent. The worst attacks on the Democrats during the Clinton administration came from people like Mary Matalin. Women who were absolutely livid in their hatred of the Left. Hillary, once in a while when she gets sharp, is pretty damn good. Arianna Huffington is a true, almost obsessed critic. But what I'm getting at is, in terms of new political ideas, I don't see where the female Marx is lurking.

**John:** It hasn't been very long that women have had the opportunity to create change. Maybe we just need to give them some time.

**Norman:** They were making that same apology thirty years ago.

**WHAT ABOUT ONE OF YOUR CONTEMPORARIES, BETTY FRIEDAN, WHO JUST PASSED AWAY. DID YOU EVER MEET HER?**

Hell yeah, I met her. Knew her for many years. She did me a disservice once and I'm not going to get into it. It would just be sour grapes at this late date.

**WHAT'S A TOPIC THAT YOUR OPINIONS SHARPLY DIVERGE ON?**

**John:** I can't think of a major disagreement that would make me storm out of a room.

**Norman:** That's right. Neither one of us has ever left an argument saying, "Go fuck yourself."

**DO YOU THINK THAT'S BECAUSE OF YOUR PARTIC-ULAR RELATIONSHIP, OR BECAUSE THINGS HAVEN'T CHANGED AS MUCH IN THE LAST SIXTY YEARS AS WE THINK THEY HAVE?**

**John:** I think it has to do with our ages. There's not the same ego battle that goes on with most fathers and sons.

**Norman:** That's a good point, I never thought of that. The age difference is very important. Because with fathers and sons, when there's an age difference of twenty or thirty years, the son is essentially overtaking the father. The father can feel threatened by the son.

**John:** You mean physically?

**Norman:** I mean in every way. Physically, sexually—If they're both vying for the same girl, who's going to get her? I don't mean that that actually often happens in father-son relationships, I just mean there's a bit of a sexual contest going on. But by the time it gets to a two-generation gap, like with John and me, that isn't present. *[To John]* There isn't a girl around who would have to make a tough decision between you and me. Another thing is, I think I've really been able to be open with you. I really think this book is about as open as anything I've ever done. Your essential purpose with this book was to get me at my best, and I appreciate that.

**John:** My pleasure.

**Norman:** I don't often give you a compliment like that.

**John:** It's a rarity.

**Norman:** Yeah, well, the moment this interview is over, just rush out and put it in the bank.

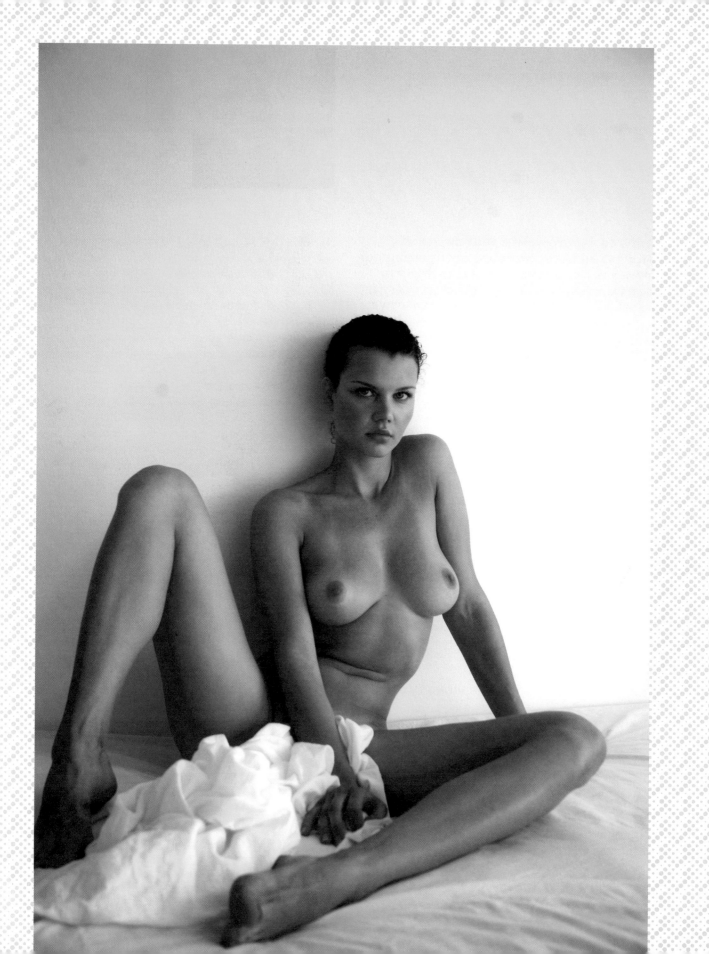

2007

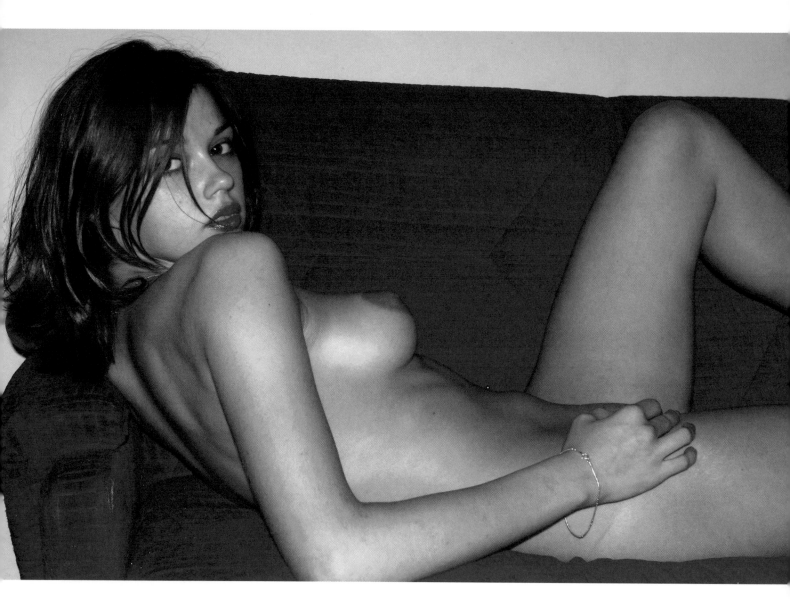

PHOTOGRAPHY BY
# MIKE DOWSON

"I have always maintained that the more you add in terms of lighting, makeup, props, etc., the more you devalue the photograph," says photographer Mike Dowson. Accordingly, he's left his models little to hide behind, though what few garments he does choose to leave them in suggest an eccentric clotheshorse: a girl in a pink slip struggles to free herself from an enormous Lucite platform shoe; a woman with huge nipples flashes the viewer from beneath a leopard-print coat; a third wears a strange, silky blue thing that appears to be clothing only in the loosest sense of the term (which suits the photo just fine). Dowson's own wardrobe appears to skew irreverent too. Though he insists there's "more to a fashion picture than shiny hair or mascara," there are a few girls here he couldn't resist making up. —WILL DOIG

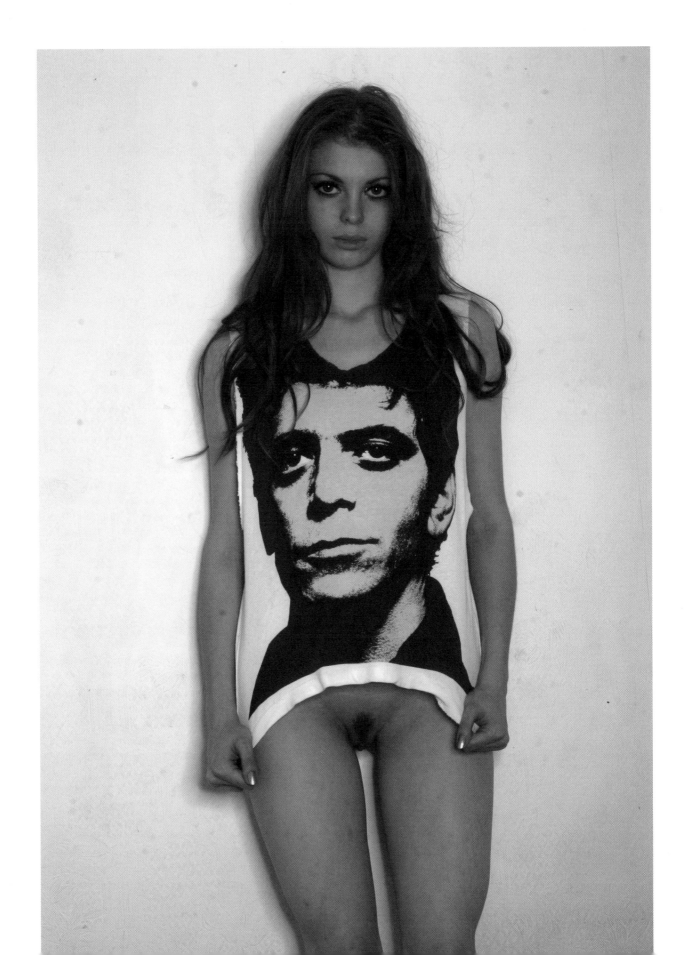

## February 28, 2007

She was a foreign journalist, assigned to interview me. One of my books was coming out in her country. We met at a restaurant

here in Brooklyn at five o'clock. We sat at a table on the sidewalk. It was late May, beautiful weather. She was beautiful. She had thin elegant arms that I wanted to grab.

She also had green eyes, a misaligned front tooth, dark brown hair pulled back, a full ass, nice legs, a long nose, a thin face, a lovely neck. She was about five-six, almost tall for a woman, and she wore a yellow skirt, a white blouse, and tan sandals with a bit of heel. The blouse had maybe come undone by one button too many. Not that I minded. I caught a glimpse of a fragile white bra.

Her English was flawed but charming. She was from the capital, _____, working for her country's most famous magazine. It was a six-month assignment, covering New York, and she was heading home soon. I was one of her last profiles. My novel was coming out in June, two years after its publication here in the U.S. We talked about the book for an hour. She had two glasses of white wine. I had a cappuccino. I don't know if it was the coffee, but I felt something in my chest, a tightening of sorts. I'm half-dead inside, but I had the thought: "Have I fallen immediately in love?"

There was nothing more to say about the book. She put her little European notepad away.

"Want to go for a walk?" I said, not wanting to lose her yet. "The light is so beautiful right now."

"Yes," she said. There was a slight husky quality to her voice and something sibilant, probably because of the front tooth.

We walked and I bored her with conversation about Brooklyn, then I said, hoping to rally, "I don't know anyone who lives in Manhattan anymore. Manhattan is the new Queens."

It was a stupid remark, one I had used before, an attempt at wit, but she didn't quite get the real-estate humor. I'm not sure I get it. She said, "I'm going to miss New York. I love it. The lunacy. There's no lunacy in my country."

*Lunacy* must be a word that is common in her language and I admired her use of it, and love sounded like "loave." I looked at her neck. It was a beautiful neck.

She lit a cigarette. We walked slowly, and we didn't talk. It was nice to just be in the perfect light and the perfect air. She was 28 but a woman. I'm 42 but I'm a boy. I don't feel like a man. It comes from being an American and being a writer. I've never had money. Living half-broke for twenty years retards your

growth. You're never quite yourself. You're always waiting to grow into your life, but you never do.

And there's something about the American character that also keeps you from maturity. I don't know why this is, but it feels true.

We went to a little park. Sat on a bench. There was some grass and trees with white flowers, and mothers with children, a last bit of playing, and there was that end-of-the-day light that even in the 21st century makes you think the world is all right. I played a man sitting on a bench with a beautiful woman, a stranger from another country.

"Thank you for walking with me," I said.

"I liked our walk," she said. She was sitting very close to me. I shifted on the bench and put my hand into her lush hair at the top of her neck, and then taking her hair in my hand I turned her toward me. She completed the turn and looked at me with those green eyes. I saw shock and acquiescence, and then I kissed her.

Our lips met right, and then her mouth opened and she tasted of wine and cigarettes and something sweet, and it was a beautiful kiss. We kept at it. She crawled on my lap and I buried my face in her neck and then kissed her in the opening of her blouse, smelling delicious perfume. We kissed again, hard. Then we parted. We looked around. There was a child crying, having fallen. A little girl in a little dress. A beautiful child. I thought of her growing up and sitting on a man's lap on a bench. The mother gathered up the child. The journalist said, "I want to go to your apartment."

She put her arm through mine and we walked to my apartment, hardly talking, but stopping twice to kiss and for me to pull her tight against me. I'm six-foot and she folded into me nicely, perfectly. We got to my apartment with its poor, second-hand furniture, and the books on the floor. I don't have a couch, only chairs since I'm a stunted person, and so we lay on my bed and kissed for a while, until I undressed her and then me. And I was standing by the bed, having just removed my pants, and she got off the bed and kneeled on my pants and took me in her mouth. She luxuriated in it, rubbing it against her face when it was wet and slick. She was moaning, but I started feeling selfish, so I lifted her onto the bed and sucked on her breasts. She was almost all nipple and I loved it.

Then I kissed her stomach and kept on kissing, until I put my tongue in her and there wasn't much taste but enough, salty and maddening. I put a finger inside her and felt some kind of birth-control object. I didn't want to jar it, so I took my finger out. At some point she shifted to her side and my head was encased between her legs and I stayed there and she came twice.

She pulled me up to kiss her and she started guiding me into her and I said, "I have condoms," and she said, "I have a thing," and I didn't tell her I knew, I didn't know if it was bad etiquette to say I had felt it, and so she guided me into

^ YURI DOJC

"MUSIC AND SEX IS SUCH A BAD MIX. IT'S CHEESY."
—LILY ALLEN, 2007

NERVE: THE FIRST TEN YEARS / 2007 / AMES

her and it had been years since I'd had sex without a condom and it was a revelation. With a condom, after about fifteen or twenty minutes, it's like my cock goes numb, the base of the condom like a tourniquet, so I have to come at that point or suffer the mortal embarrassment of losing my erection. That said, I'm not one of those guys who's against condoms, I don't mind them too much, twenty minutes is more than enough, but this sex without the condom was like heaven.

We went at it slow. Sometimes hard. I would stop and go down on her some more. We might just lie there for a bit, holding one another and kissing,

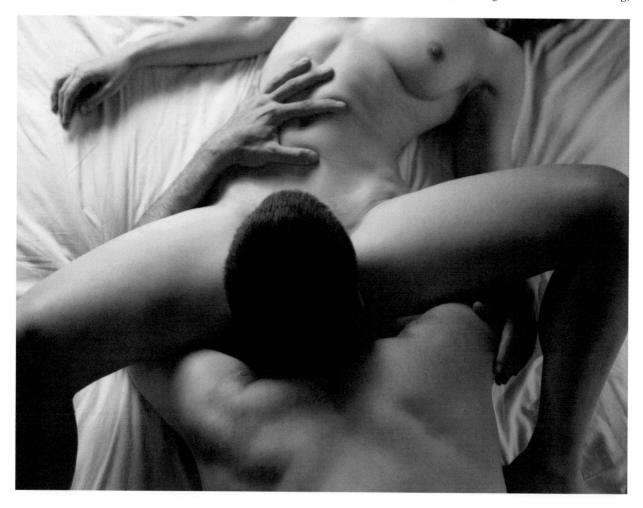

and then start the fucking again. Missionary position, she would bury her face in my shoulder and whimper quietly—she wasn't a woman who screamed, except at the end when she would come. She was very flexible and we put her legs—her knees—all the way by her head, and I went in her so deep and leaned down and kissed her deep, too. She was beautiful and vulnerable.

She got on her belly and put her incredible full ass into the air and I took her that way. She got on top of me and her hair fell across her breasts, and I sat up and moved the hair and sucked on her fat nipples. She'd looked at me, grinding against me, impaled on me, and her eyes seemed to say, "I will never know you," but all eyes say that, if I think about it.

We just kept doing it and she kept coming, and oddly I never felt that thing inside her, though I had touched it with my finger. Anyway, the whole thing was astounding to me because I just kept going. Ever since I turned 40, some kind of switch went off or on, and so the gods only give me one hard-on in an evening, maybe two, whereas when I was younger I could come three or four and sometimes five times in a night, so I've learned to make the one bullet I'm given last, but this night with the journalist was something beyond extraordinary. We had started in a dim yellow light in my room, the last bit of sun coming through the curtains, until we were in a silvery darkness, the metallic light from the street lamps allowing me to still see her beautiful body. So we had begun making love around 7:00 and didn't stop until almost 11:00, when she told me to come in her mouth, something I usually don't like to do, I feel bad for the woman, but she wanted it and I allowed myself to believe it was okay and so then we were done, and we lay there, both of us rather unbelieving.

Then she started laughing, her laugh was husky like her voice, and she said, "Now let's talk about your cock." And *cock* sounded like "cawk" and it was all so bawdy in the most appealing way, just her saying the word *cock*, and so I said, "What about it?" "I love it," she said, and love was *loave*, and, of course, as a preening male, I was deeply pleased.

She didn't spend the night. She had a roommate from her country who knew her boyfriend back home, so she couldn't possibly return to her apartment in the morning. The roommate might say something. This came out at the end. A boyfriend back home.

So I called a car for her. I saw her again a week later, and we were both aware of making it as good as that first night but it wasn't. A week after that we tried again and once more it fell short. Each time we seemed to grow more shy with each other. Then she left New York. Her article ran and was sent to me by my publisher. But I don't speak a word of her language and so I have no idea what she said.

## SEX ADVICE FROM ... ... VIDEO CLERKS

**What's a good date DVD?**

If you just want to bone, then *The Lover* or a pirated copy of *Basic Instinct 2*. It's really just an excuse to get two people together in a dark room. I remember one of my first dates with an ex-boyfriend; he rented *American History X*, and we still made out afterward. I guess he wanted to demonstrate that he was into thought-provoking films. And Edward Norton was pretty hot, doing it in his Doc Martens.

**What are the sexual proclivities of a woman whose favorite actress is Angelina Jolie?**

She thinks she's a lot sexier and kinkier than she actually is. She says things like, "I want ass play!" but when the time comes, she wimps out and says something about her period or feeling Catholic.

**What sex toy is overrated?**

Anal beads. I can envision terrible scenarios. Like, your mom visits your house and finds your anal beads and thinks they're a necklace and wears them to dinner.

**How can I have sex in a video store without being seen by anyone?**

Do it in the VHS section.

# A PLAGUE ON BOTH YOUR HOUSES
## I HAVE HERPES. MY BOYFRIEND HAS HPV.
## WE'RE MAKING IT WORK.

BY MAGGIE PADERAU

I will not admit to having herpes just to win an argument in a bar, but my coworker was spreading total fallacy and had to be stopped.

"You can't get it just because someone has a cold sore and they go down on you. Oral and genital herpes are different." Jeff said with that relaxed, confident air common to men under the age of 24, and irritating to women over 27.

"That is so not true!" I protested, feeling a sudden panic.

Jeff looked at me through his new-media glasses and cocked his elfin face at a stubborn angle. The others in our happy-hour gang waited with interest, and sipped their drinks.

"How do you know?" He wasn't being overly confrontational. As Web programmers, this was how we debated everything from cab routes to php code.

*Because that's exactly how my ex-boyfriend gave me herpes! He was your age, and as otherwise clever as you are!* I couldn't say this out loud, of course. Instead, I applied a poker face.

"Dude," I pronounced, "My stepdad was a gynecologist. I grew up reading his medical journals, like *The Female Patient*." This was not a lie, but I really only learned most of what I know because I had to learn firsthand.

Like an Encyclopedia Herpetica, I went on, unwilling to be vague. "There is herpes simplex Type 1 and herpes simplex Type 2, but you can absolutely get one from the other. The main difference is just where it lives in the body, the same as crabs are just lice in your pubic hair." Talking fast, trying to push down the passion that might have made me sound defensive, I wanted to sound matter-of-fact, because I knew these were facts.

My posse of programmer boys listened. To my relief, one replied, "Wow, I didn't know that."

I'm a member of a silent army, one the National Herpes Resource Center estimates to include at least 80 percent of the population. Scared of telling people, and afraid of transmitting the virus, we often live in a state of denial. However, the things we fear can be addressed and prevented not just with all there is to learn, but with how we can learn to be.

Most people don't have a practical understanding of how herpes is spread. It doesn't have to look like anything, and it's commonly transmitted when it's "silent." Many people consider oral sex to be a safer, less intimate activity than intercourse, according to a recent comprehensive study by the National Center for Health Statistics. But oral herpes—simplex virus Type 1 (HSV-1)—is carried by more than 70 percent of people worldwide.

For the record: a cold sore is herpes simplex 1. Kissing with a cold sore, or performing oral sex when you have one, can pass the virus to either

mouth or genitals, where it lives happily ever after as HSV-1 and/or HSV-2, respectively.

The first infection, physically the most painful, is also medically recognized to bring with it a depressive malaise, not only because you now have a lifelong virus that will cause pain, embarrassment, and create some degree of mess in your personal life. The day of my diagnosis, I couldn't lean on anyone for support. Instead, I cried a lot in the bathroom, then went to Tae Kwon Do class anyway, where each kick felt like my flesh was being pulled off with hot pokers. I'm shocked it didn't leave scars.

My ex-boyfriend gave me herpes after we were together for a year and a half. He claimed he didn't know he had it. I didn't believe him. In hindsight, getting herpes from him seemed so avoidable. I noticed that his bottom lip looked chapped, but didn't know much about cold sores. It was late winter, when dry lips are the norm.

"Did you split your lip or something?" I asked him outright.

"Yeah, I guess so," is all he said. It didn't occur to me to worry about it.

Three days later my clitoris, having been the focal point of much contact with the questionable lip, felt painfully tender and raw. Then a few other spots developed and became the sores you hear about, and the image you dread to Google. I found more on my gums, under my tongue. It was Old Testament punishment, and my body was Egypt. It felt like God was smiting my heretofore beautiful ladyflower.

I was raised Catholic. I'd even wanted to become a nun until I was about 9 and started to wonder about sex, imagining Sleeping Beauty–style scenarios where dashing young heroes sought to wake a slightly older, more womanly version of myself. Midway through college, I was proud that I'd remained disease-free. I sought to maintain my track record by becoming a serial monogamist.

The long-term boyfriend who gave me herpes was by most accounts a squeaky-clean, intelligent young man. I was serious about Will, even considered him a potential husband. I felt that we were together on a path, right up until he "somehow" gave me herpes. My doctor explained that people can have it for years without knowing it. It didn't mean he had been unfaithful, but his immature attitude was as big a disappointment. If I tried to talk about the physical or emotional aspects of having the virus, Will would cut me off, saying it made him feel guilty. It seemed unfair that I had to protect his feelings while trying to keep mine falsely positive. I stayed with him for a good long while, even though I sensed other incompatibilities. Fear I would never be able to find acceptance with a new person—and of passing the virus along—cowed me. The Flaming Lips played on perpetual repeat. The knowledge that the responsible way to enter a relationship is to tell your prospective new beau that you have herpes does nothing to make you want to try a fresh start. Until I told my current boyfriend.

Mark had been my friend for a few years and was also in a relationship, so I felt insulated from the ramifications of telling him. One day over Instant Messenger, he admitted he was struggling with an attraction toward me. With nothing to lose, I typed, "Well, maybe this will help turn you off. Will gave me herpes six months ago."

"Thank you for telling me that," he immediately responded. "I'm so sorry. I have HPV. You know, genital warts? I had them treated, but I hate how gross I feel—like I can ruin anything I touch."

Mark was the first person I ever told. I couldn't believe my relief at his empathy. Suddenly I felt desirable again. I broke up with Will that week. When Mark and I started seeing each other six months later, there was no need for the dreadful "I have to tell you something" conversation. It's extremely difficult to do this under normal circumstances. To open yourself up to any possible reaction rarely seems worth it. Negotiating the space between Will and Mark led to some interesting moments. Once, after kissing a guy, I had a private panic attack but only told him I didn't want to get romantic, so we went no further. I told another guy my status before we got intimate; he confessed to having been treated for gonorrhea a couple months before. In general, guys had an easier time accepting a virus than rejection, and most wanted to hook up anyway.

When my relationship with Mark became physical, we used condoms but understood that the viruses couldn't be prevented totally. As our relationship developed a sense of permanence, we took a pragmatic approach, mentally preparing to eventually contract each other's diseases. The chances of passing herpes to my partner—if I have no outbreaks, am not on suppression medication and do not use condoms—are 2 to 4 percent over the course of a year. Abstaining from kissing and sexual activity during an outbreak is the best prevention. A partner with no symptoms can get a blood test to check for the antibodies of HPV-2, but the results are often inconclusive. Researchers at the Louisiana State University Health Sciences Center performed a study in which 98 percent of participants shed HSV-1 DNA in their tears. Dr. Herbert Kaufman, leader of the study, says this shows the virus is everywhere and practically unavoidable.

When I first contracted herpes, I took the suppression medication Valtrex. Because I didn't have recurring outbreaks and my doctor believed my body was handling the virus well, I stopped. More than two years passed before I had a second outbreak. My doctor and I believed stress was the trigger. My job had been demanding; Mark and I were experiencing relationship growing pains. I wasn't sleeping well and felt depressed; I believed everything important was in jeopardy. Then my body started breaking down.

Embarrassingly, I didn't recognize the outbreak for what it was. First, I thought it was a yeast infection. Then I thought I had contracted HPV. I made my boyfriend answer a million questions. Over-the-counter yeast-infection creams

made the pain worse. Even though I knew what herpes looked like, I wasn't able to recognize its later manifestations. This, I learned, is common.

Mark insisted I see my doctor. He stayed calm and rational, sending me text messages to ask how I was feeling and gently reiterating his belief that I was having an outbreak. I was scared, irritable, even made him swear that he hadn't been unfaithful. I told him I felt ruined.

"Even if, God forbid, we don't end up together, we still have the most common STDs out there," Mark said. "It doesn't mean we're hopeless and unlovable; we just have to be adults about it."

Today, I dread the idea of not being with him, but not because I'm afraid of telling people anymore. We've have been together for about three years now, have more sex in more ways than anyone we know, and are both still free of each other's viruses. I've had two mild, almost invisible outbreaks since my initial infection over four years ago. I get regular Paps and the full gamut of tests. We want to marry, maybe have a kid. We have talked about herpes and risks to the baby at childbirth, and HPV's link to cervical cancer. Sometimes, we don't think about any of it, until we're reminded.

Lately, in addition to the increasingly common TV ads for Valtrex, we're bombarded with ads for the HPV vaccine and news of the surrounding controversy. Merck, the maker of Gardasil, notes that the vaccine is only approved for girls and women aged 9 to 26. At 32, I'm outside that range. According to my gynecologist, the drug researchers have presumed I've gotten married. Still, she thinks I could benefit from the vaccine. Each of the three shots in the series costs $500, and she encouraged me to see if insurance might cover it, though in her experience they don't. "Use condoms," she says at the end of our conversations.

Statistically, women become more sexually conservative after their mid-20s, and medical science reports that most women build up an immunity to the HPV virus and break it down over time. The risk is that, 5 to 10 percent of the time, the virus incorporates itself into the genetic structure of cervical cells and eventually becomes precancerous. "Great," Mark said once, after watching the Gardasil commercial, "It feels so good to know I can give a woman cancer."

I wanted to tell him that what he's given me is confidence, and a feeling of partnership I hadn't thought possible. Instead, I kissed him on the neck and said, "I know. It's all right." Mark looked at me and put his hand out, palm up. I low-fived him in a gesture of solidarity, then held his hand and fast-forwarded through the rest of the commercial. Safety is a relative concept, but I'm glad it's one that can be personally constructed, and mutually enjoyed.

"MOST PEOPLE JUST WANNA KNOW THAT YOU RESPECT THEM, AND YOU'RE NOT A SERIAL RAPIST."
—MELVIN VAN PEEBLES, 2007

# ONE NIGHT ONLY
## WHY SOME WOMEN—INCLUDING ME—
## PREFER CASUAL SEX TO DATING

BY J. L. SCOTT

I read *Bridget Jones's Diary* at the age of 16; I thought I had found my salvation. By my senior year in high school, I felt like I had already had my share of crappy dating experiences, from the kid

I dated freshman year who insisted on always wearing his varsity jacket when he had lettered in marching band to the junior spring dance where I thought a secret admirer had bought me a ticket, only to publicly find out that it was an administrative glitch and I still owed $10 to get in. These experiences could have sucked, except, as I learned from all my pop-culture single role models, from the hapless Bridget to the outwardly glamorous and inwardly neurotic *Sex and the City* ladies, dates should suck. It seemed to me that the more intelligent and self-possessed a chick-lit heroine, the less she can navigate traditional boy-meets-girl setups. But that's all part of her imperious charm, until she finds the guy who falls in love with her winsome neuroses.

I ended up going to an all-female college, which further complicated my ideas about dating. There, as confused and lonely freshmen, my suitemates and I bonded through our mutual obsession with the frat guys from a college twenty minutes away. We often drove there just to bump into one of them coming out of class. After doing this for several months, I scored a date with one of them. I saw this as proof that my ridiculously over-the-top persistence was effective, and I wanted to prolong the situation. When we ended the evening at his apartment, I explained to him that I was a virgin. "But I really want you to fuck me," I said, as I wiggled out of my jeans, already imagining how jealous my suitemates would be. "Okay," he said, visibly weirded out.

I never heard from him again, but I didn't care. In the chick-lit novel I was crafting in my mind, I was the fuck-'em-all girl who didn't follow the rules. If I didn't try to date, or deliberately sabotaged the process, I couldn't fail. None of my friends would know how terrified I was of interacting with guys. Because I didn't measure up to my friends in terms of attractiveness, I believed that fucking was the only way to keep myself on the same page.

When I graduated, I kept my circle of female friends from college, worked with all women, and lived with two female roommates. It was hard not to objectify men when I only interacted with them as hookups. Going out on weekends, not knowing where I would wake up, made me feel adventurous. I loved everything associated with fucking—the danger, the uncertainty, a story to tell the girls. Occasionally, a guy would ask for my number. I'd let the message go to voicemail, then delete it after playing it aloud for my friends.

Sometimes I would go on actual dates, usually with a friend of a friend, always with a sense of obligation. Actual dating—being picked up at my apartment, going to a restaurant that was never quite right, trading life

stories—seemed so banal. With each date, I felt the stakes get higher. Fucking on the first date meant he wouldn't call again, so I wouldn't have to veer from my well-rehearsed script.

"I can't believe it just took one beer to make you come home with me!" one guy said the next morning with a mix of amazement and self-congratulation. I just smiled. We hooked up every Saturday or Sunday for a few months, but we were never dating. Instead, I would end up at his apartment after midnight, usually when one or both of us were drunk. We would sleep together, then have a rambling conversation about our lives, which didn't intersect anywhere except his bed. When one of these late-night discussions revealed that he was actively dating other girls, I was surprised by how upset I became.

My friend Melissa, who conducts her dates with unflinching rigidity (she won't even stay for a drink with a guy if she doesn't see a three-date-minimum potential), was appalled at my haphazard approach to men.

"You're not supposed to sleep with them right away!" she said, as if explaining something revelatory. "They'll never be interested in you." That wasn't the point. I hadn't wanted them to be interested in me. I didn't want to worry about their opinions. Instead, I wanted to call the shots until a guy came along who would totally and effortlessly understand me. I hated how much my casual-hookup guy had become that ideal in my mind. For the first time in my life, I admitted to myself that I was actually seeking a relationship.

Which was exactly what my friends had been seeking that whole time, reading *He's Just Not That into You* and sending covert text messages to decipher their dates' behavior. When a friend successfully navigated the first few dates—the point when sex and weird tics were discussed—I'd feel a small tug of betrayal. I signed up for a bunch of dating sites and begrudgingly promised myself I wouldn't fuck on a first date. I tried to think positively about going out with the guys whose responses flooded my inbox: it was a reason to dress up, an excuse to live outside my $15-an-hour, postcollegiate budget, something to talk about the next day. Still, I hated how a guy would insist on walking me back to my apartment, when I knew I could always get there, by myself, at any time of the night. I hated when they called the next day and I would feel obligated to call them back, and I would feel anxious whenever I saw one of their emails. Unlike hooking up, dating—and actively seeking a long-term connection—made me feel trapped.

It was only when I'd dissect the evening with friends that I would again feel empowered and fun instead of lonely, awkward, and panicked. I gave each date a nickname—a guy with questionable hygiene became Furry-Teeth Guy, the pseudo-musician was Mr. Glam Folk Rocker, the hippie activist who lived with six roommates in a loft with bedrooms separated by office dividers became the I Heart Brooklyn Boy. Naming my dates, then excoriating them, made me

**Will becoming a gossip columnist help me get laid?**
No. Not at all. We date publicists and we date other writers. Very rarely do any of us have contact with another celebrity sexually. The closest I ever came was when Alicia Silverstone beat me with her shoe because I made fun of her for wearing leather stilettos when she's a vegan.

**I'm a C-list celebrity and I want to get my sex life written about in the gossip columns. How do I do that?**
If you're a girl, make out with another girl. If you're a guy, don't bother, because if you're C-list we're not interested in your sex life. Unless you fuck upwards. If you date a B-list or an A-list celebrity female, then you're gold.

**What should one never do if they want to stay out of the gossip columns?**
Leave their apartment. Look, you could be a celebrity who never cheats on his wife, who never solicits sex from an extra, who never stiffs a waiter. And then one day you go and yell at your assistant, and that's it. It's practically impossible to stay out of the gossip pages. The person who came closest was Matthew Broderick.

**Why Matthew Broderick?**
It's hard to attack Ferris Bueller.

feel a sense of control. Yes, I hadn't found anyone, but there was something so wrong with everyone.

One night, I invited a few friends to stop at a bar where I was on a first date. I wanted them to see the live version of what I would always recap, and I had no qualms about using him as a prop. The guy was an aspiring actor and bartender in his mid-20s. When I flirtatiously asked him what his favorite drink was, he said Sex on the Beach, and asked if I'd heard of it.

The next day, my friends laid into me. "At one point, you were making out with him, then you would turn to me, tell me how lame he was, and roll your eyes," Melissa said, exasperated. "I don't know what to do with you."

At that point, I didn't know what to do with me, either. Presented with an unattractive date, I could chalk the evening up to disappointment, or I could turn it into an experience. Of course, I chose the latter. Making out wasn't fucking, but at least it made me feel something. It turned me back into the imperious single girl, the one who was above dating and didn't need to impress a man.

Ultimately, I am terrified. I really shouldn't responsibly be allowed to have an online-dating profile. I know it's time to grow up, stop being hypercritical, and just enter the dating pool, with all its clichés and absolute disappointments. And I'm trying. But it's hard to know where to begin. Pop culture has made wacky, convoluted attempts to meet men seem like a staple of the twenty-something single girl's life—so much that my therapist once recommended I borrow my parents' dog from New Jersey for a day and bring it in the park for use as a conversation starter. While I haven't resorted to crossing state lines with my parent's sixty-pound Labradoodle, I have agreed to tag along with Melissa to one of her speed-dating events. I initiate conversations with guys at my triathlon-training sessions. Sometimes, I even return phone calls.

Or at least that's what I'll admit to my friends. Last week, I went out with a guy from a networking event for impromptu drinks after work. In true romantic-comedy fashion, the heel of my shoe got stuck in the pavement, and I had to lean down to pull it out just as he walked in. We went to the bar, where he followed my lead and ordered a bright pink, prickly-pear margarita. Right then, it was as if the laugh track in my mind was cued, except no one was there to watch. It didn't seem to be a cute story; it just depressed the hell out of me. We were in the middle of a conversation about his childhood pets when I cut the date short.

Instead of going home, I called my former fuck buddy, holding my breath until he answered. *Hey. Just so you know, I'm just calling you because I'm in your neighborhood. So . . . wanna hang out?* I let the pause linger, so he knew exactly what I meant. In the silence, I realized my mind wasn't working overtime to generate some monologue or overarching meaning to my actions. I wasn't trying to

create a story, salvage a scene, or use him as an understudy to my failed date. Instead, it was simple: all I wanted was no-rules, no-meaning sex.

He told me to come over. I hailed a cab and ran into the ladies' room of the Starbucks on his corner, slipping off my thong under my skirt and stuffing it in my purse. I felt the same way I did in high school, when I always wanted to smoke a cigarette after being forced to sit through a dinner party with my parents and their friends. I wanted to be bad and wild, not worried about doing things correctly. When he let me in, he said "Hi" as he took my top off, and at that moment, it was as if I'd stepped out of my self-imposed girl-about-town dramedy and could just be the fucked-up, neurotic, confused chick that just needs space in between all the contrived romantic encounters to find some sort of connection.

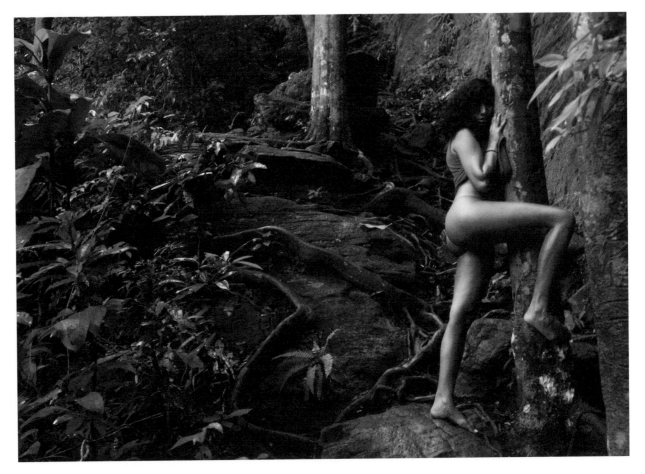

# HEART OF GLASS
## MY SEXUAL FANTASIES ABOUT NPR

BY SARAH HEPOLA

I don't remember exactly when I started having sexual fantasies about Ira Glass, but I do remember when I realized I felt a little different about him. I was listening to *This American Life* on my iPod, walking around Manhattan, when Ira Glass mentioned something about his wife. It was one of those moments meant to charm, when the interviewer bonds with the subject over some silly, common experience. "Ha, you too? My wife does that." But that's not what I was thinking. I was thinking: *Wife? What fucking wife?*

Until that moment, I hadn't realized how proprietary I had become about Ira Glass. I didn't know anything had changed in our relationship, which for years could be summed up like this: I loved his radio show. But hearing him talk about his wife that day, I felt the same queasy pang that struck me when I was 12 and discovered that Rob Lowe had a girlfriend, that Duran Duran's keyboardist was engaged. Except those crushes were based on pinups stapled in the center-fold of a teen mag, on haircuts engineered to appeal to the greatest possible number of suburban teens. What I felt for Ira Glass had absolutely nothing to do with the photos I occasionally glimpsed of him, and everything to do with the bizarre, singular intimacy of his voice in my ear.

I spend most Sundays walking across the bridge from my apartment in Brooklyn into Manhattan. Even after a year and a half in New York, I still get lost all the time, and so I was hoping to reconcile the tidy subway grid in my backpack to the stuttering, sprawling one in my mind. It was a lonely, lovely way to kill the afternoon, and Glass's show was a natural soundtrack: geographic discovery complemented by intellectual discovery. Over the course of these afternoons, I not only became more familiar with the city but also with the particulars of Glass's voice. The calculated clip. The choreographed intake of breath. I heard things I'd never caught before—a click, a sigh, a tongue passing across the lips.

I'd been listening to *This American Life* for years, but it wasn't until I heard it in my earphones, hours at a stretch, that his voice took hold of me. The streets of New York honked and spat as Glass traced out another neat narrative arc over the course of an hour. And after he had passed the microphone to another correspondent, it would sometimes be minutes on end before I realized I hadn't heard a word anyone else was saying. That I had been in some kind of lusty trance. That I had been in a darkened sound booth somewhere, tugging off the trousers of Ira Glass. But wait, no, I never *saw* the sex. This fantasy was purely auditory. A scrape of the sheets, a zip, a violent clatter. And then I would come to somewhere near Canal Street, with no idea how I'd gotten there or what the hell I was listening to.

Like I said, I get lost all the time.

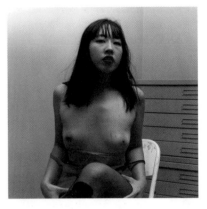

## ACT I: ROOM AT THE INSKEEP

At 9:00 A.M., the phone rings. "I think I have a crush on Steve Inskeep."

This is my best friend, and I should mention that she spends a great deal of time in her car. The only time she calls, in fact, is while she's driving, which doesn't seem like a good idea to me, either, but I'll take what I can get.

When she calls, she is listening to *Morning Edition* on her way to work, and Steve Inskeep has just done something endearing and off-color. He drank his first mojito with a rock band and pronounced it quite delicious. He sounded off on a story about Texas cheerleaders by offering his own sideline cheer. Nine A.M. is still early for me.

"Are you awake?" she asks.

"Of course I'm awake," I say, barely awake.

She goes on to explain that she hasn't always been a Steve Inskeep woman. Because she was a Bob Edwards woman, and at first, in the shaky transition phase, she scoffed that Steve was perhaps not bringing as much to the *Morning Edition* table. His voice wasn't even that interesting. But what can I say? She has a thing for earnest nerds.

"Have you seen a picture of him?" I ask.

She sounds disappointed when I ask this. "He just looks like a dad."

On second thought, let's not talk about pictures. Let's pretend they don't exist.

The amazing thing about NPR personalities is how close you can feel to them without ever knowing what they look like. Even authors, with their glossy black-and-white photos on the cover flap, aren't allowed such anonymity. Lately, there have been a lot of pictures of Ira Glass, banner ads and commercials for *This American Life*'s new television show, and this has been agonizing for me. It punctures all the daydreams I've been spinning: Ira looks too skinny, for one thing, and I hate to say this, but also too old. In my daydreams he's still a chubby, nerdy twentysomething; my fantasy, however faceless, has no room for gray hairs. Not that I would mind a few, in general.

Let's take Steve Inskeep, for instance. He has a different sonic appeal than Ira's hipster nerdiness; his baritone is more anchor chic. He's the kind of guy who might buy me a few martinis, loosen up his tie over some tapas, and get a throbbing boner for Mozart's concertos. This has its own sordid appeal; he could probably explain what's happening in Iraq, in which case I'd totally get wet. I like to envision an erotic evening in which he merely pronounces the names of Al-Qaeda operatives as if it were some kind of Salome striptease—Abu Masab Al-Zarqawi, Saif al-Adel, Abu Mohammed al-Masri. By the time he got to the third "Abu," I'd be ready to jump across the table and rip off his sensible button-down.

Perhaps this phenomenon works differently for men. A male friend of mine used to spring a stiffie listening to the afternoon traffic reporter in Dallas,

NERVE: THE FIRST TEN YEARS / 2007 / HEPOLA

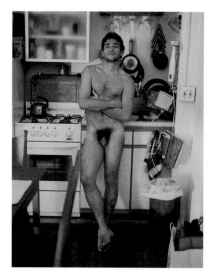

a sultry alto offering hourly interstate-congestion updates: "I see her taking off her helicopter helmet, blonde hair cascading around her face in the wind," he said. Frankly, I find that voice a bit clichéd. Neither Steve Inskeep or Ira Glass has a traditionally sexy voice, which is probably part of the attraction, kicking up as it does some latent geek-virgin fantasy I've never fully acknowledged, in which I deflower the valedictorian in a bathroom stall and teach him all about love and/or doggy style. Which is probably why the Mrs. Glass bit pissed me off, come to think of it. I could no longer indulge the glorious virgin fantasy. Someone else had loosened his collar, someone else had crushed his bifocals.

But in general, what fascinates me about radio personalities is the lack of vocal sexiness. The sheer Puritanical absence of it, making me hunt for the sex toys in the drawers, scrounge for the naked pictures under the pillow. Take Michele Norris, co-host of *All Things Considered*. For a while, I had a minor obsession with Michele. For one, there was the contrarian pronunciation of her first name, MEE-shell, which was staunchly enforced by every guest, all of whom must have been given a ten-minute primer prior to air. Then there was her dry delivery, a bit Condi Rice, though unlike our secretary of state, Michele had just the slightest undercurrent of sass—like when she unexpectedly made a joke about the day's news, a little wink between friends. And those moments reconfigured all I had assumed about emphasis-on-the-first-syllable Michele. Whereas I had once envisioned her as a stiff in a Liz Claiborne suit, I now saw her as a voracious sexual predator, barely containing her feral energy with those morning updates. I saw her with her hands lashed to the bedposts, teeth gnashing in ecstasy, raven hair taut and pulled back by some unseen hand.

I have never seen a picture of Michele Norris. Please do not show me one.

### ACT II: GROSS ANATOMY

I can't talk about NPR and sexuality without mentioning Terry Gross. For a while, when I worked from home in Dallas, I listened to *Fresh Air* every afternoon, and I still miss it. As I would wash a sink of dishes or click away an hour on the Internet, avoiding the writing I had promised myself to do, I would let my imagination curl up into whatever conversation Terry Gross was having. And it's not that I had erotic thoughts about her so much as an erotic curiosity. I found myself fascinated about her sexuality. "I'm Terry Gross. And this is *Frrrrresh Air*." Man, she bit into that name. Every single time.

I wonder if it started with the infamous Gene Simmons interview. It was a classic debacle: the bookish Gross railroaded by the tongue-wagging KISS icon. He uttered every phrase like he was between her creamy thighs, and it wasn't sexy; it was unnerving. "I'd like to think that the boring lady who's talking to me now is a lot sexier and more interesting than the one who's doing NPR," he said at one point. "I bet you're a lot of fun at a party."

In the moment, I only sympathized with Gross. It remains the most painful, cringeworthy interview I've heard to this day. But it must have sunk its hooks into my imagination, because afterward, I couldn't listen to a Terry Gross interview without wondering which way she swung.

Terry Gross would interview an AIDS specialist, Terry Gross would have a show on same-sex marriage, and like a gay-baiting Rosie O'Donnell, I would tell the cat, dozing in the corner, "Oh, she's gay, I know she's gay!" Did this make me like her less? No! It made me like her *more*. I loved the idea that she was enduring what must have felt like the heterosexual-industrial complex, secretly wearing flannel and silently slipping me the finger with every interview. I don't know why I liked this idea so much. Maybe it's because she reveals so little of herself that I felt the need to puncture the façade and grab some piece of privacy. Because I felt as though I should know her, because Terry Gross isn't like Dan Rather, or Katie Couric, or any other television news anchor shared like popcorn by America. She is someone I listened to alone, like so many of us listen to NPR alone—in the car, in the apartment, on headphones, just you and her.

In the introduction to her book, *All I Did Was Ask*, Terry Gross writes about a funny thing that happened when her husband, the writer Francis Davis, won an arts fellowship: "My mother-in-law came with us, and at one point I saw her laughing, and she later explained that the woman had pointed at me and whispered, 'Terry Gross is here. Did you know she's a lesbian?' That's one of the reasons I love working on radio: You might be a public figure but you're essentially just a voice, and this lets each person who listens form whatever image of you he or she wants—tall or short, fat or thin, sex bomb or schoolmarm, straight or gay."

If she's right, and each NPR personality is some kind of Rorschach test, then it isn't so interesting that I thought she was gay. The interesting question then becomes: Why did I *want* her to be?

^ MIKE DOWSON

ACT III: HEADPHONE SEX

The Dresden Dolls have a song about Christopher Lydon, who does a show called *Open Source*. A few choice lyrics:

*I never knew what one voice could do/*
*I was in heaven the moment I heard you/*
*My friends go out drinking and having fun/*
*I stay home with my headphones on.*

The singer, Amanda Palmer, sings it like a torch song, like Christopher Lydon might be teething her undies on an empty library table. I only heard the song recently, though I love it, and I can only imagine that Amanda Palmer feels

a little bit of the pulse in the groin when an egghead rattles off the news. Bob Mondello, Margot Adler, Reneé Montagne, Neal Conan, Robert Siegel, Kurt Andersen. Oh lord, Kurt Andersen, with all his hard-won theories on the media, the way he's so compelled by how the ugly machine works.

And maybe that's part of what turns me on about NPR personalities. Not just their intellect, but a fascination with human behavior that makes them open to any experience. Hell, if you pulled out a gimp suit, they'd just start the tape recorder and scribble some notes on a napkin.

But I think I like being in a dark and faceless fantasy, too. Because let's face it. We're all a little tired of our bodies—worrying what they look like, how they measure up, how our legs seem in thigh-highs and a garter. Frankly, I wouldn't mind disappearing into a tape whir for a while. It's nice when you think about it. Not just you or your lover blindfolded, but the entire world.

^ ROSE AND OLIVE

› TONY STAMOLIS

# CONTRIBUTORS

**STEVE ALMOND** is the author of the story collection *My Life in Heavy Metal;* the nonfiction book *Candyfreak;* and *(Not that You Asked): Rants, Exploits, and Obsessions.* To find out what kind of music he listens to, check out www.stevenalmond.com.

**JONATHAN AMES** is the author of *I Pass Like Night; The Extra Man; What's Not to Love?; My Less Than Secret Life; Wake Up, Sir!;* and *I Love You More Than You Know.* He is the winner of a Guggenheim Fellowship and is a former columnist for *New York Press.* You can visit his Web site at www.jonathanames.com.

**AIMEE BENDER** is the author of the short-story collection *The Girl in the Flammable Skirt* and the novel *An Invisible Sign of My Own.* Her stories have appeared in *Granta, GQ, Harper's Magazine, Paris Review,* and several other publications. She lives in Los Angeles, California.

**PAULA BOMER** grew up in South Bend, Indiana, and lives in New York. Her writing has appeared or is forthcoming in many journals and anthologies, including *Open City,* the *Mississippi Review, Fiction, Global City Review, Time Out New York, Best American Erotica 2002* and *2003, Storyglossia,* and *nth position.*

**DEBRA BOXER** lives in New Jersey but dreams about living just about anywhere else. Her interest in erotica began in high school when she wrote sex stories during Spanish class to stay awake. At Rutgers University she wrote her senior thesis on pornography. For four years she's been reviewing books for *Publishers Weekly* and somehow gets all the erotica collections.

**ROBERT OLEN BUTLER** is the author of novels and short story collections. Butler's short story collection *A Good Scent from a Strange Mountain* was awarded the 1993 Pulitzer Prize for Fiction and nominated for the PEN/Faulkner Award. He is also the winner of the 1993 Guggenheim Fellowship for Fiction. He teaches creative writing at McNeese State University in Lake Charles, Louisiana.

Nerve consulting editor **ADA CALHOUN** has been a frequent contributor to the *New York Times Book Review,* a freelancer for *Arts & Leisure,* a contributing editor and theater critic at *New York* magazine, and an editorial assistant at *Vogue.* She is also the editor in chief of Babble.com.

**LISA CARVER** wrote a book called *Dancing Queen,* published the magazine *Rollerderby,* and started the touring vaudeville act Suckdog. She's written for *Hustler, Index, Icon, Feed, Newsday,* and *Playboy,* among others.

**DARCY COSPER** is a writer and book reviewer. Her work has appeared in publications including the *New York Times Book Review, Bookforum, Village Voice,* and *GQ,* and in the anthologies *Full Frontal Fiction* and *Sex & Sensibility.* Her first novel is titled *Wedding Season.*

**WILL DOIG** has written for *New York* magazine, *Black Book, Out,* the *Advocate,* and *Highlights* magazine. He was raised in Massachusetts and New Hampshire. He lives in Brooklyn, New York.

**M. JOYCELYN ELDERS, M.D.,** entered the U.S. Army as a first lieutenant at the age of eighteen. She attended the University of Arkansas Medical School on the G.I. Bill and later joined the UAMS faculty as a professor of pediatrics. In 1987, Dr. Elders was appointed Director of the Arkansas Department of Health. She was nominated as Surgeon General of the U.S. Public Health Service by President Clinton on July 1, 1993, and sworn in September 8 of that year. Dr. Elders stepped down from this post in December 1994 to continue her professional career at UAMS. She tells her story in *Joycelyn Elders, M.D.: From Sharecropper's Daughter to Surgeon General.* She is writing a book, with Rev. Dr. Barbara Kilgore, on masturbation.

**PAUL FESTA** writes for Nerve.com and Salon.com about sex, culture, and politics. His essays have been anthologized in *Best Sex Writing 2005* and *2006.* He is writing a novel about three men who grow a 900-plant medical-marijuana garden in California.

**LISA GABRIELE**'s writing has appeared in the *New York Times Magazine, Vice,* the *Washington Post,* and on Salon.com. She directs and shoots documentaries for The Life Network, The History Channel, and the CBC. She is the author of the novels *Tempting Faith DiNapoli* and *Starlite Variety.* She lives in Toronto.

**JONATHAN GOLDSTEIN**'s writing has appeared in *ReadyMade,* the *Carolina Quarterly, Land-Grant,* and the *New York Times.* His first novel is *Lenny Bruce Is Dead.* He was born in Brooklyn and lives in Montreal.

**SPALDING GRAY** was a writer, actor, performer, and the author of *Swimming to Cambodia, Gray's Anatomy, Monster in a Box, Sex and Death to the Age Fourteen,* and *It's a Slippery Slope,* among other works. He has appeared on PBS and HBO and in numerous films, including *The Killing Fields, True Stories,* and *Gray's Anatomy.* He passed away in 2004.

**LUCY GREALY** was a poet and the author of *Autobiography of a Face.* She attended the Iowa Writers' Workshop and was a fellow at the Bunting Institute of Radcliffe and the Fine Arts Work Center in Provincetown.

**RUFUS GRISCOM** cofounded Nerve.com in 1997, Spring Street Networks in 2000, and Babble.com in 2005. He is now the CEO and founder of Material Media, which is developing a series of new, interactive online magazines. Rufus cofounded Nerve in part to avoid writing a novel. The strategy has worked perfectly—he has not written any fiction in more than ten years. He lives with his wife and two sons in New York.

**VICKI HENDRICKS** is the author of *Miami Purity*, a Florida noir novel she describes as "sex, sex, sex, murder, and sex—in the dry cleaners," which was originally her Master's thesis in creative writing. Her short story "Penile Infraction" is in the anthology *Dick for a Day*, and she has a chapter in the Florida crime collaboration *Naked Came the Manatee*. Her book *Iguana Love* is a novel of "obsession, perversion, and murder." Hendricks lives in Hollywood, Florida, and teaches English and creative writing.

**SARAH HEPOLA** has been a high-school teacher, a playwright, a film critic, a music editor, and a travel columnist. Her work has appeared in the *New York Times*, the *Guardian*, and on Slate.com and NPR. She is the Life editor of Salon.com.

**KEVIN KECK** will probably come and stay on your couch for an extended period of time if you ask him to. He will pay for any phone calls he makes from your house.

**JONATHAN LETHEM** is the author of a number of novels, including *Motherless Brooklyn* and *The Fortress of Solitude*. He currently lives in Brooklyn, New York.

**SAM LIPSYTE** is the author of the story collection *Venus Drive* and the novels *The Subject Steve* and *Home Land*. His fiction has been published in the *Quarterly* and *Open City*.

**MICHAEL MARTIN** joined Nerve in 2002. Under his editorship, Nerve has received several Webby Award nominations, a Webby People's Voice Award for best writing, and its first National Magazine Award nomination for general excellence online. As editorial director, he has overseen the launches of Babble.com and the Nerve Film Lounge, which earned a National Magazine Award nomination (best interactive Web feature) in its first year of operation. He has written for *New York* magazine, among other publications.

**JOSEPH MONNINGER** is the author of eight novels and numerous stories and articles. He lives and teaches in New Hampshire. He has just released his first memoir, entitled *Home Waters*, about fishing with his dog Nellie.

**JACK MURNIGHAN** has a B.A. in Philosophy and Semiotics and a Ph.D. in Medieval Literature. His stories appeared in the *Best American Erotica* editions of 1999, 2000, 2001. His weekly column for Nerve, Jack's Naughty Bits, was collected and released as a book. He used to be the editor in chief of Nerve before retiring to write full-time and take seriously the quest for love.

**MAGGIE PADERAU** is a writer in New York.

**CHUCK PALAHNIUK**'s novels are the best-selling *Lullaby* and *Fight Club* (made into a film by director David Fincher), *Survivor*, *Invisible Monsters*, *Choke*, and *Diary*. He lives in Portland, Oregon.

**JANE ROSS** is the pseudonym of a writer living in New York City.

**J. L. SCOTT** is the pseudonym of a twenty-four-year-old writer/editor living in New York City.

**ALICE SEBOLD** is the author of the memoir *Lucky* and the novels *The Lovely Bones* and *The Almost Moon*.

**DANI SHAPIRO** is the author of the novels *Playing with Fire*, *Fugitive Blue*, *Picturing the Wreck*, and the memoir *Slow Motion*. Her short stories and essays have appeared in the *New Yorker*, *Granta*, the *New York Times Magazine*, and many other publications. She teaches creative writing at Columbia University and in the graduate writing program at The New School.

**ROBERT ANTHONY SIEGEL** is the author of the novel *All the Money in the World*.

**LAUREN SLATER** is a psychologist who has been published in five volumes of *The Best American Essays*.

**LEIF UELAND** received a Master's degree in the Professional Writing Program at the University of Southern California. He has written for public radio's *Marketplace* and several newspapers, and had a play produced in Minneapolis. His first book is *Accidental Playboy*.

**JOE WENDEROTH** grew up near Baltimore. His first two books of poems are *Disfortune* and *It Is If I Speak*. He wrote a chapbook, *The Endearment*, and a book, *Letters To Wendy's*. Some of the letters also appear on the 1999 compact disc *Sweet and Vicious*, where they are read by James Urbaniak. Wenderoth is assistant professor of English at Southwest State University in Marshall, Minnesota.

**HENRY WREN** is a writer living in New York.

# ACKNOWLEDGMENTS

BY RUFUS GRISCOM

Visitors to the Nerve office often comment on how "normal" the editorial team appears. It has never been clear to me exactly what they expected—studded leather dog collars? Translucent pink plastic skirts? Apparently it wasn't a bunch of industrious people wearing glasses and V-neck sweaters. Despite appearances, Nerve editors have always been a collection of risk takers, exceptionally talented people sacrificing conservative career paths and safe holiday conversations with in-laws in order to shine a light on a subject all too rarely given it's due. Without the towering contribution that each of the following people delivered—exceeding in scale both their compensation and the precedents for a publication such as ours—this book would not exist, and Nerve.com would probably be owned by a pharmaceutical company.

I would therefore like to thank, in order of appearance: Genevieve Field, Joey Cavella, Lorelei Sharkey, Jack Murnighan, Emma Taylor, Jessica Baumgartner, Ross Martin, Deborah Grossman, Grant Stoddard, Susan Dominus, Albert Lee, Isabella Robertson, Emily Nussbaum, Michael Martin, Sam Apple, Gwynne Watkins, Virginia Conesa, Carrie Wilner, Whitney Lawson, Tobin Levy, Rachel Hulin, Ada Calhoun, Will Doig, John Constantine, Peter Smith, Jodie Abrams, and Nicole Ankowski.

A few deserve extra dollops of gratitude: Genevieve and Jack profoundly shaped the early Nerve sensibility and solidified an editorial rigor and distaste for mediocrity that has endured ever since; Em and Lo leavened the site with an air of mischief and whimsy; Susan and Emily helped broaden our purview and professionalize our process; and Michael Martin has brought to bear a cultural enthusiasm, linguistic precision, and commercial pragmatism that have defined Nerve's last six years.

My wife, Alisa Volkman, meanwhile, has done more than put up with me: she has built the ad sales business that has sustained Nerve in the last half decade, and she has been a tireless source of wise counsel, whether or not solicited.

My final and most sonorous thanks goes to our contributors, the writers and photographers who created the work in this volume and the countless exceptional pieces that we were unable to fit into this book. It is they who have put flesh on the bones of this project. And it is, of course, all about the flesh.